COLLINS
COMPLETE
PAINTING
COURSE

COLLINS
COMPLETE
PAINTING
COURSE

General Editor

Ian Simpson

Contributors

Hazel Harrison

Judy Martin

HarperCollins*Publishers*

First published in 1993 by
HarperCollins Publishers
London

Copyright © 1993 Quarto Publishing

**A catalogue record for this book is available
from the British Library**

ISBN 0 00 412802-8

This book was designed and produced by
Quarto Publishing plc
The Old Brewery
6 Blundell Street
London N7 9BH

Senior Editor Hazel Harrison

Senior Art Editor Penny Cobb
Designer Debbie Sumner

Picture Researcher Mandy Little
Photographers Paul Forrester, Ken Grundy,
Les Wies, Jon Wyand

Art Director Moira Clinch
Publishing Director Janet Slingsby

Typeset in Great Britain by Typestyles
(London) Ltd
Printed in Singapore by Star Standard
Industries Pte Ltd
Manufactured in Singapore by J. Film
Process Pte Ltd

Contents

What makes a painting?

The simplest definition of a painting is to describe it as coloured marks on a flat surface. But there is more to it than that. These marks have to communicate with someone viewing them. They might describe a person or a place or they might invoke a particular mood or emotion. Above all, in any good painting, they tell you about the artist and his or her view of the world. To attract the viewer's interest, the artist's vision has to be presented so that the painting makes an initial impact, and the marks and colours have to be arranged so that they look "right" and in balance. This book will enable you to find your own view of the world and show you how to communicate it in painting.

Painting is mainly learned by doing it. All the teachers and books in the world can only provide you with information. The learning comes through practice. Learning to paint with the aid of a book can however, for many people, be the most effective way of learning. Most importantly, in carrying out the practical work which this book suggests, you can proceed to learn at whatever speed suits you.

AIMS OF THE COURSE

This book starts from the premise that anyone can learn to paint and that painting is a natural means of expression which all children do well. Unfortunately, most soon withdraw from it in the

PART ONE: INFORMATION FEATURES

PRACTICAL INFORMATION
Special information features introduce you to the different painting media or explain helpful "basics" such as perspective or human proportions.

TECHNIQUE DEMONSTRATIONS
The features on the painting media include demonstrations of techniques where relevant. More advanced techniques are explained in Part Three.

STARTER PALETTE
Each of the media features recommends a "basic palette" of colours.

MEDIA AND EQUIPMENT
The practical information features dealing with the painting media list everything you will need to make a start.

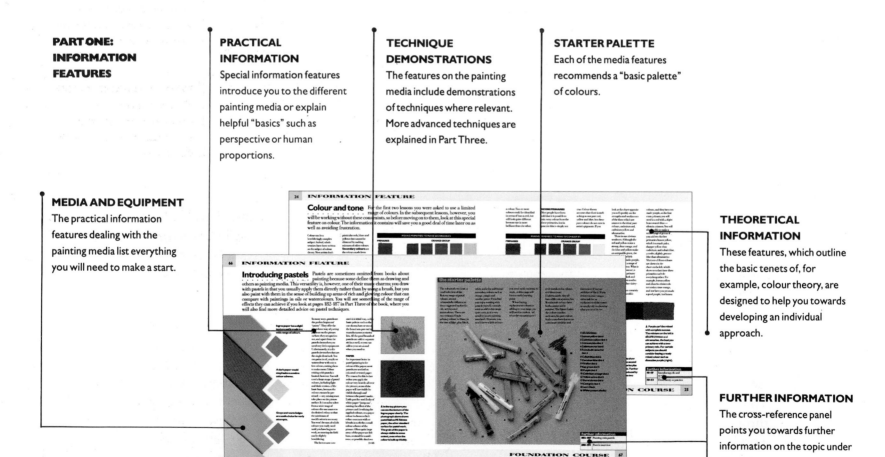

THEORETICAL INFORMATION
These features, which outline the basic tenets of, for example, colour theory, are designed to help you towards developing an individual approach.

FURTHER INFORMATION
The cross-reference panel points you towards further information on the topic under discussion.

INTRODUCTIONS
The core of the Foundation Course is eleven structured painting lessons and projects. Introductory text explains the general principles and the specific purpose of the project.

THE AIMS OF THE PROJECT
Each lesson includes an information panel setting out the particular aims of the projects and telling you how much time you will need to complete it.

SELF-CRITIQUE
The projects are followed by a number of questions for you to ask yourself after you have completed each one. This will help you to check your progress.

STEP-BY-STEP
Each project is illustrated with a full demonstration. You should not copy these; they are intended only to show how one artist carries out the particular exercise.

ALTERNATIVE PROJECTS
Each lesson includes suggestions for alternative related projects. These will give you a wider choice of subject matter; you can do one of them instead of the main project if you prefer.

OTHER EXAMPLES
Finished paintings by other contemporary artists are shown after each project. These are all related to the theme of the lesson, but show a wide variety of styles.

FURTHER INFORMATION
The cross-reference panel points you towards further information on the topic under discussion.

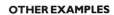

belief that painting is a special "gift" which requires a particular kind of talent. The book, which is in the form of a course arranged in three parts, aims to teach you to paint by encouraging you to see in the selective way that an artist sees. Then, by showing you how to explore the three-dimensional world in a systematic way, it aims to enable you to make your own paintings.

HOW TO USE THIS BOOK
This is not an ordinary book which you read through and then put down. It is a kind of workbook. Often it gives you specific instructions. Try to think of it, as you read it, as your teacher speaking to you. With most chapters it will be best to read the chapter straight through and then go back and step by step follow the guidance given, keeping the text open by your side as you work.

PART ONE
The first part of the book is a Foundation Course in Painting from which you will learn how to see as an artist and how to use colour to describe the things you see. It contains eleven lessons. Each has a project for you to carry out, with its own clearly stated aims so that you know exactly what to do. When you have completed your project, so that you can check what you have achieved, a self-

critique is provided in the form of a number of questions for you to ask yourself about your work. Your answers will tell you how well you have done. This is important, since with any course you need to be reassured that you are making progress. In addition to the main project each lesson has suggestions for alternative related projects. These are to give you more practice — because it is through practice that you will make progress. Or you can replace the main project with one of the alternatives if you wish — so allowing you more freedom to choose your own subjects. At strategic places between the projects there are Information Features giving you technical help and

information on, for example, perspective and the proportions of the figure.

PART TWO

The second part of this book is structured in a similar way to the first part with Lessons and Information Features. The twelve lessons in this part introduce you to the main approaches to painting. These will help you to develop a personal vision of the world and your own style of interpreting it.

Each lesson features a "key" picture by an old master or important modern artist demonstrating a particular approach to painting and, in

PART TWO: LESSONS

THE KEY PAINTINGS
The lessons in Part Two explore the major themes and styles in painting. Each one features a "key" painting by an old master or important modern artist.

OTHER EXAMPLES
In addition to the "key" painting, each lesson includes the work of contemporary artists working in a similar style or subject-area.

DETAILS
Selected details of the "key" paintings provide valuable insight into the artist's working methods.

OTHER ARTISTS TO STUDY
Each lesson provides brief descriptive biographies of other artists whose work you may like to study for further ideas and inspiration.

SUGGESTED PROJECTS
Each lesson concludes with suggestions for projects, enabling you to try out for yourself the approach that forms the subject of the lesson. Since there are several choices, you can choose one that particularly appeals to you or do more than one.

FURTHER INFORMATION
The cross-reference panel points you towards further information on the topic under discussion.

THE TEXT
The text explains the aims and ideas of the artist and his/her influence on painting today.

PART THREE:
TECHNIQUES AND
INTERVIEWS

THE TEXT
Clearly written text helps you to get the best out of your chosen medium by explaining some of the options open to you.

DEMONSTRATIONS
Technical information and step-by-step demonstrations for each of the painting media expand on the information given in Part One.

OTHER EXAMPLES
Finished paintings by contemporary artists back up the visual demonstration of techniques.

THE PROJECT
A project is set for each of the media, encouraging you to experiment with it.

BIOGRAPHIES
A brief biography of the artist accompanies each of the interviews.

FURTHER INFORMATION
The cross-reference panel points you towards further information on the topic under discussion.

EXAMPLES OF WORK
The interviews are illustrated with at least four examples of the artist's work.

QUESTION AND ANSWER
The interviews, in question and answer form, are informative and reassuring, providing insights into each artist's working methods and general approach.

addition, there are illustrations of other contemporary paintings showing how the past has influenced the present. The Information Features include more advice on, for example, using colour expressively, and this section of the book starts with a major feature on composition.

PART THREE
The third part of the book extends the information given in parts one and two by demonstrating how artists work today and how they use a variety of painting media. It will help you to decide which media and which ways of working them suit you best. As well as providing advanced technical information on the best-known media,

watercolours, oils, pastels and acrylics, it also explores more experimental approaches in collage, mixed media and monoprint. This part of the book is structured so that each topic starts with technical demonstrations of specific techniques, which lead on to a project enabling you to try for yourself a new approach to the medium concerned. This is followed by an interview with an artist who is expert in using the particular medium. These interviews, in question and answer form, are informative and reassuring and provide further insight into how artists work today. They will describe working methods which you will be able to adopt to suit your own developing identity as an artist.

PART ONE

Foundation Course

· · · · · · · · · · · · · · · · · ·

It is often said — but cannot be said too often — that painting and seeing are inextricably linked. But not everyone realizes that painting involves a special kind of seeing, which is more specific, selective and analytical than the ordinary, general perception that enables a person to carry on daily life. This way of looking at the world and the things in it, whether a small group of everyday objects or a panoramic landscape, can only be learned through experience, and it is the idea of looking and painting that forms the central theme of the Foundation Course.

The lessons and projects that follow require the minimum of materials and equipment and no prior knowledge of painting techniques. The subjects chosen are all related to the familiar things you encounter every day, such as objects on a table, your own face in the mirror, people you know, or the view through a window in your own home. At first, the emphasis is on painting what you see. The expression of ideas and feelings has a central role in art, but this comes later — initially you must learn how to assemble the building bricks for what, in time, will become your personal creation.

Looking and painting

People often imagine that artists paint from memory or from imagination. It is true that some do, but they are a very small minority; most artists develop their paintings from direct observation of objects, people and places. They either paint directly from nature or make drawings from nature to use as reference for pictures painted in the studio. The latter is a skill in its own right, which will be the subject of a later lesson, as will other ways of making paintings, but the concerns of this lesson are limited simply to painting a few objects placed on a table.

Those who have not painted before, or who have tried and made little progress, often feel uncertain as to how to make a start, or need some help getting out of a rut. The way to overcome such feelings is to begin to paint with a definite objective in mind. This lesson provides such an objective: it doesn't just ask you to paint the objects, but to do so in a particular way. Indeed, it is not even the objects themselves that are to be painted, but the spaces around them. This may sound perverse, but there are several good reasons for wanting you to work in this way.

NEGATIVE SHAPES
When you start to paint a simple still life group, such as two bottles and a plate on a table, it is perfectly natural to concentrate on the shape and colour of each object (the positive shapes) and to ignore the spaces between them

15 ▷

THE AIMS OF THE PROJECT
Painting negative shapes
———
Relating objects to each other
———
First steps in composition
———
Painting with a limited palette
•
COLOURS YOU WILL NEED
Three tubes of acrylic or oil paint: black, white, yellow ochre
•
TIME
2–3 hours

THE PROJECT
It is necessary to use paints which will produce opaque areas of colour for this project and several of the following projects, as they involve some trial and error. You can overpaint as much as you like in acrylics, and oil colours can either be overpainted or scraped off the painting surface and re-applied. If you have not used either paints before, turn to page 16, where you will find some practical advice.

Place four or five kitchen utensils on a table. They could be a pan, a measuring jug, a pair of scissors, a large spoon and a spice jar. You need to be able to see the negative shapes clearly, so if there is not enough contrast between the objects and the tabletop, put them on a white cloth or some brightly coloured paper. Try to place them so that they make an interesting pattern, with some nearer to you than others and different intervals of space between them. One of the things you will be discovering through this project is that a still life needs a variety of shapes, both positive and negative.

A LIMITED PALETTE
The project has a further and equally important aim, which is to discover the range of colours that

can be achieved by using only three tubes of paint. First, using very thin black paint, quickly draw the shapes of the objects. Then begin to paint the spaces between them, mixing colours as you think appropriate. Because you are using such a small palette you will not be able to copy the colours you see; instead you will begin to learn the importance of selection and "translation" which is an essential part of painting. You may be able to see small variations in tone and colour, which you can translate into mixtures of your three — it is surprising how many different colours can be produced from these.

1 ▶ **Using well-thinned black acrylic paint, the artist draws in the outlines of the objects. Notice the high viewpoint, which allows the spaces between them to be perceived as definite shapes, and the angle of the table, which provides opposing diagonal lines in the background.**

Henri Matisse (1869-1954), one of the greatest colourists in the history of art, made several early paintings which were restricted to these same three colours plus red.

As the painting develops, the positive shapes will begin to stand out like cutouts, so to prevent them appearing too prominent paint them with one single light colour made from a mixture of the three palette colours. Choose the one you think looks best, and try several if you need to — it is easy to overpaint in acrylic. When you feel you have done all you can, prop up your painting a few metres away and check the result.

2 ▶ **Small alterations are now made to the drawing, and the black outlines of the spoon and the edges of the plate are modified with white paint. Acrylic paint dries very rapidly, especially when thinned with water, as here, so corrections are easy to make at any stage.**

3 ▲ **A mixture of the three colours is used to block in the negative shapes, leaving the objects white. Although unpainted, they are clearly recognizable, and the balance of white and coloured shapes is pleasing. Notice how the** artist has linked the objects by arranging a series of "bridges" between them. In any still life, however simple, the relationship of the various shapes, both negative and positive, is an important factor.

tip

WORKING SIGHT SIZE
Drawing and painting accurately is much easier if you work the same size as you see, that is, so that your subject fits within the confines of your paper or board. It is extraordinarily difficult to scale up or scale down in your mind, and can be a recipe for failure. Working sight size does not mean you have to choose a particular paper size to suit. Think of using a viewfinder on a camera, and simply adjust your position until the image fits, as you do when taking a photograph. If you want to see the objects larger, for example, just move in closer.

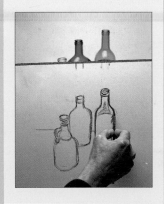

4 ▲ The painting of the negative shapes is now complete. The shadows cast by the objects have allowed the artist to introduce tonal contrasts, and there are also slight variations of tone and colour in the foreground.

5 ▼ The objects are now painted in a lighter mixture of the three colours. The paint is used quite flat, with no attempt to describe form — this is not the purpose of the exercise.

6 ▼ The high viewpoint has provided a strong pattern element, and the colours, although restricted, are nicely varied.

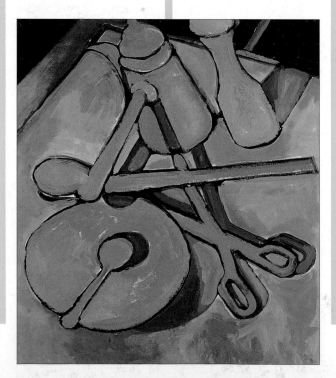

SELF-CRITIQUE

● Has the limited palette produced a colourful painting?

● Did you manage to restrain yourself from painting the objects?

● Are there interesting variations of colour in the shapes?

● Even though you concentrated on the spaces, do the positive shapes look convincing?

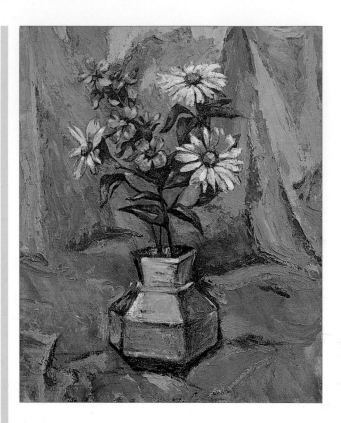

▲ Zinovy Shersher
Daisies in Vase
Acrylic on canvas
A small range of colours has been used here, but the effect is very powerful, with the blues of the flowers singing out against the more neutral colours. Notice how the artist has repeated the same blue on the top of the vase, and mxed it in with other colours in the background and foreground. In any painting, all the different elements should be related, so that the picture hangs together as a whole, and one of the ways of creating this kind of unity is by repeating colours from one area of the picture to another. Painting with a limited palette helps you to do this, as you are forced to use the same colours throughout.

(the negative shapes). As a result, you may then find that the objects look wrong — you are not sure why, but in an effort to correct, you keep on painting and repainting. If you train yourself to ignore the objects and look only at the shapes between them you will find it much easier to assess the shapes and relative sizes of the objects.

There is more than one reason for painting negative shapes. The spaces between things are just as important a part of a picture as the objects themselves, so this exercise also introduces the idea of designing, or composing, a picture. Composition is dealt with in detail in Part Two of the book, but it is relevant even at this early stage; as soon as you put a mark on paper you have begun to compose.

alternative projects

The more similar projects you carry out, the better chance you have of developing your painting and drawing ability and skill in mixing colours. You might like to try one of the following instead of the kitchen still life, or if you have done this and now have a better idea of negative shapes you could try it with different subjects.

SUGGESTED SUBJECTS
● Gardening or workshop tools
● Pot plants — choose those with large, simple leaves
● A musical instrument with its case and some music
● A "found" still life, such as pots and brushes on a dressing table; crockery on a dining table; the corner of a greenhouse with a few plant pots. Often the best still lifes are things accidentally arranged which you happen to see, without the need for making deliberate arrangements.

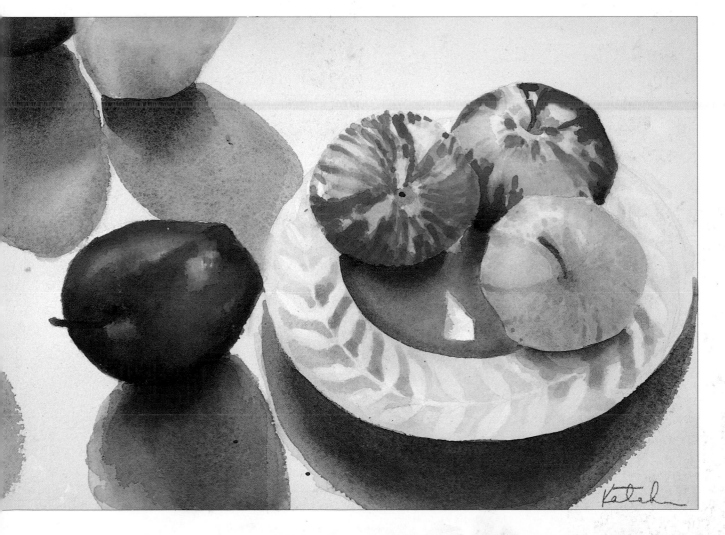

◄ Carole Katchen
Red and Yellow Apples
Watercolour
Here too the negative and positive shapes (fruit, plate and shadows) have been carefully planned. The picture also provides a valuable lesson in composing a still life. Instead of including the whole of the fruit at top left, the artist has allowed them to be cut off by the edge of the picture, using both the incomplete shapes and the complete shadows as devices to balance the foreground objects.

further information

16–19	Introducing oils and acrylics
48–51	Introducing watercolours
00–00	Composing a still life
172–177	Painting with watercolour and gouache

Introducing oils and acrylics

As mentioned in Lesson One on the preceding pages, the first projects in the Foundation Course are intended to be done in opaque paints, that is, either oils or acrylic, so those who have used neither before — or are familiar with one and not the other — will find these pages helpful. Oils and acrylics have much in common, though there is one major difference. All paints, including watercolour, are made from ground pigment mixed with some kind of adhesive binder to form a paste-like substance.

Not surprisingly, the binder used for oil paint is oil, usually linseed, while acrylics are bound with a synthetic or "plastic" resin.

ACRYLICS

This resin is both impermeable and extremely fast-drying, which can be both an advantage and a disadvantage. To take the positive side first: acrylic dries so rapidly that you never need wait for more than half an hour between stages of a painting, and because it is impermeable you can overpaint as much as you like without disturbing the colours beneath. On the negative side: it tends to dry on your palette, brushes (and clothes if you are careless)

and is sometimes impossible to remove.

One of the most intriguing characteristics of acrylic — and the one which is responsible for its growing appeal to artists — is that it can "imitate" two different and diverse kinds of paint, oil and watercolour. You can use it thick and solid, like oils, even applying it with a painting knife if you like, but if you thin it with water it behaves exactly like watercolour — indeed, it *is* watercolour, and is often used on paper in combination with real watercolour. It is thus the perfect starter medium, allowing you to experiment with widely differing painting methods with little financial outlay.

WORKING THIN OR THICK

◀ Acrylics can be thinned with water, and applied with soft brushes just like watercolour or gouache (see pages 48-51). It can also be used as thickly, or even more thickly than oil paint, and put on with bristle brushes or painting knives. You can combine both approaches in the same painting, contrasting transparent and opaque areas of colour.

Stretched canvas Canvas board Oil sketching paper

◄ Wooden palettes are traditionally used for oils. The rectangular ones usually fit into the lid of a paintbox. Plastic palettes are best for acrylic, or you can use the special Stay-Wet palette described below and shown below the white plastic one.

PAINTING SURFACES FOR ACRYLICS

You can also paint on virtually anything provided it is not glossy or oily — inexpensive cartridge paper, watercolour or pastel paper, canvas or canvas board. If you use a lot of water, however, thin paper may buckle, so it is advisable to stretch it first

◄ Oils are usually done on canvas or canvas board, but you can also paint on surfaces such as hardboard provided you prime them first. All these are also suitable for acrylics, but one of its great boons is that you can paint on anything, so you can use plain paper for early experiments.

(see page 50) or use something with more body, such as watercolour paper. Surfaces for oil paint have to be primed before use, but those for acrylic need no preparation. The canvases and painting boards sold by art suppliers are usually prepared with a primer that will accept both oil and acrylic, but make sure about this before buying; oil can be put over acrylic but not vice versa.

PALETTES

Acrylics can be mixed on an ordinary oil-painters' palette, but it is not recommended; the paint dries so fast that you may quickly ruin it. An old

plate, either china or tin, is quite satisfactory, as with the aid of hot water you can scrape the dried paint off fairly easily. If you find you enjoy the medium and want to work with it regularly, consider buying one of the special 'Stay-Wet' palettes specially designed for acrylic work.

These have a top layer of non-absorbent paper and a layer of blotting paper below, both of which fit into a shallow plastic tray which you fill with water. The colours are laid out on the top layer, and sufficient water seeps through from the wet blotting paper to prevent them drying. There is also a clear plastic cover which you can put over the whole thing between painting sessions,

which will keep the paint moist more or less indefinitely.

If you have any difficulty buying one, you can make a version of the same thing, using kitchen greaseproof paper for the top layer. The only real problem with these palettes is that you don't have a great deal of space for colour mixing, so if you are using a lot of thick paint you may have to mix on another surface. They are ideal for acrylics used in the watercolour "mode", however, and more or less essential for outdoor work.

OIL PAINTS

Oil paints are more flexible than acrylics, in that they do not dry quickly, and this enables you to move colour around on the painting surface, mixing one wet colour into another. When you are a practised painter this can be very satisfying, but until then you may find that

modifying wet colours gets you into rather a mess. If you lay too many wet colours one on top of another you will end up with nothing but unpleasantly textured mud. However, because oils stay wet for some time, you can scrape off offending areas with a palette knife and start again.

PAINTING SURFACES FOR OILS

The traditional surface for oil painting is canvas, which is attached to a frame called a stretcher. It is pleasant to work on, is light and easy to carry for outdoor work, and can be removed from the

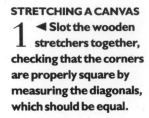

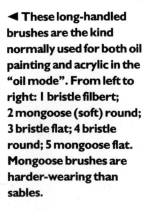

STRETCHING A CANVAS

1 ◀ Slot the wooden stretchers together, checking that the corners are properly square by measuring the diagonals, which should be equal.

2 ◀ Cut the canvas to size, allowing a margin of 5-6 cm (2-3 ins) all the way round for stapling (use tacks if you have no staple gun).

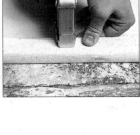

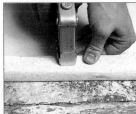

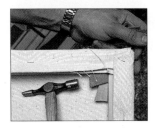

3 ◀ Fold the canvas over onto the reverse side of the stretcher and, starting in the middle of one of the long sides, staple or tack in place.

4 ◀ Put in staples or tacks every 8 cm (3 ins) from the centre to the first corner. Repeat the process on the other side and then the two short sides.

5 ◀ Mitre the corners neatly by folding one edge over the other, then staple or tack the corners diagonally to fix both edges in position.

6 ◀ Tap the wooden corner wedges into position so that the fabric is tight. If it becomes loose later on, simply tap the wedges in more firmly.

stretchers and stored without taking up much space. However, it is not cheap, and is thus not recommended for early experiments. There are several different kinds of painting board with a simulated canvas texture, or you can buy oil sketching paper which is useful because you can cut it to any size you like. You can also paint on ordinary cartridge paper or watercolour paper. Ideally, these should be primed before use (simply apply a coat of acrylic primer) but you can use them untreated if you accept the fact that the painting will not last — the oil will seep into it and it will eventually disintegrate. You could try oil on paper for some of the early projects; the absorbency of the paper will cause the paint to dry almost as quickly as acrylic.

BRUSHES FOR OILS AND ACRYLICS

You can use the same brushes for oil and acrylic. You will need bristle brushes in a variety of sizes — you could start with Nos. 2, 6 and 8. Brushes come in different shapes as well as sizes, the three main ones being rounds, flat and filberts. Unfortunately, the only way you can find out which ones you like best is through practice, but filberts, which are a compromise between rounds and flats, are probably the most versatile, so it is suggested that you start with these. You will also want at least two soft brushes — more if you use acrylic in the watercolour mode. Ideally, these should be sable, but sable brushes are very expensive, and both oils and acrylics can spoil them rapidly, so start with one of the synthetic sables or a sable and synthetic mixture, in sizes 4 and 6. It

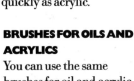

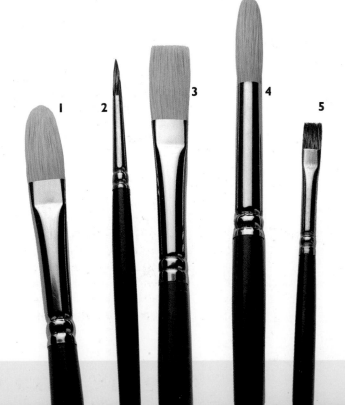

◀ These long-handled brushes are the kind normally used for both oil painting and acrylic in the "oil mode". From left to right: 1 bristle filbert; 2 mongoose (soft) round; 3 bristle flat; 4 bristle round; 5 mongoose flat. Mongoose brushes are harder-wearing than sables.

◄ Acrylic gesso is an excellent all-purpose primer for both acrylic and oil-painting surfaces.

is best to start with the minimum number of brushes and add when more are needed.

MEDIUMS AND DILUENTS

Both oil paints and acrylics can be used neat and undiluted, but usually some thinning is required. Many artists begin a painting with thin paint and build it up more thickly as they progress, saving the thickest paint for the final stages. Acrylic should be thinned with water, and oil paint with

▼ The only mediums you will need initially are turpentine and linseed oil.

turpentine (or white spirit). Turpentine, like water, is known as a diluent. Paint thinned with it dries fast, so if you use it in the early stages you will not have to wait long before putting other colours on top.

There are other substances which are used in the course of painting, and these are called mediums. For oil paint, the commonest medium is linseed oil, normally used with turpentine in a half and half mixture. You do not have to use a medium at all, but you may find it makes the paint more malleable. Several mediums are sold for acrylic paint, but the only one that is really useful when you are starting out is a retarder, which prevents the paint drying so quickly. There is more about special mediums on page 165.

The suggested starter palette shown here is suitable for both oils and acrylics. The colours sometimes vary in name, for example, there is no viridian green in acrylic, but there is something very like it. The acrylic colours are given in brackets after the oil ones. This palette shows a larger selection of colours than you will need for the initial projects; it is the one you will work up to gradually after experimenting with a smaller range. Always try to lay out your colours in a logical order. Most artists evolve their own system and stick to it so that they can always be confident of finding a colour without having to search for it. These are laid out from light to dark.

Titanium white

Cadmium yellow

Lemon yellow (Cadmium yellow lemon)

Yellow ochre

Alizarin crimson

Cadmium red

Viridian (Phthalocyanine green)

Raw umber

Ultramarine

Cobalt blue

Ivory black (Mars black)

▲ The oil colours shown here are the same in both the Winsor and Newton and the Rowney ranges. The names of oil colours vary very little from one manufacturer to another, but those of acrylics are more idiosyncratic. The names in brackets refer to equivalent colours in the Liquitex acrylic range.

Extending the colour

This lesson has a close relationship to the previous one, but departs from it in a number of ways. For the last project, only three basic colours were used, but they were mixed to make a relatively large range. In this case the range of basic colours is still limited, but this time there is no possibility of colour mixing, because paints are not to be used at all. Instead, the picture is built up from a predetermined set of colours — those provided by coloured paper.

Working with coloured paper is both enjoyable and instructive. Enjoyable because you do not have to agonize over which colour mixture best represents what you can see, and so you are free to make a picture which is not bound by the constraints of naturalistic representation. And instructive because you will have to make conscious decisions as you work, which will enable you to discover a great deal about the process of picturemaking. What you have to do is to choose which of the coloured papers to use to "translate" an aspect of the chosen subject. For example, if your subject has a prominent dark subject such as, say, an aubergine, you would use the darkest paper you have for the aubergine, regardless of whether it is the correct colour.

If you work thoughtfully you may even achieve a surprising likeness of the objects, but what is more important is that you will have gained an understanding of the process of translation which is

23 ▷

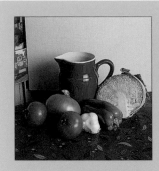

**THE
AIMS OF THE
PROJECT**
**Analysing the lightness
and darkness of colours**
———
**Balancing shapes and
colours**
———
Designing the picture
———
First steps in collage
•
WHAT YOU WILL NEED
**A selection of coloured
papers, not more than six**
———
Scissors
———
**Large sheet of cartridge
paper**
———
Paper glue
———
Pencil and eraser
•
TIME
3-4 hours

THE PROJECT
You can buy a selection of coloured papers if you like, but most people have a lot of such materials to hand if they look. You can use wrapping paper (not patterned), plain brown paper, old envelopes, flat colours torn from magazines and so on. You will need a good range of tones (the term which describes the lightness or darkness of a colour). Collect the paper before you set up your group rather than selecting objects and trying to match their colours in paper, because this would to some extent defeat the purpose of the exercise.

THE SUBJECT
Choose a selection of still life objects with plenty of variety. A fruit and vegetable group consisting of a cut cabbage, cut and uncut peppers, with perhaps some tomatoes and a half-peeled orange, will give some interesting contrasts of shape and size and bring in a pattern element, which you can exploit using the cut paper.

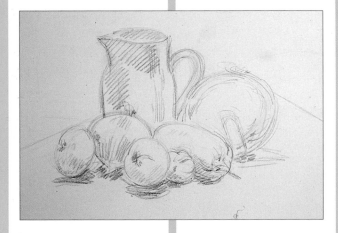

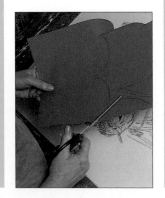

1 ▲ A drawing is made first, to ensure the correct placing of the first colours.

2 ◄ A rough outline of the jug has been drawn, with the blue paper held over the drawing. The shape is now cut out.

Arrange these on a table so that you can look down on them — the patterns made by the objects will then be stronger. Take care with the arrangement, making sure that the spaces between the objects are not symmetrical (see previous lesson).

WORKING METHOD
Once you are happy with the group, make an outline drawing in pencil to act as a guide for the paper shapes. Choose the most dominant colour or shape in the group — this could

be the background or one of the vegetables — and match this as closely as you can to one of the paper colours. This will act as a key to which you can relate the other colours. You do not have to stick it down at this stage, though you can if you wish. Sometimes it is more satisfactory to cut several of the shapes first and move them around until you are happy with the shapes and relationships. Continue working in the same way, trying to match each element of the subject as

closely as possible. If you have stuck down a shape that looks wrong, simply cut another and stick it over the first.

ASSESSING THE DESIGN
When you feel you have completed the picture, stand away from it and look at the overall effect. You may find that you have not filled the paper to the edges and thus have too much space around the objects. There may be too much on one side, making the picture look unbalanced. When

photographers print an image, they often choose only part of it, and you can do the same thing with a painting by masking off some areas, or "cropping in", as photographers call it. To try the effects of this, cut four strips of white paper about 4cm (1½in) wide and the length of the longer side of the cartridge paper and arrange them around the picture like a frame, moving them until you find the best arrangement of the subject within the rectangle. In fact you need not be bound

by a rectangular format; you could mask the picture to sit within a square if it looks better that way, or you could turn a horizontal rectangle into a vertical one by taking only the central section.

5 ▼ The main colours are now in place. This stage of the collage is similar to the blocking in stage of a painting; further refinements can be made later by sticking smaller pieces over the large ones.

3 ► The jug is the darkest tone in the still life, as well as the largest area, so this is chosen as the starting point. By coincidence, the blue paper is quite similar in colour to the jug itself, but the other paper colours do not match the objects, so the artist will choose those that relate most closely in tone.

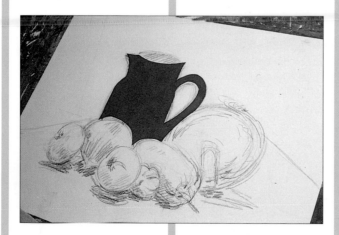

4 ► The blue of the jug has been repeated for the shadows below the vegetables, and a mid-toned beige-brown is selected for the green pepper and the lower areas of the tomatoes.

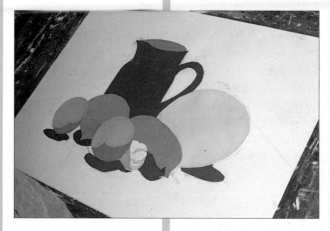

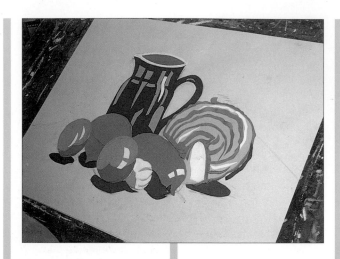

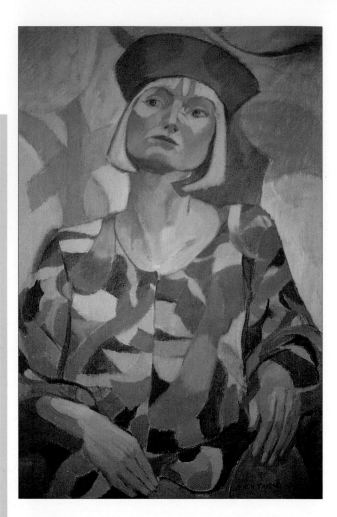

6 ▲ Highlights have now been added to the jug and vegetables, and curved strips of lighter and darker paper describe the cut cabbage. Because the base paper is coloured, small pieces of white can be used for the lightest areas.

7 ▼ Although the colours are not "true to life", the collage is a perfectly convincing representation of the still life group. Colour is only one way of describing objects — shapes and tones are equally important in painting.

▲ The finished collage is now masked in different ways to decide on the best design. Sometimes you will find that a picture looks better cropped, so that the objects are not all grouped in the centre. You might even find that the central section makes a satisfactory composition on its own.

SELF-CRITIQUE
● Did you have difficulty identifying tones?

● Are you pleased with your translation of the colours?

● Are the cut-out paper shapes convincing representations of the objects?

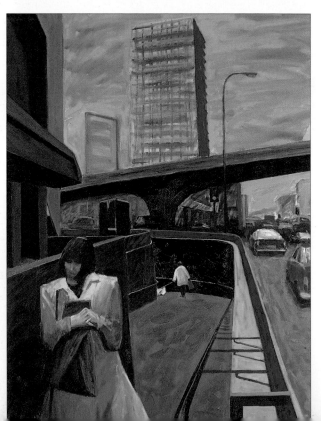

◄ Olwen Tarrant
Vesla
Oil
The colours in the face, while giving a convincing impression of flesh, are equivalents rather than precise descriptions of observed colour, skilfully "keyed up" to repeat the vivid colours in the dress.

◄ Oliver Bevan
Hanging On
Oil on canvas
This is an even more striking example of the way colour can be used non-naturalistically but still provide a powerful description of place and atmosphere.

► Olwen Tarrant
Tulips on the Landing
Oil on canvas
Pattern is always a strong element in this artist's work, and although this is an oil painting it has a slightly collage-like feeling, with the tulips treated almost as flat cut-outs.

central to painting. You can never copy the real world exactly: firstly it exists in three dimensions and a picture in only two, and secondly there are more tones and colours in it than any number of tubes of paint, however carefully mixed, can reproduce. The major task of the artist is to find equivalents for what is seen.

COLLAGE AND DESIGN
The first aim of the exercise is to find these equivalents, by looking hard at the colours and estimating how light or dark they are, but it also introduces other, more advanced, artistic ideas. When you are painting in the conventional way, with paints and brushes, it is very easy to become so involved in the pure mechanics of mixing and applying colour that the overall design of the picture becomes lost. After hours of work you may find that you have painted one part very nicely, but the picture does not add up to anything. Collage, which is the term for making a picture from pieces of paper (or cloth, or indeed almost anything) forces you to think about design, or composition, from the outset, because each piece of paper has to be cut to a specific shape. Collage is an important branch of painting, which will be explained and illustrated more fully in Part Three of the book, and if you enjoy this project you may find you want to experiment with more ambitious ways of working with collage.

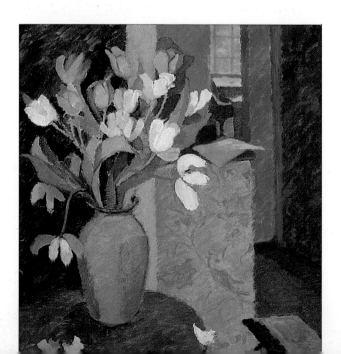

alternative projects

There are many other subjects that can form a basis for collage, and you can also vary the colours of the paper you use. If you originally worked with a selection of neutral browns and greys and found the picture looked dull, try a range of bright ones instead. Or you could try paper with different textures, juxtaposing glossy magazine sheets and matt cartridge paper — texture has a surprising effect on the quality of the colour because gloss surfaces reflect more light than matt ones. Another variation is to tear some of the paper shapes instead of cutting them, so that you have a contrast between sharp, clean edges and softer, more ragged ones.

SUGGESTED SUBJECTS
● A potted plant or flower
● A group of cushions on a chair or sofa
● A group of children's toys
● Some brightly coloured books and magazines arranged "untidily"

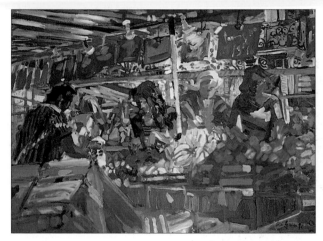

▲ Peter Graham
Street Market in Paris
Oil
Graham seldom uses colour literally, and his palette is highly personal. Here bright oranges, reds, blues and mauves are played off against each other.

23

Colour and tone

For the first two lessons you were asked to use a limited range of colours. In the subsequent lessons, however, you will be working without these constraints, so before moving on to them, look at this special feature on colour. The information it contains will save you a good deal of time later on as well as avoiding frustration.

Colour can be a bewilderingly complex subject. Indeed, whole treatises have been written on the subject of colour theory. Most artists don't go into the subject in this kind of depth — though some do, simply because they are fascinated by it — but it would be absurd to pretend that you can be an artist without knowing anything about the properties of colour. You can, of course, learn a great deal by patient observation and trial and error, but it could take a lifetime to understand why certain juxtapositions of colour work and others don't, so most students wisely take advantage of other people's work on the subject. This by no means rules out finding your own ways of using colour — you certainly will, since no two artists use it in quite the same way — but it does make it easier to learn the basic ground rules.

COLOUR TERMS

There are various words and phrases you are bound to come across whenever colour is discussed, even in the pages of this book, so it will be useful to begin by defining them.

Primary colours are the particular reds, blues and yellows that cannot be obtained by making mixtures of other colours.

Secondary colours are the colours made from mixtures of two primaries, i.e. red + blue makes purple; blue + yellow makes green; red + yellow makes orange.

Tertiary colours are mixtures of one primary and one secondary; in effect, three colours. For example, red + green makes brown.

Complementary colours are those which react most with each other and are the colours which are opposite one another on the colour wheel, such as red and green, yellow and violet.

Tone refers to the lightness or darkness of a colour.

Hue is the property of a colour that enables it to be identified as, for example, red, yellow or blue.

Intensity (also called saturation or chroma) describes the brightness of

► **Three primary colours, plus black and white, can make a wide range of other colours, both vivid and subtle.**

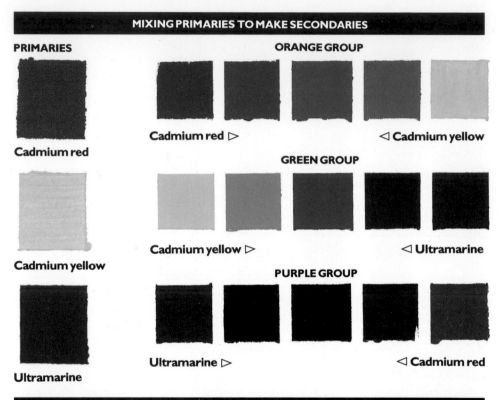

MIXING PRIMARIES TO MAKE SECONDARIES

PRIMARIES

Cadmium red

Cadmium yellow

Ultramarine

ORANGE GROUP

Cadmium red ▷ ◁ Cadmium yellow

GREEN GROUP

Cadmium yellow ▷ ◁ Ultramarine

PURPLE GROUP

Ultramarine ▷ ◁ Cadmium red

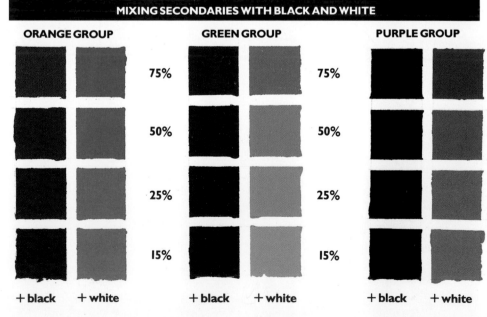

MIXING SECONDARIES WITH BLACK AND WHITE

ORANGE GROUP		GREEN GROUP		PURPLE GROUP	
+ black	+ white	+ black	+ white	+ black	+ white

75% 75%
50% 50%
25% 25%
15% 15%

a colour. Two or more colours could be identified in terms of hue as red, but still look quite different because one is more brilliant than the other.

MIXING PRIMARIES
Most people have been told that it is possible to mix every colour from the three primaries, but in practice this is simply not true. Colour theory assumes that there is such a thing as one pure red, yellow and blue, but these pure colours do not exist in artist's pigments. If you look at the chart opposite you will quickly see the strengths and weaknesses of the three which are nearest to the ideal pure colours, cadmium red, cadmium yellow and ultramarine.

There is one obvious weakness. Although the red and yellow make a strong, clear orange, and the blue and yellow make an acceptable green, the blue and red, which theoretically make purple, actually make a range of greys and browns. What is impressive, however, is that just three primary colours plus black and white have been used to produce a further thirty-three colours.

But they have certainly not made all possible colours, and they have not made purple, so the first extra primary you will need is a red with a slight bias towards blue — alizarin crimson. You will also be able to make a wider range of greens if you add two further primaries: lemon yellow, which is a much paler, sharper yellow than cadmium, and cobalt blue, a cooler, slightly greener blue than ultramarine. Mixtures of these colours are shown in the chart on the left, which shows you that these three primaries can't do everything either. For example, lemon yellow and alizarin crimson do not make a true orange, and nor have you yet made a good purple, but lemon

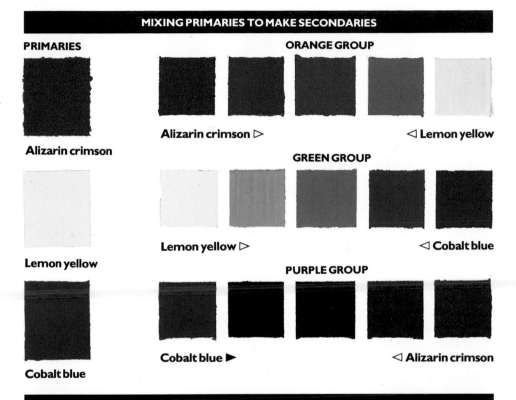

MIXING PRIMARIES TO MAKE SECONDARIES

PRIMARIES

Alizarin crimson

Lemon yellow

Cobalt blue

ORANGE GROUP

Alizarin crimson ▷ ◁ Lemon yellow

GREEN GROUP

Lemon yellow ▷ ◁ Cobalt blue

PURPLE GROUP

Cobalt blue ▶ ◁ Alizarin crimson

MIXING SECONDARIES WITH BLACK AND WHITE

ORANGE GROUP

GREEN GROUP
75%
50%
25%
15%

PURPLE GROUP
75%
50%
25%
15%

+ black + white + black + white + black + white

◀ These charts show mixtures of the second group of primaries plus black and white. Further colours are produced by intermixing the two groups.

▲ Purple can't be mixed with complete success. The mixture on the left is alizarin crimson and ultramarine, the best you can achieve with a two-primary mix. For certain subjects you should consider buying a ready mixed colour such as dioxazine purple (right).

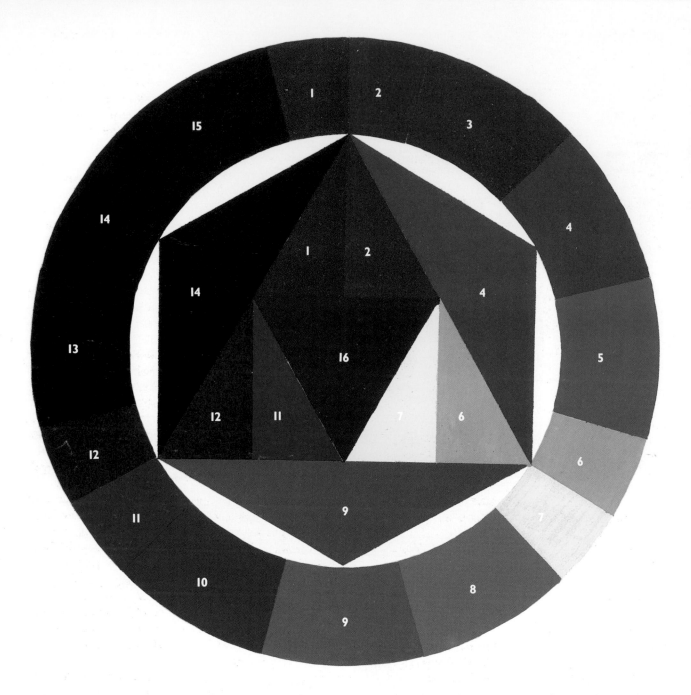

◄ With the exception of the brown in the centre, the tertiary colours are all quite vivid because they have been mixed with the colours next to them. More neutral colours are achieved by mixing colours more widely separated on the wheel (see opposite page).

PRIMARY COLOURS
1 Alizarin crimson
2 Cadmium red
6 Cadmium yellow
7 Lemon yellow
11 Cobalt blue
12 Ultramarine

SECONDARY COLOURS
4 Orange (cadmium red + cadmium yellow)
9 Green (cadmium yellow + ultramarine)
14 Purple (alizarin crimson + ultramarine)

TERTIARY COLOURS
3 Orange + cadmium red
5 Orange + cadmium yellow
8 Green + lemon yellow
10 Green + cobalt blue
13 Purple + ultramarine
15 Purple + alizarin crimson
16 A mixture of all six primaries

yellow and cobalt blue achieve a clear, sharp green. The lesson of this is that the strongest secondary colours are made by mixing those colours which have a slight bias towards each other.

THE COLOUR WHEEL
Colour wheels come in a variety of forms. Some show pure colours based on those of the spectrum, but these are not helpful in the context of painting. As you have discovered from the previous charts, artist's pigments are not pure, don't match the colours of light, and behave quite differently. The wheel shown here has been done with acrylic paints, using primary colours to produce both secondary and tertiary ones.

One thing you will notice immediately is the dramatic difference in tone between the colours shown here — no white or black has been used, yet the purples and blues are very dark compared to the yellows and any colours with yellow in them. You'll find that you often have to add a little white to achieve a really successful purple, while green can sometimes be lightened by adding yellow alone.

WARM AND COLD COLOURS

Something else you will notice is that the colours on the wheel fall into two groups, the so-called warm colours — the reds and yellows — and the cold ones, the blues and greens. Identifying these is very important in painting because the warm colours are inclined to come forward and the cold ones to recede. This is a way of creating space; if you paint a group of oranges against a greenish- or bluish-grey background you will notice how the orange almost jumps towards you.

Using colour is not, however, always as simple as that because almost all colours have warm and cold versions. Although the warm colours are generally held to be the red, oranges, yellows and any mixtures that contain these, such as red-brown and yellow-green, colour temperature, as it is called, is relative.

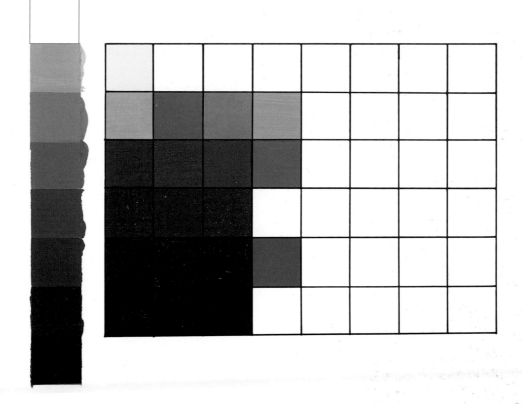

Look at the different versions of the primary colours on the wheel, and you will see that each has a warm and cold version.

COMPLEMENTARY MIXTURES

◄ **As we have seen, the most vivid secondary colours are those made by mixing two primaries which have a bias towards each other, and thus are close together on the colour wheel. Mixing complementary primaries produces the opposite effect. These neutral colours can be a useful foil in an otherwise bright colour scheme.**

HARMONIOUS AND COMPLEMENTARY COLOURS

Something else you will see in the colour wheel is that the colours next to one another are harmonious, that is, if you used them together in a painting they would not set up any kind of discord, or clash. Those directly opposite one another are quite different, however. These — red and green, yellow and violet, and blue and orange — are called the complementary colours. They also play a central role in painting, because when they are juxtaposed they set up a kind of vibration which makes both appear

brighter. A large area of green can be given an extra sparkle by the addition of small touches of red, and a little green on the shaded side of a red object brings out the colour in the same way. The Impressionists used such effects widely, claiming that every shadow contained touches of the complementary colour of the object.

The next thing you will need to learn about colour is how its intensity (or chroma) relates to tone which, as you already know simply means lightness or darkness of a colour.

MATCHING COLOUR TO TONE

◄ **Making charts like this will help you to assess tonal values. Notice that yellow is always lighter than the other colours.**

LIGHT AND DARK COLOURS

It is surprisingly difficult to judge the tones of colours, as the eye is much more receptive to hue than to how light or dark it is. However, it is important to learn to identify tones, as contrasts of light and dark have a vital role in painting, and you may find it helpful to make charts like the ones shown here (left).

On the left side is what is known as a grey scale, with white at the top, black at the bottom, and five equal steps of grey between them. Opposite each one of these has been placed the primary, secondary or tertiary colour which best matches the particular shade of grey. You could extend this chart by using some of the secondaries mixed with black or white shown on the previous pages.

Making colour charts and wheels like the ones shown on these pages is an important part of an art student's education, and

further information	
16–19	Introducing oils and acrylics
110–113	Expressive colour

▲ Primary contrasts can be effective, but you can often bring out the vividness of a colour by juxtaposition with a neutral tertiary colour.

▲ The central squares are exactly the same size, but a pale colour surrounded by a dark one always appears larger than the reverse.

you will learn about colours and their different properties by doing your own experiments. Such exercises are also enjoyable, because you don't have the worry of trying to match a colour to something you are actually trying to paint.

HOW COLOURS AFFECT EACH OTHER

Colour contrasts can be obtained by using complementary colours, or by juxtaposing different hues, or colours with different tonal values. This seems fairly obvious, but there are three other important factors that affect colour contrast, and these are less obvious.

Firstly: contrast is affected by the relative size of the colour areas. You can try this out very easily. Paint a small square of blue and surround it with a large area of red. Then reverse the colours, with the red occupying the smaller area. You will see that the colours do not look the same.

The second factor is the texture of the paint. A flat area of colour looks different to one in which the brushstrokes are visible, and if the paint is applied thickly with a knife it will look different again. You can try this out too; you may be surprised at the effect.

The third contrast, between warm and cool colours, has already been explained on the previous pages, but it is worth reiterating that the warmness or coolness of a colour does not exist in isolation. Although blue does tend to recede it will only do so if the other colours used are sufficiently warm to provide the necessary contrast. Inexperienced landscape painters sometimes make the mistake of painting background hills a vivid blue, secure in the knowledge that blue recedes, only to find that because none of the other colours match the blue in intensity, it does exactly the opposite. The strongest

► The way you put on the paint can affect the colour quite dramatically. When it is thickly applied, either with a brush or a painting knife, the raised swirls and ridges catch the light and cast tiny shadows.

colour in a painting will always tend to advance, particularly if it occupies a large area.

One of the difficulties — and delights — of using colour is that all is relative. No colour has an independent existence; it is "made" by the way it is juxtaposed with other colours. This fact is central to painting, as it is this that allows artists to simulate the colours of nature with what is, by comparison, a fairly small range of

▼ You can carry out your own experiments in optical mixing by painting on graph paper. The closer the colours are in tone the better they will mix.

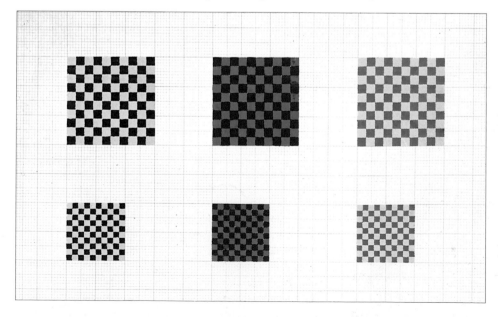

pigments. Not even a whole manufacturer's range of colours can reproduce all the colours you see; you will always have to make red look more red or orange more orange by the way you orchestrate the colours around it. The illustrations on these pages will give you some idea of how colours interact with each other, but try your own experiments too, as these will teach you far more than looking at other people's.

COLOUR AND TONE

As you have seen, when two or more colours are placed together they look quite different to the way they would if seen separately, on a neutral background. This leads to an alternative way of mixing colours — not on the palette but on the painting surface itself.

OPTICAL MIXING

Many artists have become obsessed with the fascinating intricacies of colour theory, but the French artist Georges Seurat (1859-91) was a particularly notable pioneer in this field. Having studied both scientific treatises on colour and the diaries of Eugène Delacroix (1798-1863), who had also been an ardent colour theorist, he developed a completely new method of painting. This method, known as "Pointillism" (though Seurat himself preferred the term "divisionism"), was based on the idea that it was possible to produce brighter, more vibrant secondary colours if the appropriate primaries were applied to the picture as tiny blobs, close together but not actually mixed. The mixing takes place in the viewer's eye or, to be precise, in that part of the brain which governs colour perception.

Thus the most brilliant green, Seurat considered, would be obtained by

◀ **This detail from a painting by Paul Signac (1863-1935) shows a mosaic-like application of small blocks of colour. Signac was a follower of Seurat, but he applied the Pointillist principles less rigidly.**

applying pure dots of primary blue and yellow, which when seen from a reasonable distance would fuse together to read as green. The Impressionists had used a less systematic version of the technique earlier, when they increased the brilliance of their colours by breaking them up into a mass of varicoloured brushstrokes.

DECEIVING THE EYE

In a sense, the whole business of painting — creating the illusion of three dimensions on a flat surface — is a series of optical tricks, so it is important to realize that many visual illusions take place in painting. One such is seeing a colour that isn't there. If you look hard at a colour for half a minute and then look away or shut your eyes you will automatically see its complementary. Try this by painting a red cross on the top of a piece of light grey paper, about 5cm (2 ins) in height and width and with lines about 2cm (³/₄ in) wide. Stare at it hard for a minimum of thirty seconds. Then look down at the empty bottom half of the paper and you will see a distinct green cross. This curious phenomenon is one of the reasons why the complementary of a colour appears in its shadow. When you look from a light-struck area to a shadowed one, the after-image becomes apparent in just the same way.

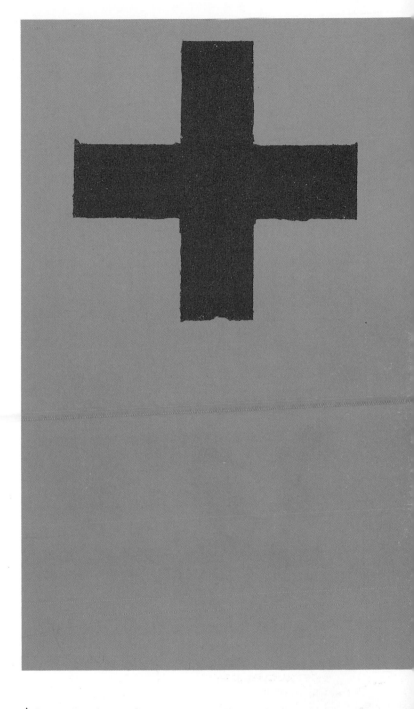

▲ **Staring hard at a colour and then shutting your eyes, or transferring your gaze to a blank, neutral area of colour will produce an after-image of the colour's complementary.**

From theory to practice

If you have studied the previous pages — and particularly if you have tried out some of the ideas for yourself — you will have learned something about colours and tones and how they behave. But in painting, as in everything else, there is a gulf between theory and practice, which the following project is designed to help you bridge. What you will be doing is choosing another group of still life objects to paint and mixing colours which describe them as closely as possible. Colour charts, valuable though they are, are not directly related to anything seen. When you are faced with reality you have a dual task: firstly that of identifying each colour in your mind and secondly that of mixing paint to translate it accurately.

PAINTING STILL LIFE

Any readers who are wondering — as they justifiably might — when subjects such as landscape and figures will appear in this course are owed some words of explanation about the present emphasis on still life. There is a good reason for it. Still life, as its name implies, is a captive subject; it does not become restless and move as a figure will, nor is it subject to the ever-changing light conditions that the landscape painter has to contend with. It can be chosen and arranged to suit each artist's requirements, and most important of all, it gives you the chance to work quietly and at your own pace without outside interference. The mechanics of painting, such as analysing, mixing and manipulating colours, cannot easily be learned when you are working in a hurry, so it makes sense to begin

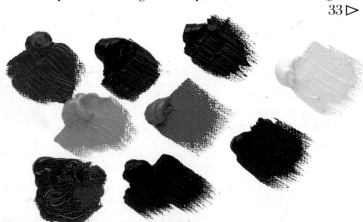

33 ▷

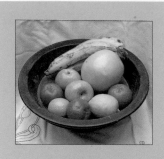

**THE
AIMS OF THE
PROJECT
Relating colour to tone**

———

Modelling form

———

Observing reflected light

———

Mixing colours
●
**COLOURS YOU WILL
NEED**
(see below left)
**Oils or acrylics: white,
cadmium red, alizarin
crimson, ultramarine,
cadmium yellow, yellow
ochre, viridian, black,
raw umber**
●
**TIME
5–6 hours**

THE PROJECT

You will not need an elaborate group for this exercise, because the idea is to concentrate on a small area and analyse the colours within it. An apple and a pear (or orange) on a plate or a table would be ideal. If there is insufficient contrast between the plate and the tabletop you should put some coloured paper below it, which will also throw up some of its colour into the fruit to provide more variety.

PAINTING IN TONE

The project has two separate stages: in the first you establish the tones, painting entirely in mixtures of black and white, and in the second you match the colours to both the tonal underpainting and the objects. This was the standard painting method of the eighteenth- and nineteenth-century academic painters, who built their paintings on an elaborate tonal underpainting, usually in brown, adding the colour only at the final stages.

You can make a preliminary pencil drawing to establish the main shapes if you like, or you can start painting straight away. Look hard at the subject, trying to see it in terms of tone rather than colour. This is

surprisingly difficult, as our eye registers colour much more readily — it helps to half close your eyes, which simplifies the images, diffuses the colour and allows you to judge the tones more easily. When you begin to paint, begin with the darkest tones, but avoid using pure black; there are no real blacks in nature, and it is certain that even the deepest shadow will be nowhere near black. Work from the dark tones, through the middle ones and up to the lightest — which will probably not be pure white — paying particular attention to the way the light and shadow describes the form of the objects.

PUTTING ON THE COLOUR

If you have completed the first stage successfully you should have a convincing three-dimensional representation of the still life. Decide which is the most dominant colour in the group, mix up the best approximation you can, and place a brushstroke on the picture surface. You will probably find this first attempt is not right: the colour may be darker or lighter than your tonal underpainting, or it may be the wrong kind of green or yellow, that is, too warm or too cool. If this is the case, try again. You are

bound to make more mistakes as you work, but the first patch of colour will be the key for the others, so it is to your advantage to get it right.

Once you are satisfied with the key colour, continue with the rest of the painting, taking care to match the colours to the tones, and asking yourself such questions as "is the colour too yellow, too red, or too blue?" You may find it helpful to hold a brushful of mixed colour up against the still life itself, as this will quickly tell you whether it is anywhere near right. Don't be afraid of overpainting, or of wasting paint — if your palette becomes too messy, clean it and lay out fresh colours. A dirty palette will result in muddy colours.

Since you are still working with a relatively small palette of colours you are unlikely to achieve a perfect match in every

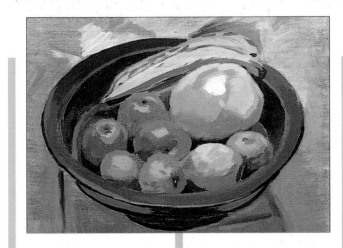

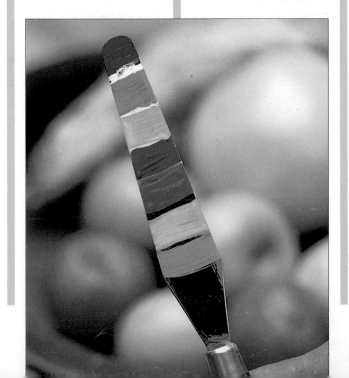

1 ◄ **Using mixtures of black and white acrylic paint, the artist begins to make the monochrome underpainting. He is working on board which was first primed with acrylic gesso and then tinted with a light wash of diluted paint. It is easier to judge both tones and colours if you start with a middle tone. This allows you to work up to the highlights and down to the darkest areas.**

2 ◄ **It is surprisingly difficult to assess colours in terms of how light or dark they are, as the eye always registers colour rather than tone. To help with this, a range of tones has been painted on a palette knife, held up to the still life, and looked at through half-closed eyes.**

3 ▲ **The tonal underpainting in acrylic is now complete. Oil paint is used for the next stage, since it is the artist's personal preference, but the painting could equally well be continued in acrylic.**

4 ▲ **To judge the colours, the same system is used as before, but this time with a range of yellows.**

case. For example, mixtures of the one yellow and one green in the recommended palette are not capable of producing every shade of green in nature, even with the addition of blue and/or black. But you will learn much more about colour mixing by using only a few colours than you would if you started with an entire manufacturer's range, and one of the things you will find out is which new colours you really need in order to achieve particular effects. Add these gradually, and only when you are confident about colour mixing.

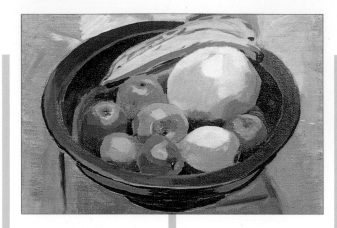

5 ▲ The colours are mixed with care, so that each one approximates as closely as possible to the monochrome underpainting.

6 ▼ Since the only yellow used was cadmium yellow, the artist found it difficult to achieve the acid colour of the lemon. For the next project, the palette will be expanded to include lemon yellow.

SELF-CRITIQUE
● Do the colours describe the three-dimensional forms of the objects?

● Have you used warmer colours in the light-struck areas?

● Do the colours create a feeling of space?

● Are there any colours that you couldn't mix?

● Have you identified any new colours you could add to your range?

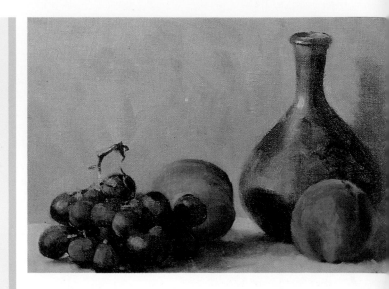

▼ Ronald Jesty
Pears and Ginger
Watercolour
Here too a wide range of colours and tones has been used to model the fruit, ranging from deep yellow to dark greenish brown. The painting also shows that tone is more than just a way of describing form; contrasts of light and dark are an important element in composition, and have been used throughout this picture. It is unusual for a watercolour in its use of very dark colours.

▲ Trevor Chamberlain
Fruit With Pot
Oil
The colours of the fruit are beautifully observed; notice the wide range of reds, yellows and pinks in the peaches, and the variety of tones on the grapes and bottle.

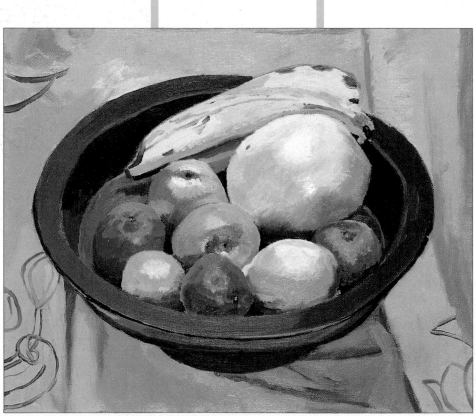

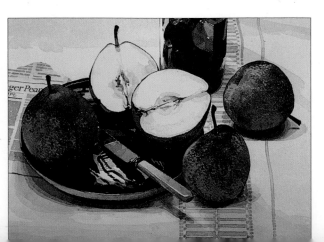

▼ Arthur Easton
Brick, Apple and Withered Carnations
Oil
Most still life painters spend a considerable time arranging their groups, but the majority aim at a natural, often haphazard-looking grouping, whereas Easton deliberately aims at artificiality — perhaps a comment on the relationship of painting to the real world. The controlled use of paint, detailed treatment and naturalistic colour heighten the effect of slightly "off-beat" strangeness.

with still life and then, if you choose, make use of the knowledge you have gained to paint a wider variety of subjects.

You may, of course, decide on still life as your chosen field. Some artists either never depart from it, or return to it at regular intervals throughout their careers. The French artist Jean-Baptiste Chardin (1699-1779) turned humble household objects into paintings suffused with quiet beauty, while Paul Cézanne (1839-1906), generally regarded as the "father of modern art", painted not only landscapes and portraits but also a great many wonderful still lifes, using them as a vehicle for working out his ideas about colour and the underlying structure of paintings. The Italian Giorgio Morandi (1890-1964) painted the same objects, usually groupings of bottles and other household objects, over and over again in different arrangements, demonstrating how it is possible to continue discovering new things in the same subject.

If you found the project lengthy and laborious, repeat the same exercise but without making the tonal underpainting — some people feel inhibited working over an under-painting. You could also carry out the same project with one or two additional colours, for example lemon yellow as well as cadmium yellow, and cobalt blue in addition to ultramarine. Almost anything can be used as a subject, provided it is not too complex.

SUGGESTED SUBJECTS
● A single flower in a vase
● A patterned cup and saucer
● A group of bottles
● A child's doll or toy

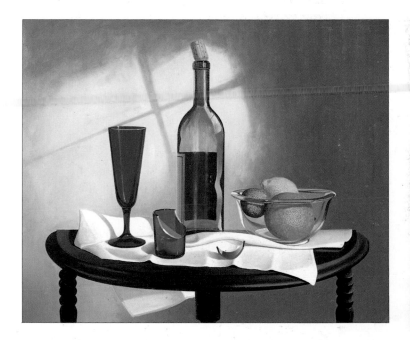

▲ Walter Garver
Morning After
Oil
There is no point in painting a still life unless you set up a group that excites you, and here the artist has clearly revelled in the jewelled colours of the glass and the texture of the fruit.

further information	
4–29	Colour and tone
92–93	Composing a still life
150–157	Painting with oils
172–177	Painting with watercolour and gouache

Painting a self portrait

Initially, this seems a much more ambitious project than the simple still lifes which have formed the basis of the previous lessons. In a way it is, but although there are obviously many differences between the human head and an object such as an apple or jug, there are also many similarities. Look at the drawings on this page and you will see that the head and features can be simplified into a series of cylinders, cubes and planes, which can be made to appear three dimensional in just the same way as the objects you painted in Lesson Three. You will not be expected to paint a cubist version of yourself, but awareness of the underlying structure of the head will help you to describe the features so that they do not appear to be stuck on, a common failing with portraits by inexperienced artists.

Painting a self portrait will also reveal things about your own face that you may not have been aware of before. Everyone is familiar with their own mirror image, but most people have also had the uncomfortable experience of finding that a photograph of themselves looks somehow wrong. We forget that the mirror image is reversed, so that we know our face the wrong way round. Because no face is entirely symmetrical, a photograph will not look the same as a mirror image. Artists often check their compositions by holding them up to a mirror; the reversed image becomes immediately unfamiliar and so is easier to look at critically.

Another thing we assume is that the mirror image is the same size as our own face, but it isn't. You can test this out very easily by looking in the mirror and making a mark for the top and bottom of your head. You will be amazed to find that the image is approximately half the actual size of your head which shows the extent to which our perceptions are governed by what we know.

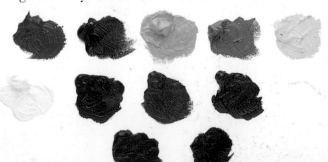

THE AIMS OF THE PROJECT
Creating a three-dimensional painting

————

Gaining further experience in colour mixing

————

Analysing shapes and forms

————

Assessing individual characteristics

•

COLOURS YOU WILL NEED
(see below left)
Oils or acrylics: cadmium red, alizarin crimson, cadmium yellow, yellow ochre, lemon yellow, ultramarine, cobalt blue, viridian, raw umber, black, white

•

TIME
3-4 hours

THE PROJECT
Position yourself so that you are comfortable and can move your eyes from your painting to the mirror, if possible without moving your head. The more you move the less easy it is to draw and paint accurately, because every slight shift changes the viewpoint. You should have a three-quarter view of your head, not a front one, as this will enable you to see more easily the shape and structure of the head. Lighting also plays a vital role in describing form, so try to arrange the mirror so that light falls on only one side of your head.

PRELIMINARY STAGES
Start by making a drawing with charcoal or a brush and well-thinned paint. Either of these will enable you to block in areas of tone quite quickly. Don't draw your features in any detail, but concentrate on the shape of your head. People's heads and faces vary widely, so decide whether yours is long and narrow, rather square or almost round.

Now begin to paint, blocking in the main colour areas, including the background, before you begin to work on the individual details. You can use the paint quite thinly at this stage, diluted with water for acrylics or turpentine (white spirit) for oils. Look for the overall colour of your face — face colours vary as much as shapes, even in the same ethnic group. You will have noticed that the number of colours suggested for this project is larger than you used for the previous one; you now have the addition of cobalt blue and lemon yellow, both useful colours for skin tones, so you should have no difficulty in mixing an accurate base colour.

MODELLING FORM
Pay particular attention to the colours and tones in the shadows, as it is these which will help to make the head look solid and real. Use cool colours in such areas, as these will recede, and reserve the warmer and brighter colours for the parts of your face which catch the light.

Once you have established the main shapes you can begin to define the features, but don't worry too much about getting a likeness; the first priority is to make the painting look convincingly three-dimensional. If you have observed the shape and colour of your face accurately you will be halfway towards getting a likeness, and as you work you will begin to focus on

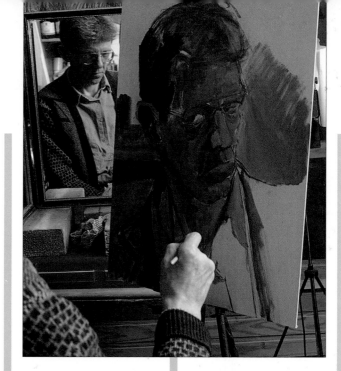

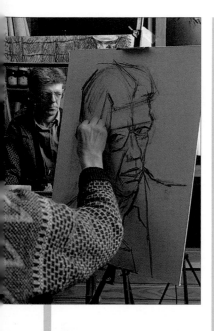

1 ◄ In normal portraiture, it is usually best to restrict the size of the head to no more than life size, as an over-large face can create a disturbing impression. However, since this self portrait is primarily an exercise in exploring form and colour, the artist has chosen to work considerably larger so that he can use his paints boldly. He begins with a charcoal underdrawing.

2 ◄ Working with oil paints thinned with turpentine, he starts by blocking in the main forms of the face, paying particular attention to the overall colour and to the shadow areas.

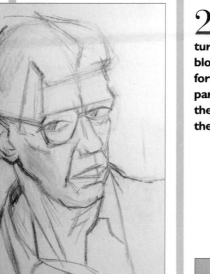

3 ► He is careful to relate the colours of the background to those of the face (see the area on the left) so that the painting has an overall unity of colour.

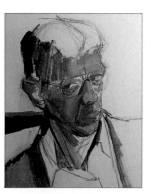

4 ▲ Careful observation of the angle of head and neck is essential, or the head will not appear to sit convincingly on the shoulders. Small adjustments are made to the line made by the tendon of the neck.

5 ▼ The main forms have now been established, and the head already looks solid and realistic. Notice the variety of colours on the face and neck, from yellows and reds to blues and deep purples, with a dark crimson used for part of the ear.

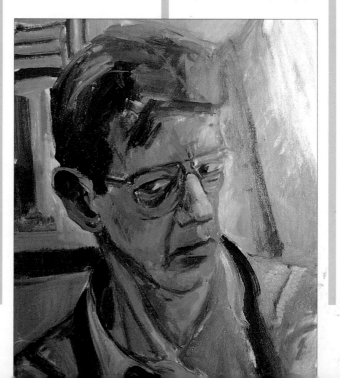

the irregularities and particular characteristics of your face, so that a true likeness may emerge almost by itself. Whatever you do, never be tempted to use a small brush to add small details such as eyebrows and lips, as introducing outlines will destroy the feeling of solidity.

FINAL TOUCHES
When you feel you have done all you can, prop up your painting a little way away and ask yourself whether you need to make any revisions. Sometimes you can see that just a touch of highlight on a nose or cheekbone will give the face life, or perhaps you may need to darken a shadow or change its colour. Don't go on working just for the sake of it, but if you can see any modifications that will help the painting then make them; artists often work and rework for long periods before they are satisfied.

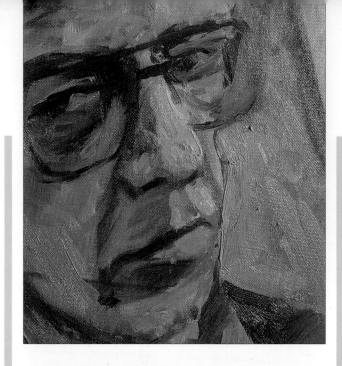

6 ◄ As you can see from this detail, and the finished painting below, further definition has now been given to the face, and some blue-greys introduced to both face and hair, echoing the colours of the shirt. Bold, free brushwork has been used throughout the picture.

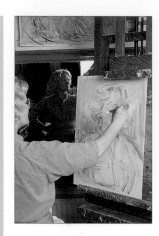

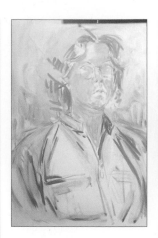

1 ▲ This artist is painting herself exactly life size. Although our reflected image is much smaller than the reality, we enlarge it unconsciously, and "scale up" when looking at ourselves in the mirror.

2 ▲ Having made a brush drawing with well-thinned blue paint, she blocks in the main colours, still using oil paint diluted with turpentine.

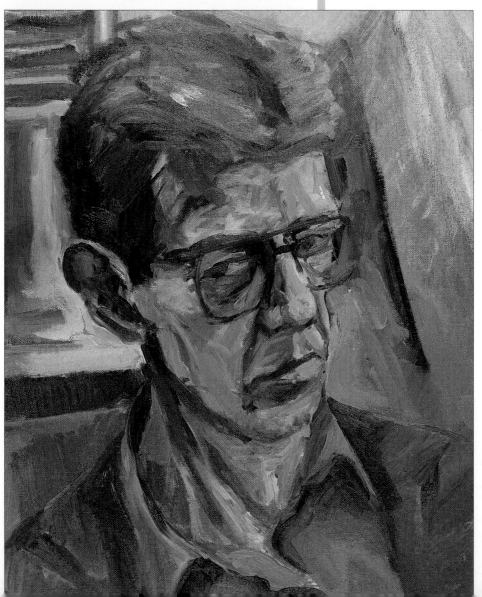

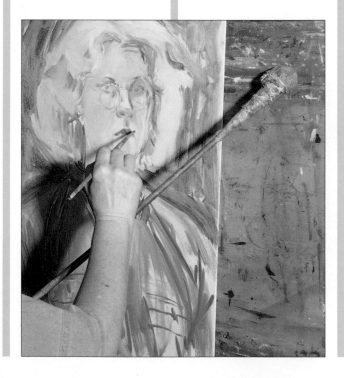

4 ► Using the side of a filbert brush, which produces a crisp line, she begins to work on the hair. This blue shadow is similar to the colour of the shirt she is wearing, another use of repeated colours to unify the painting.

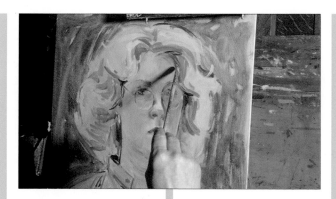

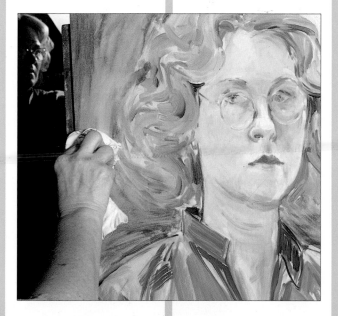

3 ◄ When you work standing up, it can be difficult to keep your hand steady enough to define details accurately, so the artist rests her wrist on a mahlstick. These useful painting aids can be bought, but are easy to make, simply by wrapping torn pieces of rag around the end of a piece of bamboo or dowel rod.

5 ▲ A rag is now used to move around the still-wet paint in the background. Backgrounds are always important, however sketchily they are treated, and need to be given consideration throughout the painting process. You can see the effect of this "rag painting" in the finished painting (right).

6 ▼ There is always a danger that a head-and-shoulders portrait may appear rather dull and static, but a lively sense of movement has been created here by the swirling brushstrokes used for the hair, echoed by the thin paint in the background. The style of painting is very different from that of the previous self portrait, but there are similarities in that both artists have used a limited palette and vigorous brushwork.

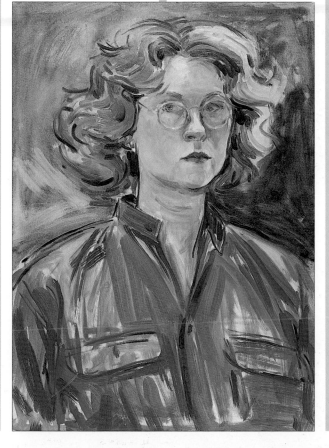

SELF-CRITIQUE

● Does the head look solid and convincing?

● Do the colours look realistic?

● Are the transitions between light and dark tones too sharp?

● Are the proportions of the face right?

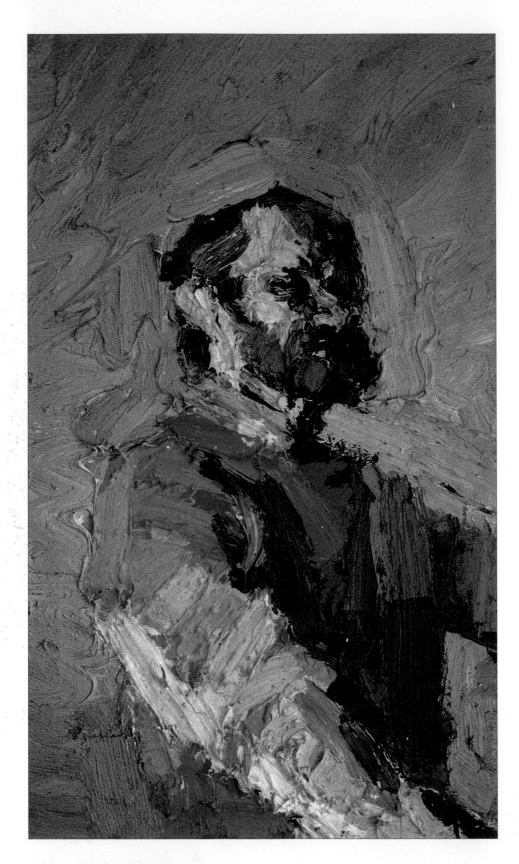

◄ George Rowlett
Self Portrait in Orange Jersey
Oil
Self-portraiture, like still life painting, can be an excellent vehicle for experimenting with colour, composition and technique. Here the artist has combined bold brushwork and very thick paint with a striking contrast of colours to produce a painting full of drama and movement.

▼ John Lidzey
The Artist at Work
Watercolour
In this painting the artist has used himself as the central "object" in order to explore effects of light in an interior. However, even with no visible features, he is recognizable as a specific person; characteristic posture and general shape can be as revealing as the details of features.

You could, of course, paint limitless numbers of self portraits. Rembrandt, (1606-69), painted self portraits throughout his life (see page 98) and many other artists have made many paintings of themselves. So that additional self portraits are different, try lighting your head from a different direction or arrange a background of a different colour or tone. Vary the composition by including the whole of the mirror in some paintings and in others making the head fill the entire picture area.

◄ Nick Lang
Self Portrait at Easel
Oil
The inclusion of the corner of an easel and other items in a self portrait not only states the profession of the "sitter" but also provides a wider choice of compositional elements. The artist has used these very cleverly in this lively painting, slightly distorting the perspective of the room to include part of the ceiling and window.

► Laura May Morrison
Self Portrait with Twin Sister
Oil
The two faces have been cleverly juxtaposed to create a picture with a strong pattern element. Yet the faces are far from being flat; the forms are delicately modelled with carefully blended colours and tones.

N. LANG '91

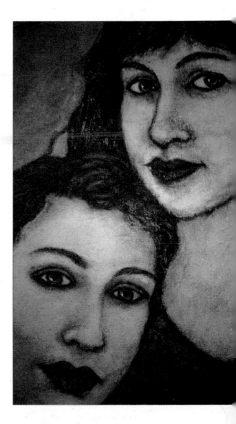

further information	
60-61	The proportions of the body and face
102-105	The figure in context
172-177	Painting with watercolour and gouache
150-157	Painting with oils

The rules of perspective

The well-known phrase "getting things in perspective" means deciding what is-important and what is not, and in painting the meaning is not substantially different. Linear perspective, to give it its full title, means judging what is large and what is not: it is a system for establishing the scale of objects at different positions in space. It all hinges on one basic and seemingly self-contradictory rule, which is that all receding parallel lines meet a vanishing point on the horizon.

This is, of course, a geometrical impossibility — parallel lines are defined as those which never can meet — but our eyes see them doing so, and it is the visual world that concerns the artist. It is interesting that perspective is quite a recent discovery in the long history of art; its laws were formulated in the Renaissance, a period when artists were increasingly relying on the evidence of first-hand observation.

On the face of it, perspective may seem — like geometry — a dry and academic subject that has little to do with self-expression. But indirectly it has everything to do with it, because understanding its laws enables you to create a convincing illusion of the three-dimensional world and all that is in it. People often think that it is only important to painters of architectural subjects, but although perspective shows its face most obviously in this field, it is crucial to all branches of painting.

THE VANISHING POINT

The basic rule is easy to understand once you know what the word horizon, often used rather loosely, means in the context of perspective. It has a simple but quite specific meaning; the horizon is the actual level of your own eyes. If you stand up, your eye level is automatically raised, and it lowers if you sit down again. All parallel lines that recede from you, for example the roofs of buildings or the sides of a straight road, meet at a vanishing point on a line that represents your eye level. If you are looking down from the top of a hill the lines will slope upwards because the

THE HORIZON

If your subject is a flat landscape (above left) the horizon will be roughly in the middle, as will any receding verticals directly in front of you. When your viewpoint is low (left), and you are looking at something corner on there will be two sets of converging parallels, both sloping down to the horizon. The high horizon provided by a view from an upstairs window (above right) causes the converging parallels to slope upwards.

VP · **Horizon**

DIMINISHING SIZE

◄ **The spaces between objects become smaller as they recede from you.**

obviously be two vanishing points, meeting on different places on the same horizon line. This is called two-point perspective.

DIMINISHING SIZE

If parallel lines can appear to get closer and closer together until they eventually meet, it follows that the spaces between them also appear to get smaller. You can observe this at first hand by looking down a long street of houses receding from you. The nearest window and door will look quite large, while the more distant ones will appear

very small indeed, with those at the far end reading as little more than small vertical lines. Estimating the diminishing size of objects is one of the most important features of perspective, and is something you will need to remind yourself of when you include figures in a painting — the subject of the following lesson. They will effectively shrink as

they become more distant, but if you are standing and so are they, their heads will be on the same level as your own.

ELLIPSES

So much for the outdoor world. But an understanding of perspective is just as important for the still life painter If you have carried out the projects earlier in this section the chances are that you found

SQUARING THE CIRCLE

◄▼ **Circles always fit into squares, so if you have any difficulty with ellipses, begin by drawing the square in correct perspective.**

horizon is high, while if your subject itself is on top of a hill they will slope downwards — often surprisingly steeply.

The precise position of the vanishing point is also determined by your own position. If you are sitting drawing in the middle of a street with a symmetrical row of houses on either side, the vanishing point will be directly in front of you. If you then move to one or other of the pavements, so that you are viewing the same street from one side, the vanishing point will still be in front of you, but no longer in the centre of your picture.

These examples assume that you are seeing one plane of the buildings flat on, with the planes at right angles to this receding to a single vanishing point.

This is known as one-point perspective. Often, however, you will be looking at things corner on, with both planes receding from you, in which case there will

Horizon · **VP**

PEOPLE

◄ **Allowing for differences in height, people's heads will be at the same level as your own, but their feet will be higher up the further away they are.**

▲ Notice how on a cylindrical shape such as a glass, the ellipses become shallower at the top. If you hold up a glass with the top rim at your eye level you will not see the ellipse at all.

it hard to make the sides of tables look right, and you almost certainly will have had trouble with plates, bowls or the tops and bottoms of bottles. Ellipses, the term for circles, seen foreshortened, are notoriously difficult because at first they don't appear to follow any rules. In fact they do, and there is an easy formula to help

you — circles always fit into squares, whose sides will converge on a vanishing point. You can test this out by drawing a grid of squares on a piece of paper, laying it down on a table and placing circular lids or similar objects on the squares, some at the front and others towards the back of the paper. Notice how the front curve of an ellipse is rounder than the back one.

PERSPECTIVE IN LANDSCAPE

Landscapes other than urban scenes do not often include convenient sets of straight parallel lines, so the perspective is less clear cut, but it is still there. An avenue of trees will become smaller and closer together as it recedes, a winding river or path will become narrower, and the

converging lines of a ploughed field will not only suggest recession but also help to describe the contours of the land.

One further way of creating space in landscape is by making use of what is known as aerial perspective. When colours are far away from you they appear to become less intense, with a tendency towards blue, and they also become paler, with the contrasts between one tone and another less and less pronounced the greater the distance. This effect is caused by dust and moisture in the atmosphere, which diffuse the light and affect the way we perceive colours. A sense of space can be created by exploiting this, even exaggerating it by making background objects more blue and increasingly out of focus.

PERSPECTIVE IN PRACTICE

If you are painting a town scene or even a group of books on a table set at random angles to one another, there will often be three or more separate vanishing points. Some of these may be outside the picture area, so you obviously can't mark them

LINEAR ELEMENTS
◄ In Brian Bennett's oil painting, Burnt Cornfield, the converging curves give depth to the landscape.

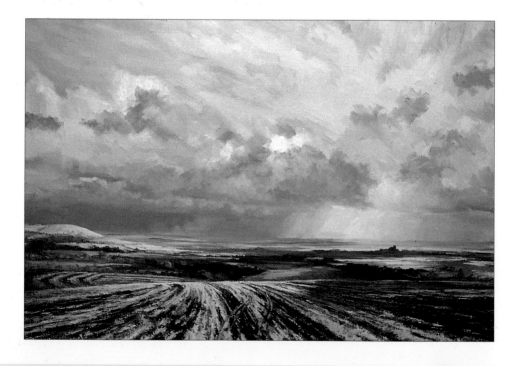

VIEWPOINT

◄ The photographs opposite show how the perspective changes as soon as you move. The first two were taken from first a standing and then a sitting position. The third and fourth shots were both taken from the same high viewpoint, with the camera shifted slightly to the right in the final one.

CHECKING ANGLES

▼ Angles can be assessed by holding up a pencil or ruler and aligning it with whatever you are drawing.

in on a preliminary drawing. You can, however, establish the horizon line, and you can use a pencil or ruler held up at arm's length to measure the angles at which parallel lines slope up or down to this. It is always advisable to use some sort of measuring and checking system, and you need not feel embarrassed about it, most artists use one. Be careful not to move as you take measurements as perspective relies on a consistent viewpoint. As soon as you alter your position, however slightly, the perspective alters too. Make certain also that the

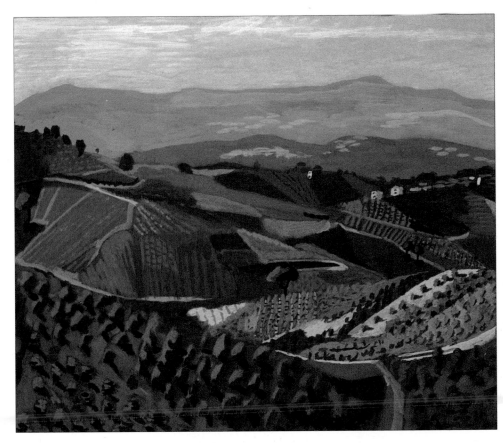

horizon line you are using as a reference is truly horizontal. The corners of buildings will often provide useful vertical references.

It is wise to make measurements for landscape also, as the accurate placing of features such as hedges, fields and stretches of water, and the angles at which they recede, is important. When you are painting a flat landscape it can be disconcerting to discover how little of the picture surface is taken up by something you know to be large, such as a lake or an expanse of sea. Judging the extent to which things

like this become fore-shortened is vital if you want to achieve a true sense of space. And be careful how you place any incidental people as it is very easy to misjudge their scale unless you assess them against some other feature of the landscape. If you can visualize the size of a figure in the foreground of your painting, lines drawn from this figure's head and feet to meet on the horizon lines will help to establish the scale of other more distant figures in your picture.

CHECKING SIZES

▲ The artist, Jeremy Galton, began by making a careful drawing, using a ruler to check the relative sizes of the fields and hills. Correct scale is important in creating a sense of depth in landscape.

Inside/outside

So far the lessons and projects have concentrated on looking at and painting objects only a short distance away. Now you have learned something about both colour and perspective, however, you should be ready to look further away, and paint the view through a window or open door. This will enable you to move from the inside world to the outside one in the course of one painting. This is a subject that has appealed to many artists; not only is it a challenge, but it also creates an element of contrast. This is always important in painting, whether it is the contrast of colour, shape, tone, or contrast within the subject matter itself.

The challenge of incorporating contrast between inside and outside is three-fold. First, you have to find a way of showing the differences between the two kinds of space — the closed-in interior and the more open and distant land- or cityscape outside. Second, you must assess the relative scale of near and far objects correctly, because this is an important way of creating space. And third, you must be able to create visual links between the two contrasting parts of the painting so that they form a unified whole.

SPACE AND SCALE

Judging scale is surprisingly difficult, and the problem lies, once again, in the conflict between what we know and what we actually see. You can see that a window frame is quite slender compared to the wall surrounding it, and you assume that it is also slender compared to a building or some other feature outside the window. But, in fact, it may be actually wider than the building because it is so much nearer to you. To take another example: when you look out of a window you can see a number of objects — buildings, the back

47 ▷

THE AIMS OF THE PROJECT
Creating space

―――

Assessing relative sizes of objects

―――

Using perspective

―――

Achieving visual unity
•
COLOURS YOU WILL NEED
(see below left)
Oils or acrylics: cadmium red, alizarin crimson, cadmium yellow, yellow ochre, lemon yellow, ultramarine, cobalt blue, viridian, raw umber, black, white
•
TIME
5–6 hours

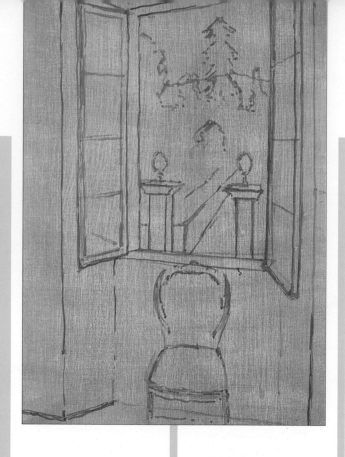

1 ▲ **This artist works in oil, and always begins** with a careful brush drawing, particularly important in this case since he is working from two different perspectives. He is painting from an upstairs window, and needs to be close to it in order for the view to fill the window frame, while to draw the chair in relation to the window he has to stand back. Painting interiors and window views often requires a degree of "cheating", but remember that the important thing is the painting, not total truth to the seen world.

THE PROJECT
Position yourself so that you can see part of the interior of a room as well as the view through the window or door. If you have chosen a window, don't just use it as a frame for the view, but include some of the wall on either side and any furniture near it, such as a table or chair. Before you start, think about how the subject will fit into a rectangular format. If you have chosen a door view, don't automatically assume that your picture must be an upright rectangle; it may look better as a horizontal one.

Since the subject is complicated, and involves assessing both scale and perspective, it is best to begin with a preliminary

drawing. You can use charcoal, but pencil may be better, as you can also employ the pencil as a measuring device for assessing foreshortening and measuring perspective angles, as described on the previous pages. Take your time over the drawing so that you can avoid having to make too many corrections at the painting stage, and as you work, keep checking the way angles and vertical and horizontal lines intersect each other.

When you start to paint abandon your preconceptions and look hard at the subject. You will observe some surprising effects. Because the light level inside a room is nearly always lower than that outside, a white window frame, seen against the light, will almost certainly not appear white. It will be dark in tone containing definite hints of colour — possibly bluish or greenish depending on what is reflected in it. What is in reality a white window frame could be the darkest area of the picture while parts outside that catch the light, perhaps the windowsill, may be the lightest.

Start by blocking in these two extremes of tone which will provide a key for the middle tones, and then cover the whole surface of the picture as quickly as possible — you cannot judge colours and tones when you still have areas of white showing. Be as positive as you can with the colours, trying to make them describe space, light and shadow. Take breaks from time to time to stand back from your painting. Assess whether you might describe these qualities better by exaggerating some of the colours and tones in the foreground or alternatively by knocking back those in the background. If one area of a painting looks wrong, it may, in fact, be another one that is to blame —

2 ► **The colours inside the room must have a relationship to those outside, so the two areas are treated together from the outset, with patches of colour placed all over the canvas.**

always try to see the painting as a whole. If you are dissatisfied but feel you can go no further, stop and put the painting away to look at another time. After a few days you can often see faults — and virtues — that are not apparent when you are concentrating on the painting.

4 ▼ **Final touches are added to the top of the tree, but care is taken not to make the colours too bright and strong, as this would make them come forward to the front of the picture and destroy the sense of space.**

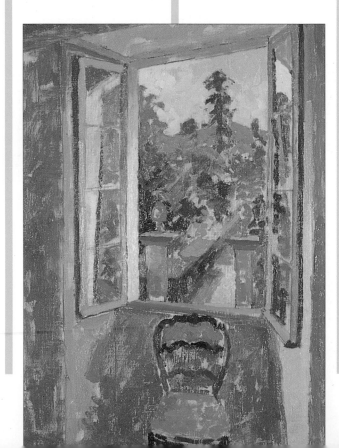

3 ◄ **Because the garden is brightly sunlit, the colours and tonal contrasts outside are almost as strong as those in the room. However, the near-white and dark grey on the edges of the window frame provide enough contrast to separate the two areas of the painting.**

5 ▼ In the finished painting you can see how the areas of warm red-brown and blue-grey wall act as an outer frame, while the window itself becomes an inner frame for the garden view. **This compositional device also helps to create the illusion of space.**

SELF-CRITIQUE
● Does the painting express different kinds of space?

● Have you got the scale of the objects right?

● Is the perspective well observed?

● Does the colour you have used unify the painting?

▲ Peter Jones
Kitchen in the Hills
Watercolour
In this elaborate and highly organized painting, the artist has controlled the colours and tones with consummate skill. Although the greens in the vegetable still life are very similar to those in the background landscape, the range of tones in the landscape is minute in comparison — and yet it is still described in convincing detail.

garden or parts of a landscape — fitting comfortably within the confines of the frame, but when you begin to paint them they usually won't fit. This is because you unconsciously enlarge them in your mind. It is necessary then to work out a compromise, either settling for seeing less through the window or exaggerating the size of the window, to fit around the enlarged background.

COLOUR AND TONE

As explained earlier, one of the ways of creating space is to use warmer, brighter colours in the foreground and cooler ones in the background. In theory this is fine, but it does not always help in practice, because you are not inventing colours but translating what you actually see. A red brick building in the background may be an important element in your subject but to make it take its correct place in space in your painting you may have to cool down a colour that you know is actually warm. Don't forget that colours also become lighter in tone as well as cooler as they recede. You may know that a group of trees or some railings outside your window are very dark because you have seen them in close up, but in comparison with a similarly dark object inside the room they may look distinctly pale.

MAKING VISUAL LINKS

This is a topic which is relevant to all painting, whether the subject is figures, landscapes, still life or the view through a window. It is particularly important here, because when you are painting something that has two distinct parts, for example an interior and a landscape, you must find a way of tying the two together in pictorial terms. One of the best ways of doing this is to create links by the way you use colours. For example, if the view outside is a landscape with a preponderance of greens, try using some green also in the interior, perhaps in a shadow or among the colours in a "white" windowsill. If there is bright sunshine outside, make the most of any patches of sunlight that come into the room.

alternative projects

Looking from one kind of space into another needn't necessarily restrict you to painting domestic interiors. You could paint a view from a greenhouse for example, looking out into a garden, and further afield, views from any kinds of buildings can make excellent subjects.

SUGGESTED SUBJECTS
● Looking out from the door or window of a workshop
● A view from inside a church looking out through the main door
● A view from a high window in the city.

▼ Ian Simpson
Landscape from a Swedish House
Acrylic
You will often find that the strong contrasts of tone seen on a window frame are enough to "push back" the landscape outside. Here the artist has further ensured a separation between inside and outside by including the potted plant with its dark leaves and vivid red flowers, which also provides a tonal balance for the dark area at the top of the window.

► David Carr
Window in Tuscany
Gouache
A small range of colours, repeated from landscape and sky to walls and window recess, has produced a quietly harmonious painting, enlivened by the pattern of the window bars and the bold, vigorous brushwork.

Introducing watercolours

The reason that watercolour was not recommended as a suitable medium for the earlier projects in this book is that most of these involved a fair amount of trial and error, correction and overpainting. Watercolour is not the best medium for such exercises, but as you grow more experienced in the basics of painting you may want to try it out. The later projects can be carried out in any medium, so you could use one or more of those as a stepping stone to using different paints, or perhaps pastels.

Although watercolour is hugely popular with amateurs and is becoming more widely used by professionals, it has a reputation for being difficult. It is true that since you cannot make extensive alterations and corrections it needs rather more initial planning than the opaque paints, but it is a wonderfully satisfying medium to use, even at the early experimental stage.

One of its great charms is that it is never entirely predictable, and because you cannot be quite sure of what may happen there is an element of risk which adds spice to the painting process. You may find, for instance, that two colours run into each other in a way that suggests a particular effect. You may not have planned it, but you might decide to go with it or to try the same method again.

WATERCOLOUR AND GOUACHE

There are two main types of watercolour, pure watercolour, which is translucent, and gouache, which is opaque. Both are bound with gum arabic, but gouache has an addition of chalk to give it

body, and pure watercolour includes glycerine to keep it moist and make it flow well. Gouache can also be used thinly, in which case it behaves similarly to pure watercolour, but without the translucency which is the hallmark of the watercolour paint, and nowadays many artists mix the two, contrasting areas of thick and thin paint to great effect.

However, this is heresy to watercolour purists, who believe that any added "body colour" (another term for opaque watercolour) destroys the purity of the paint and dulls the colours. There is some truth in this; the classic watercolour technique relies on the effect of the white paper below reflecting back through the colours.

◀ **With watercolour (top), you can alter a colour by laying another over it, but the first colour will always show through. Gouache used thickly (bottom) has considerably more covering power.**

WORKING WET ON DRY

The classic watercolour technique is also known as wet on dry because each new wash is laid over paint which has already dried. A painting in pure watercolour, unlike one in oils or acrylic, must be

EDGE QUALITIES
Laying new colour into and over a still wet wash creates softer blends of colour (above left). Laying fresh washes over dry paint makes distinct edges (below), which can be an attractive feature

of watercolour paintings. The two methods are often combined (above right). For building up fine detail (below right), it is usual to paint wet on dry with a small brush.

worked from light to dark. The strongest and deepest colours are achieved by building up — laying one colour over another — and the highlights are "reserved" by leaving areas of white paper. The basis of classic watercolour technique is the wash, which is a thin skin of paint laid over the whole paper, or a part of it.

Laying the first wash is a moment of decision, because first you have to decide where the highlights — if any — are to be, so that you can paint round them, and second you need to consider the colour and tone of the wash. For instance, if you lay a wash for a sky that is too light, you can darken it with later applications of colour, but in general, it is not advisable to overpaint too much. The colours will become muddy and you will lose the translucent quality, so always try to make the first wash as near as possible to the colour you want.

Leave the first wash to dry before laying further ones, either on top or on an adjacent area. When you have overlaid several washes you will find you have a series of hard edges where two colours overlap. Don't be alarmed by these; they are very much a feature of watercolour and can be used deliberately to

give structure and definition to the painting.

PRACTISING WATERCOLOUR
For those who have not tried watercolour before, it is good practice to try to lay, first a very flat wash, where there are no ripples or visible differences in colour, and then a gradated wash, which is one where the colour is darker at the top or bottom (graded washes are often used for skies).

Even if you never use such perfectly even washes in a painting, the exercise will give you a feeling for the way the paint behaves. For the best results, work on stretched paper, damp it all over with a sponge or brush, and prop up the board at a slight angle so that each line of paint flows into the one below as shown in the photographs.

WORKING WET IN WET
Working wet on dry is by no means the only way of working. The wet in wet technique, in which colours are virtually mixed on the paper, is a marvellous way of creating atmospheric effects, much used by landscape painters. The idea is to drop colours into a wash which has not been allowed to dry so that they fuse together with none of

▷ 50

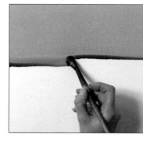

FLAT WASH
1 ▲ Sweep a band of colour across the top of the paper, then immediately reload the brush and lay another line below, continuing until you reach the bottom.

2 ▲ Washes must be laid quickly and with no hesitation, so make sure to mix up a lot of paint.

BRUSHES
▲ The best and most expensive watercolour brushes are made from sable, but nowadays there is a large range of synthetic brushes as well as sable and synthetic mixtures, which are perfectly adequate to begin with.

It is not necessary to have many brushes. A large, square-ended one (3), is useful but not essential for washes, and you will certainly need two or three pointed ones (1, 2, 4) in different sizes for more detailed work. Mop brushes (5), are also very good for washes, and are a joy to use, but they are quite expensive, and need not form part of your "starter kit".

The brushes you will need for gouache will depend on your way of working; you can use soft watercolour brushes or bristle ones — or a combination of both.

GRADATED WASH
▼ The usual procedure is to start with a band of full-strength colour at the top of the paper, adding more water for each subsequent band. For the sunset sky, however, the artist uses an alternative method, which is to work with the board upside down, beginning with well-watered paint and gradually increasing its strength. Try both methods and see which you prefer.

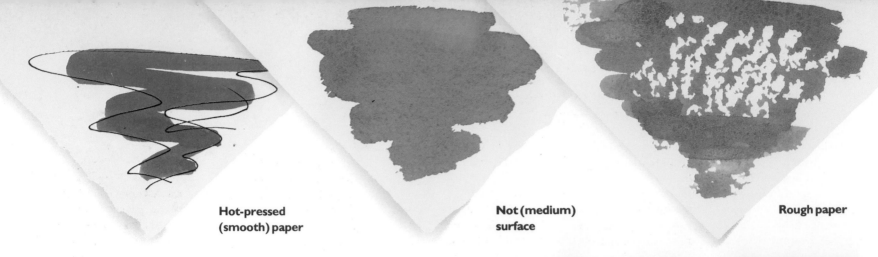

Hot-pressed (smooth) paper

Not (medium) surface

Rough paper

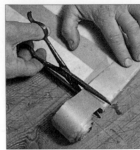

the edges characteristic of the wet on dry method. The effects will depend on how wet the first colour is and the angle at which your board is held, so you will have to carry out your own experiments. Artists

GOUACHE
▲ These samples show that although gouache is technically an opaque paint, it does not completely cover a colour below unless used very thick and dry. It is wise to avoid too much overlaying of colours, as they will quickly become muddy.

who specialize in this method learn to control the flow of one colour into another quite precisely by tilting the board at different angles and holding runs of paint with a sponge or cotton wool ball.

A whole painting carried out wet in wet can look rather woolly and undefined, so it is usual to add a few crisp details at a final stage when the main areas of colour have dried. You can even combine both methods throughout the working process, thus achieving an exciting contrast between hard edges and soft gradations of colour.

GOUACHE
Since gouache is opaque, it can theoretically be worked dark to light, but there are problems with this. Firstly, gouache is not nearly as opaque as oil paint, so a light colour will not always cover a dark one completely, and secondly, the layer of colour below is "melted" by the new application of wet colour so that the two will mix on the paper. You

can overcome this to some extent by using the paint very thick and dry, but until you are used to the paint it is best to stick to the dark over light method, beginning with colours well thinned with water and building up to thicker paint later, just as you would with oils.

PAPER
There is a range of machine-made papers produced for watercolour work, but although they vary in terms of weight (which determines their thickness) there are only three types of surface: hot-pressed, cold-pressed (or "Not") and rough. The first, although suitable for linear work such as pen and wash, is not a good choice for watercolours that are to be built up in layers, as it is smooth and becomes clogged easily. "Not" paper, which has a slight texture, is the most popular of the three, and is suitable for both washes and fine detail. Rough, as its name implies, has a heavy texture, and is rather more difficult to use. The paint will settle in the

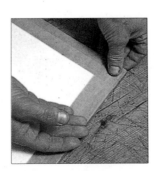

STRETCHING PAPER

1 ▲ Unless your paper is very thick or is stretched in advance it will buckle when you put wet paint on. Soak it briefly or damp it well on both sides, then place it on a board.

2 ▲ Cut lengths of the brown tape known as gumstrip, damp the gummed side carefully and, beginning with the two long sides, place around all four edges. Never use Sellotape or masking tape.

3 ▲ Smooth out the gumstrip well with your hand as you lay it down. It should overlap the paper by at least 1.3 cm (½ in).

4 ▲ To prevent the gumstrip tearing away as it dries, finish by placing a drawing pin in each corner.

Gouache paints, also known as designer's colours, are normally sold in tubes, and watercolour is sold in small tubes, pans, and half-pans. None of these is better than another, but if you are uncertain which to buy you might start with tubes.

You won't need a paintbox in this case, as you can mix the colours on any surface, such as a tin plate. The paint also comes in two qualities, "artist's" and "student's," but do not be tempted by the fact that the latter are cheaper; they are inferior paints and may lead to frustration.

The paints shown here are from the Rowney range, but the colours are standard ones produced by all the major manufacturers. The colours recommended are more or less the same for watercolour and gouache, but for watercolour, cerulean blue, a useful colour for skies, has been suggested instead of cobalt blue, and Payne's grey instead of black, which can deaden watercolour mixes. Chinese white is not an essential colour, but can be helpful on occasion.

troughs of the paper while running off the raised parts, giving a speckled, broken-colour effect that can be useful, but only for certain subjects.

Specialist art suppliers also sell a variety of hand-made papers, made from pure linen rag. These are expensive, and it would be pointless to try them until you are experienced in watercolour work and know your specific requirements; it is best to experiment with machine-made papers first. You will find that even these have their own characteristics. The very popular Bockingford paper, for instance, has an excellent surface for painting on, but tends to damage easily when drawing and erasing. Arches paper, another favourite, holds the paint very firmly, thus making it difficult to move colour around or wash it off. Saunders paper is recommended as a good all-rounder, since its surface is tough enough to withstand erasing, and you can manipulate and remove paint without too much difficulty.

GOUACHE
1 Lemon yellow
2 Yellow ochre
3 Cadmium yellow
4 Zinc white
5 Cadmium red
6 Ultramarine
7 Cobalt blue
8 Raw umber
9 Alizarin crimson
10 Viridian
11 Lamp black

WATERCOLOURS
1 Yellow ochre
2 Raw umber
3 Viridian
4 Alizarin crimson
5 Cerulean blue
6 Payne's gray
7 Lemon yellow
8 Cadmium yellow
9 Cadmium red
10 Chinese white
11 French ultramarine

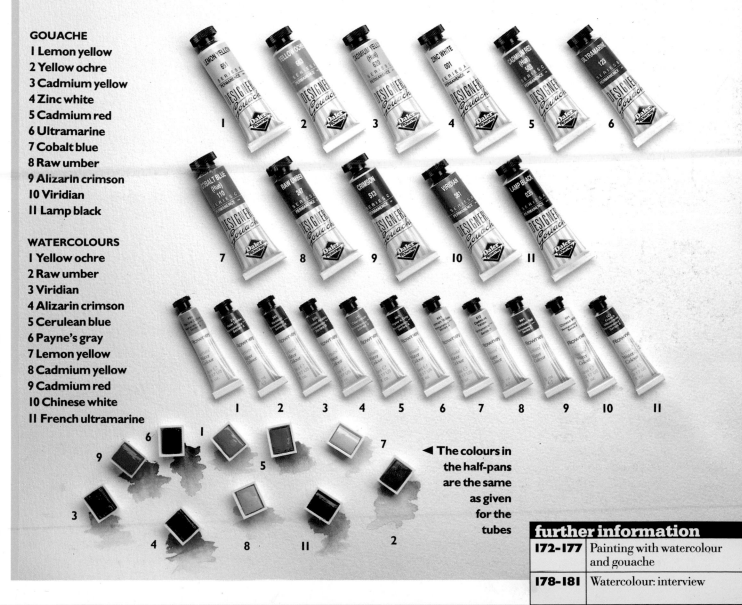

◄ The colours in the half-pans are the same as given for the tubes

Working from drawings

In the previous lessons the subjects were painted directly from life, though in some cases it was suggested that a preliminary drawing was made on the working surface before painting in order to identify and place the main shapes and design the picture. This lesson looks at a different kind of drawing: studies made as part of an information-gathering process for specific paintings.

Some artists always paint directly from nature; both Claude Monet (1840-1926) and (to a large extent) Cézanne, were committed to this approach, as are many artists today. Others, however, prefer to work in a more pre-determined way, making drawings and colour notes of the chosen subject and working them up into finished pictures when they have assessed all the visual possibilities. Some also make use of photographic reference, which will be the subject of a separate lesson.

DRAWING FOR PAINTING

Making the kind of studies which can be used as a basis for painting is quite different to simply sketching for its own sake. Studies must be thought of as the first stage in planning a painting, and you should be able to see this in your mind clearly enough to know what kind of information you will need. Most sketches, for example, are basically linear, but a line drawing, however good, will not tell you anything about the tone and colour of a subject, or where the light is coming from. Artists who work from studies develop their own systems for recording all the things they need to know in one drawing. There is more about this in Lesson Eight, but in the following project three separate studies are to be made, one in pencil, to note the main shapes, one in charcoal (or black and white paint) and one in colour. Those who are interested in trying out watercolour could use it for both the colour sketch and the final painting.

THE AIMS OF THE PROJECT
Learning to record information accurately

————

Assessing the information

————

Translating drawings into paintings
•
WHAT YOU WILL NEED
Oils, acrylics or watercolours; charcoal, pencils, sketchbook
•
TIME
4–5 hours for the studies;
3–4 hours for the painting

THE PROJECT

Choose a subject from your own surroundings, for example, the interior of a room with interesting objects in it or your back garden or patio.

THE STUDIES

Make a pencil drawing, in line only, of the main shapes you think you will want to include in the painting. If you find the drawing going off the edges of the paper (drawings have a way of expanding), extend it by taping on extra paper.

Now, using charcoal or black and white paint, make a separate tonal drawing from the same viewpoint. Don't worry if the shapes turn out rather different from the first drawing, or if you find you have changed your mind about the important elements. One of the purposes of such studies is to explore possibilities. Identify the lightest and darkest tones, and then try to

1 ◄ **A careful line drawing is made as the first stage. Since there will be two further studies before the actual painting is begun, it is not necessary to include information about tones and colours in this drawing. As the artist has done here, try to make as accurate a description as possible of the shapes of the various objects and their relative proportions. Draw everything that is there — you may decide to leave out some details when you come to plan the painting, but you want to give yourself as many options as possible.**

2 ◄ **This tone study, the second stage, has been done in charcoal, but you can use black and white paint if you are happier with a brush. You will find it easiest to begin with the lightest and darkest tones, as these will provide a "key" against which you can judge the middle ranges. If you are using charcoal, and find that the light areas have become smudged and grey (this happens easily), use a putty eraser to "lift out" the charcoal. It comes off cleanly, leaving unsullied white paper.**

studies, nor do you have to include everything you put into the first drawing, so make some small thumbnail sketches to try out different compositions before you begin. However, do make the painting larger than the studies so that you cannot copy them directly. Translating is the point of the exercise, so try to allow the painting a life of its own, and if it develops in unexpected ways, try to exploit what is happening.

It is unlikely that your first attempt at painting from studies will be entirely successful; you will probably find yourself frustrated through lack of information. But once you understand the nature of the inadequacies in your preliminary work you will be well on the road to making successful studies.

decide how many there are between them. This may involve some trial and error, but you will probably find that two or three are sufficient to make a balance between harmony and contrast.

As you draw or paint, think all the time about the final painting. If you are using opaque paints or charcoal, allow the brush or charcoal stick to follow the direction of rounded shapes, and use them also to describe the spaces between

objects. Stand back from your work from time to time and check whether the tonal pattern looks convincing, with sufficient contrast, and links between the different elements.

Finally, make a colour study of the subject, using oils, acrylics or watercolour. (If you have decided on the latter, plan to use watercolour for the finished painting also. Although it is possible to make studies

in one medium for a painting to be done in another, it is not easy, as the language of transparent paint is different from that of opaque paint.) You need not make a detailed description of the objects; concentrate on the main colour areas you intend to include in the painting.

When the three studies are complete, pin them up and check whether you have omitted any important

information. You may find you need to make some written notes to back up the colour study, for example, you might note a "patch of sunlight needs to be more yellow" or "shadows to be bluer". Remember you will be making the painting without the benefit of the subject.

THE PAINTING
The painting does not have to be the same shape and format as the

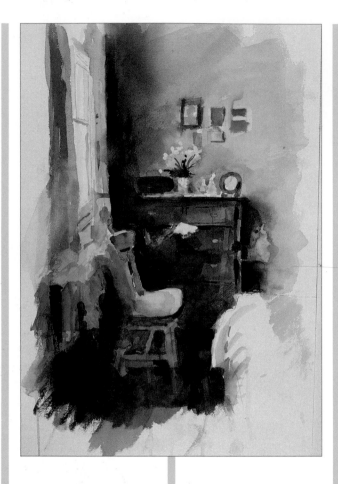

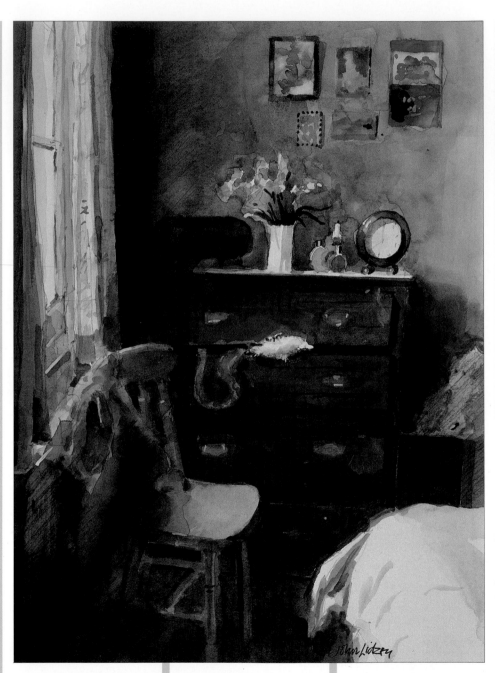

3 ▲ You can use any medium for this project, but in this case the painting is to be done in watercolour, a medium this artist works in almost exclusively, so he uses it for the colour study as well. This is rapidly executed, but important points are noted down, for instance the way the blue in the pictures on the wall repeats the colour of the garment over the chair in the foreground.

SELF-CRITIQUE

● Did you work out the balance of tones well?

● Were the colour notes sufficient?

● Did you assess the right tones for the colours?

● Were you satisfied with the composition?

● How could you improve on these studies another time?

4 ▲ Having made some further small sketches to try out various compositions (right), the artist has painted the final picture. Notice that he has made minor but important changes from the colour sketch, notably altering the angle of the chair, which now provides a slight diagonal to lead the eye in to the curtain and chest of drawers.

▼ **Small "thumbnail" sketches are useful for exploring possibilities. Quick pencil scribbles can be quite adequate.**

▼ Ian Simpson
Coastal Landscape
Watercolour and pen
This on-the-spot sketch looks deceptively simple at first glance, but in fact, because it combines colour with line, it has provided the artist with all the necessary information for the painting (bottom). With practice, you will learn how to sift and select visual information.

◄ Ian Simpson
Coastal Landscape
Oil
The painting has departed from the drawing in a number of ways, becoming more abstract and generalized while still retaining the same feeling and atmosphere. The treatment is much broader, with the complex rock structure only hinted at, and the foreground reduced to a few almost flat areas of colour.

tip

SQUARING UP
Artists who regularly paint from studies often make what is known as a working drawing from several sketches, which they then transfer to the painting surface. This can be done freehand, but when the painting is considerably larger than the studies, it is difficult to draw sufficiently accurately, hence the traditional method of squaring up. The principle is simple; all it involves is drawing a grid of squares on the working drawing, another grid of larger (or smaller) squares over the working surface, and transferring the information from one to the other. It is a slightly laborious process, but well worth the effort.

Painting the figure

You may perhaps wonder why the human figure has been singled out as the subject of a separate lesson, while there are no lessons on painting the landscape, flowers or animals. It might seem to imply that there is a particular recipe for painting the figure, but this isn't so — any more than there are recipes for painting landscape or still life. The figure is treated separately only because it is a complex subject with a good many particular attendant problems.

There are, of course, similarities between the figure and inanimate objects in terms of form and colour, but in very little else. It would be artificial — and probably impossible — to *paint* a person in a different way to a group of bottles, but it would be equally artificial to try to *see* a human being in the same way as a still life. A still life is impersonal, as to some extent is a landscape, and can be analysed objectively, but we cannot help identifying with a figure subject, simply by virtue of shared humanity, which inevitably brings an element of subjectivity into figure painting.

INTERPRETATIONS

Throughout history the human figure has been a significant art object, and although the body itself can have changed little over the centuries, artists' responses to it have varied enormously in tune with their own ideas and preoccupations, from idealization through expressionistic distortion to cool abstraction. Thus when you paint the figure, clothed or unclothed, as a portrait or as a full-length study, you will have to think not only about your subject but also about yourself and your relationship towards the figure. Why have you chosen it, and what in particular do you want to say about it? To take an example, a painting of a nude might simply be a celebration of beauty — but it might equally be a statement about vulnerability and defencelessness, or recognition of the strangeness of a person patiently sitting, unclothed in a room.

FIRST STEPS

Before you consider interpretations you will need to

59 ▷

THE AIMS OF THE PROJECT
Gaining experience in using colour

Composing the picture

Getting the proportions of the figure correct

Painting three-dimensional form

Creating space
•
WHAT YOU WILL NEED
Oils or acrylics (starter palette as Lesson Four). Watercolour is not recommended for this project, but pastels could be used as an alternative to opaque paints as they are a sympathetic medium for figure work. Advice on pastels is given on pages 66-9.
•
TIME
4-5 hours

THE PROJECT

The subject you choose will depend on the availability and willingness of family or friends. If possible, persuade someone to sit for you for a whole morning or afternoon. If not, use yourself as the subject and paint a self portrait, as in Lesson Four, but this time painting your whole body rather than just your head.

SETTING UP THE POSE

If you have a model, arrange a comfortable pose on a sofa or in a chair so that you can see the whole figure and enough of the surroundings to make an interesting painting. Take care with the set-up, trying to achieve a good balance of shapes, colours

1 ▼ Having set up the pose and chosen her position, the artist makes a light drawing of the main shapes. She has chosen red pastel for this, because both background and foreground are to be red.

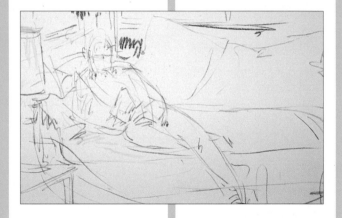

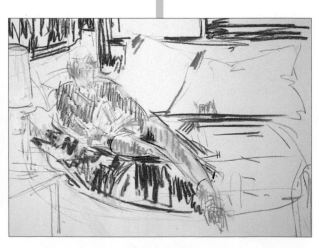

and tones. Move furniture around if it improves things, and give consideration to the lighting. You want to avoid very harsh illumination that casts dark shadows on one side of the face and body, but you need enough light to model the form and show up the colours.

Decide how much background you want to include and position yourself so that you are painting sight size (see Lesson One). The head should not come too near the top of your picture area or it will look cramped, or so far down that the figure seems to be slipping out of the picture.

DRAWING AND PAINTING

If you are using paints, begin with an underdrawing in pencil, charcoal or thinned paint.

2 ◄ **Areas of colour are laid in rapidly, with the point of the pastel sticks. Some pastellists use the side of the pastel to establish broad areas of colour, but this artist's approach is linear, and she works in the same way throughout. You will need to experiment with pastels to find the way of working that suits you best.**

Underdrawings for pastel can be done in charcoal or the point of a pastel stick — do not use pencil, as graphite cannot easily be covered with pastel colour. You may have to amend and correct the drawing several times before you are ready to paint, so if you are using charcoal, and you end up with a heavy build-up on the painting surface, spray it with fixative before painting.

When you begin to paint, initially concentrate on the broad areas of colour and tone which describe the main shapes and forms. You will find that you can create the impression of space better if you leave the paint quite thin in the background — thick paint, like warm colours, tends to advance — so build up the painting gradually, using juicier colour for the figure. Much the same applies to pastel — you can create a similar effect to that of thin paint by using a sketchier, lighter treatment in the background, perhaps leaving the paper only partially covered. Bring in more detail towards the end but don't automatically include details just because they are there, and don't worry about achieving a likeness.

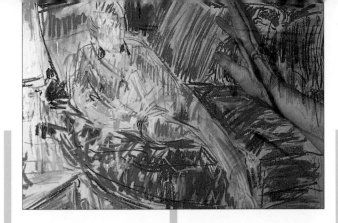

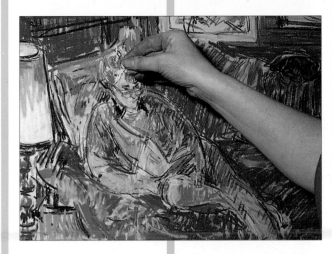

5 ▲ **In the finished painting, you can see how colour has been built up by means of a complex network of lines, with the minimum of blending and overlaying.**

3 ◄ **The colours of the cushion are slightly blended and softened by rubbing gently with a finger.**

4 ◄ **The figure and setting were brought to a fairly finished stage before any attempt was made to define the features. Touches of light colour are now added to the hair.**

SELF-CRITIQUE
● Does the figure look convincingly solid?

● Are the proportions correct?

● Could you improve on the composition?

● Have you made use of warm and cool colours and different paint textures?

● Should you have put in more detail? Or left some out?

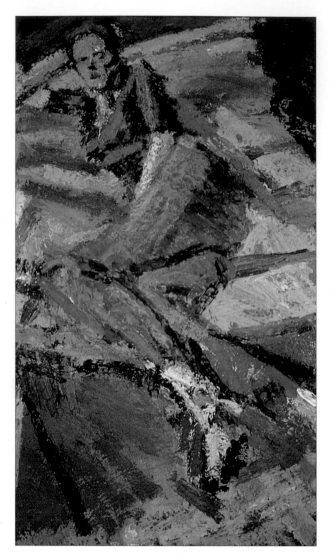

► Laura May Morrison
Repose
Oil
Here the figure is not treated naturalistically, but as the main element in a complex pattern.

▲ Peter Clossick
Reclining Figure
Oil
A daring and exciting composition, with the figure creating a series of diagonals right across the picture, and the vivid blues heightening the sense of drama.

◄ Susan Wilson
The Taos Dress
Oil
At first glance the composition appears deceptively simple, but in fact it is carefully planned. The artist has avoided placing the child directly in the centre, which is seldom successful, and has broken the symmetry further by allowing the chair to go out of the picture. This might have created an awkward effect of "slipping" to the left, but the inclusion of the chair's dark shadow provides a balance which prevents this.

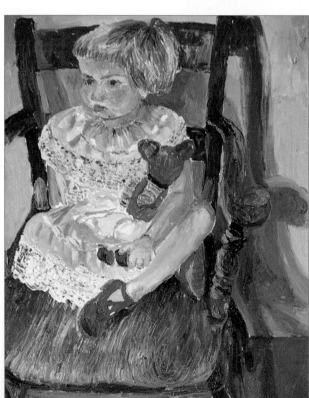

acquire the skill to allow you to depict the figure with confidence. People are not easy to paint, partly because of the complexity of the forms and partly because this branch of painting demands a higher standard of accurate description than any other. If you get the shape of a hill or tree in a landscape wrong it may not affect the painting overmuch, but a figure with legs that are too small for the body will jar because as fellow-humans we can all identify unlikely proportions.

alternative projects

If you got on well with the project in Lesson Six, working from drawings, you could try a figure painting done from a series of studies and colour notes. Or you could attempt a more ambitious painting based on studies, placing two or more people in an interior. This would be useful practice for those who are particularly interested in this branch of painting; multiple figure compositions can seldom be done entirely from life for obvious reasons.

SUGGESTED SUBJECTS
- Sunbathers on a beach
- Card players
- A person reading or knitting
- A child playing

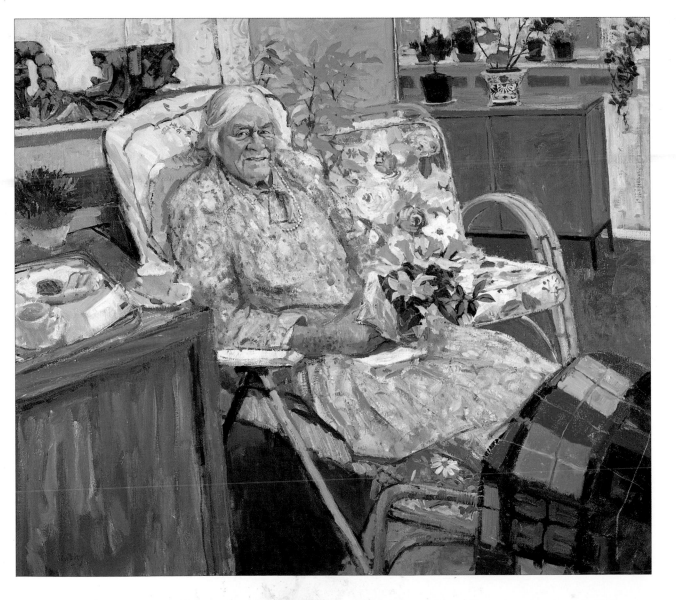

◀ Trevor Stubley
Miss Violet Bagshaw Aged 101
Oil
This sensitive portrait is a celebration of the sitter's great age, and was commissioned for a museum in the north of England. The setting has been treated with as much care as the figure, as it is an integral part of the painting's "story".

The proportions of the body and face

One of the most difficult aspects of painting the figure is assessing the relative proportions correctly — as you may have discovered for yourself if you tried the previous project. It is hard enough when you are painting from the nude, and you can see the torso and limbs clearly, but the problem is compounded when the figure is clothed, as you must try to visualize the body below its sartorial disguise.

Those who are able to attend life classes will find them a valuable preparation for all figure work, including portraiture, but drawing and painting the nude is no longer considered an essential part of art education, and the rules of human proportions can be learned very quickly. Of course, proportions vary considerably from person to person, but once you are familiar with the "standard model" you will find it easier to spot and record the individual differences that will make your painting look convincing and well observed.

PROPORTIONS OF THE BODY

The head, from the crown to the end of the chin, is normally used as the unit of measurement. The body of an adult is approximately seven and a half heads high. The legs are surprisingly long — a convenient rule to remember is that when a person is standing, the halfway point is not the waist, as you might

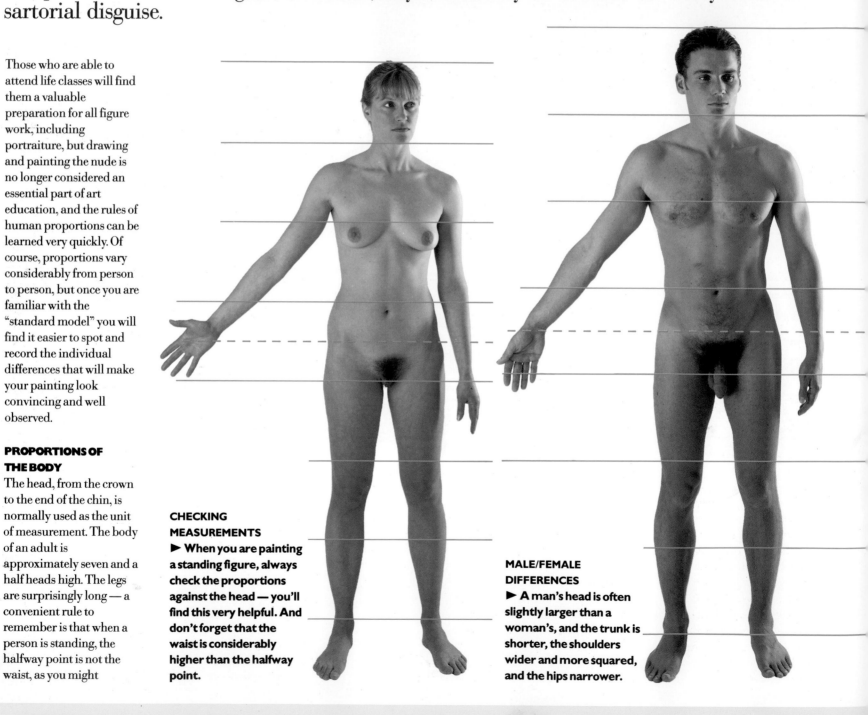

CHECKING MEASUREMENTS
► When you are painting a standing figure, always check the proportions against the head — you'll find this very helpful. And don't forget that the waist is considerably higher than the halfway point.

MALE/FEMALE DIFFERENCES
► A man's head is often slightly larger than a woman's, and the trunk is shorter, the shoulders wider and more squared, and the hips narrower.

imagine, but considerably below it.

The length of the arms and size of the hands and feet are often misunderstood. When the arms hang freely, the elbows of a man are at waist level and those of a woman slightly below it (the bone of the upper arm is slightly longer in a male). The fingertips reach to mid-thigh. The hand is large enough to cover the face from chin to forehead, and the foot is about one head in length.

The head of a child is much larger in proportion to the body, depending on age, and the legs are shorter. A baby's body is only about three heads in length, and a child is roughly five heads tall. Careful observation is needed when painting children, as their proportions alter from year to year before they reach full adulthood.

PROPORTIONS OF THE HEAD

A common mistake is to give too much space to the facial features, and to place the eyes too high up. In fact, the features occupy a relatively small area of the whole head, with the bottom of the eye sockets more or less in the middle, and the ears lining up with the brows. Seen in profile, the head is much deeper than one thinks, with the distance from back to front equal to the depth from crown to chin.

PERSPECTIVE AND FORESHORTENING

All this is easy enough to remember, but since few figure paintings or portraits are done square on you will also have to cope with the tricks played by perspective. When the head is turned away from you or tilted it becomes more difficult to apply the rules of proportion, so you will have to check these by measuring, combined with

THE HEAD
▲ **The bottom of the eye socket is the mid-point of the face. The depth of the head is almost the same as the length from crown to chin.**

careful observation. You can hold your pencil up at arm's length and use it to check the distance between features or that between the ear to the eyes, depending on the angle you are painting from. But measuring in this way can be very misleading unless it is done with great accuracy. Generally it is preferable to compare shapes and to try to relate the shape of the head to the background and the shapes of the features to each other.

Foreshortened heads, limbs, feet or hands are notoriously difficult to get right, but in a figure painting, some element is bound to be foreshortened to some degree, so you will have to come to grips with the problem. Suppose you are facing your model who is seated in a chair with one leg crossed over the other; both thighs will be acutely foreshortened. The rules of proportion will not help you here, indeed they may hinder you. Because you know that legs are long you will be unwilling to believe your eyes, which tell you something very different. The measuring system shown on page 42 is essential in such cases, as foreshortened shapes are often hard to believe. You will find it helps to use some feature of the background and any objects near the figure as a reference for measuring the length of a limb or the size of a hand or foot.

FORESHORTENING
▲ **Foreshortened bodies and limbs are not easy; you will need a combination of patience and careful observation.**

People and places

If you carried out the project in Lesson Six you will have learned something about making drawings for paintings. This is an extension of the same idea, but this time you are not restricted to an interior in your own home — you will be going farther afield and drawing people in an environment of your choice. Sketches and studies are an essential preparatory stage for any subject that includes more than one person; although you will occasionally find obliging groups who will sit still for long enough to be painted — sunbathers on a beach, or elderly Greek gentlemen at café tables, for example — these are unusual bonuses for the artist. Few, if any, artists can invent figures, so they build up a store of visual reference which can be used for paintings made in the studio. This is also useful practice even if your main interest is landscape. You will sometimes want to include a figure or two, perhaps to give a sense of scale, provide a colour accent or accentuate a focal point, and a badly realized figure can destroy the credibility of a painting.

A PERSONAL SHORTHAND

The difference between this exercise and making the considered and deliberate studies which were the subject of the earlier lesson is that when drawing people in a setting you have to incorporate more information in a single drawing. Written notes are an invaluable aid to visual ones, but you must be sure you know what they mean. For example, there is no point in

65 ▷

► From the vantage point of a public bench in a busy city, the artist made several rapid pen sketches of different groups of figures, backing these up with written colour notes.

THE AIMS OF THE PROJECT
Drawing figures on location

———

Making colour and tone notes

———

Relating figures to their setting
•
WHAT YOU WILL NEED
Large sketch book or paper and drawing board, drawing and painting materials. Any medium can be used for the final painting.
•
TIME
2-3 hours (for the sketches)
3-4 hours for the painting

THE PROJECT

First decide on a location that interests you and where there are always bound to be people. Cafés and museums are both good, as they will provide somewhere for you to sit, but you can choose an outside location if you prefer, such as a park, a street market, or a station.

THE SETTING

Begin by drawing the setting for the figures, which might be just a table with a window behind it, or parts of the trees and seats in a park, with background buildings. Don't get too bogged down in detail, but try to provide a convincing backdrop for the figures. Make a note of the direction of the light and the weather conditions, i.e. sunny or overcast, because this will affect the way you use light and shade in the painting.

THE FIGURES

Now draw in as many figures as you can, standing, sitting, bent over a newspaper, carrying shopping or anything you notice. If you see an interesting posture, such as someone gesticulating or walking with shoulders hunched against wind, record it. Don't rub

1 ▲ After looking through all his sketches, he decided on a combination of two, and made his working drawing accordingly. This was then squared up (see page 55) ready for transfer.

2 ▲ Watercolour painting requires a careful drawing, so the squared-up drawing was transferred to the painting surface. The first colours are now laid wet into wet.

anything out, and draw one figure over another as though everything were transparent. It doesn't matter if the drawing is messy and crude. What matters is the information you gather.

Make colour and tone notes as you draw, and also note the relationship between the colours and tones of the background to the figures. For example, note whether a particular figure is light against a dark tree, or dark against a light wall. Apart from your main drawing, make any separate studies you need which will remind you of the particular light and atmosphere of the place.

PLANNING THE PAINTING

You should have included more figures than you need on the main drawing, so when you plan the painting, choose those that will make the most interesting composition. You will probably have to

3 ▲ **The angle of the board is an important factor in watercolour work. It is usually slanted upwards slightly for broad washes, so that the paint can run down the paper. Here, however, the artist wants the colour to stay in place, so the board is placed flat.**

make some working drawings to help you decide on the best arrangement of the figures and the size and shape of the painting. You may at this stage find that you need more information, in which case you should return to the same location to make more studies, and possibly take some photographs as well (see Lesson Nine for advice on working from photographic reference).

4 ▼ **The painting is built up gradually, with each area of colour kept separate except on the foreground figure, where colours have been deliberately allowed to bleed into one another. One of the secrets of watercolour painting lies in deciding where you need a crisp edge, achieved by laying paint on dry paper, and where colour-runs and blends will be more effective.**

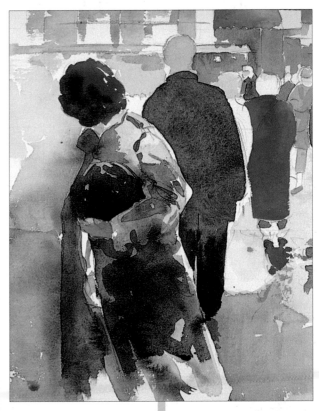

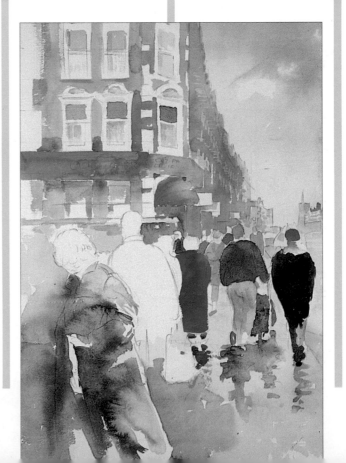

5 ▲ **This detail shows how the wet into wet and wet on dry methods can be combined. On the woman's hair and the man's trouser legs, dark colours have blended into lighter ones to create a soft effect, while the application of new paint onto a dried underlayer has produced the distinct hard edges needed to define the folds of the woman's coat.**

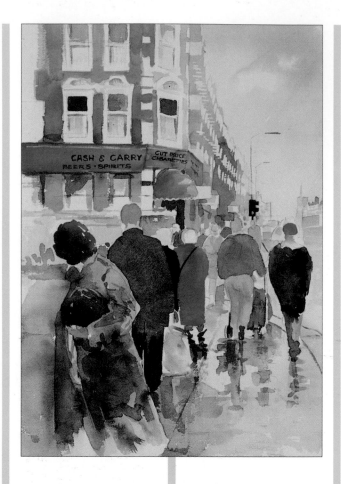

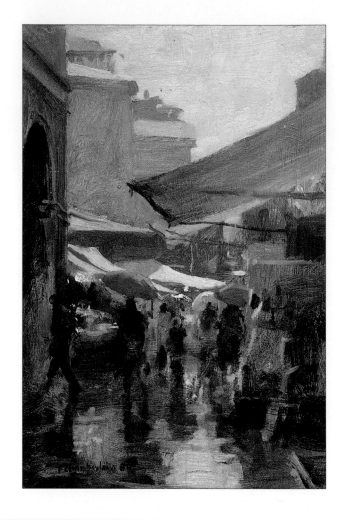

▶ Trevor Chamberlain
Rain, Rialto Market, Venice
Oil
If this had been a large oil painting it would almost certainly have had to be worked from sketches. However, Chamberlain likes to paint directly from the subject, and works on a very small scale — this picture is no more than 25cm (10 ins) high — which enables him to lay colours very rapidly. The sweeping brushstrokes and blurring of the colours by working wet into wet are marvellously descriptive of the subject.

6 ▲ **The finished painting**, lively and full of atmosphere, looks almost as though painted on the spot rather than worked indoors from drawings. The artist has resisted the temptation to overwork; a watercolour can quickly lose its freshness if too many colours are laid over one another.

SELF-CRITIQUE
● Did the drawings you made on location provide sufficient information from which to paint?

● Did you remember to note the direction of the light?

● Did your colour notes make sense later?

● Would you use the same method of recording colours and tones again or could you improve on it?

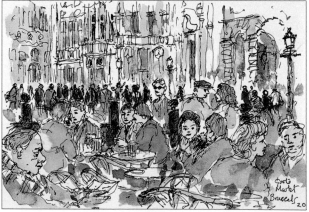

◀ Ray Evans
A Market in Brussels (sketchbook study)
Pen and watercolour
Evans has many sketchbooks filled with drawings of people, places and landscapes, some of which he later uses as a basis for finished paintings. The more you sketch, the more ideas you will have for paintings.

writing down "blue coat" against a drawing of a figure; this will mean nothing if you do your painting a month or even a week later — there are countless different blues. If you can identify the colours you might use to make the blue you could describe it in these terms — "dark ultramarine with a touch of violet" or some such, but you may not be experienced enough in colour mixing to do this. An alternative is to refer to things whose colours you know well, for example you might note a brown as "dark coffee" or a yellow as "yolk of egg" (some artist's sketches are veritable poems of visual allusion).

Tone is rather harder to pin down. You will give yourself a headstart if you use a sketching medium that allows you to express tone, such as charcoal, soft pencil or a graphite stick, but failing this you could use a numbering system. If you think you will have four main tones in your painting, you can number the various areas of the drawing 1-4, either starting from the darkest and working up, or vice versa.

PRACTICAL TIPS

When drawing figures in a setting, most people start with the human interest and hope that the setting will look after itself. It is not hard to see why — after all, the figures are the centre of interest — but you will soon find that a figure or group seen floating in space does not provide the reference you need. And apart from this, it is easier if you begin with the setting. Suppose you want to make a painting of a group of people in a café, with other groups behind. If you draw the tables, chairs and general layout of the room first and then add the people, there will be a fixed reference point for the figures and you will be sure to get the scale right. The same applies to figures in the street. Once you have drawn the main features of the buildings — in correct perspective — it is a simple matter to relate the figures to doors and windows. A common mistake among inexperienced painters is failure to grasp the fact that perspective affects everything, and figures diminish in size, like everything else, according to their distance from you. (Turn back to page 40 if you need a refresher on perspective.)

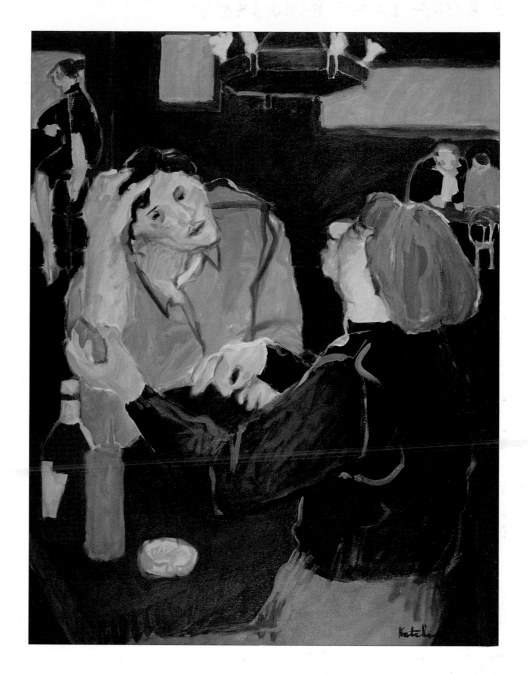

▲ Carole Katchen
White Horse Tavern
Oil
Always try to look for people's characteristic gestures and mannerisms. Here they are beautifully captured, giving a convincing impression of a lively talker and her silent listener. Although there are other people in the room, the artist has cleverly employed devices to isolate the two main figures. The couple on the right are not only pushed back in space but involved in their own private conversation, while the girl on the stool looks out of the picture, her attention fixed on an unseen protagonist.

Introducing pastels

Pastels are sometimes omitted from books about painting because some define them as drawing and others as painting media. This versatility is, however, one of their many charms; you draw with pastels in that you usually apply them directly rather than by using a brush, but you also paint with them in the sense of building up areas of rich and glowing colour that can compare with paintings in oils or watercolours. You will see something of the range of effects they can achieve if you look at pages 182-187 in Part Three of the book, where you will also find more detailed advice on pastel techniques.

Ingres paper has a slight texture and is made in a wide range of colours.

A dark paper would emphasize a sombre colour scheme.

Greys and warm beiges are a safe choice for early attempts.

In many ways, pastels are the perfect beginners' "paints". They offer the most direct way of putting pigment on the picture surface; they are quick to use, and apart from the pastels themselves you need very little equipment. Unfortunately, it is the pastels themselves that are the single drawback. You can paint in oil, acrylic or watercolour with only a few colours, mixing them to make more. Colour mixing with pastels is limited, however. You will need a large range of pastel colours, including light and dark versions of the basic hues, because the colours cannot be pre-mixed — any mixing must take place on the picture surface. It is usual to select from a wide range of colours the one nearest to the desired colour so that the minimum of modification is necessary. You won't be sure of which colours you really need until you have begun to work, so entering the field can be slightly bewildering.

The best course is to

start in a small way, with a basic palette such as the one shown here or one of the boxed sets put out by manufacturers as starter kits. All the good brands of pastels are sold as separate sticks as well, so you can add to your set as and when you need to.

PAPER

An important factor in pastel painting is the colour of the paper; most pastels are worked on coloured or toned paper. The reason for this is that unless you apply the colour very heavily all over the picture, some of the paper will inevitably be visible through and between the pastel marks. Little patches and flecks of white paper "jump out", ruining the effect of the picture and devaluing the applied colours, so a paper colour is chosen which either contrasts with or blends in with the overall colour scheme of the picture. Often quite large areas of the paper are left bare, to stand for a mid-tone, or possibly shadows

▷68

▲ In the top picture you can see the texture of the Ingres paper clearly. The photograph above shows pastel laid on Mi-Teintes paper, the other standard surface for pastel work. The grain of the paper is always visible to some extent, even when the colour is built up thickly.

the starter palette

The colours shown here, a small selection of the Rowney range of pastel colours, are not substantially different to those suggested earlier for oils, acrylics and watercolours. There are two versions of each primary colour (or three, in the case of blue) plus black, white and a few additional secondary colours such as orange, purple and another green. If you find you enjoy working with pastels you will certainly want to add to this range quite soon, as it is very small by pastel-painting standards. However, you won't know which colours you need until you begin to work, so this range will form a useful starting point.

When buying replacement colours or adding to your range you will need to understand what the manufacturer's code numbers for colours and tints mean. Unfortunately, they all have different systems, but Rembrandt colours have both a name and a number. The figure 5 after the colour number indicates the pure colour; higher numbers denote an admixture of white and lower ones (fewer) an addition of black. If you decide on other ranges, either ask for an explanation of the system or simply rely on choosing what you need by eye.

THE COLOURS
1 Lemon yellow tint 6
2 Cadmium yellow tint 4
3 Crimson lake tint 4
4 Cadmium red tint 6
5 French ultramarine tint 8
6 Cobalt blue tint 6
7 Cerulean blue tint 4
8 Viridian tint 6
9 Sap green tint 5
10 Purple tint 4
11 Cadmium orange tint 6
12 Yellow ochre tint 3
13 Burnt sienna tint 6
14 Cool grey tint 4
15 Ivory black
16 White (cream shade)

SIDE STROKES

► **By making strokes with the side of the pastel stick you can build up broad areas of colour. Here the pastel has been broken into a short length. You will usually have to break the stick; if you try to make strokes with the full length of the pastel it will probably break under pressure in any case.**

VARYING THE STROKES

► **The depth of colour you achieve depends on the pressure on the stick. Here the pastel has been angled slightly so that there is more pressure on one end than the other. Notice how the colour of the paper affects that of the pastel, giving it a deep, rich glow.**

or areas of the sky.

The texture of the paper is also important, both to the colour and to the character of the marks you make. Pastel papers have to have a slight tooth to hold the soft pigment and prevent it slipping off the surface. There are two inexpensive and easily available papers made specifically for pastel work, but you can experiment with a variety of other surfaces, such as watercolour paper, printing paper or rough cardboard. There is more

about suitable working surfaces in Part Three.

WORKING METHODS

There are very few rules about working in pastel, and each artist evolves a personal method. Some begin by using the flat side of pastel sticks to lay in large areas of colour, rather like washes in watercolour, adding more detail gradually with the point of the stick. Some work from the top to the bottom of a picture, completing each area more or less independently with

either the side or the point of the stick as occasion demands. Others build up their images by means of a series of lines, seldom if ever using side strokes. There is one important rule, however, which is that you should never make a preliminary drawing in pencil. Pencil leads make slightly greasy marks which tend to repel the chalky pastel colour, making it difficult to cover them completely. Rather, use a pastel pencil, charcoal or the tip of a soft pastel stick.

For those who have not used the medium before, it might be helpful to correct a common misconception. Books about using pastels will often tell you how vital it is to get the drawing right at the outset because you can't erase. This is true but misleading. You can't erase a pastel line as you would one in pencil, but it doesn't matter because you can work over any lines or areas that have gone wrong, even at quite a late stage in the painting. Pastels are opaque, and you can lay light colours

over dark and vice versa with no ill effects. Of course, you cannot go on overworking for ever, but sometimes you can make quite drastic changes provided you spray the area you want to work over with fixative first.

HATCHING
◄ There are many different ways of "mixing" pastel colours on the paper surface. By using the hatching technique of laying a series of roughly parallel lines in different colours or tones you will achieve an optical mixing effect with the lines merging to give the effect of continuous colour.

DIFFERENT EFFECTS
◄ Hatched lines need not be straight; a more informal effect can be made by curves and loosely scribbled lines. You can also lay one set of hatched lines over another to create complex colour effects. This technique is known as crosshatching.

▼ Cotton-wool balls and cotton buds are useful for blending colours.

PAPER COLOUR
◄ When two different pastel pigments are laid lightly one over the other so that the paper shows through, the paper in effect acts as a third colour.

ADDING BLACK
◄ Black is an important colour in pastel work, as laying it over another colour is the only way to achieve a really dark tone. Take care not to completely cover the colour below.

BLENDING ONE COLOUR
◄ When you want to create a soft effect, for instance in a sky, the pigment can be gently rubbed into the paper. Here a finger has been used, but for larger areas a rag or a piece of cotton wool would be suitable.

BLENDING TWO COLOURS
◄ Colours can be quite thoroughly mixed on the paper by laying one down on top of another and rubbing them into one another.

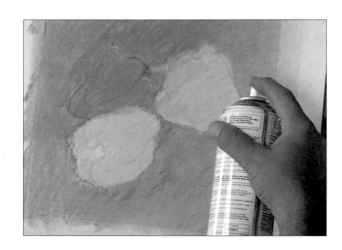

USING FIXATIVE
▲▼ A light spray of fixative helps to prevent the pigment flaking off or smudging. It can darken the colours slightly. Use it sparingly, holding the can about 30cm (12 ins) from the paper and spraying from side to side. On very light papers some protection is given by spraying from the back, as shown below.

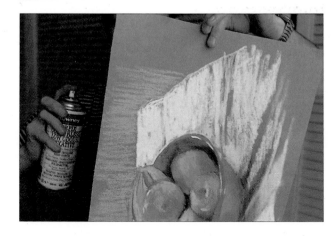

▼ A torchon, made from tightly rolled paper, is useful for blending small areas.

Working from photographs

Most artists nowadays use photographic reference to some extent, often to back up studies and sketches made on location, but sometimes for ideas — a photograph can provide the initial inspiration for a painting. The French artist Maurice Utrillo (1883-1955) painted his Paris street scenes from picture postcards in the privacy of his studio partly because he hated being watched at work, and the British painter Walter Sickert (1860-1942) based many of his highly personal and atmospheric urban scenes and figure compositions on photographs sometimes taken from newspapers.

THE CAMERA NEVER LIES?

In a sense the camera never lies, in that it faithfully records the patterns of light which pass through its lens onto the film. The problem is that we don't see like cameras and a photograph differs in many ways from what we actually see. Photographs can therefore be extremely difficult to work from, more so than painting directly from the subject or using drawings. They often don't contain the detail you imagine they do; the colour is often suspect, and since they are themselves two-dimensional it is difficult to avoid recreating in paint a photographic illusion of space.

As mentioned earlier, however, the biggest problem with using photographs is that the camera does not really record what we see. Most people will have experienced taking a picture of a beautiful landscape with a range of background mountains, only to find when the print arrives that the mountains look tiny, distant and quite uninteresting. This is because of our tendency to scale up background objects, which was

73 ▷

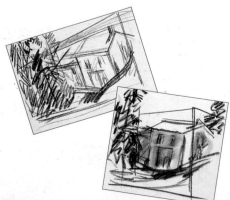

◄ **Several quick charcoal sketches are made to try out various different arrangements of the elements in the photograph.**

THE AIMS OF THE PROJECT
Using photographic reference

———

Selecting the information the painting requires

———

Making a personal interpretation
●

WHAT YOU WILL NEED
It does not matter which medium you use for this project so you could try out one you have not used before. If you are too practised in terms of technique you may be tempted merely to copy the photograph rather than interpret it.
●

TIME
2-3 hours for the drawing
4 hours for the painting

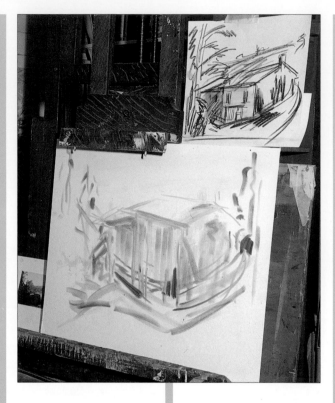

1 ▲ **The artist has selected one of the drawings, and with this pinned above her canvas, she begins the painting by making a brush drawing in thinned blue oil paint.**

2 ► **Still using the paint thin, she places dabs and patches of colour all over the picture so that she can judge the relationship of one to another. Here she uses a square-ended brush to make a series of marks for the foliage.**

THE PROJECT

If you have your own store of photographs, choose a colour print of an outdoor scene that you are familiar with (if you have already photographed it, the subject must have appealed to you). Otherwise you could use a picture postcard or an image in a magazine. Avoid scenes including people or animals, unless they form such a minor part of the image that they can be ignored. If at all possible, use a photograph of somewhere you know well.

MAKING A WORKING DRAWING

Look at the print critically to see how you might translate it in the painting. Don't accept either the composition or the format as necessarily the best one; you might, for instance, make a vertical shape out of the central section of a horizontal-format print. Make several quick drawings of the main shapes, and try to add to these by extending the drawing on all sides. Or if you decide to use only part of the photograph, mask off the area you have rejected and make drawings of the section that interests you. Choose one of the drawings as the basis for the painting. Its dimensions should be three times those of the photograph, or larger if you like.

THE PAINTING

The painting should be based on your working drawing and one photograph, with the former used to block in the painting. Pin your painting surface so that you can see it clearly and draw on it the main shapes of your composition. Your working drawing will probably be smaller than the painting, and if scaling up is difficult, you can use the squaring up method described in Lesson Six. If you are using water-colours, take care to keep the drawing lines light, otherwise they will show through the paint in the lighter areas.

Once you begin to paint, pin the photograph up by the drawing so that you can refer to both. When a small image is scaled up, much larger shapes sometimes look empty and uneventful. If you find this happening in your painting examine the photograph closely to see whether there are any suggestions of texture or slight contrasts of colour and tone that you can develop. Use your imagination and don't try to copy the photograph, let the painting dictate to you what you should do. Treat the photograph as you would if you were painting directly from the actual subject. Select what is important to you and your painting and leave out anything irrelevant. If you are brave enough, put the photograph away for a time and return to it only when you need to. When you have finished, compare the print and the painting and decide whether you have achieved a personal interpretation.

3 ▼ She continues to build up the painting, using linear brushstrokes rather than solid areas of colour, and allowing much of the white canvas to show through.

4 ► Now a relatively small round brush is used to introduce some strokes of turquoise blue into the foliage on the right of the house. A similar colour has been used among the greens for the trees on the left.

5 ▼ The edge of the roof is defined with a deep blue line of shadow. The palette used for the painting, although bright, is not extensive, consisting almost entirely of yellows, blues and yellow-greens.

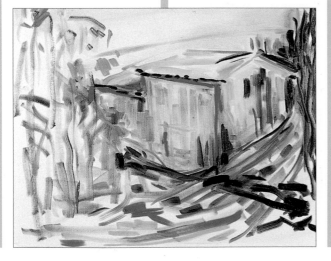

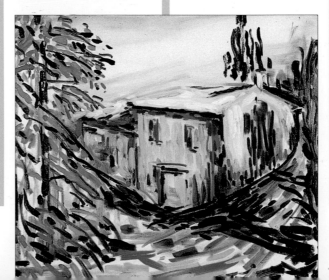

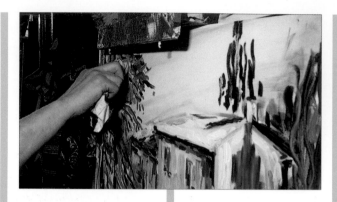

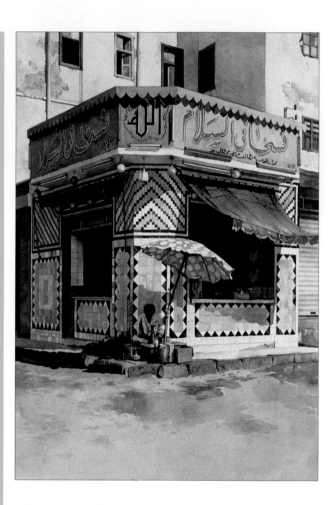

SELF–CRITIQUE
- Have you copied the photograph rather than translated it?

- Did the photograph provide sufficient information?

- Have you used your imagination?

- Has the exercise given you confidence?

6 ▲ The photograph has not been referred to since the painting was begun, as the artist preferred to rely on her own feeling for colour, as well as her memory of the scene.

Sometimes it can be easier to work from a black and white photograph, which does not dictate a colour scheme.

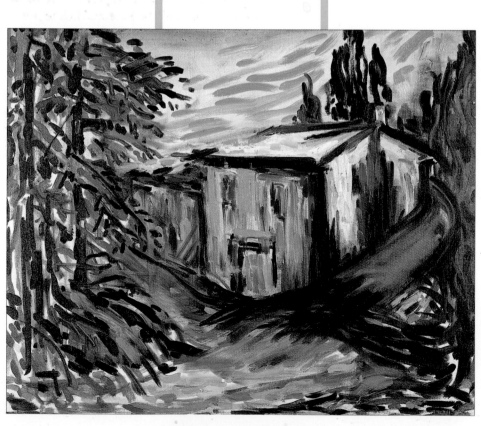

▲ Moira Clinch
Shop in Egypt
Watercolour
This photograph (right) was taken specifically for the painting, but although the composition was not altered, the colours are very different. The lovely candy-floss pinks do not appear in the photograph, and the tonal contrasts are infinitely more delicate in the painting.

▲ Hazel Harrison
The Mountains of Naxos
Pastel and charcoal
The squarer format used for the painting has given a more powerful upward thrust to the mountains, and additional movement is given to the composition by the clouds and the curving shapes on the hills in the middle distance.

mentioned in an earlier lesson, something which the camera cannot do. If you make a drawing and take a photograph of the same view, you will find they look quite different. Almost always the drawing provides better reference for the painting you have in mind. Another difference between photography and drawing is that the camera has one fixed point of view. When we draw, we automatically pan around a little both to left and right as well as up and down, and thus include more of the view than you would see through a camera viewfinder. A photograph of the same view is bound to be limited and disappointing.

MINIMIZING THE PROBLEMS

It would nevertheless be unhelpful to deny the value of the camera as an additional "sketchbook". Not everyone has time to draw extensively, nor is it always possible to make studies of the things that interest you. For example, fleeting effects of cloud or the strange light effects before a storm can be captured in seconds through the lens, but would be gone even before you began to sketch.

Some of the problems can be overcome once you are aware of the camera's limitations. For instance, if from past experience you know that a certain detail is unlikely to come out clearly in a photograph, move in closer and take another shot. If the subject is a wide sweep of landscape, take several photographs, moving the camera slightly each time; when you come to plan the painting you can make a photo-collage of these by sticking them together. It is also helpful to make written colour notes, particularly about sky and shadow colours, which colour prints often misrepresent.

◄ Rosalind Cuthbert
Lake Garda from Tenna
Watercolour and pastel
Here the photograph was used only as a reference for the shapes of the mountains and lakes. The artist has given free rein to her imagination, and there is little resemblance in terms of colour.

FOUNDATION COURSE

Working on location

Most of the earlier painting projects have been based on subjects in and around the home, but now you are being asked to take your painting materials outside and complete a whole picture on the spot. It is not, of course, obligatory. Anyone who finds the prospect daunting or feels they aren't yet ready for it can continue working indoors from studies and photographs. You don't, however, need to go far. You could, in fact, paint in your own garden. Some artists never work out of doors, but if you are interested in landscape rather than still life or portraiture you should at least try it. There is no substitute for direct experience of nature, with the landscape and weather surrounding you, and the speed at which you have to work can produce a spontaneity and fluency that may surprise you.

EQUIPMENT

You may need some extra paraphernalia for outdoor painting, though some artists get by with the absolute minimum. Whatever medium you choose, you will obviously want a sketching easel if you like to work standing, while those who prefer to sit may have to invest in a folding stool of the kind sold by artist's suppliers. These are low enough to allow you to put your paints on the ground beside you. If you are working on paper, you will need a light drawing board — a piece of plywood cut to size is perfectly adequate — and drawing pins, clips or adhesive tape to hold the paper in place.

Clothing will depend on the climate. Hot sun can dazzle you as well as make you uncomfortable, so a wide brimmed hat is a good idea. In changeable or outright cold weather you would be well advised to carry an extra sweater and possibly an outer garment such as an anorak. Wear old clothes if possible, as they can be spoiled by paint.

Oil painters will need a bottle of turpentine or white spirit for thinning paint and cleaning brushes plus a jar to pour some of it into, plenty of rags or kitchen paper, and an easy-to-carry paintbox or bag. A sturdy rucksack or a bag with a shoulder strap is useful for

77 ▷

THE AIMS OF THE PROJECT
Adjusting to a new way of working

Making a spontaneous statement

Achieving the best composition

Learning to edit nature
•
WHAT YOU WILL NEED
Any medium can be used, but don't choose one you haven't used before. Understanding the way your paints behave is essential when you are working quickly.
•
TIME
3 hours maximum

THE PROJECT

The aim is to complete a painting in one morning or afternoon session. This may sound daunting, but Monet once gave himself no more than seven minutes for a painting, or "until the sunlight left a certain leaf". You could prepare yourself, however, by choosing the location beforehand, perhaps the day before you intend painting, unless you already know the subject very well. Monet's swiftly-painted landscapes were usually of places he had observed over a period of time and often painted before. Choose somewhere convenient, and if you think you might be thrown off balance by the comments of passers-by, look for a fairly private place. For town-dwellers, a garden or park could be ideal, while those living in the country will probably know of suitable secluded spots. Walk around your chosen place and try to find a good viewpoint to paint from, exploring the possibilities thoroughly before making up your mind. A home-made viewfinder made by cutting a rectangle from a piece of card can be helpful here in isolating what will make an

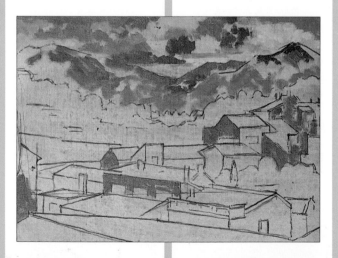

interesting picture.

When you begin to paint, cover the surface of the canvas or paper as rapidly as possible. But don't rush — one of the difficulties of working against the clock is that you have to fight a tendency to panic. It is quite probable that the light will change as you work, but do not try to amend the painting to keep up. Make a note of the direction of the light before you start (you can put a small cross at the edge or in the margin of the picture, and delay painting any shadows until you have established the main features of the painting. If the weather changes so dramatically that you cannot continue, stop and consider finishing the painting another day at roughly the same time. But don't allow yourself more than three hours in all for this painting or you may lose the spontaneity that characterizes this method of working. It is worth mentioning that paintings made on the spot don't necessarily have to be produced in a few hours. Cézanne spent days and days struggling with his landscapes in Provence, painting and repainting.

1 ◀ **The painting is in oil, on a small canvas board, and the artist has begun by making a brush drawing. When the subject is at all complex, it is a good idea to make the drawing the day before if possible. Changing light does not affect the drawing, but is hard to cope with once you have begun to paint.**

2 ◀ **In changeable weather like this, the colours of clouds alter rapidly, so these are blocked in at an early stage.**

3 ▼ **Since the quality and direction of the light affects all the colours in the landscape, it is important to work over the whole picture at the same time.**

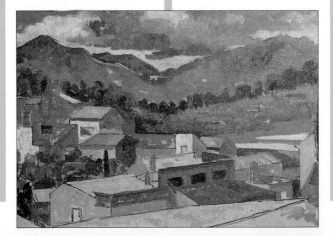

4 ▲ **Warm pinkish-reds echoing the colours in the distant hills, are added to the buildings. The mauve-blues also appear in the hills, and on the undersides of the clouds.**

5 ▲ **The sky, which changed considerably as work progressed, was left alone after the early stages. You have to be tough with yourself about clouds, and not try to alter them as you paint.**

6 ▲ **The final touches, which bring the painting to life, were the points of light on the hills and trees and some further definition of the roof in the foreground. Although he works slowly and thoughtfully, the artist had no difficulty in completing the painting in one session. This was partly due to the small size of the canvas: it takes a long time to cover a large canvas, so it is wise to restrict yourself to a small scale.**

SELF-CRITIQUE

● Have you conveyed a feeling of the subject?

● Did you include elements that would have been better left out?

● Do you think the composition is satisfactory?

● Do you think you could have worked better in another medium?

● Did you enjoy painting from nature?

▲ Mark Baxter
Sketchbook studies
Oil
Oil is an excellent medium for small outdoor studies. The English landscape painter John Constable made countless oil sketches of clouds, some quite tiny, and often painted on paper or cardboard. These lively, energetic studies have something of the same quality.

▼ Philip Wildman
Bridge Over the Tiber
Oil on paper
In this atmospheric sketch, the artist has captured the essentials of the scene — the light and colour — and excluded irrelevant details. Painting on location requires some self-discipline — you have to decide quickly what is most important and ignore the rest.

holding everything. Your easel will have to be carried separately, unless you buy a sketching bag which has straps so that it can be attached.

Acrylics and watercolours both require water, so don't forget a bottle (plastic mineral-water bottles are ideal as they are light) and jars. For acrylics, the "Stay-Wet" palette described on page 16 is useful, as without it your paints will harden and become unusable within an hour or two. Watercolourists should also provide themselves with a small sponge for controlling paint and rags for cleaning up the paintbox from time to time. Pastellists are fortunate since there are no extra requirements specific to this medium. Kitchen paper for cleaning the hands is useful, however, as they quickly become covered in pigment.

PLANNING THE PAINTING

One of the common faults with on-the-spot landscape painting is poor composition. There are two main reasons for this, the first being that unless you make preliminary drawings the composition is often determined by chance — what accidentally fits on the rectangle. The second is that, because working on the spot compels you to work fast you can easily overlook the necessity of editing nature.

If you are using paper on a drawing board you can follow a simple strategy which allows you to take a more flexible approach to the format of the picture. Take a larger sheet of paper than you need, and when you begin to work, leave generous margins all the way round. If you find the picture needs to be horizontal rather than vertical, as you may when you are halfway through the painting, you can still extend it sideways or in any other way that you choose.

The second potential problem can often be solved by giving a little thought to the painting before you begin. Remember that you do not have to include everything just because it is there. If something jars in terms of colour or shape, decide to leave it out. If a shape, such as a tree, dominates one side of the picture area and clearly needs a counterbalance on the other, think about bringing in some feature from another part of the landscape.

▲ Jeremy Galton
St Judes, Hampstead
Oil on board
Galton is deeply committed to painting on location, whatever the weather, and goes out equipped with thick clothes and hot-water bottles to help him withstand the cold. This carefully controlled painting gives a real feeling of the direct experience of winter. It is almost but not quite monochromatic — notice the slightly warm brown of the trees, and the hint of blue in the background buildings.

further information	
16-19	Introducing oils and acrylics
91	Composing a landscape or townscape
94-97	Painting an impression
150-157	Painting with oils

Learning from the past

Prior to the establishment of art schools, most artists learned to paint in the studios of successful painters. As apprentices they copied their master's work, and once they were sufficiently competent they sometimes even blocked in the master's paintings, leaving perhaps only the finishing touches to the master himself.

The tradition of copying persisted even into the Impressionist era, Pierre-Auguste Renoir (1841-1919), for example, copied the work of the great eighteenth-century masters such as Antoine Watteau (1684-1761) in the Louvre — which influenced his love of light, luminous colours — and Cézanne in his figure paintings returned constantly to arrangements based on the work of Michelangelo (1475-1564), Rubens (1577-1640) and Poussin (1593/4-1665).

As art education developed, copying the work of the "Old Masters" was seen as an important part of every young artist's education, and even today many would agree that it is a valuable discipline. Just as taking written notes in a lecture concentrates the mind and helps to commit ideas and facts to memory, copying a painting compels you to analyse the organization of the picture and the way the artist has used the paint. You can seldom do this in an exhibition, where you look at a painting and then move on to the next one.

Actual copying continues to be practised by some artists and students today, but is no longer obligatory. Many modern artists, however, make visual references in their work to paintings they admire, sometimes using the same compositional elements or re-interpreting a particular theme. There is usually an element of tribute in this, for example the modern British painter Francis Bacon (1909-92) produced a series of paintings based on van Gogh's self-portrait, *The Artist Going to Work*, as a direct homage to a painter who had influenced him deeply.

USING REPRODUCTIONS

You may find it helpful to try copying a reproduction of a painting you particularly admire. Although this will not give you as much insight into technique as the

81 ▷

THE AIMS OF THE PROJECT
Learning to analyse colour relationships

Using collage to translate these relationships into similar ones

Working with "ready-made" composition
●
TIME
First stage: one day
Second stage (optional): half to one day
(the time taken will depend on the complexity of the painting chosen)
●
WHAT YOU WILL NEED
A selection of coloured papers

Scissors, glue and cartridge paper for the collage

Paints and any surface chosen for the painting

1 ▲ A Cézanne landscape has been chosen, as the distinctive brushstrokes will translate well into collage.

2 ▼ A large selection of blues and greens was required. These were taken from magazines, and collected over a period of time.

THE PROJECT

There are two separate stages to this project, the second one being optional. The idea is to choose a painting you like, use it as the basis for a paper collage, staying as close as possible to the composition and general arrangement of tones and colours, and then, putting aside the original picture, make your own painting from the collage.

THE COLLAGE

Decide on the painting you want to use as your starting point. This should be a reproduction of either a painting you like or one

which you wish to know more about. It could be a postcard reproduction or a reproduction in a book. It must be in colour. Try to avoid too complicated a subject — a landscape or still life will give you a chance to explore colour and tonal relationships and make use of warm/cold colour contrasts to create space and form.

As soon as you have decided on the subject, start looking through any coloured papers you have, such as magazines and other printed material, for a selection of colours for your collage. You will probably need a wide range of colours, but only small pieces, so it should not be necessary to buy coloured paper.

When you have assembled the materials, prop up the reproduction of the painting and make a drawing on your working surface. Then begin to cut or tear the pieces to the right shapes, examining the colours and tones in the painting very carefully and trying to match them as closely as possible. If you are not sure, hold the chosen piece of paper next to the painting and you will immediately see whether it is too bright, dark, warm or cold a colour. If you don't have the correct colour — and there is no way you could

possibly have all the right colours — use the one you think is the nearest. Don't worry if you make mistakes, this is part of the learning process and will help you to recognize the properties of colours, for instance whether a particular green is biased towards yellow or blue and how each colour you put down is affected by the surrounding colours. Once you have decided on the main colours and shapes begin to stick them down, developing the collage until you feel it is complete.

THE PAINTING

When you think you have finished the collage, place it a little way from you and look at it to decide whether it makes visual sense. Remember it is to be used as the subject for a painting and if you feel it does not give you sufficient information for the second stage, don't start the painting yet. Return to looking at the reproduction and developing the collage until you feel you have something you can work from. When you have done all you can with the collage try making the painting. Put aside the reproduction you used and don't try to copy the collage. A painting can never look the same as a picture made with cut paper.

3 ► Each piece of paper is held up to the book reproduction and carefully matched before cutting and gluing down. Notice the variety of different blues even in this small section.

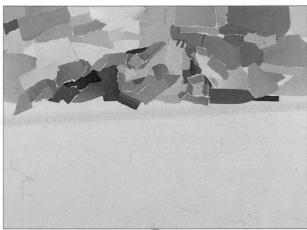

4 ► The sky and mountain top are completed first so that the colour relationships can be assessed before moving on to the foreground. Although there are many different colours, they have been kept relatively close in tone so that the effect is not too "jumpy".

5 ▼ The darkest tone in the top part of the picture, the blue on the

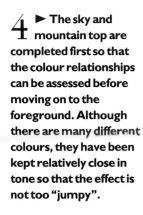

side of the mountain, is now balanced by an equally dark green.

1 ◄ A Cézanne landscape was chosen for this also, but one with a greater degree of definition and more distinctive foreground detail.

6 ▲ When translating a painting into another medium, such as coloured paper, the important things to look for are the tones of the colours, their "temperatures" (whether they are warm or cold) and the way they relate to each other. Here the colour relationships have been well observed, and the collage has an unmistakable flavour of the original painting. It was not, however, taken to the painting stage; instead the student began another one (right).

SELF-CRITIQUE
● Did your collage have the main colour scheme of the reproduction?

● Did you manage to translate the tonal relationships in the reproduction successfully?

● In your own painting, is the reproduction on which your collage was based still recognizable?

● Is your painting an improvement on the collage?

● Do you think you might have done better if you had chosen a different reproduction? If so, what would you choose now?

2 ► Again, the colours, although resembling the original, were limited by the papers available, and the forms have been simplified and treated in a more abstract way. You will often find that the medium and the painting itself begin to "make suggestions" of their own, so try to be receptive and let the picture evolve.

3 ◄ Although the collage was not quite complete, the student decided to move on to the final stage, the painting. She was pleased with the broad approach, and decided to retain this as far as possible in the painting by applying oil paint with a knife, which ensures a bold treatment. Since the collage was unfinished, she was forced to invent the colours at the top.

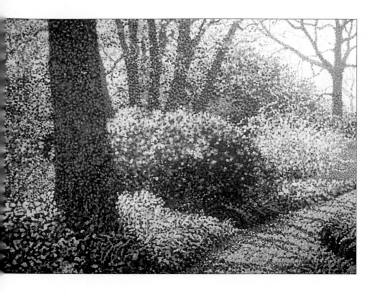

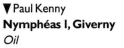

◄ Mary Anne Reilly
The First Day of Spring
Oil
Reilly says that the greatest influence on her work was a year she spent in Paris studying the Impressionists and Post-Impressionists at first hand. Her painting technique is a personal adaptation of Seurat's Pointillism (see page 21).

original painting, you will find that it helps you to understand composition and the distribution of colours, shapes and tones.

You can also learn a lot about composition simply by making quick pencil sketches of paintings, either from books or in an art gallery. You will often find that even a rapidly executed impressionistic landscape which doesn't immediately strike you as being "composed" has a definite pictorial structure. In the project that follows, you will be making a transcription rather than a direct copy, using a different medium from the original. This will enable you not only to learn about the organization of the painting but to make your own personal statement within a borrowed framework.

▼ Paul Kenny
Nymphéas I, Giverny
Oil
Kenny, like Monet, loves both light and water, and has paid homage to the great Impressionist by painting the subject Monet made

famous, the water-garden at Giverny. His method differs from Monet's however, in that his oils are done in the studio from watercolour sketches, while Monet painted directly from the subject.

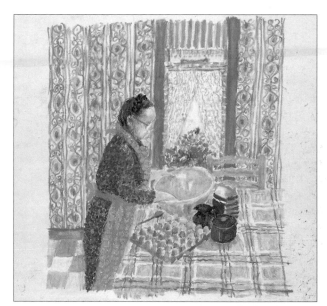

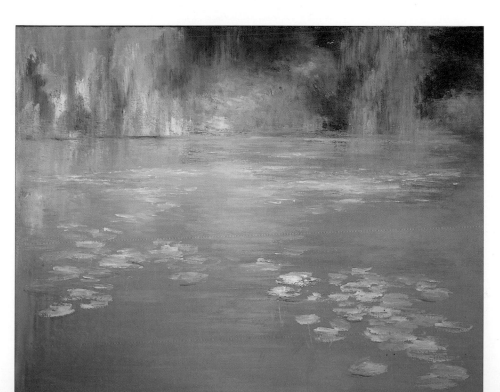

▲ Moira Clinch
The Artist's Mother
Oil pastel
This painting, done during the artist's student years, pays homage to Pierre Bonnard, whose lyrical interiors have inspired generations of painters.

PART TWO

Themes and styles

· ·

This section of the book introduces you to the major styles and themes in painting, both past and present. It is structured in a similar way to Part One, with a series of lessons and projects for you to try out, but in this case each lesson also features a "key" painting by an old master or important contemporary artist demonstrating a particular approach. The section begins with a major feature on composition, which is vitally important to all painting whatever the style or subject matter.

Composition

In working on the projects in previous lessons, you have already tackled some of the basic principles of composition. Deciding how large the picture should be, how the objects you are painting should be grouped together and positioned within the picture area, choosing different elements of line and shape, tone and colour, and applying them in ways that make your painting look right as a whole — all these are the ingredients of composition.

In the following pages, you will be studying themes and styles in painting; the techniques and approaches that make each painting uniquely expressive of the artist's idea. But first you need to consider the elements of composition in more detail, as the first step in understanding how you can realize the particular effects you want to achieve in your finished painting.

SIZE AND SHAPE

The majority of pictures are rectangular or contained by a rectangle.

Partly this is just practical — paper is sold in rectangular sheets and it is easier to make a stretcher for canvas or cut a panel for painting in this regular format, than to prepare a painting surface of a different shape. Visually, a rectangle gives a clear-cut, evenly balanced picture area within which you can organize the elements of your painting. Artists can, and do, make paintings that are round, elliptical or irregularly shaped. This may be because the painting is planned for a particular place, but the shape of a painting usually grows out of the demands of an individual subject or approach. Unusual shapes for painting are something that you can consider later if they interest you.

Working with a

CREATING SPACE
◄ In her watercolour, **Sunday in Central Park**, Carole Katchen achieves a generous sense of space on a small scale by means of both the broad curve travelling diagonally and the set-back position of the figures.

rectangle, you can choose to make the picture square, or to have a longer dimension from top to bottom, or from side to side. A format in which the upright dimension is longest is often referred to as a portrait shape, one in which the width is longer is called landscape. These terms, however, don't imply a rule for composition — a portrait or figure can occupy a wide canvas, and a landscape can be given vertical emphasis.

When you begin work, you have to choose paper or canvas of appropriate size and, unless you are making a square painting, decide whether you will use it as a portrait or landscape shape. This depends on your choice of subject and what you decide is the best view of it.

Some artists start painting without deciding on the final dimensions of the painting, letting the shape gradually emerge. Alternatively, an unusual format — a long, narrow rectangle, say — may suggest a particular treatment of the subject.

If you work on paper,

DRAMATIC PROPORTIONS
▼ The elongated format of **Black Iris** by Barbara Walton (mixed-media) focuses all attention on the elegant flowers and long stems.

objects naturally relate to a personal sense of scale; and when you paint them over life-size, you encounter problems in achieving the correct proportions and spatial relationships.

THE DYNAMICS OF THE RECTANGLE

Generally, a square is a balanced, self-contained shape; a rectangle with horizontal emphasis is soothing to the eye; and a vertical format is more thrusting and confrontational. However, the impact of a painting is usually more dependent on what you put into it than on its actual shape, although there are exceptions. In an elongated rectangle, the emphasis of the longest side can be a dominant factor. You would find it hard to counteract it completely by the opposing rhythms or directions you create in your composition.

As soon as you put a mark down on your working surface, whether it is a line, a blob or a clearly defined shape, this mark begins to interact with the overall shape of the picture. Firstly, it will seem to come forward from the "background" of the paper or canvas. Secondly, it will take your eye to a particular part of the overall rectangular shape. As you add other

MOVEMENT AND DIRECTION

▲▶ Lesley Giles's **Sailing Boat** (watercolour) has an implied movement that counteracts the stable rectangle. The viewpoint of Stephen Crowther's **At the Water's Edge** (oil) exploits the strong line of the promenade.

lines, individual brush strokes or colour areas, they alter the original relationship and react together, forming links or oppositions. These are "abstract" interactions, occurring alongside the pictorial content of your composition, so the framework of your painting has an independent presence.

DIVIDING THE RECTANGLE

One way of becoming used to controlling the

SHAPING THE IMAGE
▲ Ian Simpson has joined pieces of paper to extend this watercolour study. The irregular panels accentuate the effect of looking through the window panes.

you don't have to fill the given rectangle. You can trim it or, later on, use a mount to contain the picture area. You can even extend it quite easily if your painting becomes too large for the paper by attaching another piece of paper to it. Altering the dimensions is more difficult if you are working on canvas or board. It is easiest to begin with a format that will work for the painting you have in

mind. If you find when you start to develop the composition that something important slips off the edge of the picture, you can adjust your composition by redrawing and overpainting.

When you select a size of paper, board or canvas for your painting, consider it in terms of the actual scale of your subject. A small landscape can be powerful, but you might prefer the spacious feel of a large picture. If you choose a large picture area for a small-scale subject, however, say a still life or portrait, it may mean that you end up painting the objects larger than life size. This can look strange because figures and small

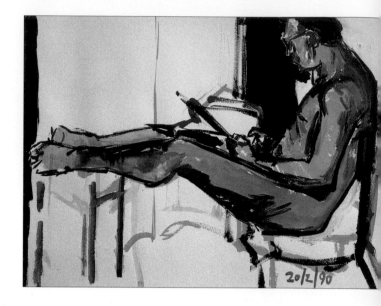

TRIANGULAR COMPOSITION
◄ The overall shape of Arthur Easton's oil painting, **Stone Jar, Cup and Withered Rose** is a clean, balanced triangle with the jar and rose at its apex.

composition of a painting, regardless of its subject, is to think of the main divisions of the picture area as forming a framework of simple shapes. For example, in still life paintings, you will often see that the group of arranged objects roughly forms a triangle. To create visual interest, a tall object is placed near the back of the group and other objects are spread out sideways across the foreground. The front of the group forms the base of a triangle and the tall object becomes its apex.

The objects arranged in the spaces between the base and the apex don't necessarily form precise slanted sides to the triangle, but you may be able to see how a connecting line runs along the outlines, or touches important features of the objects on each side.

To balance and anchor the triangle, there may be a horizontal line running behind it. This could be the edge of a table, with possibly a vertical line at right angles to it. The horizonal and vertical lines will be arranged to cut the triangle off-centre, creating balance by asymmetry. Once you have discovered the basic structure of the painting, you can also look at its

subdivisions — how individual objects are proportioned and whether they overlap each other or have spaces in between.

This kind of scheme can equally apply to a figure group in an architectural setting, for instance, or a clump of trees in a landscape. Artists don't always define a basic framework before starting to paint, or see objects as geometric shapes, but with experience the organization of paintings becomes instinctive. However, when you are learning to plan your compositions, you may find it helpful to practise dividing the picture plane into abstract frameworks using different kinds of shapes and varying their proportions and the dynamics of their lines. Curving lines and shapes behave differently from straight lines and angles. These elements can create an underlying rhythm in your painting, giving impact to the solid forms that you portray and the way they are positioned on

RHYTHMIC BALANCE
▲ **Nude Man** by David Cuthbert (acrylic) forms an elongated triangle with the points at feet, head and buttocks, but the figure's heavy contours form a strong, rhythmic, non-geometric shape.

VERTICAL DIVISION
▼ An emphatic centre line is unusual, but works well in Ian Simpson's **Garden View** because the trellis creates a balanced, formal grid that underpins the colourful informality of the garden.

the background.

As a rule, it is advisable to avoid placing an emphatic line or shape in a way that divides the picture area in half vertically or horizontally. An even division causes the eye to lose direction and move randomly from one half of the picture to the other. Often an important division falls off-centre and elements on either side of it are composed to create an asymmetrical arrangement. This creates a balance, but avoids the risk that the picture will seem so evenly balanced as to become bland and uninteresting.

ORGANIZING PICTORIAL SPACE

The central problem in representational painting is recreating a three-dimensional effect on a two-dimensional surface. To do this, you regard the paper or canvas as a window, called the picture plane, behind which the spatial arrangement of the picture can be organized in layers, receding in parallel to the picture plane.

Perspective systems (see pages 40-43) are a way of formalizing this layering, allowing you to suggest receding space by means of the principle of convergence. They also allow you to deal with the apparent differences in

scale and proportion which will indicate where objects are located within that space. As explained earlier, the basic guideline for perspective is the supposed horizon line, which corresponds to your eye level. Your viewpoint in relation to the subject is also very important in establishing the framework of a composition. The viewpoint can affect the mood of a painting, as well as its formal structure.

FILLING THE SHAPES

Up to now, the elements of composition have been discussed in terms of linear frameworks which apply equally to drawing and painting. Sometimes in painting, however, colour and tone are used freely over the underlying framework of the painting. With an impressionist

▷ 88

Before starting a painting, spend some time making simple pencil or charcoal thumbnail sketches, drawing the basic shapes and directional lines you can see in your subject. Start by making a framework of connecting lines that contain the overall shapes, then start to break down the large areas into smaller sections, paying attention to the

relative height, width and depth of different elements in your subject, the interaction of straight lines and curves, and the links between shapes in different parts of the picture.

When you have made a variety of quick sketches, play around with the size and proportion of the picture. Try drawing a rectangular frame around

each sketch to increase the background area or push the edges of the picture closer into the subject, perhaps allowing important shapes to be cut off at the sides, top or bottom of the frame.

▲ **The picture frame encloses a conventional view of the subject, with vertical and horizontal stresses evenly balanced.**

▲ **Moving into the subject, the artist makes the vertical stress more central and the background more busy and active.**

▲ **Featured so closely, the tree becomes an abstract shape that divides the background and breaks up the balance.**

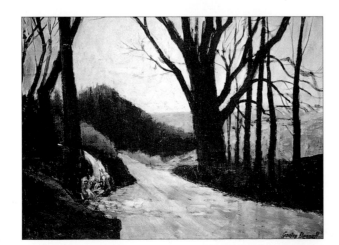

LAYERING THE IMAGE
◀ A road leading the viewer into the picture, as in Gordon Bennett's oil painting **Winter Landscape**, creates an immediate sense of receding space. Layered shapes and strong tonal contrasts emphasize the effect.

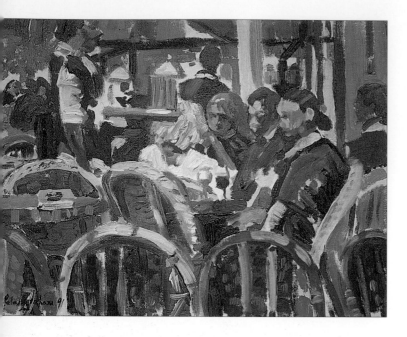

POINTS OF FOCUS
◀ In his oil painting **Le Viennois**, Peter Graham has set the main figures back to feature the pattern of chairs in the foreground.

balance and emphasis of your composition is altered. You have to orchestrate the abstract elements of the painting and work towards a representation of your subject.

approach (see page 92) or some kinds of abstract painting (see page 144) the composition can look casual, as the framework of the picture isn't apparent.

If you follow the approach to composition so far defined, once you have achieved a satisfactory structure for your painting, the additional factors of tone and colour are brought into play. Tonal values are used to create light and shade, enabling you to model three-dimensional form and convey atmosphere. Colour explains the nature of things — local colours are an aid to identification — and can also be expressive (see page 108). Textures and patterns can add to the description of objects and materials and provide decorative elements in

your paintings. But no matter how freely tone, colour, texture and pattern are used, they still function as abstract elements of your composition, and affect the rhythms and dynamics of line and shape.

As you begin to apply tones and colours the

SIMILARITY AND CONTRAST
When looking at a subject for painting you automatically look for ways of organizing the information in your mind, albeit subconsciously. You may look for similarities of shape and colour, and be startled by emphatic contrasts. There is a

tendency for the viewer to practise what is known as "visual grouping", bringing together items with common characteristics even when they are spatially separated. You can make your composition more cohesive and harmonious, by providing links between similar objects. Alternatively, you can enhance its dramatic impact, by counteracting the viewer's expectations.

Similar colours which link different parts of a painting together can be very valuable. A touch of blue in the foreground of a

ACTIVE BRUSHWORK
◀ The strong shapes of the child and her shadow in **Losi Bathing** (oil) enable Susan Wilson to apply colour and texture very freely.

SPACE AND COLOUR
▲ In **Lake Constance** (oil), George Rowlett creates a clear landscape structure that supports the intense colour he has used in all but the most distant areas.

landscape, for instance, can discreetly echo an expanse of blue sky. If you have no such links in a painting — if every area or brushstroke is a new and different colour — the effect is busy and disturbing, undermining any simple underlying structure. Similarly, linking shapes and tones in different parts of the painting gives the viewer related points of contact. A great variety of unrelated elements can make a painting confusing and illogical.

▷ 90

The varying viewpoints that you can take when painting reveal different aspects of the subject's mood and character, as well as presenting alternative ways of composing the picture.

High viewpoint In terms of composition, this is useful — the high view puts a great deal of information clearly on display and reveals how the subject is spatially organized. It can, however, create a detached, even superior impression, especially with human subjects, as it provides an unfamiliar view of people. If you use an imaginary high viewpoint for a townscape or landscape, you will need to work out the formal perspective arrangement.

Normal eye level This is your actual experience of objects seen from a normal sitting or standing position. It provides a straightforward view that is easily understood because it is familiar. The information works from front to back of the subject rather than from top to bottom as in a high view, so it is important to organize the depth of your picture effectively.

Low viewpoint This is an unfamiliar view and can create an unusual composition. Things close to you can seem very large, but the drawback is that they may obscure other interesting features.

Frontal viewpoint This is a direct view which sometimes seems confrontational. It simplifies spatial concerns, as the objects can usually be clearly indicated receding one behind another, but the resulting painting can appear formal and unsympathetic.

Oblique side view This viewpoint suggests that you are glancing in on your subject. It can be casual or mysterious in mood, and the way important shapes relate to the picture rectangle can create great dynamism and impact.

Distant view The character of the subject influences the effectiveness of taking a long view. In a landscape, the distant viewpoint can help you to express its spaciousness and variety. If you position a figure or still life to appear relatively far away, it can enable you to show it in an interesting context, but it may make the main subject seem marginal and insignificant.

Close-up view Homing in on the subject helps you to create a detailed statement and dramatic differences of scale. You might paint just a face in close-up, or a huge, detailed flower standing in front of an unfocused, small-scale landscape. This kind of view compels the viewer to respond actively to the picture because the information has to be well defined and dramatically presented. It can, however, make the subject of the painting intrusive and create a feeling of unease.

A view of a tennis court from a window (top) shows an overall perspective that seems normal and acceptable. The higher viewpoint (centre) exaggerates recession and brings the detail of the tree branches into the foreground. From ground level (bottom) the horizontality of the ground plane is emphasized, with the fence becoming the prominent feature.

When organizing contrasts in a painting, bear in mind that the shape and size of an area of colour is as important as its tonal value or intensity. Extreme contrasts of tone and colour — black against white, or one colour against its complementary one — do not work well when they are equal, as they tend to cancel each other out. However, a complete imbalance of shape and size can be highly effective. You can see in many different kinds of painting that, for example, a spot of light set against a huge shadow area, or a tiny stroke of one intense colour on an expanse of its complementary colour, can create a dramatic, vibrant effect.

BEING SELECTIVE

Whatever your subject or style of painting, you do not have to include everything you see before you. Part of the process of composing a picture is choosing key elements and discarding unimportant or distracting features. This could mean eliminating whole objects — bushes or parked cars in a landscape, for example. It also means ignoring the kind of detail that is inappropriate to the scale of your painting, or lost over distance — when you see a grassy field from afar, you see only broad areas, not the individual blades of grass; but even if it is near to, you still don't necessarily have to grapple with the details.

When you are deciding what and what not to include, keep in mind the pictorial value of the elements. A telegraph pole may seem superfluous to the content of your landscape, but it could provide a useful vertical emphasis. Think about how each component functions not only as part of the "reality" of the painting, but also in contributing to the composition.

If you find it difficult to decide what to include in your painting, break down your view of the subject into simple, manageable shapes and paint them in flat areas of colour. When you see how they work two-dimensionally, you can move on to selecting more detail from the information in front of you and building up the composition gradually.

VISUAL BALANCE
▲ **Still Life with Kettle** by Arthur Easton (oil) has a strong tonal pattern, enlivened by the very bright touches of colour. These elements complement the symmetry.

SHAPE AND LINE
► The structural harmony of Rosalind Cuthbert's watercolour **Barton Rock** is echoed in the gentle colour variations set against patches of deep tone.

BREAKING THE FRAME
► All of the figures in Pat Berger's **Flaked Out** (acrylic) lead out of the frame, but the dynamics of the group, organized on a strong diagonal, create an image of great impact.

THE EDGES OF PAINTINGS

For centuries, the conventions of composition demanded that the "events" of a painting should take place entirely within the picture rectangle. While dynamic lines and shapes might be arranged to lead the eye around the picture, the composition was usually organized in ways that kept the viewer's interest within the painting and no vital element would be cut off at the edges. A figure group might be framed by trees which run off the sides of the painting, for example, but the trees are not important in themselves; they form an archway which concentrates the viewer's attention on the central subject.

With the advent of photography in the mid-nineteenth century, artists discovered that informality could be highly effective in a composition. "Snapshot" images began to appear in paintings where some of the visual information was indistinct and out of focus. Photographs sometimes cut off objects and people in strange ways, and painters began to

▷ 92

composing a townscape or landscape

Viewpoint Move around to get different views of your chosen subject. Consider where you will position the horizon line on your paper or canvas to govern the extent of sky and land seen in your picure. Remember that a low horizon compresses the space given to the landscape, so you need to work out how to layer the view effectively, whereas a high horizon provides a greater ground area in which different features can be located. If you are working at ground level in a town or village, look for views through the buildings and down the streets that will give your composition an interesting structure and sense of space.

Focal points Look for individual features that will make good points of focus — an imposing old tree, for instance, a colourful facade, or the pattern of a stone wall or wooden fence. Use colour accents provided by flowers, buildings or farm machinery to counterpoint the broader colour areas in an open landscape.

Scale and format Decide how much of the view you wish to incorporate in your painting and whether it is best suited to a restful horizontal format or to a rectangle which has a dramatic vertical emphasis.

Any location offers a number of possible views that vary in terms of basic structure and incidental detail. The panorama (top) of a seaside town gives a strong sense of place through a complex, detailed composition. Focusing interest on the harbour, the artist finds a dramatic bird's-eye view (centre) that forms an open, almost abstract image. This contrasts with the picturesque effect of a conventional ground-level view (bottom) showing the town's local character.

further information	
150–157	Painting with oils
162–167	Painting with acrylics
172–177	Painting with watercolour and gouache

composing a figure painting

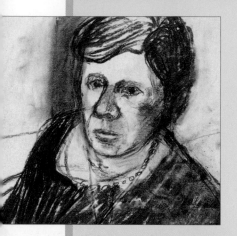

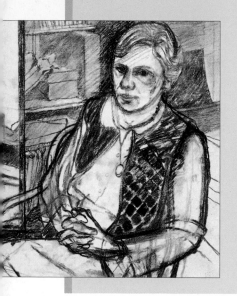

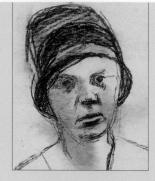

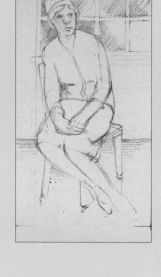

Posing your model If you want to create an impression of character and lifestyle rather than just a figure study, arrange the subject so that the sitter's clothing and the objects in the room say something about your model.

Figure in a setting If your subject is posed in a particularly appropriate setting, for example, the sitter's study or greenhouse, think very carefully about the scale of the figure in relation to its surroundings. Do you want the figure to be a dominant element, placed squarely in the foreground and seen large against the background, or to be an integral part of the picture, easily absorbed into the overall view?

Lighting When painting a figure straightforwardly from life, or making a formal portrait, you need strong light from one direction that helps to reveal form and does not camouflage it by creating strong cast shadows. Soft lighting tends to flatten forms and make the painting lack a feeling of space. Lighting a portrait from above or below can make a dramatic impact.

Viewpoint Remember that figure paintings usually create associations in the viewer's mind and that he or she is very responsive to the sense of

Focusing on the head alone creates a confrontational, isolated portrait with tonal drama (above). The full-figure pose is more calmly neutral (right).

The close-up portrait gives little sense of the model's location, and her character must all be conveyed in her face (top left). The farther view (left) takes in detail of clothing and background that add to the variety of the artist's description and make a more complete picture.

scale. If you choose to take an unusual viewpoint, such as very low, very high, angled sideways or in tight close-up, this tends to produce a more dramatic and atmospheric painting than one which is sight-size with a normal eye level.

Format The format of your painting may be suggested by the subject. A single seated or standing figure usually works best in a portrait format rectangle, whereas a figure group may need the lateral space of a horizontal rectangle to avoid compressing it.

appreciate how they could use the same kind of effect. They discovered that allowing figures and objects to be cut off by the edges of the picture had the effect of drawing the viewer into the scene. It also created a more complex dynamic effect between the picture area and the shapes within it.

These pictorial devices were first exploited by the Impressionists, and have become widely used in twentieth-century painting. Part of your process of selection should include where to place the outer edges of your painting in relation to the subject. It is not essential to include all the objects in their entirety.

GROUP DYNAMICS
◄ Viewpoint and composition interpret the mood of a figure group. In her oil painting **Tea Party at Cowes Yachting Club** Naomi Alexander uses a circling arrangement that keeps all the figures within the frame and unifies the group, an effect enhanced by the repetition of colour from one area to another.

Arranging a group

When you choose objects for a still life, think about their similarities and differences, and how these can be linked and contrasted within the arrangement. First, position the objects together to form a group and then move them around until you find the most interesting combination of shapes. Consider how the objects overlap, and the spaces between them. Look at your group from different viewpoints before you change things around. From one particular position, it may be excellent.

Found subjects

Arranged still lifes can look very contrived, and you may be able to find interesting subjects in your home which require no special arrangement, such as ornaments on a shelf or clothing thrown onto a bed. Visualize these found arrangements as compositions for paintings and move any object you think may look ugly or ambiguous, trying not to lose the informality that initially attracted you to the subject.

Colours and textures

Decide whether it is the colours and textures, or the

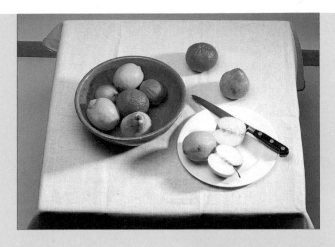

▲ The high viewpoint separates the still life from its context and organizes the shapes very formally.

► The objects are spread quite evenly across the tabletop, defining the horizontal plane and adding no strong emphasis.

►▼ With the corner of the table leading toward the viewer there is no single directional line to follow. These arrangements make more play of the interaction of shapes.

▼ Although the frontal view of the table reinstates the strong horizontal, it is softened and counteracted by the draped cloth and more complex grouping.

variety of the objects that interests you. If you are mainly interested in shape and form, don't include more than one or two patterned objects, as patterns tend to obscure shapes. However, if you want a decorative effect, patterns can enliven the colour and detail.

Backgrounds A plain background throws three-dimensional form into clear relief; a heavy patterned or textured background can intrude into the still life group. Where elements of the background form strong directional lines, consider carefully where and how these should link with the objects in the foreground.

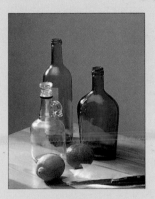

▲ The staggered arrangement of objects makes a zigzagging line through the composition that introduces another element to interact with the basic shapes. There is an ordered and logical definition of height and depth.

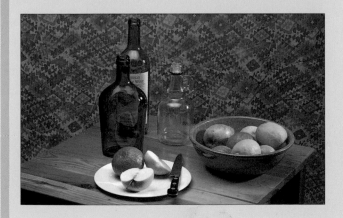

Painting an impression

Impressionism set the standards of a new realism that we now take for granted. Despite all the innovations of twentieth-century art, Impressionist paintings still seem fresh and inspirational, and the approaches remain valid for application to contemporary themes. The term "Impressionist" was originally coined as a critical insult, implying that the paintings appeared hasty and unfinished, and that the artists were careless in their perceptions of form and colour. Yet what we see in the work of Claude Monet, the great figurehead of this movement, is a detailed, analytical process of observation and record, which nonetheless results in images that are vital, colourful and celebratory.

THE DIRECT APPROACH

Of the new concepts developed by Monet and his colleagues, two principles featured importantly. One was the requirement to complete a painting by direct reference to the subject — for example, working outdoors in the landscape, building up an image of the immediate view. Previously, on-the-spot sketches were made which would then be used as reference for a formally constructed studio composition. The other principle was the technique of working directly onto white canvas, often allowing new colours to blend with undried layers below, a method known as working wet into wet. This contradicted the traditional method of developing a painting slowly layer by layer, beginning with a dark or mid-toned ground and proceeding to a monochrome underpainting in which the main forms were modelled in tone alone. When this had dried, colours were introduced, usually in the form of glazes (successive layers of thin paint) and more detailed brushwork.

These concepts were not previously unknown but the Impressionists were the first to adopt them as standard procedures for painting finished works. The immediate impression of the subject became the final image without the imposition of artistic theories and conventions. Essentially, they understood that a painting should reflect the transience of observed

96 ▷

Claude Monet (1840-1926)

Poplars on the Epte, 1891 Paintings in the *Poplars* series range in coloration from lush greens, clear blues and rich red-browns to scintillating sunset hues — orange, gold and pink — reflecting from the foliage and water. The brushwork is equally varied. In some pictures, the shapes of trees and clouds are elaborated in heavy swirls, with vigorously hooked and pasted brushmarks; in others, the brushwork is so broken that the trees are constructed with tiny dots and dashes of brilliant colour shot through with fine linear marks.

Monet painted the poplars from his "floating studio", a converted rowing boat moored on the river that enabled him to become completely enveloped in his landscape themes. He was so keen to complete the series that he had to finance a wood merchant's purchase of the row of poplars in order to delay the felling of the trees.

▼ Monet uses heavy, evenly weighted brushstrokes for the simple colour areas of clouds and sky. The shapes of the clouds are fully described, but the strokes soften the edges and allow the warm yellows of reflected sunlight to bleed into the cool blues of the sky. His treatment of the tree tops is similar, but the darker tones and colour contrasts define the forms more solidly.

**CAMILLE PISSARRO
(1830-1903)
PIERRE AUGUSTE
RENOIR
(1841-1919)
ALFRED SISLEY
(1839-99)**

Together with Monet, these artists formed the core of the Impressionist movement, and in their early careers they frequently worked closely together developing new themes and approaches. However, each had an individual and characteristic manner of applying Impressionist principles.

**EDGAR DEGAS
(1834-1917)**

Although he took part in all but one of the Impressionist exhibitions held between 1874 and 1886, Degas departed from some of the main Impressionist principles. Primarily a figure painter, he hardly ever worked outdoors and his paintings often show an emphasis on line and contour, rather than the colour massing of Monet's Impressionism. Technically, his work is very rich and inventive. His approach to composition, much influenced by photography, also broke new ground, with figures posed informally and occasional oblique framing of the image that causes important elements to be cut off by the edge of the picture.

**BERTHE MORISOT
(1841-95)
MARY CASSATT
(1845-1926)**

Unusually for the time, two women painters had an active and respected role in the development of the Impressionist style. Their work evolved in parallel with that of their male colleagues, while introducing the extra dimension of notionally "feminine" subjects — both produced beautiful studies of mothers and children, for example. Cassatt worked closely with Degas, while Morisot's paintings proved a strong influence on Edouard Manet (1832-83), persuading him to abandon the use of black paint which had previously been such a powerful element of his compositions.

**PIERRE BONNARD
(1867-1947)**

In the next generation from the original Impressionists, Bonnard developed a personalized treatment of mainly domestic subjects that extracted every spark of light and colour within his view. His vibrant compositions include figure studies of his wife and simple interior settings.

◄ This detail shows the essence of the Impressionist style. Individual marks are laid on quite freely, even crudely, but in the context of the whole picture they add up to an impression of distinct, separate elements within the landscape. The tree trunks and branches are mere slashes of warm brown creating a linear emphasis that cuts across the dense massing of greens and blues.

further information	
74-77	Working on location
150-157	Painting with oils

THEMES AND STYLES

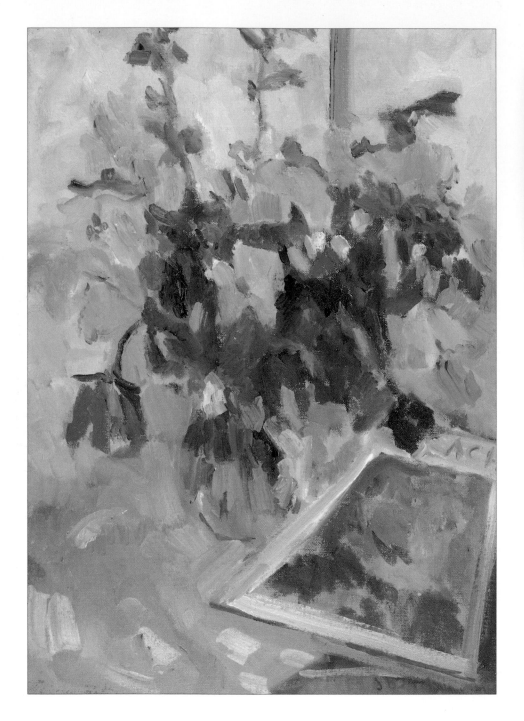

▲ George Rowlett
Marion in the Rotherhithe Garden
Oil
The strong impression of light in this painting is achieved by the dramatic contrasts of tone and hue. These are arranged to emphasize the direction of the light source, flooding in to the picture from the right and forming hard shadows.

realities. They reflected the ways in which solid form and surface detail can appear to change with changing circumstances — above all, the variable effects of natural light. Another significant feature of Impressionism was that it challenged traditional concepts of composition and drawing. It was no longer considered necessary to have objects precisely defined and clearly distinguished from one another. Paintings did not have to be tidy and distinct in close-up as long as they could be read at a distance.

RESPONDING TO THE MOMENT

The practical guideline for an impressionist approach is to free your mind from what you know, or think you know, about your subject and respond directly to the purely visual sensations of colour and light. Monet described it thus: "When you go out to paint, try to forget what objects you have in front of you, a tree, a field. Merely think, here is a little square of blue, here an oblong of pink, here a streak of yellow, and paint it

▲ John Denahy
Spring Flowers and Auerbach Catalogue
Oil
Simplifying the still life into basic shapes focuses interest on the variety of colours. The artist has flattened the detail of the catalogue picture in comparison with the real three-dimensional forms.

exactly as it looks to you, the exact colour and shape, until it gives you your own naive impression of the scene." This "naive impression" is not simplistic, as the word naive sometimes implies, but it is unique — consisting only of what you saw in that place at that moment. As Monet stressed, your painting records this impression "exactly as it looks to you".

Monet's working method was described in 1888 by the journalist Georges Jeanniot, who accompanied the artist as he went out to paint the landscape near his home. "Once in front of his easel, he draws in a few lines with the charcoal and then attacks the painting directly, handling his long brushes with an astounding agility and an unerring sense of design. He paints with a full brush and uses four or five pure colours; he juxtaposes and superimposes the unmixed paints on the canvas. His landscape is swiftly set down and could, if necessary, be considered complete after only one session..."

The impression is at the same time a transient and a bold statement, a vivid recreation of innumerable individual perceptions, as described in Monet's instruction quoted above. It frees the artist from the idea that an exceptional painting necessarily requires hours of painstaking work, although we need to guard against the supposition that a first quick impression is naturally the freshest and best. Monet's advice to young artists included the remark that they should not be afraid to paint badly; painting an impression is a process of trial and error, but even the errors contribute to the store of experience every artist must acquire.

SERIES PAINTINGS

Monet was preoccupied with the relationship of light and colour from early in his career, and pursued his impressions in the streets of Paris, in the towns and villages along the banks of the River Seine, and on the coastlines of Normandy and Brittany. After his move to Giverny in 1883, where he remained settled for the rest of his long life and constructed the famous water garden that was the subject of his final works, he developed the method of working in series. He focused on a single subject and portrayed it on several different

the projects

PROJECT 1
An immediate impression

To familiarize yourself with basic principles for capturing an impression, choose a subject from the following and try the technical approach suggested below:
- A vase of flowers
- A flower bed or vegetable garden
- A street scene with brightly painted houses
- A beach with brightly coloured beach huts
- A row of market stalls
- An agricultural landscape, with colourful fields divided by hedges and fences.

Work in oil or acrylic paint, so that you have a range of textural qualities at your command and limit your palette to six colours and white. Don't use black in the projects in this lesson. The Impressionists believed that black did not exist in nature and they excluded it from their palettes. Black is a useful colour but it can sometimes deaden colour mixes.

Keep mixing in the palette to a minimum; instead apply bright, distinct colours to the working surface and allow the hues and tones to mix and merge as you build up the brushstrokes.

Select a few brushes of different sizes — round, filbert or square, hog hair or synthetic bristle — and use the shape of the brush, applied in small strokes of varied directions, to help you create the broken colour effect. Don't lay down great sweeps of a single colour and don't blend the colours too much or they will become muddied.

PROJECT 2
Series paintings

Choose a view from your window and make three or more paintings recording the scene at different times of day, or on different days under conditions varying if possible from bright sunlight to clear, cool light, to a rainy or misty atmosphere. Observe carefully how the atmospherics affect local colour and the clarity of shapes and forms.

canvases simultaneously, changing the canvas according to changes in the time of day, the quality of light and the weather conditions. *Poplars on the Epte* is one of several series made between 1888 and 1926, which included paintings of haystacks in a field, the cathedral at Rouen, morning light on the Seine, and the garden and waterlily pool at Giverny.

In the series paintings, Monet developed a comprehensive logic of Impressionism that enabled him to record the variations of his motif. Different colour themes and qualities of brushwork describe the range of visual effects produced by the same object or location seen under particular conditions. Although Monet was the supreme landscapist, one can see in his own work and that of his contemporaries, how the active brushwork and broken colour effects typical of impressionistic renderings can also be successfully applied to other subjects, including figures and interiors, architectural structures and still lifes.

further information	
74–77	Working on location
150–157	Painting with oils

Painting a likeness

W hen considering the problems of painting a likeness, it is natural to identify first with the human angle, and to summon mental pictures of faces you know well. They may belong to family or close friends, for example, or to famous media faces, such as politicians or film stars. But a painted likeness does not have to be of a person; it could portray an animal, an object, or a location. The element that will make it a true likeness rather than a generalized impression or caricature, is the accurate observation and translation into paint of those features that represent the subject's character as well as the appearance. In a sense, any strictly representational interpretation of a subject is a likeness, or portrait, of it; but even with a non-human subject, it is necessary to look for special details that will animate your painting.

PORTRAITS OF PEOPLE

The first step towards creating a likeness is to choose your model. Only one person is always available to pose for you, and that is yourself. Self portraiture is a special challenge, because it fully tests your powers of objectivity. You need to study yourself as someone you don't really know, and go beyond vanity or self-criticism. Because you are your own most accessible model, you may build up a collection of self portraits over the years, and it can be fascinating to see both how you have changed and how your vision of yourself has altered. The development of your technique will also have enabled you to vary the mood and interpretation.

Whether you study yourself or other people, you get most out of working from a live model. The human face is a complex structure which continuously reveals different aspects of its structural forms and surface details. No model can keep a pose completely static, and slight movements may alter your perception of the overall shape of the face, or the skin colour or texture, or the interlocking planes created by bones and muscles. The adjustments you make to your painting in response to these small but frequent changes help to build a rich and comprehensive portrait.

This being said, photographs are a useful aid to the

101 ▷

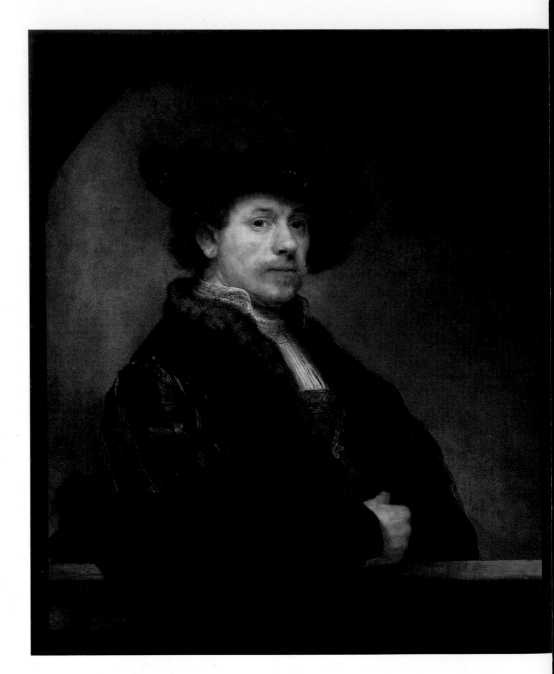

Rembrandt van Rijn (1606–69)

Self Portrait, 1640
In his series of self portraits, of which there were over one hundred paintings, drawings and etchings spanning a period of forty years, Rembrandt created an unmatched pictorial record of the artist and the man. This is a comparatively youthful work, in which Rembrandt depicts himself as the successful painter, expensively dressed and with an air of calm assurance, in sharp contrast to his later, more sombre

and searching self portraits. The technique also differs from that used in his later works, where he built up the paint thickly in rich impastos. Here the face is rendered with great delicacy, using quite thin paint over a greenish-grey base. The soft, fluid colours have been blended together almost imperceptibly, giving the flesh an almost luminous quality. The pose and composition are believed to have been borrowed from Titian's *Man With a Blue Sleeve*, painted c. 1512, and the technique may also owe a debt to the master.

other artists to study

MICHELANGELO DA CARAVAGGIO (1573–1610)

Like Rembrandt, Caravaggio favoured rich colours and dramatic contrasts of light and shade. Many of his figure paintings represent Bible stories, while others are simpler portrait-style works. We don't know who his models actually were, but every individual has a distinctive personality which adds depth to the narrative associations.

SIR ANTHONY VAN DYCK (1599–1641)

As court painter to the English King Charles I, van Dyck produced many exceptional portrait

records, often placing the subject in an elaborate setting. His study of *Charles I from Three Angles, c.* 1636, is a fascinating composition, showing in one painting the king's profile, full face and three-quarter views.

GEORGE STUBBS (1724–1806)

One of the few major painters celebrated for animal studies, Stubbs is known for his stunning, regal portraits of glossy thoroughbred horses. He published a volume of engravings called *The Anatomy of the Horse* in 1766, based on his own researches. His work also encompasses detailed but expressive paintings of wild

beasts, such as lions and cheetahs.

JOHN CONSTABLE (1776–1837)

Constable's ability to reproduce a precise sense of place means that even now, people visit "Constable country" in Suffolk, England, to examine what is left of the artist's most famous locations. His major paintings are among the best-known and most frequently reproduced of landscape works, but his sketches and colour studies are also appreciated for their wealth of specific detail on individual aspects of his subjects.

◄ The shape of the hand is formed firmly and simply, with minimal shadow detail. Colour and texture in the dark clothing is also conveyed by economical means, with gentle tonal gradations that light up the rich hues and velvety nap of the fabrics.

▲ Tonal modelling of the flesh is very subtly applied to show the curves and planes of the face. The

strongest highlights and shadows are reserved for the detail of facial features.

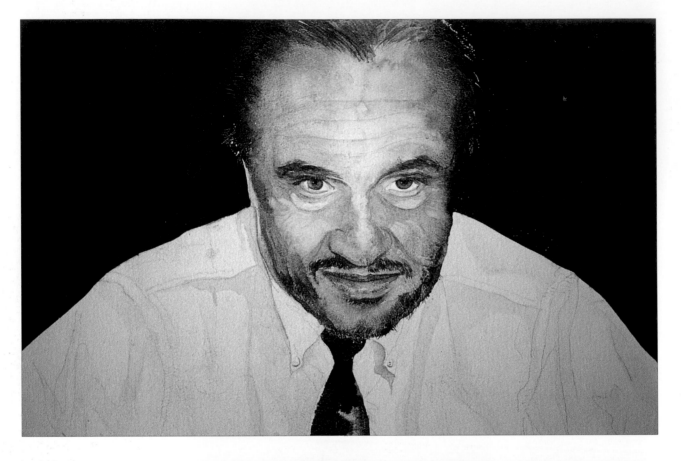

► Peter Clossick
Jane Aged Four and a Half
Oil
A likeness is not necessarily conveyed by details of facial features alone. The posture — the weight and balance of the body as well as its basic shapes — conveys the subject's age and character, and can influence our recognition more strongly than the likeness in the face. Here there is no exact indicator of scale, but it is obvious from the shy pose, the proportions of body and head, and the fluid shapes of the limbs that it portrays a young girl rather than a young woman — and a particular young girl.

▲ Sandra Walker
Power Broker
Watercolour
A close-up portrait filling the frame of the picture has a confrontational aspect which is entirely apt for the mood and character of this subject. The large shapes are dramatized by the powerful monochromatic emphasis, dividing the image into strongly contrasted areas. The subtle colour variations of the flesh tones and the sharply drawn details of features focus attention on the face.

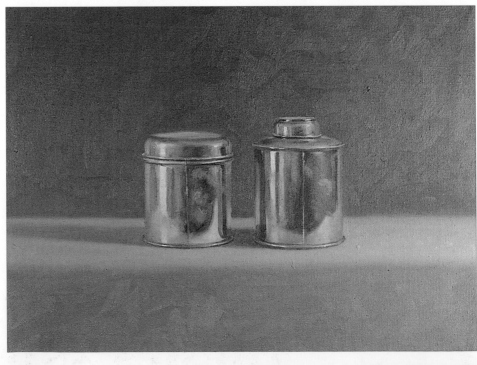

◄ James Moore
Two Brass Canisters
Oil
The apparent simplicity of an ordinary object provides the ingredients of a perfect likeness. The artist has been absolutely precise about the shapes of these cans — their contours alone would provide a telling description — but he has paid equal attention to the exact nuances of tone and colour on the surface.

the projects

PROJECT I
Paint a half-length portrait of yourself
Alternatively, you can use another model. Whichever you decide upon, organize the composition so that attention is focused on the head. Use what you can learn from the Rembrandt portrait to work out how to set up the pose, lighting and background.

PROJECT 2
Make a family study
Use snapshots, or videos if possible, and sketches as reference. Look for the family resemblances between individuals and the characteristic features that describe each particular person.

PROJECT 3
Make a painting of a treasured object
This could be an ornament or souvenir, for example. Give it a simple setting and try to capture every detail of shape, colour and texture that gives the object its unique presence.

A portrait can be a head study only, a bust of head and shoulders, or a half- or full-length figure — the last two may be shown standing or seated. As you include more of the figure, your picture area also encompasses more of the clothing, accessories and background surrounding your subject. The way you select and interpret these components can provide further information about the subject — such as their style of dress and environment at home or work. They can also create a more complex arrangement of forms and colours within the picture.

DISCOVERING KEY ELEMENTS

Some people seem to find it quite easy to pick out the elements that produce a true likeness, while others can paint perfectly adequate faces and figures without quite capturing a characteristic portrayal of an individual. Aside from the possibility of an inborn talent, there is no trick or shortcut to creating a likeness. It depends upon careful observation and a willingness to look again and re-analyse the essential details. It cannot be said too often that once you have a clear vision of what you are trying to portray, you are halfway to being able to paint it. The other half is technique, which is usually easier to learn.

The same things that make a human portrait work as a likeness apply to other subjects. A tree, for example, can be young or old, and will have distinctive features according to its age and species. The same applies to animals, and may also be true of objects: compare the character of an old copper pan to a modern aluminium one. The differences lie not only in shape and colour but in signs of use, such as dents and scratches that catch the light. Every visual problem requires you to consider the basic elements of the subject. You can observe and translate these aspects into an interesting two-dimensional design using the properties of paint to describe shape and contour, local colour, tonal modelling, surface texture and edge qualities. The trick is to break down what you see into manageable areas, and return to refining the overview once your picture has broadly emerged.

portraitist. Many formally commissioned portrait painters take photographs to use as reference between sittings. Photography often eliminates a lot of the subtleties of form, but sometimes the camera's quick reaction captures dramatic modelling of the features, or a fleeting expression, that you might use as a theme for a painting. In addition, high-quality photographs, such as those in news journals and glossy magazines, can tell you a lot about the characteristics of different age groups, nationalities and physical types. Study of such pictures will help you to convey something about the age, character and even lifestyle of each model — the different proportions of child and adult faces, for instance; variations of skin colour and texture due to age or exposure to the elements; the typical lines of a smiling mouth as compared to one that is sullen.

The figure in context

For most artists, figure painting is much more than a technical exercise. The true fascination of human subjects lies in the sense of identification, when the painting portrays either a particular person or a descriptive type and puts the subject into a specific context — which could be a place, an activity or event, or an unfolding story.

Manet's painting suggests all of these elements. The central figure is a straightforward portrait, and we recognize her occupation from her surroundings; but the mirrored conversation provides an additional intrigue. The atmosphere of the bar is created both through complex close-up detail — the lush descriptions of the bottles, fruit and flowers on the bar — and the sketchier treatment of the broader background, conveyed through the mirror, with its crush of bodies and scintillating lights.

The relationship of the reflected foreground figures defies normal proportion and perspective — they are not much diminished by the additional "distance" created by the mirror. And if you transpose their spatial relationship to the foreground area of the painting, it appears that the man should be standing directly in front of you within the picture frame, effectively blocking your view of the barmaid.

Since we know that Manet did a great deal of preparation for the painting, it is obvious that these ambiguities were deliberate; his decisions were made to convey his idea. It is important to remember that when you construct a composition, you can select and adjust different elements to enhance the purely visual qualities and to evoke a mood or narrative. Your painting does not have to be a faithful record, especially if, as in the Manet, you are putting together a variety of elements, perhaps recorded at different times and for different reasons.

COMPOSING FIGURE WORK

Because the human figure has been a dominant theme in art for centuries, there are innumerable examples you can consult for inspiration on subject, style and technique. Although you are naturally familiar with

105 ▷

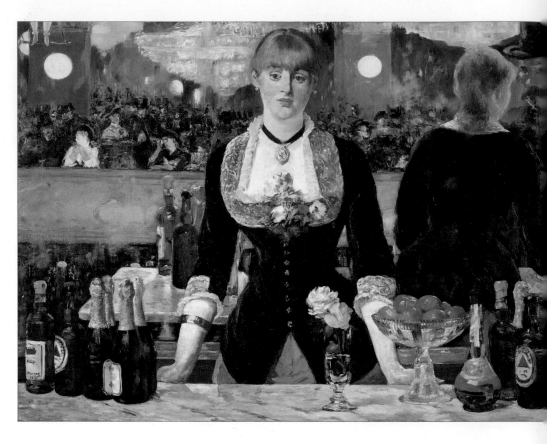

Edouard Manet (1832-83)

Bar at the Folies-Bergère, 1881
This painting has the immediacy of an on-the-spot impression, but it is a composite image assembled from key elements taken from different sources. Manet made sketches in the cabaret bar, noting figures and objects, and also the atmosphere of the busy, brightly lit scene. The painting of the figure was done in his studio, using one of the Folies barmaids, Suzon, as the model, with recreations of the marble countertop and still-life elements. Some of the background figures have been identified as friends of the artist, giving the image a more personalized frame of reference.

In placing the figure centrally in the composition, and taking a close viewpoint, Manet draws the viewer into the picture. But the device of the mirror behind the bar enables him to open out the space and describe the wider context. A narrative is created by the mirror reflection of the tall gentleman apparently talking to the barmaid, giving her an active role in the scene not apparent from the direct frontal view.

There are some quirky touches in the organization of shape and form — notice, for example, the cut-off legs of what is presumably an acrobat suspended in the top left-hand corner of the picture.

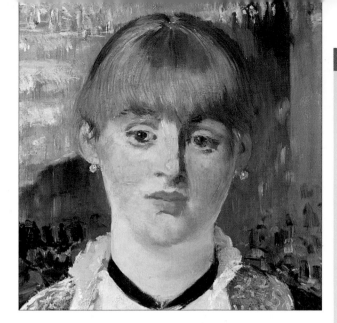

▲ Manet models the face with loose brushstrokes that cohere into a smooth, serene portrait. Bright white highlights pinpointed on the dark eyes give the model a luminous gaze.

▼ The figures in the mirror are indistinct, suggesting the distance created by the reflection. But Manet has used strong tonal contrasts and bold shapes in this part of the painting.

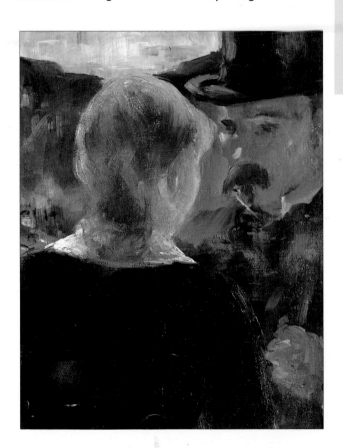

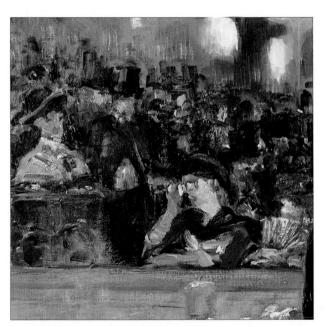

◄ A mass of tiny, active brushstrokes flicks across the mirrored crowd, picking up lights, shadows and colour accents that convey the complexity of forms through varied degrees of definition.

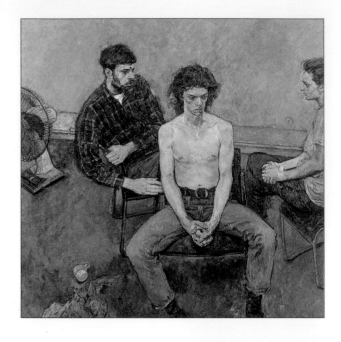

▶ Carole Katchen
Zach's in the Afternoon
Oil
By contrast with Mortimer's painting, the mood here is relaxed and intimate. The artist uses strong shapes, densely worked lights and darks, and inviting colours to create atmosphere. She simplifies the detail, but provides a charmingly descriptive portrayal of the people and the setting.

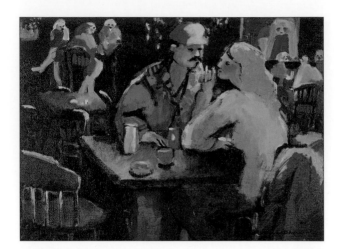

▲ Justin Mortimer
Three Seated Figures
Oil
The central figure is confrontational, while the others are in self-enclosed, defensive poses. A sense of isolation is emphasized by the muted, bare environment, although figures and background are painted with active brushwork and subtle touches of beautiful colour.

▶ Daphne Todd
The Daughters of Mr and Mrs Giles Curtis
Oil on wood
Individual character comes through the poses and expressions — the calm concentration of the older girls offset by the playful posture of the one behind, but they form a close-knit group, and naturalistic colours contribute to a gentle, domestic mood.

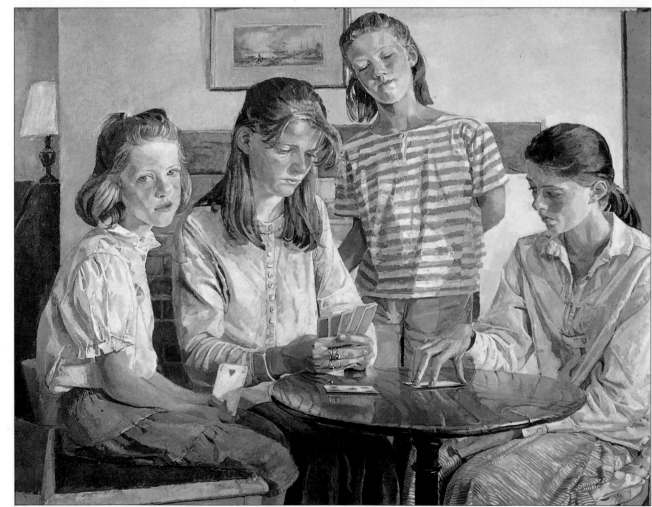

figures on a day-to-day level, this does not make them easy to paint, particularly if you hope to convey an idea at the same time as making a fairly accurate and recognizable representation.

If you are focusing on a single figure, it is best to have a live model to pose for you. As explained in Lesson Six in Part One of the book, your painting comes alive if you include props and background detail that simply make the composition of your picture more interesting, or help to convey a personalized impression of your subject. Working from life ensures that you have a full range of information, from which you can select the most telling details.

Even if you do focus on a single figure, you may wish to include other figures peripherally in the surroundings, as in the *Bar at the Folies-Bergère*. As explained, Manet included portraits of his friends among the bar customers, but he also painted them in such a way as to capture the impression of a crowd — a mass of figures each of which is only partially seen and rendered inexactly, as glimpses of individual features just occasionally emerge. As reference for this kind of approach, you can use photographs and sketches (see Lesson Eight for advice on sketching people).

FIGURE GROUPS

A group of figures in which all the subjects are approximately equal in scale and importance is a different proposition. Here there are dynamic shapes and rhythms, caused by the figures' interactions, that you need to organize effectively in relation to each other and to the pictorial space and outer frame of your composition. The impracticality of getting several people to hold a formal pose means that you will usually be working from sketches and/or photographs, probably selecting people and background details from different sources.

The dynamics of a group are more than just formal aspects of composition, providing the shapes, colours and textures that you put on the page. They also set the mood of the picture, and can even tell a story. An active relationship between the subjects is expressed by the angle of the bodies, the way they may lean towards

each other, overlap and communicate by gestures — a hand held out from one figure to another, a pointing finger or an embracing arm implies direct interaction, whereas folded arms, hunched shoulders and bodies turned away from each other express unease and tension within the group. Alternatively, you might want to emphasize the isolation of one person in the group by physically separating them from the others. Coming in very close, so that the figures press on the edges of the picture, creates a confrontational mood.

When you have the figures positioned, you may also have certain spaces between them, and surrounding the group, that you need to treat positively. As with a single figure, the background can play an important narrative part. It can, on the other hand, be purely decorative, or it can be played down and "pushed back" to focus attention on the human subjects. You need to think hard about how the background links the figures and complements them as a group.

One drawback to working from photographs is that you will probably have to put together figures which have been photographed from different distances and are not in scale with each other. The lighting, also, may vary widely in the photographs. Pay careful attention to the relative scale of both whole figures and individual parts of their bodies, and make sure the strongest highlights and shadows do not appear inconsistent — if necessary, restrict the tonal key of the whole painting to make sure any obvious variations are minimized.

the projects

PROJECT I
Constructing a figure group
Choose two or three sketches or photographs from your existing reference sources that show an interesting relationship between three or more figures. Use the information to draw a fairly complex grouping, with forms overlapping and interwoven. Paint it quite straightforwardly, with realistic tones and colours.

PROJECT 2
Emphasize a mood
Pick up some distinctive aspect of the previous painting — the closeness of the figures; a dynamic movement leading the eye into or out of the group; a figure isolated from its fellows. Reconstruct the composition to give this aspect greater emphasis. For instance, if you have pushed the figures closer together, think about how the limbs and main body

shapes have become interlocked; if you have pulled them further apart, consider how the background colour or detail can be manipulated to underline the mood you are trying to convey. You may wish to take a more imaginative, expressionist approach to this project (see Lesson Eighteen).

Expressionist approaches

Expressionist painting goes beyond appearances, using devices of technique and composition to develop mood and atmosphere. By distorting or exaggerating particular aspects of the subject, the artist directs the viewer's response towards the emotive qualities of the picture. The picture is drawn subjectively rather than objectively. An Expressionist painting is not necessarily "unreal", and it need not be threatening in the way of van Gogh's *Night Café*, but it has to challenge our normal perceptions of reality.

COMPOSITION AND STYLIZATION

Many different devices are employed in the *Night Café* to develop the sense of unease and imminent violence that van Gogh wished to convey. The perspective of the room is based on normal conventions, with the side walls and floorboards appearing to converge towards a vanishing point. At first the room seems to be a large open space, but there is something odd about it — perhaps it is too large, seeming to open out and threaten to engulf the viewer. The exaggerated directional lines of the walls and floorboards, emphasized with slashing brushstrokes, create a curious sense of momentum, as if you might suddenly find yourself hurtling towards the cavity in the back wall. Although brightly lit from behind, this doorway has a crude, ugly shape harshly outlined in black.

Other elements in the composition follow the distorted perspective, so chairs and tables placed near the walls are thrown out to the edges of the picture. The café customers occupying them become isolated and almost insignificant. This leaves the billiard table occupying the wide centre space, casting its coarse shadow. The café proprietor is an ambiguous figure, confronting the viewer directly. We do not know whether he is welcoming or hostile.

Distortion and stylization are characteristic features of the Expressionist approach. As in this van Gogh, the impression of space and distance can be heightened through exaggerated perspective. In landscape, architectural and interior subjects, selective

109 ▷

Vincent van Gogh (1853–90)

The Night Café, 1888
Van Gogh's own words emphasize his use of colour in this painting to represent intense emotional qualities: "I have tried to express the terrible passions of humanity by means of red and green…I have tried to express as it were the powers of darkness in a low public house, by the use of soft Louis XV green and malachite contrasting with yellow-green and harsh blue-greens — and all this in an atmosphere like a devil's furnace of pale sulphur."

In creating his visual impression of the café as "a place where one can ruin oneself, go mad or commit a crime", van Gogh also used sharp tone contrasts to suggest harsh lighting, and a distorted perspective that funnels you through the open space of the room towards the small doorway at the back. The attitudes of the figures convey various degrees of misery and apprehension.

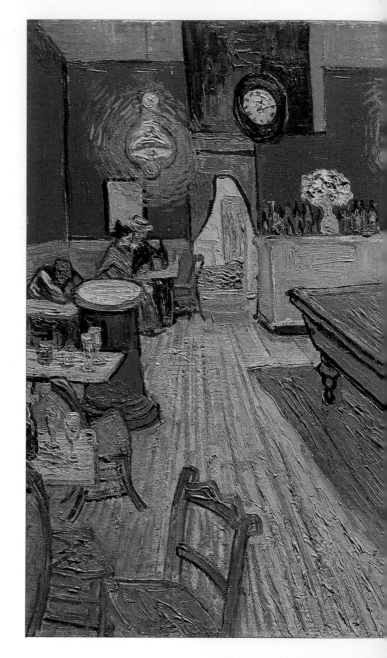

► The figures are drawn as simple, basic shapes that accommodate van Gogh's heavy brushwork and thickly impasted paint, but the poses are expressive. Dark lines emphasize their contours and heighten the colours.

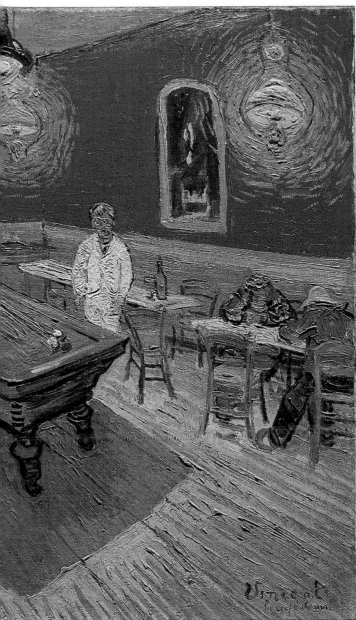

other artists to study

JAMES ENSOR (1860-1949)

To convey his pessimistic view of humankind, the Belgian artist Ensor transformed ordinary people into a gallery of nightmarish, macabre figures, some even wearing grotesque masks. Often his paintings have a strong narrative background, while others express emotions and atmospheres through figurative imagery.

EDVARD MUNCH (1863-1944)

There is nothing veiled about Munch's highly charged emotional Expressionism, as demonstrated by the titles of some of his most famous works, such as *The Scream*, 1893, *The Kiss*, 1892, *Jealousy*, 1895 and *Self Portrait in Hell*, 1895. The shapes, colours and textures bridge a gap between reality and a privately conceived world.

EMIL NOLDE (1867-1956)

Nolde's paintings cover a range of subjects from biblical themes to simple studies of flowers and landscapes, with moods varying from menacing to benign. His watercolours, particularly, demonstrate a wonderfully expressive use of pure colour.

ERNST LUDWIG KIRCHNER (1880-1938)

Kirchner's imagery is heavily stylized, and often semi-abstract. Both the subject matter and his technique, which uses strong colour and gestural brushwork, are typical of the Expressionist approach in painting.

FRANCIS BACON (1910-92)

Bacon developed a highly personalized form of Expressionism in which violent distortions of form and space feature prominently. His colours are rarely harsh or garish in the manner of earlier Expressionist works, but even the colour harmonies somehow contribute to the disturbing effect of his paintings.

► The glow of the lamp is painted as a radiating pattern of colourful strokes, using the sulphur yellow that dominates the picture, and also slashes of green that make the illumination stand out through complementary contrast with the red background.

further information	
40–43	The rules of perspective
110–113	Expressive colour
150–151	Impasto

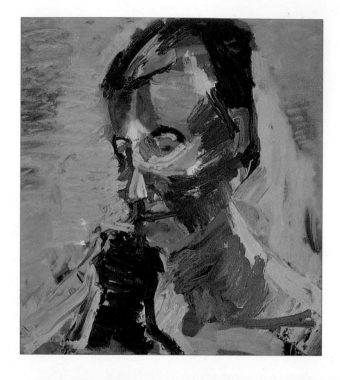

◀ Peter Clossick
Lynn Clare
Oil
Heavy brushwork and
dramatic colour changes
provide a striking portrait.
Form is directly expressed
by the movements of the
brush modelling a series of
planes and curves. The artist
has used complementary
contrasts in warm brown
with cool blue, green with
pink, but the particular
tones and hues create
discordant notes that
suggest a turbulent mood.

▼ George Rowlett
Night Canal, Venice
Oil
A particularly Expressionist element is the use of active
brushwork to disrupt the
stability of solid forms, as in
an architectural subject.

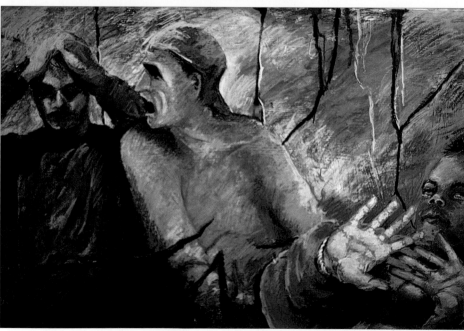

◀ Gwen Manfrin
Bedlam
Pastel and acrylic
The poses of the figures and
their relation to the picture
frame convey a powerful
sense of chaos and distress.
Harsh lighting and texture
are also disturbing features; the painter uses the actual
textures of the materials
and high-toned pastel
colours to achieve these
qualities.

composition and distortion of the subject can create a particular mood. Paintings from the figure commonly use a method similar to caricature. The characteristic features of faces and bodies are exaggerated, even to the point of deformity, as a means of emphasizing the narrative point of the image or its associations. It can also be helpful to simplify detail, so that a person or object is reduced to those essential ingredients that still make it recognizable. But Expressionism does not always aim to provoke or disturb. Sometimes Expressionist devices are used to create lyrical, appealing visions of alternative realities.

COLOUR AS EXPRESSION

As described by van Gogh, the colours of the *Night Café* are intense and hectic, with dominant high-key tones that create an unnatural brightness throughout the room. The "blood red" of the walls and vivid green of the ceiling are directly complementary (see page 27), creating a powerful discord. The clashing of values is emphasized by the use of several different greens, ranging from acid yellow-greens to pale sea-green tints. The intensity of these vivid colours is enhanced by their contrast with areas of dark tone.

A startling feature of the painting is the dominant yellow, used as the theme colour in several of van Gogh's major works. Although yellow has some pleasant associations, particularly with sunlight, it is not always easy on the eye and a large expanse of brilliant yellow can have a disturbing effect. The particular hue and tone of the main colour in this painting make it solid and suffocating.

Expressive use of colour always involves a subjective element, but there are also predictable interactions between colours that can be exploited to create a particular mood. Deliberate contrasts of hue or tone can introduce discordant notes to a composition, underpinning the portrayal of a violent event or uneasy atmosphere. Conversely, colour harmonies and carefully related tones can help to evoke calm and pleasant emotions. The expressive attributes of colour are further explored on pages 110-113.

the projects

PROJECT 1
Expressing mood
Paint a self portrait in oil or acrylic using colour and brushwork to describe a particular mood. For example, an angry portrait might have intense, strong colours and harsh lines describing eyes, nose and mouth; a tranquil image could put an emphasis on harmonious colours (not strictly naturalistic) and fluid, curving shapes.

PROJECT 2
Expressing character
Using a photograph as reference, make a brush drawing of an animal or a bird intended to express its character — the power and aggression of a beast of prey, for example, the sinister quality of a vulture or the timidity of a deer or rabbit. Use a limited, non-naturalistic colour range appropriate to the mood of your subject and avoid the temptation to make a simple likeness. Instead, pay attention to the variety of brushmarks you can use to describe the creature expressively.

PROJECT 3
A sense of place
Choose an interior or exterior view — one not containing too much distracting detail — and make several colour sketches investigating the "sense of place" through varying moods. Select specific features of the scene as the basis of each composition, then interpret the shapes and develop the colour scheme in a manner appropriate to the chosen theme. Try using pastel or watercolour to lay in the colours freely.

EXPRESSIVE MARK-MAKING

A typical feature both of van Gogh's work and of later expressionist painting is the extremely vigorous brushwork. The masses of heavy directional strokes construct form and texture with exaggerated emphasis. Subtlety is not a feature of the *Night Café*; notice how the glow from each lamp has been transformed into an extraordinary Catherine-wheel of intense citrus colours — yellow, orange and yellow-green — with each brushstroke clearly visible.

Drawing with the brush is used as a means of expressing mood and atmosphere. Outlining individual shapes and forms is a way of attracting attention to features that have been distorted or exaggerated. Areas of colour composed of interactive brushmarks — dots, dashes, ticks and scribbles — allow flat surfaces and simple planes to take on an expressive character. Coherent form or a uniform surface effect can still emerge from this mass of strokes, as in the floor of van Gogh's café, where many different colour values and brush movements describe the receding planes of the floorboards.

Expressive colour

The use of colour as a means of expression always involves a high degree of subjectivity. The perception of colours and their interaction operates at many different levels of physical and emotional response. There is no definitive way of describing the properties of specific colours, and therefore no proof that everyone sees the same attributes in them. We are also influenced by taste and fashion and by the association of colours with things — such as blue for the sky, green for foliage, and yellow for summer sunshine.

Painters have always used colour both descriptively and expressively, assuming a certain degree of common ground in our responses to colour sensations. Colour theories have been evolved that attempt to identify ways in which we respond to colour interactions but for a variety of reasons, these theories are not infallible in practice. However, they provide some useful signposts for using colour creatively. Ultimately, you must deal with colours only as they appear to you and learn to have confidence in your judgement of their effects in your paintings.

COLOUR INTERACTION

The purely visual sensations of colours — hue, tone and intensity — are the basic ingredients of colour interactions and you can manipulate these in various ways. If your treatment of a subject is fairly realistic, to produce an expressive painting you can exaggerate the properties of the colours you observe and so strengthen their impact.

The strongest sensations come from sharp contrasts — one colour against its complementary colour, a light tone against a dark tone, warm colours against cool colours. A contrast is a form of opposition, so these interactions tend to

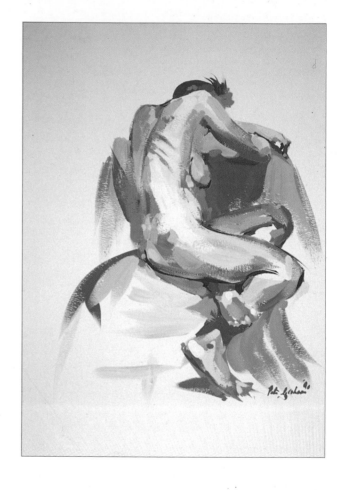

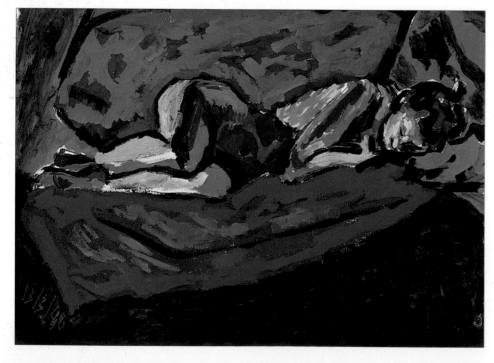

CREATING COLOUR IMPACT

◄ David Cuthbert's **Sleeping Nude** is modelled with strong oppositions of both colour and tone. The artist exploits complementary contrasts as well as intense highlights and rich, dark shadows.

MODELLING WITH COLOUR

▲ The tonal balance of **After Ingres** by Peter Graham is muted and discreet. He uses variations of colour temperature to describe the form, offsetting warm pinks and oranges with cold mauves and blues.

be active and aggressive. The more extreme the contrast, the more dynamic its visual effect.

Complementary contrasts — these are most intense when you use colours at full saturation: for example, a brilliant vermilion paired with a strong emerald green; cobalt blue and sizzling orange; sunshine yellow against a bright mid-toned purple.

Tonal contrasts — the most extreme tonal contrast is that between black and white, so when using colour you must use a comparable scale, finding rich, dark hues that can be paired with pale pastel colours.

Warm/cold contrasts — an obvious example of this is a hot, heavy crimson paired with a light icy blue, but the same colour can have a different "temperature" in different circumstances. Lemon yellow, for instance, will appear cool against orange, but relatively warm against light blue or yellow-green.

HARMONIES

If you wish to evoke a serene or harmonious mood in your painting, you should choose colours that are related to one another by hue or tone. Select colours adjacent to

112 ▷

To imagine how these options can relate to an actual subject, take the example of a portrait treated in different ways. Obviously the same principles apply to other subjects. To take complementary contrasts first — you could introduce subtle green, blue or violet shadows to offset the pink and yellow bias of the warm flesh tints. Or, for a more extreme effect, you might translate these variations into quite intense contrasts of red/green, orange/blue,

yellow/purple. The lights and shadows in the portrait could be interpreted as strongly opposed tones emphasizing the lightness and darkness of the colours rather than their particular hues.

Warm colours tend to advance, while cool colours recede, so you can experiment with the modelling of form by employing pale but cold colours in the shadows and hollows of the face — such as pastel blues and violets or citrus greens and

yellows — and introducing strong touches of warm, mid-toned colours — cadmium red or orange, for instance — in the curving planes of the face that catch the light.

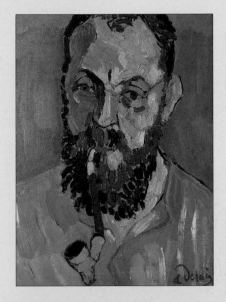

▶ In **Portrait of Henri Matisse** by Andre Derain, the colour contrast is so powerfully stated that it divides the face into two parts, in each of which the opposite colour is included for counterpoint. The heavy impasto technique enhances the impact.

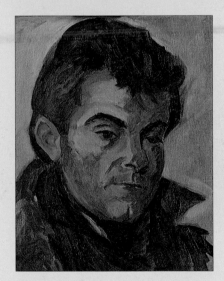

▶ Expressive use of colour need not result in an image that is particularly dramatic or unconventional. This naturalistic, informal portrait by Rosalind Cuthbert subtly opposes the predominantly warm browns with cool green shadows.

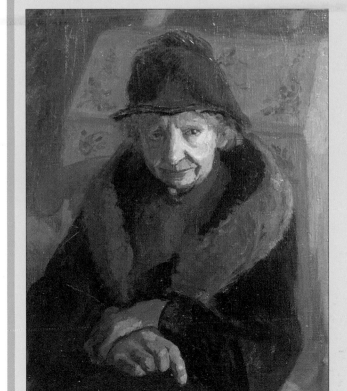

◀ This sympathetic portrait of **Mrs Snow** by Stephen Crowther is economical with tone and colour. The very pale face draws attention against the strong black shapes of the coat, and the warm, mid-toned red is balanced by the neutral colours.

ultramarine, cobalt blue,
Prussian or
phthalocyanine blue and
cerulean.

REVERSING EXPECTATIONS

Another way of using
colour expressively is to
counter the viewer's
expectations by choosing
an entirely non-
naturalistic colour scheme,
such as blue or green to
represent the flesh colours
in a portrait, or purple and
pink fields in a landscape.
This can have a shocking
or dramatic effect,
depending on the context,
but if you select and
organize the colours
effectively, attractive but
unexpected harmonies can
be produced that enliven
the picture.

SURFACE COLOUR

▲ In Arthur Maderson's
**Hazy Dawn near
Rotherhithe**, the harmony
of warm and cool colours is
overlaid on an under-
painting in shades of grey.
By building up the oil paint
in layers the artist achieves a
unified atmospheric effect.

HIGH-KEY HARMONY

◄ Although **Campanet** by
Olwen Tarrant is composed
with contrasts of opposite
colours, her use of a close
tonal range and a broad
spread of pale tints creates a
harmonious mood.

each other on the colour
wheel — blue and green
with an intermediary blue-
green, for instance, or a
range through blue and
blue-purple to true purple.
Similarly, varying tones of
a single hue are naturally
harmonious, so use tints
(the colour plus white) and
shades (the colour plus
black) together with the
pure hue. You can also
create effective harmonies
by selecting variations of a
particular colour that have
a common identity but
different chromatic
qualities, such as different
kinds of blue; say,

COLOUR ASSOCIATIONS

Colours have symbolic and
associative qualities
connected both with the
real world and with
cultural traditions. Red, for
example, is an active,
aggressive colour, used for
danger signs and often
taken as being symbolic of
anger, passion and
violence. It is the colour
that our eyes perceive most
rapidly, in terms of a direct
physical response. Greens
and blues are the colours
of nature, of the sky, the
sea and many plants, and
because of this they are
often associated with

DOMINANT COLOUR

▼ A large area of one colour has a dramatic effect, giving impact to the solidity of the shapes. In Laura May Morrison's painting the figure is strikingly isolated on the rich yellow ground. It is simplified and portrayed in a thematic colour range to form a satisfying whole shape that has enough textural detail to draw in the viewer's interest.

DARKNESS AND LIGHT

► In **Bristol Cityscape at Night** (right), Tim Pond translates the dark mood of night light into colour. The blue, grey and purple blocks form a dense, low-key harmony, although some individual hues are quite bright. Against this, the pattern of smaller shapes in red and acid green suggests reflected light on the corners and edges of the buildings, and paler tones bring some low light to the skyline.

harmony and serenity. Studies of responses to colour suggest that a room with green decor can actually have a calming effect on its occupants. But when colour is used symbolically green is usually equated with jealousy and blue with depression.

Using colour alone as an indicator of mood in a painting is unreliable because you cannot predict a viewer's emotional response to an abstract expanse of a particular colour. Generally, however, colour associations in paintings are identified through the context in which they are seen. A room painted red has in itself a powerful impact. If a picture of a red room contains angry people making threatening gestures, the colour of the room becomes associated with the anger of its occupants and its impact is intensified by the context.

When you are using expressive colour to enhance your paintings, keep in mind that you must exploit the visual sensations of colours to strengthen any associative references. The fact that each person's perception of colour is unique and indescribable does not mean that colour in painting is not a communicative element. It is precisely because we all see colours differently that there are so many potentially exciting and imaginative ingredients for your paintings.

Reduction to essentials

.

An interesting aspect of this Turner painting is that he possibly did not consider it to be a finished statement. The accepted method of developing a major painting in the nineteenth century was to make a number of studies and preparatory sketches and then, once back in the studio, to select from this information and assemble a highly finished, often large-scale work. This was particularly true of landscape painting, where creating a formal composition on the spot would have been time-consuming and impractical. So *Norham Castle, Sunrise* may have been for Turner a step on the way to a further interpretation that never materialized. Perhaps he intended only to record essential features of the landscape that he could elaborate later. Yet now, in purely visual terms, we see it as a complete, descriptive statement of the subject.

A SELECTIVE APPROACH

The process of distilling the essence of a subject can it long and hard enough for its details to become familiar. You can then gather sufficient confidence to eliminate any distracting detail and give the subject visual impact. In *Norham Castle, Sunrise,* Turner has selected only the most fundamental forms of the castle and its landscape, together with particular qualities of light and atmosphere. However, in previous studies he had pursued a more detailed approach using both oils and watercolours. These demonstrate an interest in the topographical lie of the land, and incorporate precise descriptions of the solid shapes and apertures of the castle ruins. They also focus on much incidental detail — figures and animals on the banks and in the shallows of the river.

Many modern artists take a similar approach to getting to know a subject, particularly if they are working and reworking a selected theme. They gather reference sketches and photographs that record the subject's different physical aspects and moods, then reinterpret them visually and technically in a series of studies and paintings.

The process of distilling the essense of a subject can

117 ▷

Joseph Mallord William Turner (1775-1861)

Norham Castle, Sunrise, c.1845
This dazzling late oil painting is a synthesis of Turner's perceptions over a long acquaintance with his subject. He first painted the ruins of Norham Castle in 1797 and during his career produced a number of watercolours and colour studies on this theme. In this painting, he handles the thin oil paint freely, almost as if it were watercolour, allowing fluid, atmospheric effects to develop and reducing the form and substance of the landscape to a few minimal but highly descriptive cues. The open perspective draws the eye to the misty shape of the castle, with the range of colour organized in such a way as to give the subtle, heavy blues a dominant presence. But the inclusion of the briefly sketched animal in the foreground is a master

▲ The atmospheric quality of the painting mainly derives from colour glazes that describe form and space with minimal variations in the tones and hues. In this area of the image, runs in the blue glaze evoke the form of the castle and mound. White impasto breaks through the pale sky tints.

▼ The cow is almost a flat shape, its form hinted at with fragile strokes of rich, warm colour, and its reflection a mere smudge on the water surface. The surrounding glow of early sunlight is conveyed with a heavy application of opaque, light yellow in which the movement of the brush can be seen.

stroke; it establishes a sense of scale and distance, and the linear treatment and warm colour offset both the central mass of the castle and the delicate atmosphere created by the surrounding hues.

other artists to study

JAMES ABBOTT McNEIL WHISTLER (1834-1903)

Whistler wanted to emphasize the aesthetic nature of his paintings rather than the subject. This was a conscious reaction against the dominance of the subject matter typical of Victorian painting of his time. He gave his paintings titles like *Symphony* or *Arrangement in Grey and Black*. His *Nocturne in Black and Gold* was so much reduced to essentials that it was described by the eminent critic Ruskin as "flinging a pot of paint in the public's face". Whistler sued him and won. His famous portraits are more detailed but nevertheless reduced to highly selective studies of juxtapositions of areas of closely related tones and colours.

HENRI MATISSE (1869-1954)

Because of Matisse's resounding contribution to twentieth-century art, it is impossible to isolate only one aspect in which he conveys a supremely masterful touch. However, his appreciation of pure form and his sympathy for specific shape and contour are visible throughout his varied *oeuvre*.

GIORGIO MORANDI (1890-1964)

The majority of Morandi's work is concerned with domestic and local subjects such as still lifes of bottles and dishes, and the buildings and landscape near his home. These he studied endlessly in small-scale oil paintings and etchings, developing his sense of essential forms and patterns of light and dark.

ARTISTS' SKETCHBOOKS AND STUDIES

Go to the library and look at detailed monographs on your favourite artists, but instead of focusing on the major paintings, look at the examples of quick sketches and studies reproduced alongside them. In these, you will see all kinds of rapidly executed imagery that homes in on the broad impressions and telling details of varied subjects.

▲ David Ferry
Telendos Island
Watercolour
The traditional medium for landscape studies, watercolour is ideal for quick studies that evoke a sense of place. Its fluid washes indicate the variety of natural forms and textures by economical means.

▲ Nick Swingler
Fleeting Elm
Acrylic, oil and pastel
An informal technique of finger painting, using a mixture of media, produces an exciting blend of low-key colours and active textures that express a certain kind of landscape without describing it directly. There is a lovely contrast of space and mass.

► Peter Clossick
Helen Seated
Oil
Powerful individual brushstrokes are used to describe the overall balance of the pose and individual elements of the form. The impression is of a rapid, direct response to the subject that beautifully captures a transient mood.

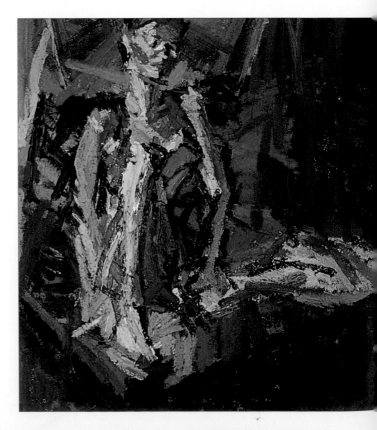

be more immediate, however, and can simply depend on practicalities. If you have not much time to study, say, a landscape or townscape view that you see during a holiday, or if your subject includes movement, thereby naturally incorporating rapid changes, your method of noting its visual qualities has to be quick and instinctive. When out sketching, you may also have limited materials at your command — for example, coloured pencils that require a direct, basically linear approach, rather than paints that you can mix and overlay, or a small range of watercolours from which you have to devise useful equivalents for the colours and tones that you see. Such restrictions compel you to respond immediately and selectively to your subject, and to decide in an instant which are its most essential aspects.

LOOKING FOR THE ESSENTIALS

There are no definitive guidelines for identifying the essential qualities of a subject, because the key to what is chosen lies in the artist's personal response. Any painting is developed from a combination of what you see in the subject, and the other particular sensations you experience from it at a given time. Your own estimate of what is essential in a subject will change if, for example, you see the same scene or objects under different lighting conditions or if your own mood changes radically. Similarly, if you are painting a moving subject you have to decide which individual elements of the movement sequence most accurately represent the whole.

Your points of reference could be based on the fundamental elements of pictorial composition and, partly, on the qualities of the particular materials that you are working with. The essential shape of an object can be described by its overall solid mass or by its contour — you can take a painterly or linear approach. Looking for the essence of an object does not necessarily mean eliminating surface or structural detail. The characteristic appearance of a specific building may be more the arrangement of the windows on its façade, than its simple outline shape. In a still life, you could represent an orange simply by correctly

recording its colour, but you might also want to paint the pitted texture of its skin. There are many ways of evoking such physical qualities without getting into painting a precise or realistic "portait" of the subject. You will need to experiment with ways of handling colour which seem to you to translate the significant features of the subject.

Sometimes you will find that, in haste or by accident, you achieve just the effect you were looking for by chance. When this happens, spend some time analysing how and why your painting works, trying to remember the processes by which the image occurred. In this way, you can find out how to take control of accidental effects and put this experience to use in future projects.

the projects

PROJECT 1
Close to home
Choose an accessible subject such as a still life, part of the interior of your house, or a nearby landscape view. Spend some time just looking at it, then go away from it and make a painting from memory, trying to identify the essential features of the image in your mind's eye. When you have completed the painting, go back to the subject and make a comparison.

PROJECT 2
Colour studies from nature
Make a series of colour sketches, as if they were research and preparation

for a separate painting. In each one, concentrate on a different aspect of the subject — shape and form, local colour, light and shadow. Consider the kind of information you will need to jog your memory of the scene when you rework the image later.

PROJECT 3
Colour studies from photographs
Use photographic references, such as animal pictures or family snapshots, and make colour studies using only the information in the photographs. Gradually reduce the amount of detail you include.

PROJECT 4
On the spot
Make on-the-spot watercolour sketches of a busy location full of movement — a shopping precinct, a market, a café, or a dancing class, exercise class, or gymnasium. Draw a basic framework for the subject with a brush, incorporating, say, the shop fronts, market stalls, or interior setting — then use line and colour to follow the movements of the people as they move within the framework, relating the scale and form of the figures to their environment.

further information

150–157	Painting with oils
172–177	Painting with watercolour and gouache
182–187	Painting with pastels

A statement in detail

· ·

This beautiful still life by Courbet demonstrates that a memorable painting need not be highly ambitious in scale or subject matter. The impact of this composition derives from the artist's precise rendering of both form and colour. The way the fruits are described gives them tactile as well as visual qualities; the kind of realism that makes you feel you could reach out and take one of the apples from the dish. The composition of the painting has been carefully arranged to make a complete statement. Nothing could be added or subtracted without disrupting the balance. The solid massing of the forms creates the picture; the dish of fruits becomes a compact, indivisible shape that is, unusually, placed almost centrally on the picture plane — but the arrangement of the pewter pot, wine glass and pair of apples on the tabletop provides an off-centre balance, avoiding a bland, symmetrical effect.

SELECTING A SUBJECT

When you want to focus on a subject in such a detailed manner, a still life group is ideal. You can choose objects of a size that makes them easily manipulated, so that you can take time to arrange the composition exactly as you want it, and also easily visible — you can get close to your subject in order to see every aspect very precisely.

Although the group consists of simple, everyday objects, the Courbet still life is quite a complex arrangement. The number of fruits in the bowl means that the main shape is broken up into a variety of interlocking planes and curves, and the surface detail includes comparable variations in colour and texture. If you were arranging a similar still life you could simplify your task by selecting, for example, only three apples, which you could group closely together. Asymmetry could be created by introducing another object positioned to lead the eye outward from the main group. This could be different in shape or scale — a few grapes, perhaps, or a kitchen knife.

One of the lessons of this subject is that the most ordinary objects can provide you with a great many

120 ▷

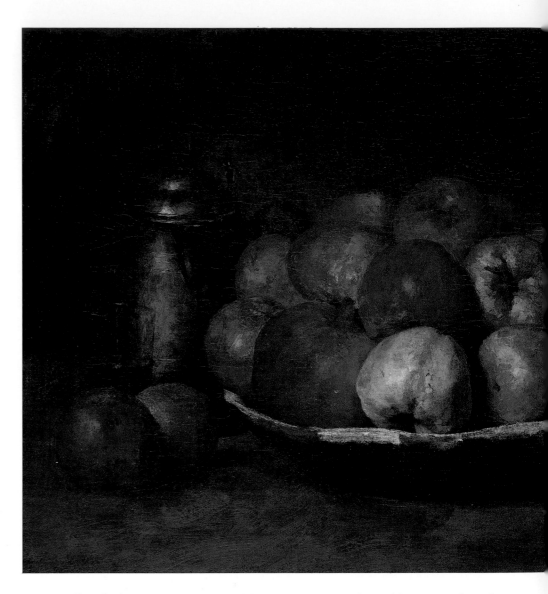

Gustave Courbet (1819-77)

Still life, Apples and Pomegranate, 1871-2. Courbet's treatment of this simple, everyday subject creates a rich, impressive image. The forms of the fruits are so keenly observed that they appear absolutely solid and sculptural. The three-dimensional quality of the painting is enhanced by strong contrasts of light and shade. The natural colours of the apples provide a striking complementary contrast of bright red and green, with local colours and tonal modifications that are predominantly warm, offset by the cooler, acidic hues of the green apples and yellow highlights. The pewter pot on the left introduces another useful contrast, with its muted greys relieving the dense mass of colour. Its height and shape also serve to adjust the balance of a composition that is otherwise nearly symmetrical.

▲ The shape of the pewter pot is in heavy shadow, the detail of its form reduced to the highlights describing the curves of lid and rim.

▼ You can just make out the brushstrokes worked around the curves of the apple; though not fully blended, they construct a unified form.

The frontal viewpoint focuses all attention on the still life group, and the simplicity of the setting — a shallow space consisting of flat planes and discreet colouring — emphasizes the modelling of three-dimensional form.

other artists to study

ALBRECHT DÜRER (1471-1528)

Dürer's famous watercolour *The Young Hare,* 1502, is a wonderfully evocative animal study, seeming to describe every hair and whisker. Similarly, in his *Piece of Turf,* 1503, he applies the same detailed observation and description to simple wildflowers and grasses.

JEAN-BAPTISTE-SIMÉON CHARDIN (1699-1779)

Chardin's still lifes are regarded as classics of the genre — precise, detailed statements typically composed of quite ordinary objects, such as basic foodstuffs or the props in his own studio. The coloration and brushwork are subtle and delicate.

DUTCH STILL LIFE PAINTERS OF THE SEVENTEENTH CENTURY

The elaboration of detail and sensitivity to colour variations in the complex Dutch still lifes demonstrate how intensely any small-scale subject can be analysed — from books and musical instruments to food and flowers. Few of these artists — such as Ambrosius Bosschaert (1573-1621), Pieter Claesz (1597-1661) and Jan Davidsz de Heem (1606-83) — are as well known individually as are other seventeenth-century masters such as Vermeer (1632-75) and Rembrandt, but their work is widely appreciated and sets an exceptional standard for acute observation and realism.

▼ Trevor Stubley
The Artist's Palette
Oil
The detailed statement constructed here is about context and mood, rather than precise description of individual objects. The shapes are broadly simplified yet remain recognizable. The artist's feeling for the materials and equipment of his craft is expressed in the substantial qualities of the painted surface and its exuberant colours.

visual qualities to work on in your painting. You can create a striking image using everyday things that are immediately to hand. Courbet's painting, in fact, is believed to have been made while he was imprisoned for his involvement with the Paris Commune of 1871. It is known that the canvas had been used previously as under X-ray another still life composition is visible underneath. Even in the most limiting circumstances, Courbet found means of exercising and challenging his skills as an artist, working with restricted resources.

PICTORIAL ELEMENTS
In a realistic statement of this kind, selection remains important. You do not have to record every last detail, but everything you put into your painting should be there for a reason, contributing to both the imagery

and the surface qualities. As you can see from this example, it is important to get the shapes right to make the group appear convincing. You need to pay attention to individual volumes and contours, and to the interaction of solid forms and the spaces between and around them. Local colour plays an important part. It may be helpful to create a colour theme, either restricting the variation of colours in the objects or choosing distinctive contrasts of hue, such as a complementary pairing (see page 27). Tonality can be a vital element in making a three-dimensional composition. You might, for example, choose to light your subject in a way that creates a dramatic chiaroscuro (light-dark) effect, as in the Courbet, emphasizing the volume of the objects, throwing them into relief against their background.

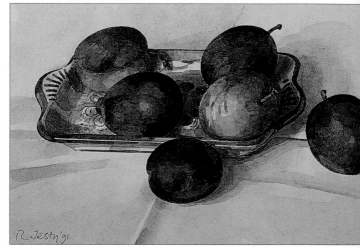

▲ Ronald Jesty
Victoria Plums
Watercolour
Like the Courbet picture, this is a beautifully simple still life, allowing the clear shapes and rich colours of the plums to carry their own presence. The varying strengths of colour and tone in the watercolour

washes have been expertly handled to convey the surface texture of the fruit with remarkable realism. Notice how their soft forms are contrasted with the hard edges and linear highlighting of the dish.

◄ Roy Preston
Raw Sienna
Watercolour
Old buildings have many naturally picturesque qualities, but here the artist chooses to isolate a single dynamic element, making the most of the colours and patterns. The rough, irregular textures of brickwork and wood are created from overlaid washes, brush drawing and spattering. Their uneven patterns are nicely counterpointed by the hard lines of the wire grille in the door. The close, frontal viewpoint makes a shallow three-dimensional relief, modelled by the contrast of warm and cool colours in the restricted palette.

ALTERNATIVE THEMES
In a still life, you have absolute control of the visual arrangement and can plan in a way that enables you to study it at length, undisturbed. Although simple themes can be very rewarding, you might like to introduce a more personal element into your choice of subject, so that the group of objects is not only a visual motif, but also suggests some kind of narrative or association. A theme common to many still life paintings is a reference to "being an artist" — for instance, the picture might show the arrangement of equipment and painting materials on a studio table. In a similar way, you could make paintings of objects that relate to a particular hobby or interest, or a memorable occasion in your life. The visual and technical aspects of these paintings should be approached in the same

detailed, analytical way, but the picture becomes special and individual through the hidden references.

Of course, a statement in detail does not have to be inspired by a still life. Ideally, your subject needs to be accessible, so you can study it closely; but a person or an outdoor theme, such as a corner of your garden, could be the basis of a detailed painting. Such objects also enable you to incorporate associative references, if this extra element appeals to you. There is a tradition in portraiture, for example, of including props and images in the background that relate directly to the person who is the subject. You could try this out either in painting a relative or friend prepared to model for you, or in a self portrait.

Working to a theme

Most paintings have some guiding idea behind them. The intention may be only to achieve a detailed, realistic rendering of a particular subject, but alternatively, you may want to create a more personalized kind of imagery that conveys a message or mood. This lesson concentrates on the ways you can enhance the subjective content of a painting, so that the picture expresses a narrative or associative idea, rather than only portraying things objectively. Of course, as can be seen in many kinds of thematic paintings, a picture is often both objective and subjective. So when concentrating on the imaginative theme of a painting, do not neglect the other important elements of the work.

DEVELOPING THE IMAGERY

One thing you need to decide is whether the concept that you wish to express in your painting will be conveyed directly or obliquely. In *The Day of Doom*, for example, the timber-yard fire is used as a metaphor for nuclear war and the common theme is the people's terror of an uncontrollable, destructive element. To make the nuclear threat more visually explicit, it would be necessary to incorporate specific symbols and pictorial references relating, perhaps, to missiles in flight or the aftermath of a large-scale explosion.

It isn't essential, however, for the particular associations in the artist's mind to be conveyed literally to the viewer. This is especially the case if you are dealing with social realism, such as poverty and war, where your paintings would compete with the vast flow of dramatic pictures supplied by the media. Some artists actually use such pictures as the starting point for their own interpretations of the graphic associative content, but ultimately the paintings they produce may depart considerably from the sources.

Concepts such as nuclear war or ecological crisis are only one kind of inspiration for thematic paintings. Your source could be drawn from literature, mythology or history. The theme may incorporate a sequence of events that you wish to illustrate, either as a theme in its own right or as an allegory for current events. This

125 ▷

Carel Weight
(b. 1908)

The Day of Doom, 1962-72
This painting uses a specific event to symbolize a broader theme, relating a personal experience to a more generalized sensation. Fear of nuclear war was rife during the 1960s, and the artist chose to express the feeling of doom shared by many people by portraying the most terrifying event of his childhood. Here we have a raging fire in a timber-yard near Weight's home which threatened to engulf the surrounding houses and shops of the closely built city suburb. The artist returned to the location to gather reference for the painting and found the streetscape little changed. The buildings are described with a sense of their ordinary realism, but the flames and smoke in the background explain the imminent threat. This is enhanced by the urgent, exaggerated movements of the figures who seem to be trying to escape the confines of the picture frame. The expressive quality of the image is increased by the heightened colour combinations of the houses and street, and the vigorous calligraphic brushwork.

other artists to study

AMBROGIO LORENZETTI (active c.1319-48)
Lorenzetti's complex compositions have a kind of realism unusual for the time, but titles such as *The Effect of Good Government on Town and Countryside*, 1338, and *Allegory of Bad Government* demonstrate that the pictorial devices serve a grand underlying theme.

GOYA (FRANCISCO DE GOYA Y LUCIENTES) (1746-1828)
As first official painter to the Spanish court, Goya was required to paint formal royal portraits and the results were not typically disposed to flatter his subjects. But his violently imaginative vision was fully unsheathed in later works dealing with mythology — *The Colossus*, 1808-12, and *Saturn (Devouring his Children)*, 1820 — and political commentaries such as *May 3rd, 1808*, 1814, depicting a French firing squad executing Spanish insurgents; and the series of etchings known as *The Disasters of War*, begun in 1810.

PIETER BRUEGEL THE ELDER (c.1525-69)
Bruegel's paintings are full of activity and incident, depicting themes as various as biblical events, proverbs, myths and the passage of the seasons by means of imagery based on the ordinary people and lifestyles of his day. The wit and wisdom of his commentaries is contained within complex, often elaborate compositions, packed with significant detail.

PAUL GAUGUIN (1848-1903)
In his paintings made in Brittany during the first part of his career, Gauguin put religion into the context of French peasant life, using strong shapes and clear colours to create a representational but non-realistic interpretation. His later Tahitian paintings similarly used the atmosphere of his current surroundings to give form to mystical and emotional themes.

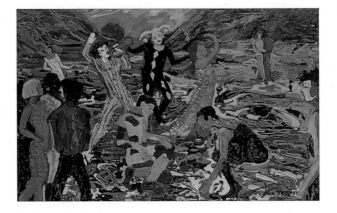

▲ Olwen Tarrant
Dance the Night Away
Oil and wax encaustic
The exuberant pattern of the dancers is echoed in their swirling background, and is enhanced by the fluid texture of the paint. Encaustic (paint mixed with hot wax) has to be dropped onto the surface, and is not easy to use, but it yields particularly clear and brilliant colours.

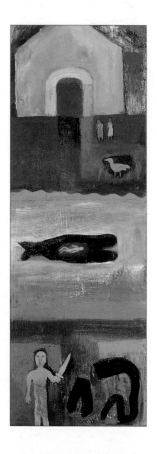

◄ Albert Herbert
St George and the Dragon, Jonah and the Whale and the House of God
▼ **Moses on the Mountain of God**
Oil

Religious or mystical narratives and symbols have been staple themes of art in all societies and cultures. In the twentieth century, overt expressions of Christianity in western art have often been deemed "unfashionable", but Herbert's paintings show how the old stories can be reinterpreted with passion and humour. He combines his religious feeling with great delight in the variable, lush textures of oil paint.

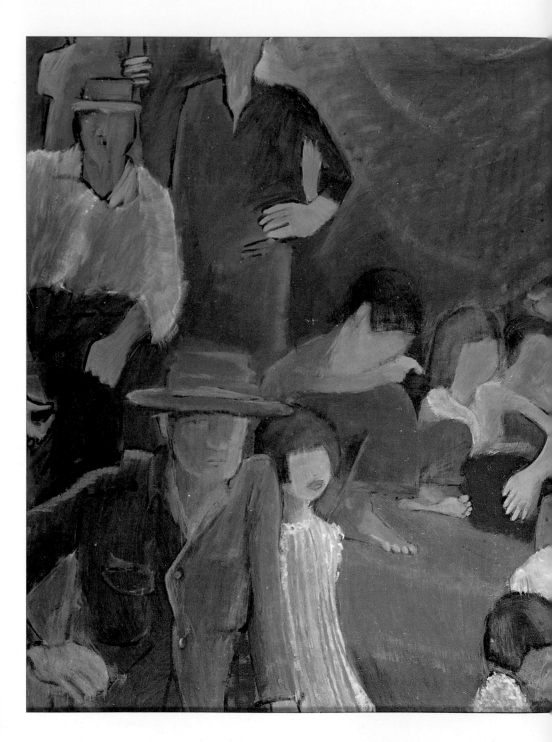

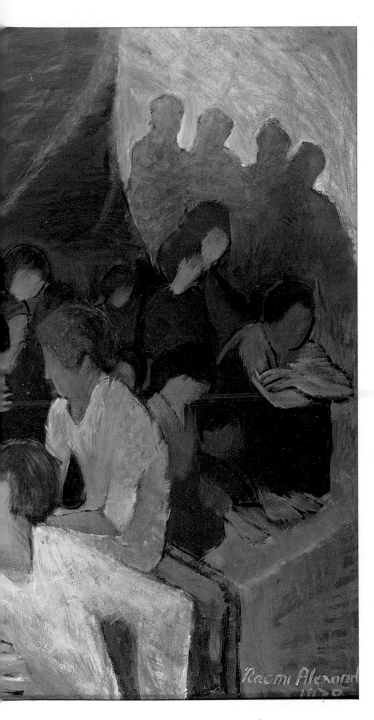

▲ Naomi Alexander
Boat People
Oil
The artist's Polish background gives her a special feeling for refugees, here focussed on the plight of Vietnamese boat people, much reported in the late 1970s. She often uses press photographs as a source of imagery.

can be done either as a series of related paintings, or by devising a picture that encompasses different parts of the story in different areas of the canvas. A complex architectural device sometimes used in Renaissance paintings divides the picture into distinct parts, with different elements of the narrative occurring within individual structures such as rooms, colonnades and courtyards. The viewer travels through the pictorial space while following the sequence of events.

Artists often mount an exhibition of several pictures exploring different interpretations of the same theme, or illustrating a continuous narrative. As well as picture series, the structure of the diptych or triptych can be used to divide the image area. In these instances, two, three, or even more, separate paintings are designed to be viewed as one picture. The classic model for this approach is provided by many beautiful and elaborate altarpieces depicting biblical themes and lives of the saints.

STYLE AND TECHNIQUE

When your theme incorporates a mood evoked by the objects or events you are depicting, or if your imagery is directly symbolic of an emotional theme, an Expressionist approach (see pages 106-109) is often the most appropriate. You may, however, be dealing with a subject that needs to be stated quite coolly, allowing the pictorial content to make its own impact. In this case, a detailed super-realist approach could provide the necessary detachment. Or a gently impressionistic style (see pages 94-97) might allow the significance of the painting to emerge more gradually.

Your ability to make the most of any kind of picture naturally depends on your technique as much as your imagination. It is useful to try out a series of works that constitute "variations on a theme", because you can then investigate different media and techniques at the same time. Whatever your subject, the visual effect of a charcoal drawing will differ from that of a watercolour, which is different again from an oil painting of the same subject. Often, as you develop your practical skills, the qualities of your materials and the effects they create suggest new ways of approaching subjects.

PROJECT 1
Make a painting depicting a news story
Select a current news story that interests you and collect newspaper and magazine photographs relating to it. Work out different ways of putting the visual information together to make a descriptive commentary on the whole story, either as one painting or in a series of pictures. Try different techniques, using paint, pastel or collage to create effects which are interesting in their own right.

PROJECT 2
Make a composition based on an event you have experienced
The painting should symbolize an emotional, social or political theme. If possible, make preparatory sketches and studies from life, perhaps of the location where the event occurred, and of the people or objects involved in it.

THEMES AND STYLES 125

Painting and structure

O ne of the central issues of representational painting is how to transcribe three-dimensional space and form into a two-dimensional picture. A three-dimensional structure underpins every scene, object or figure that you may wish to paint. In developing a composition, you have to find a satisfactory way of constructing both the overall image and its individual components. Certain theories and principles of composition have evolved to meet this challenge — perspective systems for "building" three dimensions on a flat surface, for instance, or theories of colour interaction that imply schematic formulae for achieving particular visual effects. However, for every artist, it is a skill to be learned through practice. Each artist's problems are determined by the subject and his or her technical skill, and there is never only one solution.

Throughout his career, Cézanne was explicitly concerned with this aspect of composition, relating it primarily to landscape, still life and figure subjects painted in oil and watercolour. His early works show the effort he put into the task, often with rather crude and clumsy results. Like the Impressionist painters who were his colleagues, Cézanne frequently met with abuse or plain lack of interest from the critics and established artists of his day. In his later paintings, however, especially the series of works devoted to Mont Sainte-Victoire, he achieved a fusion of technique and observation in which the solid permanence of three-dimensional form is conveyed with many subtleties of rhythm and coloration. His work was a profound influence on artistic developments in the early twentieth century, and he has been claimed as "the father of modern art".

BASIC STRUCTURES

Methods of structuring a two-dimensional image often relate initially to drawing skills. Outline and contour are used to construct individual shapes and volumes, which can be interwoven or overlaid to develop space and depth in the composition. Perspective systems are primarily described in terms of line drawing, creating

129 ▷

Paul Cézanne (1839-1906)

Mont Sainte-Victoire, c.1886-8
Use of the pine tree as a half-frame for the landscape both enhances the sense of distance and softens the stark frontal view of the mountain's mass. The colour variations are almost schematic, with the bright greens and oranges of the foreground giving way to cool blue-greys and subtle red-browns as the landscape recedes. However, a greater intensity of colour is used in the interaction of foliage and sky, and Cézanne's habit of working across the whole canvas through each stage of the painting creates many subtle linkages of hue and tone. The deliberately applied brushwork helps to construct the planes and divisions of the landscape, , and sets up strong directional emphasis leading the eye through the picture.

▲ Cézanne's brushwork follows form and direction, allowing the colours to integrate easily. The emphasis of the marks helps to lead the viewer through the picture space.

▼ Cézanne painted slowly, often making alterations over a sustained period of time. Here the layering of strokes shows revisions have been made to basic structures.

Details of local colour and texture are generally subordinated to the overall organization of the painting. Cézanne provides just enough visual information for us to distinguish the basic forms of buildings and the individual features of the landscape.

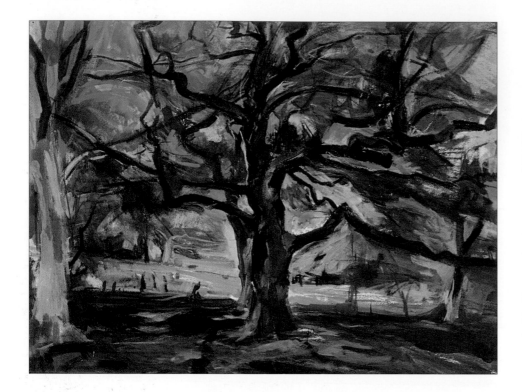

▲ David Carr
Oak Tree
Gouache
It is usual to avoid a composition based on a central division of the picture plane, but with an imposing dramatic subject like this, the artist can make a virtue of placing it centre stage. The spreading branches create a balanced asymmetry anchored by the firm vertical of the tree trunk, and echoed in the strong, dark shadows on the receding horizontal plane.

▲ Lesley Giles
Fortifications
Watercolour
Flat shapes and intense tonal contrasts make a powerful structure. The painting is quite small-scale, but conveys the monumental aspect of the subject.

◄ Rosalind Cuthbert
Still Life on a Washstand
Watercolour
Space and structure can be formalized rather than illusionistic, a principle central to Cubism, and arguably more "realistic" since this incorporates varied angles of perception.

the impression of structure and spatial recession through a linear framework. This is a perfectly valid way to investigate pictorial space. When you sit down to paint a figure, a landscape or a still life, it is almost instinctive to sketch in a linear "map" of the composition before you turn your attention to filling the shapes with tonal modelling, colour and surface texture.

You can, however, begin by seeing your subject as an arrangement of surface planes and colour areas, blocking in broad shapes with masses of colour and tone before refining the form and detail. For some artists, this is the starting point; for others, it is the second stage following a linear treatment. The way you begin to structure an image, however, relates directly to the way you see it. Some people naturally tend to identify things by their "edge qualities", seeing first the contours of individual objects and the points and lines that represent junctions between them. Others absorb whole shapes and the linking or layering of surface planes. There isn't a right or wrong way of seeing, but it is helpful to pause from time to time to analyse why and how you instinctively pick out particular elements, so that you can learn to extend your skills of observation. The more you can see in your subject, the more options you have for translating it into paint.

COLOUR AND TONE

Colour is an important element of structure — not only the tonality that models forms with light and shade, but the impact of hues and their interactions, which can be related to the impression of pictorial space. Some colours are said to be likely to advance or recede from the picture plane; but rather than relying on theoretical formulae, it is essential that you consider colour relationships in the actual context of your work. By organizing the effects of harmony or contrast, creating subtle linkages across the picture plane, and relating the tone and intensity of applied colours to the arrangement of your composition, you can do much to enhance the impression you are trying to convey.

In a landscape, for instance, if you put strong colours at the horizon, they may reach out to the foreground

and flatten the space. Cézanne's *Mont Sainte-Victoire* is an object lesson in organizing colour to create spatial recession — beautifully layered, with subtle tensions between related and complementary hues of gradually diminishing intensity. But you must remember that the way a colour works within the image depends not only on its innate properties of hue, tone and intensity, but also on its relative scale and value within the overall composition. It is not impossible to make strong colours work in the middle ground or background (they can be a useful enlivening factor) but they need to be discreetly handled. A tiny touch of strong red has quite a different impact from that of a distinct, solid shape painted in the same colour.

SURFACE VALUES

By studying Cézanne's painting carefully, you will notice the visibility of the brushwork. He has not smoothed out the transitions of colour and shape, but has given the brushwork directional emphasis appropriate to the forms he is describing and has also varied the scale of the marks within different areas of the composition. The linear elements of the painting create specific rhythms, pulling to the left in the foreground, then travelling rightwards at the foot of the mountain, before the directionals converge at the mountain peak.

When you are focusing on the structural qualities of an image, you need to consider how your brushwork and paint texture contribute to the construction. Translucent glazes and broken colour enable you to layer the surface effects corresponding to the planes and textures in the subject. Opaque, heavy colours create a more dense, uniform surface that differently affects the structure. Again, there is no right or wrong way of approaching these elements, just alternative solutions to be aware of as you develop both composition and technique.

the projects

PROJECT I
Set up a still life on the floor
Do this beside your easel so that you can paint the still life from above. You will find that this helps you to see the shapes and forms quite clearly, so the still life grouping can be quite complex, but it should be composed of items with distinctive shapes.

PROJECT 2
Find an exterior view with a strong perspective element
For example, search out a receding country road or city street. Start your painting with a linear brush drawing mapping out the perspective effect, then start to insert colours and tones, managing differences of hue and intensity in a way that enhances the sense of space and distance.

Painting through drawing

Many people make a clear distinction in their minds between drawing and painting. Traditionally, drawing has been defined as dealing with line and contour where painting explores mass and volume. As drawing is often thought to relate primarily to monochrome interpretations, where the business of painting is to express the world in colour. In part, this attitude derives from actual divisions between the two activities established by systems of art training. Students would first be taught draughtsmanship through the use of point media such as pencils, charcoal and pen and ink; and then, when judged of a certain standard, would move on to the mysterious business of mixing and manipulating colours. Drawing seems to have had an implied status as a secondary skill, both the techniques and results being somehow less important than those of painting.

Beginning with drawing and moving onto painting is simply one method of acquiring experience as an artist, and to see these activities as radically different is inhibitive. The basis of developing any skill or style is learning to observe thoroughly and analytically, and to translate the visual information through your chosen medium. When you are painting, you are also drawing, because drawing is just a way of reconstructing things two-dimensionally — you can do this with a pencil or a brush, by drawing lines or by blocking in colour areas.

MATERIALS AND TECHNIQUES

The kinds of marks particular materials make tend to influence the ways you handle them. With a point medium such as a pencil or pen, it is easier to draw lines than to shade broad masses, so the tool itself encourages you to take a linear approach. Using a brush and fluid paint medium, it is equally easy to produce either kind of mark, and you almost certainly integrate line and mass instinctively when you are painting.

Pastel is a medium that focuses attention more closely on the combination of drawing and painting

133 ▷

Edgar Degas (1834–1917)

Woman Sponging her Leg, 1883
The inventiveness of Degas' pastel work is both technical and figurative. He experimented freely with this direct colour medium, developing methods of layering the colour thickly to build up an active, complex surface. In the interior studies of women washing he took a subject that is both mundane and intensely intimate, and created an informal style of composition that admits the viewer to a private world. The nude figures and shabby furnishings are drawn as simple but sensual shapes, sometimes contained within emphatic contours. Degas used pastel to construct solid form from a mass of individual marks — dashes, ticks and scribbles — orchestrating the colour interactions to produce subtly brilliant effects of light and texture.

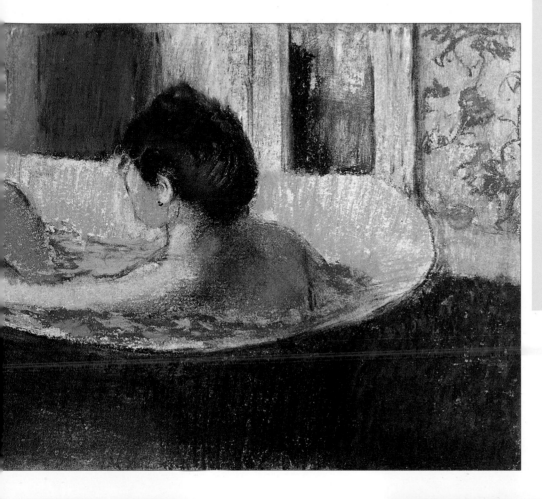

other artists to study

HENRI DE TOULOUSE-LAUTREC (1864-1901)

Lautrec's paintings and prints convey his masterful draughtsmanship, with linear qualities creating an immediate impact but also beautifully integrated with painterly colour and texture.

GEORGES ROUAULT (1871-1958)

Rouault's paintings typically show a strong graphic feeling for line, often reinforced by the use of dramatic black contours. His apprenticeship was served in a stained-glass workshop, where he discovered the pictorial values of clear definitions and strong colour.

OSKAR KOKOSCHKA (1886-1980)

Kokoschka's Expressionist style has a dominant linear force. Even in large-scale paintings, shapes and contours are traced over and over, built into networks of vibrant calligraphic lines that coalesce into colourful masses.

▼ The shadows on the skin have a soft grainy quality typical of broad, chalky pastel strokes. On the hair, the artist has blended the colours more thickly and intensely to create a glossy texture.

◀ Pastel provides rich qualities of colour and texture unlike those of any paint. Variations between line and mass are easily formed by natural movements of the hand and pastel stick. This detail shows rubbed areas and overlaid strokes forming solid and broken textures; subtle neutral tones are contrasted with deep hues. Through the heavier masses, Degas interweaves linear contours and gestural marks.

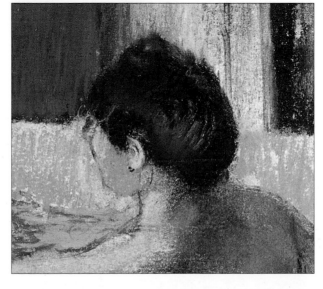

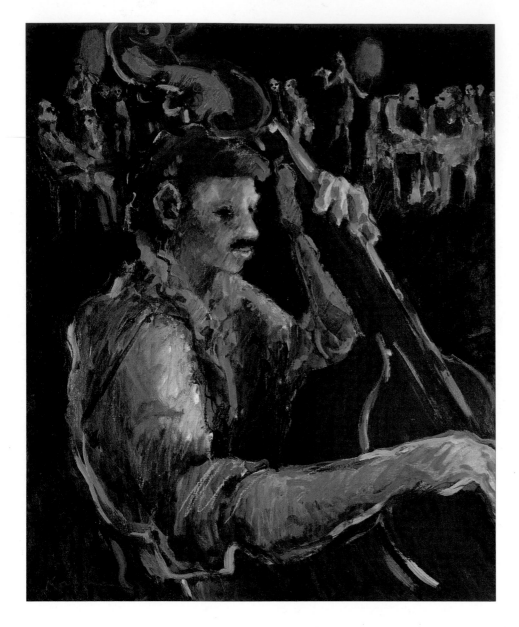

▼ Neil Watson
Front Street, Beaufort
Acrylic and ink
The architectural subject is defined with a strong linear framework, over which thin colour washes pull together the flat planes and structural detail. The hand-drawn and painted image works rather like a print in the layering of surface colours and textures.

► Janet Boulton
Folding Table with Black and White Cloth
Watercolour
Geometric structures may include both the simple planes of the subject and imposed patterns like this chequered cloth. The artist makes a beautiful rhythm of repetitive shapes, utilizing the strong directional lines and curves in the objects.

▲ Carol Katchen
Jass Bass
Mixed media
Alternating areas of glazed and opaque colour, overlaid with vigorously hatched and scribbled pastel marks, build a vibrating, energetic image appropriate to the subject. The activity of the figures is emphasized by the heavy, dark ground.

► Donald Pass
Frosty Field
Watercolour
Linear features such as receding tracks and furrows enhance the description of space and distance in landscape, and make interesting surface texture.

Janet Boulton

the projects

PROJECT I
Make some quick watercolour studies of water running from a tap
Use the tip of your brush to follow the movement of the stream of water and the linear reflections. This will loosen up your technique and give you practice in drawing with the brush rapidly and confidently.

PROJECT 2
Make a detailed study in pastel, watercolour or oil
Find something with a pronounced linear texture such as a wicker basket, a net curtain, a patch of grass or a tangle of plant stems. Work out ways of varying your techniques to convey both the broad shapes and masses and the intricate detail of individual forms and surface textures.

PROJECT 3
Apply similar techniques to a figure study
If you can't find someone to pose, use a mirror with yourself as model, or draw part of your body, such as foot and leg or hand and arm. Study the planes and contours of body and limbs, and the surface colour and texture of the skin. Build up layers of calligraphic marks, as in the Degas, to round out the forms.

skills. The size and shape of a soft pastel stick is well suited to linear mark-making, but the velvety colour also spreads easily if you wish to create blocks of solid colour or an atmospheric haze. It is the most direct of the colour media, because it has very little binding material, so the pigments are pure, and you manipulate the colour with your fingers, without the intervention of a brush or other tool that makes its own mark. Degas took up pastels because he found that when his eyesight began to fail, the strong colours and immediate techniques were easier to control than paint. But he also experimented with adding fluid media to the powdery pastel, using solvents and varnishes to blend and set the colours. Modern artists can take advantage of ready-made products that extend pastel's potential such as thick, juicy oil pastels and water-soluble types.

While it is exciting to investigate the potential of other media, don't neglect the variety that you can introduce into your paintings by drawing with the brush and finding inventive ways of applying and mixing colours on the canvas or paper. This applies whether you are using oil, acrylic, gouache or watercolour. In many of the examples in this book, you can see how vigorous, directional brushmarks, broken and ridged brushed textures, and rhythmic interactions between line and mass can activate the surface of an image without diminishing its impact.

SUBJECT MATTER

Any subject can prove sympathetic for combined techniques of drawing and painting, but while you are investigating this approach, it may be helpful to choose something that offers you immediate visual cues. In landscape, for instance, the linear frameworks of large trees and rippling textures of grassy fields; in figure work, the strong contours of the nude body or the varied textures of elaborate clothing. This is an interesting approach for tackling "difficult" subjects. Another work by Degas, *Jockeys in the Rain*, brilliantly uses slashing pastel strokes to convey the downpour, and the well-known *Tropical Storm with Tiger* by Henri Rousseau (1844-1910) exploits a similar technique in paint.

Fantasy, memory and dreams

Surprisingly few paintings come direct from the artist's imagination; most are firmly grounded in the real world. Even when the imagery is overtly fantastic or shocking, it has usually evolved from a combination of observed realities and imaginative possibilities. Artists are by nature inquisitive, and fantastical paintings can emerge from studying the character of things very closely, and then working on a "what if" principle. What if you take an ordinary scene and insert one quite out-of-character element? What if something known to be solid and enduring was suddenly made to seem changeable or fluid? If pigs could fly, what would they look like when flying?

Some artists do seem to invent their own eccentric, highly personalized worlds, constructed from unusual volumes and perspectives and populated with strange humanoid forms or unfamiliar creatures. However, it is pretty well impossible to imagine something completely beyond your own experience. A weird townscape might consist of architectural forms that couldn't stand up in the real world, but this implies that the artist knows something about true perspective and relationships of space and form, in order to be able to invent an opposite effect. An image supposed to represent a living being, however extraordinary its shapes and features, will enevitably evoke references to some aspects of real human or animal forms.

SOURCES OF IMAGINATIVE COMPOSITION

Different kinds of experiences create personalized visions. Storytelling is the basis of "other worlds"; you might choose to illustrate something you have read or heard — from a novel, poem, song or play, for example, or a scenario that you have developed for yourself. Dreams are a direct resource — not everyone remembers dreams in much detail, but sometimes you wake with a startlingly clear picture in your mind of one part of a dream, and there is often a fantastic element because dream logic doesn't conform to normal routines and expectations.

The kind of fantastic imagery described as

136 ▷

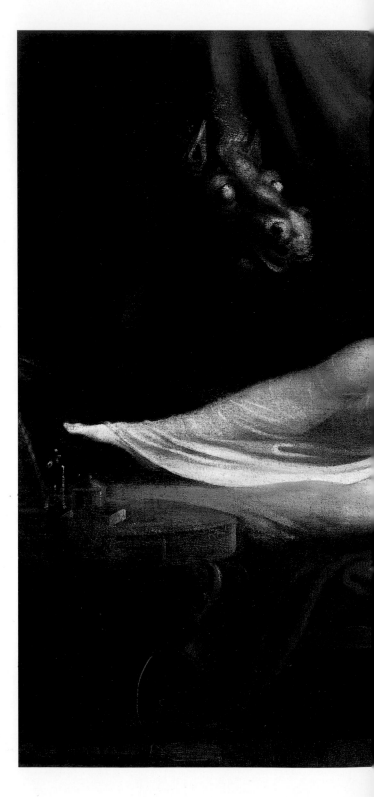

Henry Fuseli (1741-1825)

The Nightmare, 1782
The combination of the erotic and grotesque in this painting caused a sensation when it was first put on exhibition, and it was an instant success. Highly respected in his lifetime, Fuseli was ignored for about a century after his death, until the Expressionists and Surrealists rediscovered his works. *The Nightmare* has since become an icon of the style of imagery that seems to tap into dark, subconscious fantasies. It is interesting that the composition is formally organized to create a balanced structure, and employs well-established pictorial conventions, such as the heavy chiaroscuro, to achieve its dramatic effect. Although the style of execution creates a heightened sense of realism, Fuseli employs distortion and inserts imaginative detail to enhance the theatricality of the image. The graceful lines of the woman's body are anatomically incorrect, while the horse's head is exaggerated to the point of caricature, but made menacing by its horrid, blank eyes.

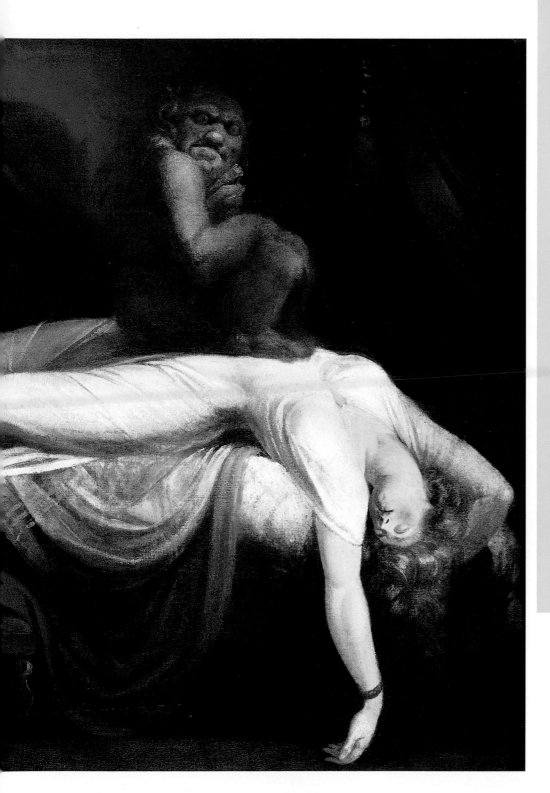

other artists to study

**WILLIAM BLAKE
(1757-1827)**

Blake's images are based on myths and biblical themes, as well as his own songs and poems, and he developed a highly personalized style and technique to portray his unique visions.

**GUSTAVE MOREAU
(1826-98)
ODILON REDON
(1840-1916)**

These major figures of the Symbolist movement produced many rich, elaborate and technically inventive images conveying other-worldly values. Drawing on history and mythology, the works include detailed observations of reality — mixed with imaginative symbolic forms.

**RENÉ MAGRITTE
(1898-1967)**

Magritte's deadpan bowler-hatted men and bland domestic interiors participate in a variety of events by turns ambiguous, surprising and shocking. His paintings continually throw up questions — "What is this really? Could this happen?" — that show how the most mundane situation needs little intervention to turn it into the stuff of confusion and nightmare.

**SALVADOR DALI
(1904-1989)**

Dali played with meanings and associations in his imagery and with a vivid style of hyper-realism, producing one of the most consistent and recognizable expressions of the "alternative realities" proposed by Surrealist artists of the mid-twentieth century. However, being highly eclectic and also long-lived, Dali encompassed a great range of experiment in the course of his career.

**MARC CHAGALL
(1887-1985)**

Strange people and creatures exist in dreamlike settings, able to defy gravity and otherwise go beyond the normal reference points of the physical world. Chagall's style of lyrical expressionism creates a world of brilliant colour and sensuous form, alive with narrative symbolism.

Surrealism typically involves a reversal of expected forms. It incorporates juxtapositions of ordinary objects in unusual relationships; everyday scenes disturbed by something additional or out of place; subversive changes in the apparent scale or weight of environments and objects; people taking up impossible poses, strangely dressed, or involved in activities that seem to have a ritual logic inaccessible to the viewer. Some kinds of Surrealism are semi-abstract, drawing up the viewer's memories and associations, but refusing to confirm or deny any specific interpretation.

Memories are a source of personalized imagery, and memory plays tricks with observed realities. Have you ever returned to a place where you were taken on

▲ Rosalind Cuthbert
The Nightingale
Mixed media
An interesting feature of imaginative composition is the ability to play with scale and space, putting real objects into unreal relationships. The dream-like quality is enhanced by techniques that create soft veiling of the colours.

▶ Daphne Casdagli
The Story of Horys II
Collage and acrylic
Ancient mythologies and cultural symbols are rich sources of subject matter.

holiday as a child, and discovered that previously clear, detailed memories do not correspond to what you see? Scale is an important aspect of childhood experience. An open landscape by the sea or in the countryside can seem vast and unconquerable to a child, but when you return to the place as an adult, you find you can walk right across it in a matter of minutes. In the same way, even well-meaning adults can seem huge, grotesque and threatening to a child at a vulnerable moment. The way you remember a scene, event or person from another part of your life can provide you with a picture of a non-objective reality.

COMPOSITION AND TECHNIQUE

From whatever source you derive your subject, an imaginative composition gives you great scope for the arrangement of the image and the surface treatment. It may draw on "real" references, but it doesn't have to convey them in an objective way. Surrealism can be very effective if you use controlled, careful drawing and painting techniques to create a hyper-real image. The disturbing element is all the more shocking if the viewer has the impression of seeing a "true" picture. But you can manipulate purely formal elements, such as shape, colour and tonal modelling, to develop a non-realistic image that follows its own rules — pink elephants, blood-red rivers; whatever conveys the emotional impact of the narrative you want to put across. You can simplify and distort actual forms, play with the conventions of scale and perspective in pictorial design, create peculiar textures and surface rhythms relating to the thickness of the paint and the movements of your brush.

A sketchbook recording anything unusual or specially interesting that you see, and in which you can also note down imaginative ideas that come to you, is a useful personal resource. The way sketchbook pages evolve randomly, with a collection of images from different locations and events, sometimes suggests unexpected combinations of pictorial elements. A scrapbook of photographs culled from newspapers and magazines functions in a similar way. The Surrealist painter Max Ernst (1891-1976) produced a

the projects

PROJECT 1
Paint your memory of a scene or event
Or paint one that you have dreamed. Whichever you decide upon, exaggerate the mood and atmosphere as you remember it. Think about how you can construct the picture in a way that expresses your relationship to the subject. For example, a very low viewpoint produces a perspective that makes objects and people seem huge and looming; a high viewpoint or aerial perspective puts you outside the image, as an alien observer hovering above. You can also use dramatic elements such as non-objective colour and heightened tonal contrasts to emphasize the interpretive qualities.

PROJECT 2
Make a collage from drawings or photographs
Putting together images that describe new composite forms or create a disturbing mood in an ordinary context. Try making two or three paintings based on your collage. One should reproduce the image faithfully, then paint one or two that take a more expressive approach (see also pages 110-113).

◄ Catherine Nicodemo
Love scene
Pastel and watercolour
A gentle, lyrical mood is conveyed by the undulating curves of the landscape and harmonious rhythms of the figure groups. The structure of this painting creates a feeling of serenity, as do the clear, translucent hues and rich, dark tones of the watercolour palette. The story behind the image is not explicit, but the underlying emotional content is unambiguously portrayed.

series of fascinating works by collaging together pieces taken from Victorian engravings that were originally book illustrations.

As well as looking at the work of other painters, you can get some useful ideas about imagery and technique from current styles of illustration in books, magazines and posters dealing with fantastic and dream-like subjects. The immense popularity of science fiction, horror stories and magic realism in literature and films has produced specialized illustrators who achieve an exceptionally high standard in their work. Although the images were originally designed for reproduction only, many have become collectors' items.

Abstracting from nature

For some people, the word "abstract" automatically signals that a painting will be difficult to understand and possibly uninteresting to look at. Abstraction frequently evokes an unsympathetic, even hostile reaction, because it seems to reject our common experiences of seeing and interpreting the world around us.

It is true that an abstract work is one artist's unique response to particular themes and methods, and in that respect it is not as readily accessible to the casual viewer as, say, a recognizable still life or figure painting. But it is also true that such a work contains the kind of perceptions that are common to us all, and that we have studied in previous features in this book. For example, an abstract painting can be a two-dimensional rendering of three-dimensional space and form; or it may obey particular conventions of composition and division of the picture plane. It is also composed of the same materials as other paintings, and therefore represents similar preoccupations with technique and surface values.

The idea that figurative and abstract approaches are worlds apart is absolutely false. But this is not helped by some artists and critics who have felt it necessary to create a kind of competition between them, and to claim one approach as being more universally valid than another. In fact, since abstraction became a common, even for a while dominant, form of painting in the middle of the twentieth century, the two apparently different disciplines have usefully exchanged developments of style, concept and technique so stimulating both areas of image-making.

If you are one of the people who has felt excluded from abstract art, this is most likely because you have not been given the means to relate it to things you do know and understand about painting. This article, and the following feature on abstraction, may leave you knowing a bit more.

SOURCES OF ABSTRACT IMAGERY

There are two basic methods of developing an abstract style. One is to use objects and images from the real world as reference points from which you evolve a

Victor Pasmore (b.1908)

Spiral Motif in Green, Violet, Blue and Gold: The Coast of the Inland Sea, 1950.
This painting refers, not to a particular location, but to an inner experience of the forms of landscape — hence the "inland sea" of the title. Pasmore had previously produced abstracted versions of scenes observed, and was here beginning to move into more formal explorations of abstraction loosely based on landscape themes. The spiral motif was a key element in a limited series of paintings. The spiral adapts partially and wholly to the rhythms of landscape features, and the colours are appropriately distributed. But although it is easy to read the spatial relationships of land, sea and clouds in the image, it was the completed picture which suggested the figurative title, not vice versa. The full title identifies the painting primarily through the basic ingredients of its composition.

other artists to study

NICOLAS DE STAEL (1914-55)

Strong shapes and heavy impasto together with brilliant colour theme variations evoke the lights and textures of landscape and townscape.

GRAHAM SUTHERLAND (1903-80)

In work based on the landscape and its individual features, Sutherland evolved a fascinating range of semi-abstract pictorial equivalents to natural forms and environments.

WILLEM DE KOONING (b.1904)

Working alongside the purely abstract modes of his fellow artists in the New York School of the 1940s and 1950s, De Kooning focused the human figure as a source of abstraction in his well-known *Woman* series. Other works show explicit references to landscape origins.

STUART DAVIS (1894-1964)

Davis' work exhibits a refreshing variation on the abstracting from nature theme, utilizing man-made forms and graphic imagery to develop a decorative abstract style.

personalized, "abstracted" interpretation. The other is to employ purely formal pictorial elements and material qualities such as non-referential shapes and colour relationships and surface effects directly relating to the material properties of the chosen medium. The second approach is investigated on pages 144-147.

Abstracting from nature we can take to mean deriving abstract imagery from things actually seen. Landscape is a frequently used resource for this kind of approach, perhaps because its enormous scale enables

us to look at it in broad terms and disregard incidental detail that cannot be clearly identified at a distance. But this basic method can equally well be applied to other themes like figures, natural and man-made objects, indoor and outdoor environments, and actual events.

To describe this process of abstract analysis in the most simple terms, we can take possible examples and relate them to figurative interpretations. For instance, a landscape of fields, hedgerows and distant hills can be seen as a series of rhythmic shapes each of which has a dominant colour; an abstract painting of such a view might look something like the image that a figurative painter would achieve while blocking in the landscape

▲ Nick Swingler
Landscape Euphoria
Acrylic
Abstraction is frequently involved with the pure sensations of colour and texture available from a particular medium or mixed-media approach. A natural subject such as flowers can suggest ways of unleashing these properties freely, but from a basis of observed reality.

► Roy Sparkes
Doris Tysterman
Watercolour and pencils
Some natural forms have very strong, characteristic shapes that can be isolated and rearranged.

in the early stages of the painting — broad contours and colour areas not yet broken up by the particular detail of individual features. In the same way, a face can be seen as an elliptical shape coloured an overall uniform pink. Arms and legs can be interpreted as basically cylindrical forms and clothing as separate areas of bold colour and pattern.

Often, in any subject, you can identify linked and repeated shapes and forms that give a sense of unity to your interpretation. The same type of linkage can be made within the range of hues and tones that you see, so that you discover a pattern of similarity and contrast. Abstraction means initially breaking down what you see before you into simple, sometimes very obvious visual elements. You can then start to examine the detail, as you would in a representational painting, and see what other information you are provided with that enables you to reinterpret and elaborate your basic image.

HOW FAR DOES IT GO?

So far, we have examined a fairly simplistic approach that opens the door to abstraction but does not wholly bridge the gap between what an artist sees and what goes on the canvas or paper. This is because at some point a new conceptual leap may occur that eliminates some of the links between observed and interpreted realities.

For instance, if you were working on an abstracted landscape, you might see a sudden shaft of sunlight falling on a grassy field, which might then become a slash of bright yellow on your painting. As you step back and see the effect on your image, it may occur to you to give the yellow a different hue or tone, or to turn the slashed brushmark into a distinct, hard-edged shape. Alternatively, you might suddenly decide that every area that had previously represented green grass should be painted bright red, to completely change the character of the painting. Or you might create a broad pattern corresponding to the linear texture of the blades of grass, not necessarily in naturalistic colours. As such ideas develop, you gradually remove the particular associations that would enable an

the projects

PROJECT I
Collage from a landscape or still life
Choose a landscape theme — a view that is familiar to you — or set up a simple still life, and create an abstracted colour study using cut and torn pieces of coloured paper collaged to your base paper (see pages 202-205 for more about this working method). Try to deal with distinctive, strong shapes, eliminating small-scale detail. Don't worry about making the shapes too precise, and you can allow the paper pieces

to overlap and modify each other, and you can make changes simply by gluing pieces over each other.

PROJECT 2
A painted abstraction
Repeat the project above, but using paint to create the colour areas. Apply the paint in different ways to vary the surface qualities within the different shapes. For instance, use heavy impasto contrasted with patches of transparent colour glazing; or opaque, flat colour next to active, broken brushwork.

PROJECT 3
Drawing with colour
Using a similar subject, make a colour drawing with brush and paint, following the contours of shapes and including some detail elements, such as interesting textures or patterns on the surface of the objects you are looking at. Try using a bright-coloured piece of paper for your painting in this project, so that you have to select your paint colours boldly to make sure they have an impact.

▶ Robert Tilling
Distant Light
Acrylic
This is an interesting ambiguous abstracted image — it could be a formalized interpretation of a real landscape view; or it might be a purely abstract arrangement of shapes that evokes essential qualities of open landscape. It is a clean, well-balanced, satisfying composition.

uninvolved viewer to relate elements of your painting directly to those of the original subject.

If you are interested in abstraction and have not previously understood it very well, try looking at abstract paintings in these terms and imagining what might have been the inspiration for specific shapes and colours. But keep in mind that in abstract art there is also an emphasis on the material, surface qualities of the painting, and it is often more directly influential than in figurative works.

The picture surface

The traditional concept of the picture plane sees the canvas or paper as a kind of window pane. Within the picture area you look into an illusory three-dimensional space which is receding from you and implied as spreading horizontally and vertically, although cut off by the sides of the picture frame. Perspective systems are used to enhance the impression of depth and construct apparently solid volumes and the spaces between them; methods of organizing colour and tonal relationships enable us to relate surface detail to underlying structures and to model forms with contrasts of light and shade.

A key concept of certain kinds of abstract painting is total rejection of this illusory pictorial space. Critic Harold Rosenberg, explaining the work of American abstract expressionists in the 1940s, described the canvas as an "arena" in which the painterly action took place. The surface effect was not a picture, but a record of an actual event — the laying down of substance and colour. This is most easily appreciable in Jackson Pollock's (1912-56) drip paintings and in large-scale colour field paintings, where the effect of abstract marks and shimmering hues evades analysis in the conventional terms of pictorial composition.

It is sometimes difficult to see the common ground between completely different styles of painting, yet the most basic factors common to all are extremely simple. Any drawing or painting arrives by means of the artist manipulating a medium on a surface, so the surface of the picture has a substantial presence of its own, whether or not it coalesces into a pictorial representation. Every artist is concerned with how to apply the medium, although the ways of doing so may vary according to whether you are trying to construct realistic form on the flat plane of your canvas or paper, or achieve a purely abstract sensation of colour and texture.

DESCRIBING SURFACE VALUES

In abstract work a close involvement with surface values is unavoidable. In figurative work, however, it is easy to lose sight of the fact that what you are putting down on the surface is only paint. In the forefront of your mind, you are thinking about the visual properties of an apple, or a dog, or a face, or fluffy cloud, and perhaps forgetting how paint spreads on a surface, and how colours interact, and how different brushes make distinctly different marks. But what happens on the surface of an apple is not the same as what happens on the surface of your canvas when you successfully paint an apple. You need to be constantly aware of the independent qualities of your materials that can make an image work for you in a particular way.

When you begin to appreciate these surface qualities, it is useful to study the works of your favourite painters and see how they created their effects. You may be surprised just how crude is some of the detail in highly realized masterworks. Seen close to, the hands in a Rembrandt figure dissolve into vibrant slashes and blobs of barely connected colour; in a formal court portrait by Van Dyck, the

DEFINING FORM
◄ In **Environs of Pamajera** by Alex McKibbin the all-over activity of the brushmarks creates a very complex surface, although the watercolour application is relatively light. Suggestions of form and space emerge from colour and tonal variations.

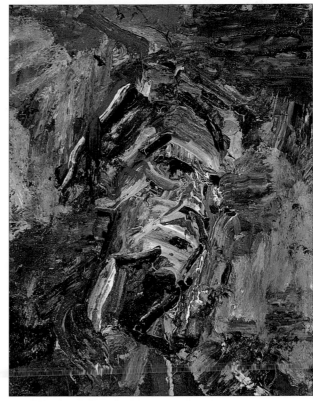

EQUIVALENTS
▲ The fluidity of the oil paint in **Tidal Water** by James Morrison (above) matches the atmospherics of the landscape in quite a literal manner.

MATERIAL VALUES
▼ The variety of materials in a collage provides different surface values suited to parts of the image as in Barbara Rae's **Spanish Terrace**.

luxuriant folds of a velvet dress are formed of raw-edged, gestural brushmarks and lace consists of freely drawn, calligraphic lines and twirls. It is fascinating to see where a colour that seems to stream forward from the surface is actually an underlayer glancing through a heavier application of a darker tone, and how the most luminous, atmospheric effects sometimes reverberate from solid, opaque colour.

If you don't learn to get comfortable with the physical properties of your materials, your approach may be over-controlled and the resulting image disappointingly tame. However, there is room for subtlety, and not all striking effects come from bold or exuberant methods. But if a painting is not working well, you have nothing to lose — try attacking it with colour and gesture, emphasize shapes and contours, make lights and shadows more intense. Once you get the picture surface working in its own terms, you can always modify anything that seems overdone and retrieve some of the gentler qualities of the image.

PAINT TEXTURE
▲ Heavy impasto oil paint gives actual substance to Peter Clossick's **Head**. The marks have weight and direction, creating form.

Pure abstraction

In abstract painting which makes no reference to the real world, it is the basic ingredients of colour composition and execution that, in effect, become the subject of the work. Some artists, like Piet Mondrian (1872-1944), arrived at a form of pure abstraction by working their way through figurative styles and processes of abstracting from nature. Others, particularly in the late twentieth century when so many more examples of abstract work have been produced, seen and commented upon, have moved very quickly into this way of thinking and working early in their careers.

It may be impossible to eliminate completely all references to the normal range of human visual experiences, and sometimes a viewer may feel that, for example, a landscape reference can be seen in a particular painting that purports to be wholly abstract. This is because we tend to see marks on canvas or paper as suggesting space and form, and when we are looking for references to real situations or objects, we may claim to identify what seem to us reasonable associations. However, this is unconnected with the artist's intentions; when working in a purely abstract mode, the artist is dealing with shapes and forms, colours and textures in terms of what they actually are, not what they represent.

COMPOSITIONAL ELEMENTS

As in any form of image-making, the abstract artist deals with basic elements of pictorial construction — line, mass, colour, tonality, surface texture and pattern, shape, contour, spatial depth and apparent volume. If the painted image is not to refer to anything known, the important question seems to be, where do you start? What prompts the artist first to put down a line rather than a block of colour? Why position the line in one place rather than another? What should be the next mark, and why? It is because such questions cannot usually be answered precisely, or by reference to something else, that many people find it difficult to become interested in abstract art. The logic of an abstract painting seems too personal and inaccessible.

The artist makes positive and negative responses in

Piet Mondrian (1872-1944)

Composition with Red, Yellow and Blue, 1937
In several compositions of the late 1930s, Mondrian's already severe grid constructions were presented even more austerely, with colour reduced to a minimal role. In this example, the grid is relatively heavy and complex, a strong contrast of black and white. The three primary colours that constituted the artist's total palette of pure hues are held in a discreet balance — two rectangles bounded by the black grid, two cutting through it which are so elongated as to act more or less as additional grid lines.

producing an abstract work. Its logic can lie in what the painting is supposed to do, and in what it should not do. Mondrian is a good example to study because his geometric grids and limited colour range are so apparently restrictive and severe. His intention was to create "dynamic equilibrium", a sense of movement and tension in an image that also had absolute balance.

Mondrian chose the right-angle as a pure and constant factor — it is a fixed and balanced relationship between two lines. When using this to construct squares and rectangles, however, he still had a great deal of scope to vary the proportions and interactions of these simple geometric shapes. In limiting his colour range to the three primaries and the neutral colours of red, yellow, blue, black, white and grey he had a palette which incorporated absolute qualities of hue and tone. As these were applied to the geometic grid, they further influenced the tensions and balances in the painting.

What these paintings are not supposed to do is to create an impression of three-dimensional space, or refer to external reality. In this sense, Mondrian challenges both himself and the viewer to discard received notions of pictorial space. We might tend to relate a grid structure to architectural frameworks. The use of black and white usually implies light and shadow, a means of modelling three-dimensional form. But Mondrian's paintings lie flat on the picture plane, and neither the colour nor the construction suggest any element of real space and form. This requires careful judgement of the proportions of the shapes and the extent of the colour areas, and their interactions. Painterly features are also eliminated — the colour is flat and opaque, the marks made by the brush are virtually invisible.

THE RANGE OF ABSTRACTION

Mondrian aimed at, and achieved, what he described as "an expression of pure reality", but as you can see from looking through any book on modern art, straight lines and limited colour are by no means the only ingredients of abstract art. It is interesting to compare Mondrian's work with that of the German-born

other artists to study

WASSILY KANDINSKY (1866-1944)

An influential figure in the development of abstract art, Kandinsky is credited with having produced the first completely abstract painting, a watercolour painted in 1912. He developed a free style of abstraction through series works under the titles *Composition, Improvisation* and *Impression.*

KASIMIR MALEVICH (1878-1935)

Like Kandinsky, Malevich was a pioneer of abstraction, but in the movement known as Suprematism he produced what were among the earliest hard-edged abstracts (predating Mondrian), using strictly geometric shapes and limited colour.

MARK ROTHKO (1903-70)

In large works consisting of rectangles, borders and stripes with heavily brushed, painterly textures, Rothko was a pioneer of the style of abstract work that came to be known as "colour field painting".

JACKSON POLLOCK (1912-56)

The leading figure of the New York School of Abstract Expressionism, Pollock developed the famous "drip painting" method of spattering and pouring the paint onto large canvases laid on the floor. It is sometimes assumed that this meant the work was allowed to evolve almost randomly, but the effects are, in fact, highly controlled and expertly manipulated.

MORRIS LOUIS (1912-62)

Louis developed the form of abstraction in which paint was laid as "stains" and "veils", pound onto unprimed canvases to produce loose runs and broad waterfalls of shimmering colour.

FRANK STELLA (b.1936)

Stella was a leading figure of hard-edged abstraction in the 1960s, with austere stripe paintings in closely controlled colours. He later moved into a more active, expressionist style of work, creating paintings that were actually three-dimensional reliefs covered with brilliant patterns and textures.

American painter Hans Hoffman (1880-1966), some of whose paintings also conform to a grid-like structure and contain very strong colours and tones. Yet Hoffman's work is vigorous, free and gestural, the colours and textures of the paint are rich and varied. A suggestion of three-dimensionality sometimes occurs when shapes overlap and colours seem to advance or recede but, as with Mondrian, the image exists on the surface of the canvas and is self-referential — the viewer is not led into an illusory pictorial space.

Looking at abstract painting in terms of simple definitions, there are distinctly different styles. In hard-edged abstraction, shapes are sharply defined although not necessarily geometric, and colour interactions are usually strictly controlled. Another style is gestural painting, which is visually busier and more complex

▼ Terry Frost
Sun Slip
Oil
Arcs and circles are recurring motifs in the artist's work, through which he investigates varying relationships of colour and tone. A restricted palette of very intense, saturated hues produces a dynamic, self-contained image.

◀ Terry Frost
Yellow Triptych
Oil on board
The formal device of using separate panels to construct a unified, single image has been frequently used for figurative work required to tell a story or encompass different aspects of one subject.

Here it is adapted to a purely abstract mode, exploring different configurations of similar visual elements.

the projects

PROJECT I
Geometric abstraction
Choose a single kind of geometric shape such as a square, circle, ellipse or triangle and use it as the basis of a brush drawing, repeating the shape in different sizes and positions, which you then fill with colours. Think carefully about whether you are trying to create a sense of space or keep the picture absolutely flat, and also about why you are choosing certain kinds of colours and what they contribute to the structure of the painting.

PROJECT 2
Gestural abstraction
Using oil or watercolour, start by making very free marks on your canvas or paper, initially using lines to create rhythm and direction, then adding broad areas of colour and texture to develop the image. As you progress, study the surface qualities and colour interactions that emerge and make deliberate decisions to enhance those that work successfully and to adjust those that do not.

with vigorous brushmarks, splashes, spots and dribbles activating the picture surface. There are also more decorative forms of abstraction, in which the picture surface appears heavily patterned. There are other categories, and works by individual artists who draw on all of these conventions and may use multi-media approaches.

You may find that it is easiest to develop an approach to pure abstraction by beginning with abstracting from nature. As you work through particular images, you will become gradually more interested in what is happening on your canvas or paper, and you may forget about the actual source. You can start to deal directly with colour interactions; relationships of line and mass; textural contrasts; or developing a composition that suggests space while also emphasizing the flatness of the picture surface. Try to pin down your intentions and ask yourself if the painting is really working in terms of what you tried to do. But beware — it is more tempting to let yourself get away with unsatisfactory solutions in abstract than in representational work, as you have no external points of reference by which to judge what the picture should look like.

You will realize that many of the preoccupations involved are the same as those you had to apply to figurative work, but at some point your subject becomes the painting itself and your own instinct, technical skill and experience will eventually enable you to carry it through.

▲ Judy Martin
Dual Shape
Gouache and acrylic
This is one of a long series of paintings originally derived from a landscape subject. The shapes of two trees were isolated and gradually developed into wholly abstract forms, using crossed brushstrokes as a way of eliminating naturalistic references while maintaining an active surface texture.

PART THREE

Media and methods

· ·

Just as Part Two will have helped you to develop a personal way of looking at the world, this part of the book looks at the different media and techniques you can use to interpret it. In addition to providing technical advice on the best-known painting media, it also explores more experimental approaches such as mixed-media work, collage and monoprint. Throughout, there are demonstrations of specific techniques as well as a selection of finished paintings, and each section concludes with an interview with an artist who is skilled in using the particular medium.

Painting with oils

Oil paint is a tremendously versatile medium, and can be used in any number of ways to suit all styles and subjects. Ultimately, each artist has to find his or her own way of working, but although there are really no hard and fast rules, there are some general guidelines and hints on specific techniques which those new to the medium may find helpful.

FROM THIN TO THICK

One of the commonest mistakes is to build up the paint too thickly at the outset, so that each new colour mixes with those below and becomes muddied and messy. Once you have become more confident you can make use of the way the paint mixes on the working surface by deliberately painting wet into wet, as the Impressionists did (see page 94), but this requires a light touch and a sure hand, so it is better initially to begin with a thin underpainting, blocking-in the main shapes with paint well diluted with turpentine (or white spirit). This will dry very quickly, and you can then move on to thicker and oilier paint, saving the thickest till last.

There is also a technical reason for working from thin to thick, or from "lean to fat", as it is known. If lean (thinned) paint is laid over paint with a high proportion of oil in it, what happens is that the lean layer dries first, and when the fat (oily) layer below begins to dry it shrinks a little causing the dry paint on top to crack.

FROM DARK TO LIGHT

Another good general rule is to work up from the dark tones and leave the lightest colours until last. This is particularly important for any painting you intend to complete in one session, when you will of necessity be working wet into wet, at least in some areas of the picture. Because oil paint is opaque unless thinned, it should be just as easy to lay dark colours over light as vice versa, but in fact it is not. Opacity is relative, and the light colours, formed by the addition of white, have more covering power than the dark ones. You will find this out for yourself if you try to apply dark brown or blue over a light, still-wet colour; the dark colour will

BRUSHWORK

1 ◄ Although oil paint can be used thinly, as in the previous demonstration, the buttery quality of undiluted paint allows you to use the marks of the brush in an expressive way.

2 ◄ Here the paint is used thickly, with no medium, and the sweeping strokes made with a well-loaded brush give a feeling of energy and movement to the landscape and sky.

3 ◄ The brush is now used to almost model the shapes of the clouds. As in the previous demonstration, the artist is painting wet into wet, though the thicker paint creates a very different effect.

mix with the one below and lose its character.

Whether you are working wet into wet or over a dry underpainting, it is usually advisable to reserve the thickest paint for the highlights, while the paint in dark areas such as backgrounds and shadows can often be left quite thin. This juxtaposition of different paint textures helps to describe form and spatial relationships, because the more solidly applied paint will tend to appear to come forward in the picture. In many of Rembrandt's paintings the backgrounds are so thinly painted that you can see the canvas through the paint, while the light areas are built up almost three-dimensionally.

BRUSHWORK

One of the most attractive features of oil paint is that it can be used in different thicknesses, allowing the texture of the paint and the marks of the brush (or knife, or fingers) to play an important role in the finished picture. When oil paint was first invented it was used thinly and smoothly (as it still is by some artists today), but it was not long before artists such as Titian (c. 1487-1576) and then Rembrandt began to exploit the physical characteristics of the paint and the marks made by the brush became an integral part of the composition.

Brushwork can be descriptive, if it follows the direction of a form; it can be expressive, as van Gogh's was (see page 106), or it can simply be used to create a pleasing and lively surface texture. Whatever form it takes, it needs to be given as much thought as any other aspect of a picture, and it must be consistent throughout. This does not mean that you have to use the same size and shape of brushstroke everywhere, but that the overall approach must be the same. If you were to paint one area of a picture perfectly flat and use bold, directional brushstrokes for another, you would sacrifice the unity of the painting — always aim at variety within unity.

IMPASTO

This is the term used for paint applied very thickly. Some artists reserve it for certain areas of a painting,

KNIFE PAINTING

1 ► Thick paint, known as impasto, can be applied either with a brush or a knife.

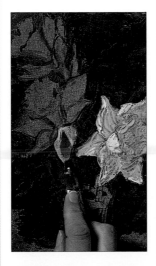

2 ◄ Painting knives, which are made in a variety of shapes and sizes, are capable of surprisingly delicate effects.

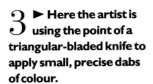

3 ► Here the artist is using the point of a triangular-bladed knife to apply small, precise dabs of colour.

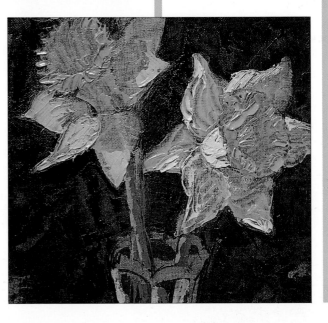

4 ◄ The effect produced by the knife has an edgy, lively quality quite unlike brushwork.

MEDIA AND METHODS

▲ Brian Bennett
Sowthistle and Grass
This strong but delicate painting has been done entirely with painting knives. Notice the relatively broad sweeps of paint in the background, contrasting with the sharp definition of the grass heads and stalks. Fine lines can be achieved by flicking on thick paint with the side or point of the implement.

WET INTO WET

1 ► Painting in this way involves laying colours over and into one another while still wet, producing softer effects than painting over a dried layer below. You can use paint straight from the tube, or diluted with a medium to make it more fluid, as here.

2 ► Working with a small, soft brush, the artist blends one colour into another. For thicker paint, a bristle brush would be more suitable.

3 ► The pale grey used for the highlights is modified by mixing slightly into the still-wet green paint below, producing gentle gradations of tone and colour.

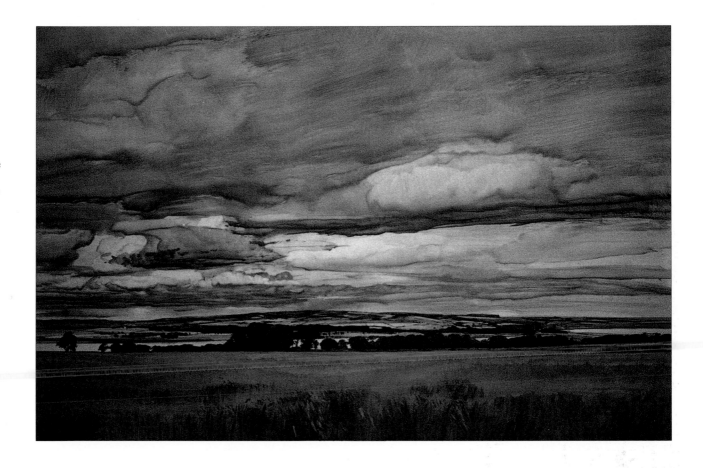

► James Morrison
Harvest
The paint has been used fairly thinly, but the brushwork is wonderfully descriptive, following the direction of the moving clouds. The painting also shows a highly effective use of a restricted palette to capture the atmosphere of the storm-threatened landscape.

such as highlights, as Rembrandt did, but others build whole paintings in almost sculptured paint, often using painting knives and their fingers instead of brushes. Van Gogh would sometimes squeeze paint onto canvas straight out of the tube and manipulate it with a brush into short strokes or swirling curves.

Using impasto is enormously satisfying, and worth trying even if you subsequently find it is not the technique for you. Paint is expensive when used in these quantities, but you can buy a special impasto medium, which thickens the paint without changing its colour. You can use brushes or painting knives, which are purpose made, with delicate, flexible handles. The marks painting knives make are different from brushmarks, because they press the paint onto the surface, leaving a series of flat planes with small ridges at the edge of each "stroke".

GLAZING

This technique is virtually the opposite of impasto. The paint is thinned so that it becomes transparent, and used almost like watercolour, in a series of thin layers sometimes laid over one another. You can use one of the mediums sold specially for glazing; ordinary painting mediums, such as turpentine or linseed oil, can be used and will certainly make the paint transparent, but the glaze will tend to run down the surface of the canvas instead of staying where you put it.

Glazing is a laborious technique. If you are laying one glaze over another each layer of paint must be allowed to dry before the next one is applied, but these transparent veils of colour create a rich and luminous effect that cannot be achieved with opaque paint. You can save some time by glazing with oils over an acrylic underpainting — remember that you can use oil paint

SGRAFFITO

1 ◄ **For this technique, which involves scraping into wet paint to reveal another colour below, the first colour must be thoroughly dry.**

2 ◄ **Any pointed implement can be used for scratching, depending on the effect you want. Here a small screwdriver produces little ridges in the thick paint.**

3 ◄ **The handle of a paintbrush, which does not score so deeply into the paint, is excellent for softer, broader marks.**

4 ◄ **The combination of smudged, sweeping brushstrokes of thin paint and sgraffito into thicker paint gives a lively and convincing impression of the lacy fabric.**

▲ Peter Clossick
Study in Blue
One of the ways of creating space in a painting is to vary the texture of the paint, using it thinner in the background. Clossick has brought the figure into prominence both by strong tonal contrasts and by the use of thick impasto for the face and hands, while for the background he has smeared and blurred the colours to create an "out of focus" impression.

over acrylic with no ill effects. Glazing can also be combined with thick paint, providing the latter is completely dry. Rembrandt's portraits and Turner's landscapes both show glazing over thick, pale impastos.

In the early years of oil painting, a technique called under-modelling was used in conjunction with glazes. This involved painting in white only on a mid-toned ground. Highlights were built up quite thickly, while in shadow areas the paint was left thin enough for the ground colour to show through. Thin, transparent glazes were then applied over this underpainting, the white paint reflecting back through the applied colour to create a wonderfully rich effect. The brilliant reds and blues of garments in early Renaissance paintings were achieved in this way; such effects are impossible to duplicate in opaque paint.

COLOURED GROUNDS

There is no reason why you should not paint on a white surface; both Turner and the Impressionists favoured white canvas because the light reflecting back through the paint gave a luminous quality to the work. However, a large area of white can be very intimidating, and also makes it difficult to assess the first colours you put down. There is a danger of painting in too high a "key" (i.e. in over-pale colours) because almost any colour looks very dark by contrast with white. For this reason, many artists like to pre-colour the canvas or board by laying a layer of thin

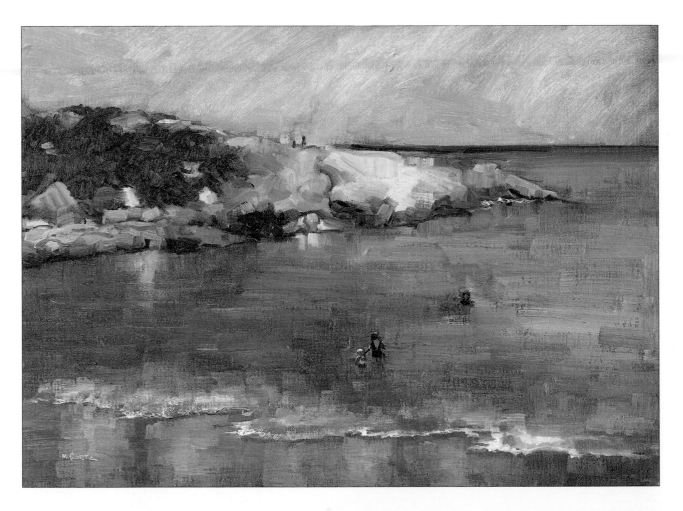

◀ Mary Anna Goetz
Rockport Beach
Here you can see how the warm golden-ochre colour of the ground has been exploited, with the patches allowed to show through the blues enhancing them by contrast. The varied brushwork creates a lively sense of movement as well as describing the forms of the rocks and flat planes of the sea.

▼ George Rowlett
Roses and Clematis
All Rowlett's paintings are worked very rapidly, in thick, juicy impasto, often applied with knives or fingers. By means of an expressionistic approach (see page 106), he conveys the essence of his subject, whether it is a landscape, a portrait or a group of garden flowers.

KNIFE PAINTING

At first, a painting knife may not seem as sensitive and versatile as a brush but it can produce exciting, expressive textural effects as well as brilliant, smooth, glassy areas of colour. By applying one wet colour over another with a knife, a variety of interesting colour effects can be created. These include the smooth blending of one colour into the other, streaks of the two colours combined, and broken colour similar in appearance to marbling.

The main difficulty in using oil paint with a knife is that drawing precise shapes and painting detail is difficult. Although drawing with the edge of the knife is possible, a painting knife tends only to produce little dabs of colour or patches which have one straight side.

You could use a painting knife for any subject but, for your first project, it is worth choosing one which you have already painted, perhaps one where the painting was not as successful as you had hoped. Start by drawing the main shapes of your subject on the painting surface, using either charcoal or a brush and thin paint and then block in the main area of the painting. Mix the colours on your palette and apply them with a painting knife as if you were spreading butter. Don't thin the paint. Use it straight from the tube. At this stage, use your largest painting knife and reserve the smaller ones for later on.

Experiment with spreading, scraping and freely "trowelling" the paint to discover the possible range of textures. Use both the flat of the knife blade and the edge, which you will find can produce quite sharp lines. You should try mixing colours both on your palette and on the picture surface. Try also making partial mixes which, if applied with a sweep of the knife, should produce some exquisitely subtle colour effects. Don't forget that one of the features of knife painting is a smooth glossy paint surface and incorporate some areas of smooth paint in your picture as well. After mixing and applying each colour, wipe your palette and painting knives clean with a rag or kitchen paper.

Once the whole picture surface is covered, assess the overall effect and decide whether you need to introduce more detail or a greater variety of marks. Your painting should look lively and exciting but you will be lucky to achieve this at the first attempt. If your painting isn't completely successful the experience of working in this way will still have been valuable.

You don't necessarily have to apply the paint to a whole painting using a single technique. The French painter Maurice de Vlaminck (1876-1958), for example, painted areas of his pictures in a conventional way using brushes, but often used a knife to create dramatic skies and exciting foregrounds.

◀ Philip Wildman
Still Life with Mandolin
This, like Brian Bennett's painting on page 151, was painted with knives, but in this case the working surface was paper rather than canvas, which absorbs the oil and gives a more matt finish. Paper is a surprisingly sympathetic surface for oil paint, but it should be primed first (see page 16), as otherwise the seepage of oil could eventually cause it to rot.

◀ Susan Wilson
Poppies
A riot of glowing colours combine with bold brushwork and an unusual composition to give a powerful feeling of life and energy to this still life. The artist's delight in her medium is very evident.

paint (known as an *imprimatura*) all over it — you can use acrylic for this if you want it to dry quickly.

The choice of colour is important, as it acts as a background for the applied colours to play against. Neutrals and mid-tones are easiest to work on, the most used being subdued browns, ochres or greys. Some artists like to use a colour that contrasts with the subject — for example, a warm red-brown to show up green foliage — and deliberately leave small areas of the ground colour uncovered as pastel painters do (see page 66). Rubens (1577-1640) always painted his figure compositions on a yellow-brown ground, leaving this colour to stand as the mid-tone.

❝ I use blurry newspaper pictures quite a bit to give me ideas for compositions — the last thing I want is a perfect photograph. I take black and white photographs from the television too. The hazier they are the better — too much detail interferes with my imagination. **❞**

Naomi Alexander

Naomi Alexander attended Hornsey College of Art in London, where she studied textile design and lithography. She worked as a textile designer and later a picture restorer before embarking on her career as a professional artist. She is now a member of the Royal Institute of Oil Painters (ROI) and of the Society of Graphic Fine Arts (SGFA), has held several one-person shows and exhibits regularly at annual mixed shows including the Royal Academy. She has won several important awards, and examples of her work are in various private collections and commercial institutions.

▲ Alexander often uses black and white photographs as a starting point for compositions, and these two have become paintings. The top example was photographed from a video of a television drama series, and the other is a newspaper cutting.

Q **Have you always wanted to be a painter?**

A Yes, since the age of three. My mother was a great encouragement, so I never really had any other thought.

Q **She's a sculptor, isn't she?**

A Yes, she is now, but not then. She only began when she was sixty, and now she has work in several museums.

Q **Did you have any special training when you were young?**

A Yes, I started at fourteen under a private teacher, learning to paint in oils. Then I passed the Slade entrance exam when I was sixteen, but failed to get in — I was very intimidated by the interview, with all these men firing questions at me about art history. All I really knew was that I admired van Gogh. So I went to Hornsey Art School instead, and specialized in lithography and textile design.

Q **Why did you make that choice?**

A Well, I had to make a living, and I didn't feel I could rely on fine art for that. After art school I went to Israel and worked for Maskik and Bathsheva Arts and Crafts, the equivalent of Liberty's in England.

Q **When did you become a picture restorer?**

A After I'd come back to London and married. A dealer friend told me about an opening as an apprentice. I didn't actually have much

interest in restoring other people's paintings, but I thought I could learn from it.

Q And were you right?

A Absolutely, and I loved it. It taught me the basis of real painting — all the things you don't learn at art school. Often I had to paint a lot back — two-thirds of a picture might be missing and I had to put it in in the style of the artist. And cleaning is very exciting too, when you see the picture beginning to emerge. Art school taught me drawing, but restoration was my education in painting, learning about glazes, building up colour, and even making my own paints. I don't do that now, but I do know which paints to use.

Q Were you paid for your work?

A No, for five years I worked for nothing, going up to central London every day, and often bringing paintings home to work on. I used to carry Breughels in the Underground in a Sainsbury's carrier bag! One day a top dealer came in and I heard him praising my work — for which I was never given any recognition — so I decided the time had come to set up on my own.

Q When did you start to paint for yourself?

A Abram Games, the poster artist, who was a friend, encouraged me a lot, and told me to stop wasting my time

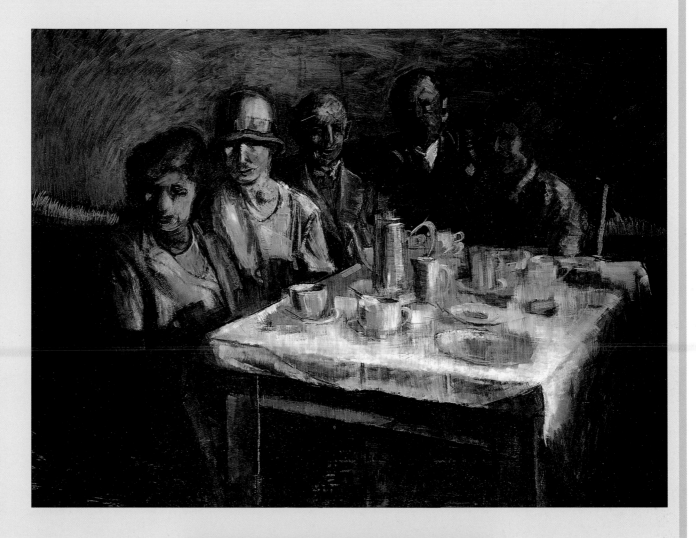

▲ **Tea Party at Riga Before the War**
A free translation of a photograph of the artist's family taken shortly before they fled from war-torn Poland.

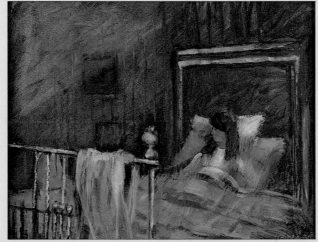

◄ **The Brass Bed**
The gentle domestic interiors of Edouard Vuillard have been an important influence on Alexander's work.

painting other people's pictures. I had an exhibition at the Ben Uri Gallery, and that was the real turning point — it almost sold out. I was forty-one! And in a terrible dilemma, because I still loved restoration work, and it's hard to do that and painting at the same time unless you have two studios. But when I began to get commissions and to exhibit at the Royal Academy, I realized I actually could paint, so restoration went by the board. I still do the occasional one, though, because I

▼ **Wimbledon Tea Party No. 2**
The brilliant colours are built up in thin, overlaid layers and transparent glazes.

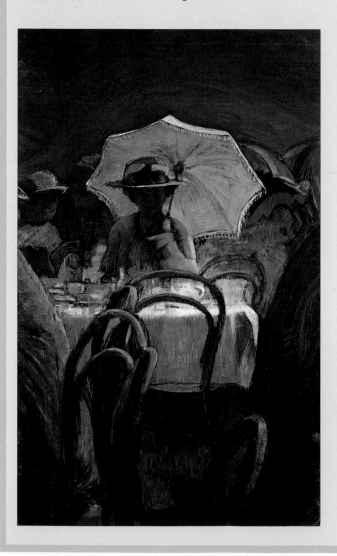

simply can't turn things down.

Q You do copying as well I believe?

A Yes, that started when I became one of the Mall Gallery's artists. They phoned me to ask whether I could do copies and I said "of course". I'd never done a copy in my life, but I couldn't turn that down either. My first commercial copy was for an American who had bought Queen Adelaide's bed and wanted the queen herself to hang above it — all bright and

▲ **Misery**
The black background and simple colour schemes of muted complementaries contribute to the feeling of despair and abandon.

new, with my own signature on it. I've also had commissions for portraits in the style of another artist.

Q What kind of people do these commissions come from?

A I did a painting in the style of Sargent for a member of the Royal Fusiliers, whose mother had died. He bought me a book of Sargent's paintings, and lent me her jewellery and one of her favourite dresses, and told me what colours she liked to wear and so on. The main problem was that she wasn't actually the elegant Sargent type, so it was quite a challenge, but I enjoyed doing it. If you have an affinity with the artist it's interesting working in this way, but direct copies are very tedious.

Q To come back to your own work, can you tell me something about your technique?

A I like thin glazes, so I always work on a very smooth surface — glazes tend to get interrupted by a canvas grain. I paint on hardboard panels for preference, primed with ordinary emulsion, but recently I've had to work on canvas — I'm afraid the public think they're buying something special if a picture is on canvas — galleries tell me they can't sell these things on "bits of hardboard". The canvases do have to be gesso-primed, with many coats, to make a smooth surface, and it all takes twice as long as preparing a piece of

hardboard. I could work on wood — oak — panels, and have done sometimes, but pieces of oak are rather narrow, so the pictures have to be quite small.

Q What medium do you use for glazing?

A I use a lot of Wingel — I'm addicted to it. It makes the paint transparent but quite gooey, and it dries very fast, so I can build up a painting very quickly with it. It worries me though, that it does tend to discolour, so now I'm trying poppy oil and walnut oil.

Q Apart from the artists whose work you restored, who influenced your technique, are there others you look to for inspiration?

A My most direct inspirations are Vuillard, Bonnard and Sickert. Sometimes I will work from one of

my own sketches, but sometimes with a book of one of these artist's work next to me, asking myself which colours he would use, and what kind of underpainting. Once I've started the painting I put the book away — it's just a way of getting inspiration.

Q Do you ever use photographic reference for your work?

A Oh yes, I'm very reliant on photographs. I use blurry newspaper pictures or old family snapshots quite a bit to give me ideas for subjects and compositions — the last thing I want is a perfect photograph. For instance *Tea Party in Riga Before the War*

▼ The Monastery of Mar Saba, Israel
Several versions of this were painted from sketches made during a trip to Israel.

was based on a family snapshot. In fact it was very sharp and clear, so I had a copy made which deliberately blurred the image. I take photographs from the television too.

Q How does that work?

A Some television plays are so beautifully photographed, so I video them, stop the tape in the place I want and take black and white photographs. You tend to get a stripe across it, and quite a hazy image, but the hazier it is the better — too much detail interferes with my imagination.

Q So you will use this general idea as a basis for a painting, but inventing your own colours?

A Yes, that's right. I never use colour photographs — I don't want to be influenced by the original colours, and besides, I see pictures as tones. When I'm planning a picture and painting from life I use a dark shield, similar to sunglasses, that takes out all the colours so that you can work out the tones. I also have a square reducing glass (difficult to obtain now) rather like a

wide-angled lens on a camera, which often gives interesting effects, and I use distorted photography too. Another device I'd find it hard to do without is the Elitoscope.

Q Is that some kind of projector?

A Yes, it is — it throws a reduced image onto the canvas by means of mirrors. So if I'm working from a sketch I make a reduced photostat to fit onto the mirror and project it. I used to square everything up, but it takes ages. This way I can experiment with many different images, moving them around the canvas to position them. It's helpful for changing a composition. For example, I can cut out a figure from a photograph or drawing and add it onto the painting simply by projection.

Q You use sketches and photographs for your paintings. How much sketching do you do?

A A great deal — I'm a compulsive sketcher, especially when I'm in a new environment — then I feel guilty if I'm sitting doing nothing. A painting is basically a drawing, so one must

always draw, even though very few sketches will be used for paintings. I don't do it because I want to — I just have to, and it's the same with painting. The only time I really enjoy it is when I feel I have to make an immediate painting from life. I often hate the idea of starting work, and am quite intimidated by the blank canvas until I get started. I usually work on a dark ground, which produces quicker results.

Q Do you paint every day?

A Not every day, no, I have many commitments to the art world as well as to my family, and I have to adjust my painting schedule accordingly. I have a clear monthly schedule though — I set myself a target, and probably will work six or seven hours a day one month and then perhaps not at all for a week or two. If I have to work to a deadline I can be pretty determined, but I'm afraid I'm stuck being a woman. When we were first married my husband said he visualized me with a paintbrush in one hand and a soup ladle in the other — and that's it — I'll never be able to put down the ladle.

Painting with acrylics

If you have used acrylics for some of the projects in Part One you may already have discovered some of the charms of the medium. Oddly enough, although more and more artists are working in acrylic, the paints have had rather a bad press in the amateur art world. Perhaps it is because they are a relative newcomer in the field of artist's materials — they have been with us for only about fifty years, while oil paints have been used since the fifteenth century. There is a tendency to regard them as synthetic, plastic paints, but in fact, acrylics are one of the great gifts from science to art, and we should be suitably grateful for them. They are, without doubt, the most versatile of all the artist's media.

THE NEW PAINT

Acrylics were invented in the 1930s for use in external mural paintings, but they first hit the art world in America in the 1950s, and the quality most admired was the rapidity of drying. This enabled Abstract Expressionist painters such as Jackson Pollock to build up heavy impastos, often using the colour straight from the tube or even pouring it on from a bucket, knowing that the paint would be dry in a fraction of the time of oil paint used in a similar way.

Other artists were quick to recognize a further advantage: acrylic can be used on unprimed canvas, while those working in oil have first to prime their working surface to prevent the oil from being absorbed into the canvas and rotting the fibres. One artist in particular, Morris Louis, exploited this in his large abstract paintings, laying transparent washes over the bare canvas, and following this with a succession of further washes laid one over the other in overlapping shapes.

The methods and painting styles of these first exponents of the new medium were many and varied, as are those of artists working in acrylics today. To some extent this very variety constitutes a problem for those who are just beginning — when you have a paint that will do virtually anything, what is it that you will ask it to do? And which artists should you look to as your role models? Those working in oils, watercolours or pastels will usually have a few favourite painters whose techniques and styles they particularly admire, but since acrylic can so successfully imitate other media it is much harder to identify — in fact, you can't always be certain that a picture has been painted in acrylic.

The only course is to try out the paints and the various different painting mediums and find your own way of working. If you have a natural leaning towards watercolour, try using acrylics thinly on paper, but if you have found that you enjoy laying on thick slabs of oil paint with a knife, do the same with acrylics. Even if you start by making the paint imitate another medium, you will quickly discover how to exploit its own characteristics.

WORKING THICK

Acrylic straight out of the tube has the consistency of double cream, and you can apply it just as it is, without using water or a painting medium. If you are familiar with the "lean to fat" method of building up an oil painting you may like initially to stick to this. But there is no need to — you can apply the paint thickly from the start if you prefer. Remember, however, that once the paint has dried you cannot remove it, so if you want to overpaint a mistake you may achieve a heavier build-up of paint than you want.

If you like to build up really thick impastos, using either bristle brushes or painting knives, the method is the same as for oils (see pages 151-3), but you will need a different medium to thicken the paint. There are several sold for acrylic work, and these are described on page 165. One, a kind of special putty, called modelling paste, is shown in the illustration (right and far right).

TEXTURE

The real purpose of modelling paste is to build up areas of semi-sculptural texture, something you can really only do successfully with acrylics. The paste can be applied directly on the working surface with a brush or knife to build a kind of relief-sculpture effect, which you then paint over (the surface must be rigid or the paste may crack as it dries). You can also use a method

164 ▷

▼ A variety of substances can be mixed with acrylic paint to give it extra thickness and texture. Modelling paste, shown in the first picture, bulks it out to a very solid consistency. Sand (middle), sawdust or wood shavings (bottom) could be useful if you want to contrast areas of texture with smoother paint.

TEXTURED GROUNDS
▲ Modelling paste, shown opposite mixed with paint, is more often used to lay a textured ground, applied to a rigid support with a palette knife or painting knife. You can paint over this surface either with thin glazes or thick, solid colours.

▼ The paint is affected in different ways according to how you lay the textured ground. A very rough texture creates the broken-colour effect you can see on the left, while the gentler texture on the right causes a slight mottling of the paint.

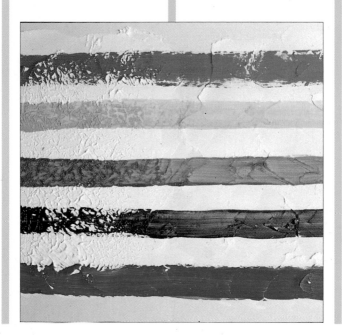

GLAZING
1 ▼ The principle of glazing is the same for acrylic as for oils, but it is easier and less laborious in acrylic because of the faster drying time. You can glaze over thick paint or build up a whole painting in thin layers, as here.

2 ▼ The artist is working on board coated with acrylic gesso, and the paint is thinned with acrylic medium, which also makes it more transparent.

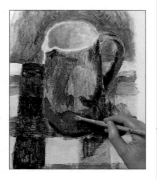

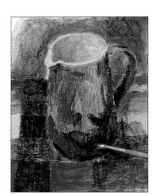

3 ▲ Plain water can be used for glazing, but it can make the paint sloppy and unmanageable, as well as giving a rather dull, dead surface.

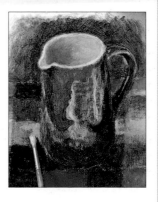

4 ▲ Notice the way the earlier colours show through the new ones, giving a deep, rich glow.

5 ▼ Because the paint has been used very thinly, the slight ridges of the brushstrokes used for the gesso ground are still visible, creating additional surface interest.

MEDIA AND METHODS

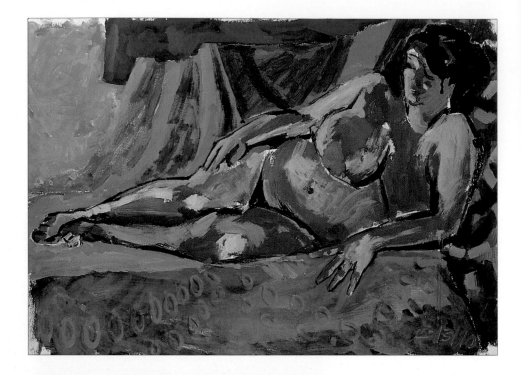

▲ David Cuthbert
Melanie
Acrylic is an excellent medium for the kind of bold, vivid colour effects seen in this painting. Because it dries so fast, there is no danger of new applications of paint mixing with earlier layers and muddying the colour.

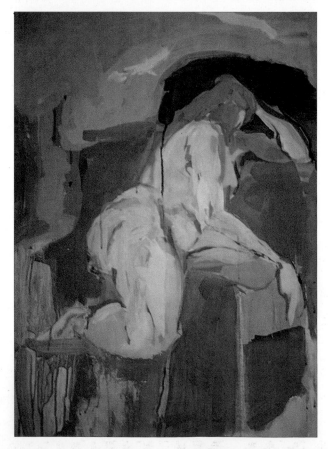

◄ Ingunn Harkett
Reclining Figure
Here the paint has been thinned with water to a gouache-like consistency, and the artist has encouraged the colours to flow and dribble down the surface, emphasizing the vertical thrust of the composition.

called imprinting, in which you press objects into a thick layer of the paste to leave an indented pattern. Texture paste is frequently used for collage work; it has strong adhesive qualities which allow you to stick even quite heavy objects such as pieces of wood or metal onto the surface of a picture.

WORKING THIN

Using acrylics in the same manner as watercolours is similar, but not quite the same, as using watercolours themselves. You can lay transparent washes in exactly the same way, diluting the colours with water and

166 ▷

acrylic mediums

◄ Pat Berger
Cactiscape
The versatility of acrylic is clearly demonstrated by the contrast of styles on these pages. It is as well suited to the kind of minutely detailed photo-realism seen in this painting as to rich impastos and broad sweeps of expressive colour.

When used on their own, acrylic paints have a rather dead, matt surface which some people find unattractive. You can make them look more like oils by mixing the paints with one of the specific mediums listed here. Each of these will slightly change the character of the paint in different ways, so it is worth experimenting with them until you decide which one best meets your requirements.

Gloss medium An all-purpose mixing medium, which increases transparency and gloss and improves the flow of the paint. It can also be used as a final varnish.

Matt medium This is an alternative to the gloss medium for those who prefer an eggshell finish. It increases transparency when added to colours, and can be used for matt glazes. Not recommended as a final varnish, as it can cause clouding over dark colours.

Gel medium When mixed with colours, it increases their transparency and brilliance but does not alter the consistency.

Heavy gel medium Thickens paint while increasing transparency and colour brilliance, giving more of the appearance of oil paint. Useful for impasto work, as it holds the marks of the brush and knife well. It will also keep paints workable for a longer period.

Opaque gel medium An economical way to increase paint volume for impasto work. It bulks out the paint without affecting the colour, and like heavy gel medium holds the marks of the brush or knife well.

Retarder When mixed with paint, this slows the drying time. Do not use more than 20 per cent of retarder to colour, or paint skins may form.

Modelling paste Used to build heavy textures and three-dimensional effects on a rigid surface. If mixed with a 50 per cent gel medium, the paste can also be used on canvas or other flexible surfaces. Acrylic colours can either be mixed into the paste, or it can be painted over with either acrylics or oils.

► Nick Swingler
Tropical Tones
Here the brilliance of the colour derives in part from the way paint has been scumbled and scrubbed over earlier layers. You can see this broken-colour effect particularly clearly in the dark area of foliage on the left, where flecks of brilliant blue show through the near-black.

applying them with soft sable or synthetic brushes onto watercolour paper. But with watercolour there is a limit to how many washes can be laid one over another before the colours begin to mix together and become muddy. With acrylics there is no such limit, because the paint cannot be moved when dry. Each layer of colour remains separate, allowing you to create complex and intricate effects without loss of colour brilliance. You will achieve particularly clear and sparkling effects if you try to restrict yourself to mixtures of the most transparent colours, such as ultramarine, phthalocyanine blue and crimson, which are more transparent than other colours, a disadvantage when you are working thick, as they have less covering power.

If you are not aiming specifically at watercolour effects, or the contrast between transparent and opaque colours, you can use the paint very much as gouache is used, starting with thin washes and gradually moving towards more opaque paint. For this kind of work, you may like to try mixing the colours, particularly the opaque ones, with a little gloss or matt medium, which will intensify colour and increase its transparency. The pale, white-based colours can look rather dead and dull if mixed with water alone. Experiment as much as you can, and don't feel bound to paint on watercolour paper alone — acrylics can be used on any surface, unless it is oily or shiny. Try out a smoother one, such as mounting board or a rougher one such as canvas.

GLAZING

The principle of glazing is the same as for oil painting (see page 153), but acrylic is even better suited to the technique since you don't have to wait long for each layer to dry. Since a glaze is transparent, the effects are most noticeable when a dark colour is laid over a lighter one, though you can subtly modify a colour by glazing light over dark. You can use water or acrylic (gloss or matt) medium to thin the paint, but medium will produce richer colours and a livelier finish. As in oils, thin glazes can either be built up in layers or applied over an impasto paint surface, where the transparent layer of colour adds a touch of delicacy.

◄ Ian Simpson
Mumbles
Because its speed of drying enables you to make changes as you work, acrylic is an excellent medium for outdoor work. Simpson likes to work on paper because this allows him to extend the composition if necessary by joining on another sheet. In this case he was working fast with no preliminary drawing, and increased the height of the painting twice because he decided to make more of the foreground.

A TOWNSCAPE
Acrylics can "imitate" other media, but they have their own qualities, too, and this project aims to encourage you to discover these qualities. Because they dry so quickly they are particularly useful for working outdoors, and so the subject for this project is a townscape. If working in a public place worries you, you could paint a view from a window.

For this project, use the paints in their fairly thick, opaque form. You can paint on ordinary cartridge paper but board may be better, since you will be less likely to use the paint thin. If you already have some acrylic mediums, you may want to try them out in this project, but you don't need to. The project can be completed using only tapwater to dilute the paint slightly. To make a start, draw the main shapes of the subject in thin paint and block them in in simple areas of colour. Try to make the paint thick and opaque as soon as possible, and make the textures of the buildings a feature of your painting. Look for stained walls and rough surfaces. There may also be a glass roof, for example, and a variety of other surface textures provided by slate, tiles, stones and bricks. Experiment with ways of translating these textures. Remember that once a colour has dried it is permanent and if you paint over it you can scrape through the top colour while it is wet revealing the previous colour underneath. Some effective textures can be made in this way by using a painting knife or simply the wooden end of your paintbrush. The top layer of paint can also be partially removed with kitchen paper or a dry brush.

Look also for features of your subject which will allow you to try glazing and painting wet into wet. For the latter technique you may find retarding medium useful, as otherwise you have to work quickly before the paint dries.

◄ Neil Watson
The Capitol, Raveish
Watson works both in watercolour and acrylic, and here has used the paint fairly thinly, but has worked on canvas rather than paper. Bold, sweeping brushstrokes in sky and foreground contrast with delicate, linear details on the building.

> **"** I try to convey a quiet tension which will hopefully creep up on the spectator and tap him or her on the shoulder. I'm interested in how ordinary objects can be made mysterious by the way the painter interprets them…All painting is about illusion — it's really a kind of magic. **"**

John Sprakes

John Sprakes attended Edinburgh College of Art, to which he won a scholarship, in the late 1950s, and held his first solo exhibition in 1968. Since then he has exhibited regularly, and has won several important awards. His work is represented in both public and private collections in Britain and America. He was elected a member of the Royal Institute of Oil Painters (ROI) in 1987, and of the Royal Society of British Artists (RBA) in 1990. He lives in Nottinghamshire and paints full time.

▲ **The Month of June**
In spite of the realistic portrayal of the objects, the painting can be appreciated on one level as an abstract. The cat, with its detached gaze, presides over a skilfully orchestrated interplay of shapes and colours.

Q **When did you start working in acrylics?**

A My early work was mainly in oils, but I began to experiment with acrylics during the '60s when they first became widely available, and I found they suited my way of working. They dry fast, which I like, because you can layer colours without them mixing on the surface, the colours are strong, and the paints are enormously versatile.

Q I notice that you are a member of the Royal Society of Oil Painters. Does this

mean you still do paint in oils as well?

A Not very often now. The ROI does accept acrylics — if they're on canvas or board they count as oil paintings. But although most of my work is in acrylic I do sometimes work in tempera, which has similar properties to acrylics in the way they are handled.

Q What can you tell me about your technique?

A I start with the paint as thin as possible, so that I can make alterations later, and I like to block in the main areas quickly, so I use hard, wide brushes and sponges. I feel it's important not to be too specific in the early stages, so I concentrate on broad statements of colour and tone, working across the whole picture at the same time. Then I begin to alter things, which I do constantly, reconsidering and repainting. I use thin layers of pigment, sometimes allowing an underlayer to show through, which gives a luminosity you can't achieve with thick paint, and I tend to use broken colour, particularly where there are large, passive areas. The

quality of the surface is an important part of a painting, and I sometimes make my own paints by mixing pure powdered pigment with acrylic medium.

There's something I would like to say about technique in general, though. The physical act of painting plays a vital role in the construction of a picture, but technique is only a means to an end — assisting the artist to realize his or her ideas. You have to avoid becoming a slave to technique.

Q Do you paint on canvas or board?

A I use a variety of fine surfaces, but I like them fairly smooth, so I mainly paint on fine weave canvas or hardboard, with an acrylic gesso ground. Also I like unprimed card — acid-free mounting board. This is where you get a particularly close parallel with tempera painting — it's a very absorbent surface, and the paint sinks into it, giving a matt effect I very much like. You don't achieve quite the

same transparency and luminosity as you do with tempera done on a gesso ground, but it does produce a rather nice flat, soft, delicate feeling.

Q What would you say are your primary concerns as a painter?

A I'm interested in space and the forms that inhabit space. I try to construct my paintings using both considered pictorial compositions and

incidental situations with figures, objects and environments. Some of my paintings are autobiographical; they say something about my life and the people around me and the objects I use — sometimes things I have collected, things with personal associations. I use these in juxtaposition — I like the different use of objects where one is diametrically opposed to another in character, colour, texture and presence.

Q There seems to be a slight Surrealist flavour to some of your pictures. Would you agree?

A Yes, I think so. I try to convey a quiet tension which hopefully will creep up on the spectator and tap him or her on the shoulder. I'm interested in how ordinary objects can be made mysterious by the way the painter interprets them. All painting is about illusion — it's really a kind of magic. A three-

▶ **Room C30**
This still life was set up in a classroom, where the letters and symbols on the blackboard suggested the composition.

◀ **Evening at 126**
The slight feeling of unease derives from the stance of the figure. She seems not so much a welcoming hostess as a protective guardian of her bottles and glasses.

around and so on. This gives me enough information to develop passages of light, form and reflected colour when I begin the painting, which I only do when I've made a series of drawings to explore the pictorial possibilities. I would never go straight into a painting without doing a good deal of this preparatory work. Then I look at the drawings and decide on the composition I find the most powerful and exciting, and then go on to the painting, still with the model there.

Q From what you have just said, I assume that you never use photographic reference?

A No, I've never worked from a photograph in my life. It's not that I think it's wrong — I've seen artists who use photographs very successfully and produce beautiful work — it's just that it doesn't suit me. I find that if you are painting a group of objects, say

dimensional illusion on a two-dimensional surface.

Q You seem to paint mainly figures or objects in interiors. Do you ever go out into the countryside and paint landscapes?

A Yes I do. I enjoy painting

landscapes very much, and I'm particularly fascinated by gardens. As I've said, I'm very much concerned with space, and a large, enclosed garden is like a room outside — the space is confined. Landscape itself can be very grandiose and intimidating. I have, of course, painted hills and moors and valleys

and skies and so on, but I prefer nature in microcosm. In an interior I like the light that filters in through windows and doors, and you see the same sort of effect in a garden or orchard, with light coming through trees onto an enclosed space.

Q How do you set about one of your figure paintings? Do you work from a model?

A Yes, sometimes I'll have a model posing for up to a week. For me, it's very important to work from life, to observe the subject as fully as possible, moving it

some apples on a table, you could paint them thirty or forty times and the act of discovery increases through the constant "looking with intent". It's almost like a surgeon's knife — as an artist you are dissecting, analysing, looking at the forms and taking them apart in your mind's eye. You can't do any of this with a photograph — it's already a two-dimensional illusion — you can't walk round it or go up close and examine it.

Q Your emphasis on repeated drawing reminds me of Degas. Is he an artist you particularly admire?

A Yes, I find both Degas and Lautrec inspirational. Mainly for the way they both use drawing as an act of discovery, an investigation into the seen world. But there are a lot of painters I admire — you could fill a book with them. I studied at Edinburgh College of Art in the late 1950s, when William Gillies was Head of Painting, and Scottish painting in general, with its wonderful vibrant colour and light, has had a tremendous influence on me.

But I would never name one artist in particular as my "favourite painter" — I just think there are many marvellous paintings from all periods of history. Good painting is good painting, whether it's a religious painting or a 20th century abstract. In fact I sometimes get a bit irritated with inflexible attitudes towards different approaches in painting — some people make this distinction between abstract and figurative — observed — painting, but it doesn't matter what kind of painting is practised provided it is sincere, well perceived, and honestly and thoughtfully produced. I admire paintings that have the power to invoke in the spectator new ways of seeing.

Q Do you work straight through on one painting, or have several on the go at once?

A Several, usually, because I try to work very hard at being a professional painter. I work seven days a week, from about 10.30 a.m. to 6.00 p.m. and then sometimes in the evening too. Typically, I'd have three on the go — this might be a figure painting and a

still life or interior in natural light and something else in artificial light — or in summer I might paint out of doors in the evening.

Q What sort of artificial light do you use?

A Just ordinary tungsten. Of course you have to restrict that painting to artificial light; you can't start working on it in daylight as well. Sometimes when you look at it in daylight the colours look — not wrong so much as different. It's the yellows that are affected most — they do tend to alter, but I

think you've got to be adaptable if you're a painter, and try to get the best out of your working situation. Sitting around doing nothing would bore me to death.

Q Several of the artists I have talked to have said that they paint because they have to — they don't actually enjoy it. What do you feel about this?

A Well of course, it is something you have to do — a kind of compulsion — and it is hard work. It demands long hours; it's a solitary activity, and often it is stressful and full of disappoint-

▲ **August Incident**
The precisely controlled, hard-edged shapes and strong contrasts of tone give this painting much of its power, while its serenity derives from the limited colour range, consisting almost entirely of warm and cool blues.

ments — one's expectations of a piece of work and the realization of it don't always match. There tend to be more lows than high points, but there are those times when things do work a bit and begin to come together — they can be wonderful moments, and that really makes up for it all.

Painting with watercolour and gouache

Part One of the book provided a brief general introduction to water-based media, the generic term for watercolour and gouache, but although this may have whetted your appetite it certainly will not have told you all there is to know. There are countless different ways of working, and there are also many special techniques you can use to make the painting process easier and to create particular effects. In these pages we will look at some of the more interesting and useful of these.

As has already been said, there is essentially little difference between watercolour and gouache, indeed it was only relatively recently that the two became established as separate media. Gouache, or opaque watercolour, has the older history, being a direct descendant of the tempera paint used since the time of Ancient Egypt, while the special characteristics of transparent watercolours only began to be exploited fully in the eighteenth century. The techniques described here, with one or two exceptions, are suitable for both media.

MASKING AND SCRAPING BACK

As anyone who uses transparent watercolour will discover, the traditional technique of reserving highlights by carefully leaving bare areas of paper works best when the shapes left unpainted are large and uncomplicated. Small, intricately shaped highlights, such as ripples catching the light on an expanse of water, are a very different matter, and you may become so obsessed with painting carefully around them that your painting will become tight and fussy. There is now a way to overcome this problem, which is to use masking fluid to "stop out" the areas to be left white. Masking fluid is a kind of liquid rubber sold in small bottles and applied with a brush; you simply paint it on, and leave it to dry. When you lay a wash on top, the masking fluid acts as a resist, and once your wash is dry you can remove the fluid by rubbing gently with your finger or an eraser.

Purists tend to regard such methods as "mechanical", perhaps even "immoral", but using masking fluid is not just a way to overcome a problem;

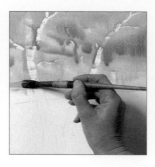

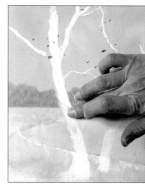

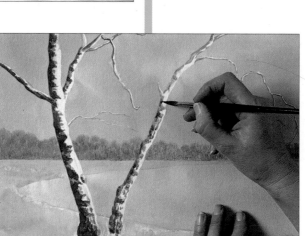

MASKING FLUID

1 ◄ Masking fluid is painted onto the tree and allowed to dry before washes are laid for the sky. This allows the artist to paint freely without worrying about spoiling the highlight areas.

2 ◄ Once the background is complete, the rubbery fluid is rubbed off with a finger. A medium (Not surface) paper is best for this method; the fluid is sometimes impossible to remove from rough paper.

3 ▲ Further work is now done on the tree, which was a formless white shape when the fluid was removed.

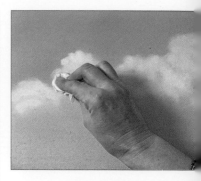

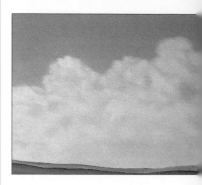

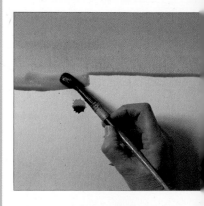

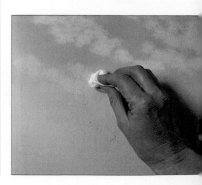

LIFTING OUT

1 ◀ **With the blue wash still wet, areas are lifted out with a piece of crumpled tissue to give a deliberately uneven effect.**

2 ◀ **Less pressure was used towards the bottom of the sky; clouds are always smaller and less distinct above the horizon.**

1 ◀ **In this case two washes have been laid, and the blue is to be lifted out to reveal the dried pink wash below.**

2 ◀ **Again, a small piece of tissue is used to dab into the paint. For broader effects you might try using a sponge, rag or large piece of cotton wool.**

it is a technique in its own right, which enables you to create exciting effects. When you apply masking fluid, what you are doing, in effect, is painting in negative.

You can't make very fine lines with masking fluid, as it is too thick, so for really tiny highlights, such as the light shining on the edges of blades of grass in the foreground of a landscape or flecks of seaspray thrown up by the wind, the best method is to scrape into the paint with a sharp point — a scalpel or craft knife blade is ideal. Most watercolour papers are tough enough to withstand this treatment, but don't try it on very thin paper as you may tear it.

There is less of a problem when using gouache to create highlights. They can be added in opaque paint, but the above techniques are still relevant in certain cases. You can't make such fine lines with a brush as you can with a blade, nor can you achieve such clear whites. It is a curious fact that paint can never quite match the brilliance of white paper, so for really sparkling highlights it is often better to use methods which reserve the surface of the paper.

LIFTING OUT

Soft-edged highlights cannot be achieved by any of the methods described above. They can, however, be created very easily by lifting out, which simply means removing areas of paint with a small sponge, blotting paper, cotton wool or a rag. Lifting out is the perfect technique for clouds; you can suggest wind clouds in a blue sky simply by laying a wash and then sweeping a sponge lightly across it while the paint is still wet. You can also lift out dry paint, though it will need a little more coaxing, and you may not be able to regain the full whiteness of the paper. Some pigments have more staining power than others, for example, sap green and alizarin crimson will both dye the paper to some extent, and papers themselves vary in the way they hold the paint.

WAX RESIST

This attractive technique can also be used for highlights, but it has much wider possibilities — you can create quite magical effects with a combination of

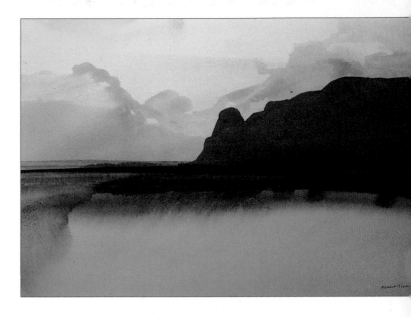

▲ Robert Tilling
Winter Headland
Tilling's watercolours, in which he explores effects of light on water, are worked wet into wet. He lays broad, sweeping washes, encouraging the flow of paint by tilting the board, which allows considerable control.

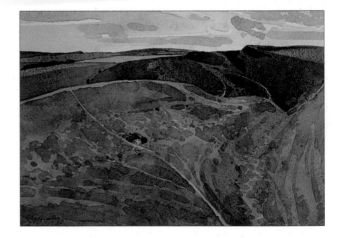

▲ Ronald Jesty
Maiden Castle
Jesty's watercolour technique could not be more different. He builds up his complex effects by overlaying successive washes, allowing each to dry first (wet on dry).

MEDIA AND METHODS

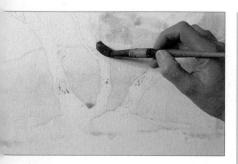

WAX RESIST

1 ◄ Here wax resist is to be used to suggest the texture of tree bark. The artist has scribbled lightly over the tree with a white wax crayon before laying a background wash.

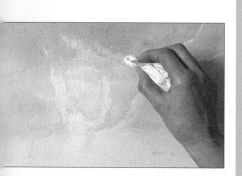

2 ◄ Before working further on the tree she lightens parts of the sky by gently dabbing with a tissue.

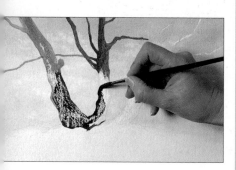

3 ◄ The dark paint slides off the waxed areas, leaving a distinct pattern of broken white lines.

4 ◄ The effects you achieve with wax resist vary according to the amount of pressure applied and the paper you use. This is a medium (Not surface) paper; a rougher one would give a more pronounced speckling, as the wax would adhere only to the raised "peaks" of the paper.

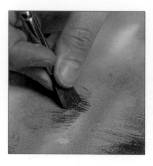

DRY BRUSH

1 ▲ A square-ended brush is the best for this technique, with the hairs fanned out slightly between thumb and forefinger. The paint must be fairly dry, so before you begin, flick off the excess or dab the brush slightly on blotting paper.

2 ▲ Dry brush is a technique often used for grass textures, as here, or for hair and fur in a portrait or animal study. Effects of considerable depth and variety can be created by building up layers of different colours and tones.

watercolour and wax. The method (less suitable for opaque gouache than watercolour) is based on the mutual antipathy of oil and water. If you draw or scribble lightly with an ordinary white household candle and then overlay this with a wash, most of the paint will slide off the waxed areas, leaving just a few beads adhering to the wax. You can vary the effects by using different colours of wax crayon — you need not restrict yourself to white — and by the pressure you apply. A heavy application will repel all the paint, while a light one will impart just a slight texture to the subsequent washes.

TEXTURING TECHNIQUES

The fluid nature of watercolour does not seem to lend itself to creating texture effects, but in fact there are a number of tricks of the trade which can help you here, wax resist being just one. Perhaps the best-known technique in this context is dry brush, which is often used to suggest the texture of old bricks and stone in architectural subjects, and the effect of massed foliage or grass in landscapes. You can work over a colour already laid, or straight onto white paper, and several layers of dry brush work can be laid one over another to build up colour effects, very much like hatching and crosshatching in drawing. Dry brush is a particularly useful method for gouache, as it enables you to lay fresh colours without disturbing the ones below.

For watercolours, the brush normally used for dry brush work is a square-ended one, with the bristles slightly splayed to produce a series of fine lines. You can use a similar brush for gouache work, or an oil-painters' bristle brush. The technique, particularly with watercolour, takes a little practice: if the paint is too wet it will simply turn into a wash, but if too dry it will not go on at all.

Another popular method, well suited to textures like sand or pebbles on a beach, is spattering. There are two basic ways of doing this. The first is to dip an old toothbrush into fairly thick paint and then quickly draw a knife blade or plastic ruler across it, and the second is to load a bristle brush and tap it sharply against the handle of another brush, or the palm of

◄ Elisabeth Harden
Stairs at West Dean
Here the artist has made deliberate and effective use of the tendency of certain pigments to separate out, or precipitate, giving a granular effect. This sometimes occurs when one wash is laid over another, and sometimes when certain colours are mixed together. Artists often use granulation to suggest texture, or simply to enliven areas of colour, as in this case, where the effect is more exciting than a flat wash.

▲ Rachel Gibson
Californian Poppies
In watercolour work, lively sparkling colours like these are seldom achieved without planning. A careful drawing enabled the artist to place each colour very precisely. There is no overlaying of washes, though some colours have been worked wet into wet.

▲ David Carr
Siena
This painting shows an assured and confident use of the gouache medium. Carr, who also works in oils, prefers gouache to transparent watercolour, as it enables him both to

exploit brushwork and to vary the thickness of the paint. Notice the opacity of the paint used for the clouds.

▼ Alex McKibbin
Environs of Pamajera
Here the artist has skilfully combined loose wet into wet washes with crisp, calligraphic marks to produce a lively, energetic interpretation.

your other hand. Both methods will release fine droplets of paint onto the paper, but the toothbrush produces a finer spray.

Spattering is often used to enliven a bare expanse of foreground, and is an excellent technique for suggesting the textures of pitted rocks or old stone walls. It is best restricted to one area of a painting, and should not be overdone. It is important to choose a colour and tone for the spattered paint that does not contrast too stongly with the paint already laid. A contrasting colour or one that is much darker in tone will give an unpleasant spotted look — the effect should be subtle, not overbearing.

A less conventional way of suggesting rough textures in transparent watercolour (or gouache used thinly) is to sprinkle crystals of coarse rock salt into wet paint. As the salt dries, it sucks up the paint, so that when it is removed, pale, snowflake shapes remain. This technique is fun to try out even if you can't visualize using it in a painting. You can achieve a wide variety of effects depending on the wetness of the paint and the density of the salt granules. The clearest shapes are produced by applying the salt to a damp wash; if the paint is really wet the shapes wll be larger, softer and less distinct. You can build up quite intricate patterns and textures by several layers of wash and salt, one over the other, but this is time-consuming as the salt takes some time to dry.

ADDITIVES
The usual "medium" for watercolour is, of course, water, but there are other substances that you can add to the paint which slightly change its character. One of these is gum arabic, the binder used in the manufacture of the paints. You can buy this in small bottles, specifically as a paint additive; a small quantity mixed in with the paint makes it rich and glossy (always dilute it with water or the gum may crack). Gum water, the term given to diluted gum arabic, is particularly useful for any part of a painting that is to be built up in small brushstrokes, the paint will remain where you put it instead of spreading out. Gum water is also an aid to lifting-out techniques; paint mixed with it

is easier to remove when dry.

A medium sometimes used by artists who work wet into wet is ox-gall, which is a water-tension breaker, and improves the flow of the paint. Ordinary washing-up liquid can be used for this purpose. You can also try out a few less conventional additives for special effects, for example, mixing paint with soap will thicken it so that it retains the marks of the brush — this could be the ideal method for painting a stormy sky.

For gouache work, there is one particular medium that overcomes the problem of each new layer of paint picking up the one below. This is called acrylizing medium, and is a polymer resin additive that makes gouache paint water resistant. It also alters its consistency, making the paint into something resembling acrylic itself (see pages 16-17), so that it is sufficiently thick and creamy to be applied with a painting knife or as brush impasto.

the project

Light tones in gouache
You can paint dark pictures using gouache, but one of the features of this medium is this ability to produce beautiful, soft, light tones. To exploit its particular feature, assemble a still life group as near to a completely white group of objects as possible. You may have an existing arrangement of objects which will provide you with a suitable subject. You could, for example, use some white eggs on a white cloth in front of a white wall, or a white dress hanging over a white chair in a white room. You might think that such a simple subject can't

make an effective painting, but in fact some masterpieces have, in fact, been painted from the simplest of subjects. There is, for example, a beautiful small painting of just a simple white cup and saucer by the French painter Fantin-Latour (1836-1904).

If possible, arrange your group so that the light falling on it is soft and there are no strong shadows. Don't imagine that you will only be able to see a series of greys. You will find that there is quite a difference between the local colours of the "white" objects, and there will also be reflected colours in your group.

Resist the temptation to see the shadows as dull, lifeless greys. There won't be any strong obvious colour differences in this project, but if you really look you will see soft, subtle changes from one tone and colour to another.

Don't treat the gouache paints like watercolour; use it thick. Try not to over-state any dark areas in your subject. Your painting will be predominantly white or near white, and a small shadow under a plate, for example, which seems quite dark in reality, may need to be translated into a much lighter tone to look right in your painting.

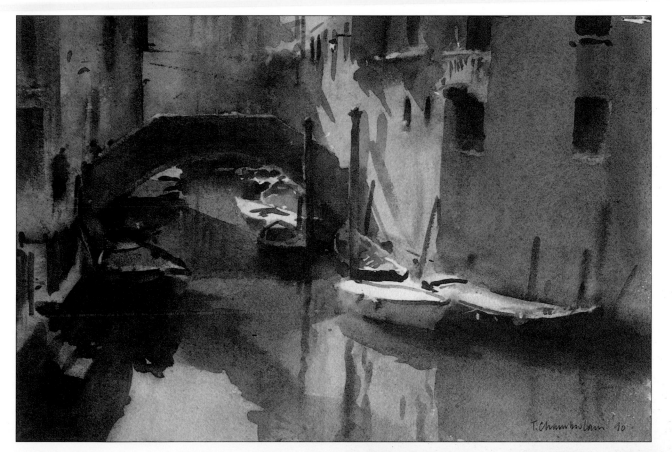

◄ Trevor Chamberlain
Quiet Canal, Venice
The gentle light and soft colours are beautifully described by painting mainly wet into wet. This technique needs to be carefully handled or the effect may become too "woolly", and here the sharp edges of the boats provide essential touches of crisp definition.

> **❝** Sometimes I think it would be good to have a technique which is sure and masterful, but I don't want to paint as a technician. I love the danger of the unpredictable, but at the same time I'm afraid of it. I work with a brush in one hand and a mop of damp cotton wool in the other. **❞**

John Lidzey

After attending Camberwell and Hornsey Schools of Art in London as a part-time student, John Lidzey became first a typographer and then a graphic designer. In the late 1960s he began teaching, and at the same time worked on systematically developing his personal style of watercolour painting. He now devotes all his energies to painting, and exhibits at several London galleries as well as one in Suffolk, where he and his wife live. In 1990 he was awarded the Daler/Rowney prize for the most outstanding painting at the Royal Watercolour Society Annual Open Exhibition.

Q How did you start painting in watercolour? Did you learn at art school?

A No, I didn't really learn anything at art school. I was only a part time student, and I was studying typographic design not fine art. I started getting interested when I was working in a graphic design studio, using colour in the form of markers and so on. Then what happened was that I decided to do an Open University course — to stretch my mind more than anything else, and this involved getting up early and working for an hour every morning, and then coming home and putting in another hour. When I'd finished and got my Humanities degree I decided to use this extra time to paint. Every morning I'd put in an hour's work on watercolours, then drop everything and rush to work, then come home and paint again. Looking back over what I did in the light of what I know now, the paintings weren't much good. I think I gave most of them away or sold them for a couple of pounds on market stalls.

▼ **Cottages at Dusk**
A sketchbook study exploring the effects of late-evening light.

Q You obviously became used to a working routine. Do you still paint every day?

A I do, yes, I really treat it as a nine to five job, and paint even when I don't want to. In fact, I almost never do want to — there's always a terrible reluctance to start. If I only painted when I felt like it I wouldn't produce much — if anything. It gets a bit easier when I'm into a painting, but not much — there are problems all the way and you have to constantly think, not only about the subject but about what the paint is doing, and how you can control and exploit certain effects.

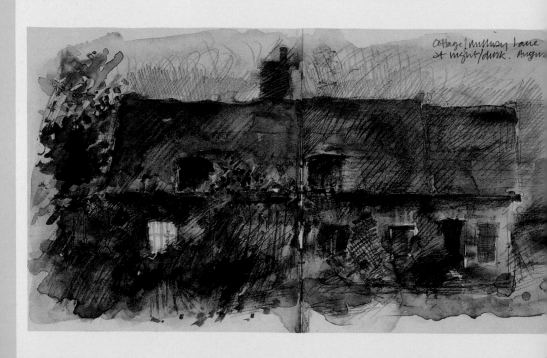

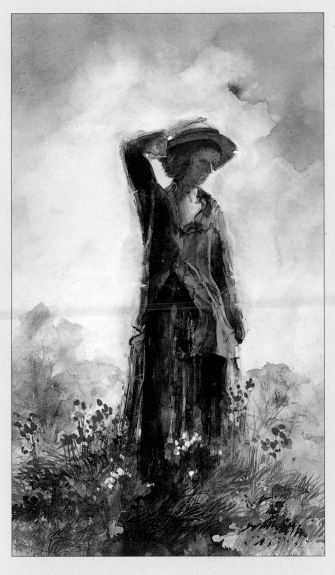

▲ Elsie in a Straw Hat
The free, fluid treatment of the sketch (above) has been maintained in the finished painting, though both figure and foreground are more sharply defined.

Q **Serious painting really is hard work, isn't it? People don't always appreciate that.**

A No they don't. When people say that "painting is so relaxing" it makes me squirm.

Q **Did you have any sort of lessons in watercolour technique?**

A No, I really evolved my own way of working by trying things out. I think there's a danger in learning from someone else. You see students at evening classes becoming very reliant on their teachers and trying to paint in the same way — they can't see any other approach as valid.

Q **But presumably there are some watercolourists of the past you admired?**

A Well, of course, Turner is the obvious example — I don't think there is any watercolourist who doesn't look at Turner. What I find exciting is the way his imagination takes off, so that what might be, for instance, quite a mundane harbour scene becomes an exhilarating sweep of colour and brushwork. It's the marks he makes on paper that are so impressive — his manipulation of painting materials to suggest effects on the extreme edges of belief and even beyond. I like the Norwich painters, too, like Cotman, though he has less to say to me in terms of approach — his paintings are more highly organized and planned, rather tighter in technique. I like the painting to develop as it goes along.

Q **Watercolour is a very suggestive medium isn't it, in the way you can exploit accidents. Can you tell me something about your technique?**

A Well, sometimes I think I can't cope as a watercolourist. My procedure seems

to be based on responding to things that are going wrong as the painting proceeds. Sometimes I think it would be good to have a technique which is sure and masterful, but again I don't want to paint as a technician. I love the danger of the unpredictable, but at the same time I'm afraid of it, so I work with a brush in one hand and a mop of damp cotton wool in the other.

The effect I enjoy is that of the subject being seen through a veil of paint. So I break up the paint surface as much as possible. Even the first broad areas of colour are never allowed to go down flat, and after that I use a process of painting and blotting, sometimes also feeding small amounts of pure colour into wet washes to emphasize the uneven effect, and sometimes even rubbing in beeswax, Vaseline or anything else that will break up the surface where I want it to. I work on the paint after it has dried too, scratching out or rubbing areas of tones, and often allowing clean water to run over colours, followed by judicious sponging.

Q. You sometimes draw on top of the watercolour don't you?

A I often have trouble with dark areas of colour — I suppose watercolour is not at its best as a tonal medium. I occasionally use gouache paints to strengthen low tones, or if I'm not too bothered about losing colour values I'll rub in charcoal or conté crayon. Conté is particularly good where I want to partially obscure the subject — the veil-like effect again — so I use it to hatch over areas of the painting. Remember in the '60s, when everybody used to quote Marshall McLuhan — "the medium is the message"? Well, in my work I want the effects of paint on paper to be the message, not the subject.

Q You paint a lot of landscapes, but I believe you don't like working directly from a subject. Why is that?

A Well of course one of the things is the weather — the sun goes in and the wind blows the paper and so on. But the main thing is the amount of detail that gets thrust at you — I find it very difficult to make decisions about how to simplify things…like a group of trees, for instance, that could be treated just as a broad shape…when it's all there in front of me. Back in the studio I can sift things out and concentrate on my own response to the scene. I sketch out of doors a great deal, but sketching is different — it's a private act. I always feel under a strain producing finished work in the studio, but I'm relaxed when I'm sketching — bad drawing, dirty thumbprints and so on are all ingredients of sketchbook work.

Q So do you compose your landscapes from on-the-spot sketches?

A Yes, mainly, but I also use photographs. I think most artists do, though this always seems to shock amateurs. Actually, I find that photographs can be quite interesting, particularly for interiors. They're often bad because the camera can't cope very well with extremes of light and shade, so you may find, for example, that you've got a very brightly lit window with everything else in the room in dark shadow. It isn't true to life, but it can sometimes suggest ways of doing things. Unlike the landscapes, I do quite often paint the interior scenes directly from the subject, but sometimes I take photographs first, as a sort of preliminary exploration. Once I start to paint, though, they go on one side, and I don't refer to them again.

Q Is there anything you actually dislike painting?

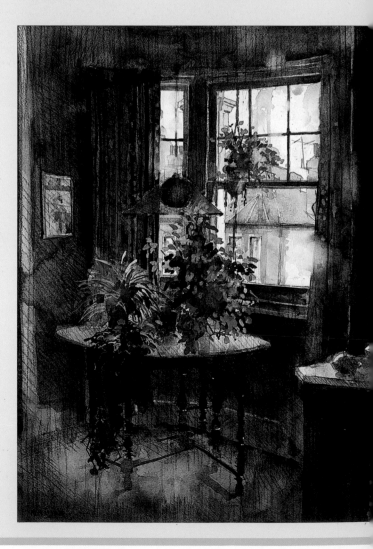

A Yes, I hate doing commissions. As I've said, I'm less interested in the subject than the picture, but for them it's the other way round of course, if someone wants you to paint a picture of their house. I feel that the client wants a kind of photograph in paint, and this always inhibits me, even when they've told me

they like my style of painting. It's the same when someone says "look at that lovely view, why don't you paint it?" If it's a lovely view I'm almost certain *not* to want to paint it — I like to paint the unpaintable. For instance sometimes I work in the evening when it's almost too dark to see the paper and the colours I'm mixing. This gives me all sorts of problems, but I find the struggle of coping with these technical difficulties often results in work which has qualities I might never achieve in perfect conditions.

Q **Light seems very important in your paintings. Do you see this as your primary interest?**

A Yes, but in the interiors more than in the landscapes. I'm always excited by things like the patterns of light and shade, and the way you get little highlights running across the picture. When there's a table in the picture, for instance, the whole

thing may be in shadow except for a tiny bit at the edge, and that can describe the whole object.

Q **You've mentioned Turner as an influence, but do your interiors owe anything to other artists?**

A I've always admired the Camden Town painters — people like Sickert, Gillman and Spencer Gore — all oil painters, of course. I love Seurat too — not so much the big paintings but the marvellous conté crayon drawings, mainly people or one person in an interior, but also figures out of

doors, silhouetted against the light in a way that one doesn't actually see, but is marvellous. I've mentioned using conté with watercolour, and I think I first did this after seeing these drawings. Another — not exactly an influence but a source of ideas — is looking at students' work. They aren't necessarily good — though some are, of course — but you see every style

from the academic to the vulgar or even outrageous. All the possibilities are on display.

► Chiffonier with Beads
The use of the photograph as a backdrop for the beads and bottles assures their place as the centre of interest.

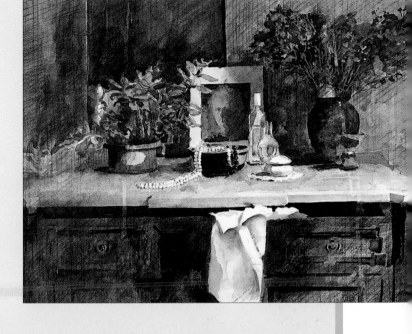

Q **From all the things you've said, I gather that you will always be a watercolour painter — do you feel wedded to the medium?**

A I do, yes. I try out others on occasion, but none of them offers me what watercolour does. I can't see ever abandoning it.

◄ Anna with Cat
The darkly clad figure and shadowed areas of the room throw the brightly lit white bedspread into prominence, and the touches of yellow-gold introduce a note of warmth to a predominantly cool colour scheme.

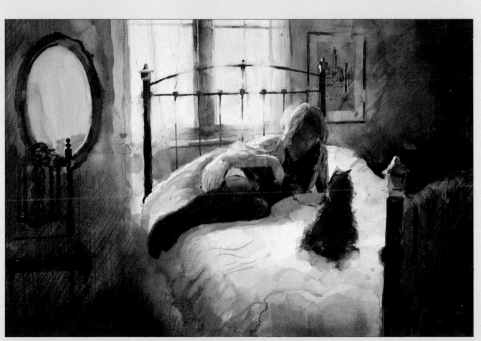

◄ Interior with Plants
Conté crayon has helped to build up the dark tones, and there are touches of opaque paint on the plants.

Painting with pastels

The section called *Introducing pastels*, in Part One, dealt only with soft pastels, or chalk pastels as they are sometimes called. These are the most favoured for pastel painting, but there are other kinds of pastels, two of which can be combined with soft pastels, and are useful at certain stages of a painting.

PASTEL TYPES

Pastel pencils, which are thin sticks of pigment encased in wood, are ideal both for making preliminary drawings and for adding intricate detail. They can be sharpened to a fine point to produce clear, crisp lines, and because their wood casing prevents them snapping they can be controlled very precisely. It is a good idea to have a few of these on hand, though you won't need very many — in any case, the colour range is limited.

Hard pastels, which contain a higher proportion of binder to pigment than soft ones, are rectangular in section, so that you can sharpen them to a point with a craft knife. In general, they are most suited to a linear approach, but they are sometimes used for blocking-in the composition, their advantages being that they don't crumble or clog the tooth of the paper too much and can be erased fairly easily. Like pastel pencils, the colour range is relatively small.

The third type, oil pastel, is really a medium on its own, with very different characteristics from the others. These pastels are made by combining pigment with an oil binder, and so they behave more like paints than chalks, giving thick, buttery strokes of colour. The choice of colours varies with the manufacturer, as does the consistency of the pastels.

Some artists become addicted to oil pastels, and use nothing else. Their great attraction is that you can both draw with them and use them as paints, building up strong, rich colours and creating interesting textural contrasts. If you dip them in turpentine or white spirit the colour melts, so that you can apply wet colour to the paper, or you can work over dry colour on the paper with a spirit-moistened brush or rag. The surface of the paper does eventually become clogged if you try

184 ▷

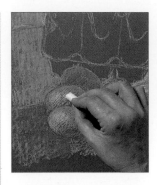

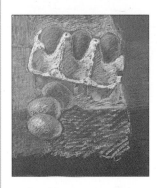

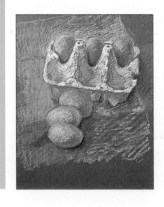

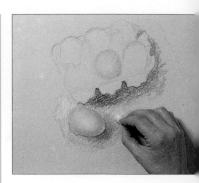

OVERLAYING COLOURS

1 ◄ Rich effects can be built up by laying one colour over another without blending, so that the colour beneath shows through the later layers.

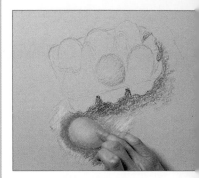

2 ◄ The effect depends very much on the pressure you apply; here the artist uses very light, feathery strokes of the pastel stick so that the colours beneath are not obscured.

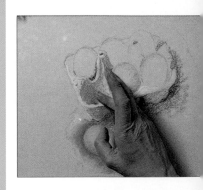

3 ◄ The colour of the paper is important when you are working in this way. Here the dark grey-brown provides a contrast to the delicate colours.

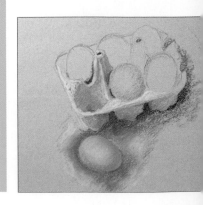

4 ◄ The picture has a lively sparkle, with the network of overlaid diagonal strokes of the pastel giving a feeling of energy and life.

BLENDING

1 ◄ The main colours are blocked in with light, diagonal strokes.

2 ◄ The egg is then gently blended with a finger. A torchon or piece of cotton wool can also be used, but the finger is perhaps the most sensitive "tool".

3 ◄ Further colours have now been laid on the egg box, and this is now finger-blended in the same way.

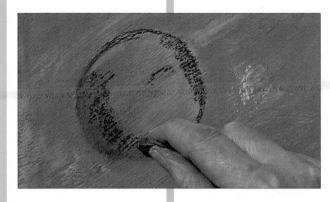

4 ◄ The smoothness of the egg has been beautifully captured, with the gradations of tone and colour almost imperceptible.

LAYING A GROUND

1 ◄ Both the colour and the texture of the paper are important in pastel work, and many artists prepare a ground of some kind. Here thinned acrylic modelling paste (see pages 163 and 165) is laid on watercolour paper.

2 ▲ You can decide whether to make the pastel strokes follow the same direction as the brushmarks, as here, or go "against the grain".

3 ▼ The texture of the ground has broken up the pastel strokes, giving a completely different quality to that of pastel on smooth paper.

OIL PASTEL

1 ◄ Oil pastels can be used dry, just like ordinary pastels, but by dipping a brush or rag in white spirit you can spread the colour out on the paper and mix one colour into another.

2 ▲ Further dry colours can be added over the "painted" areas, allowing you to contrast different textures.

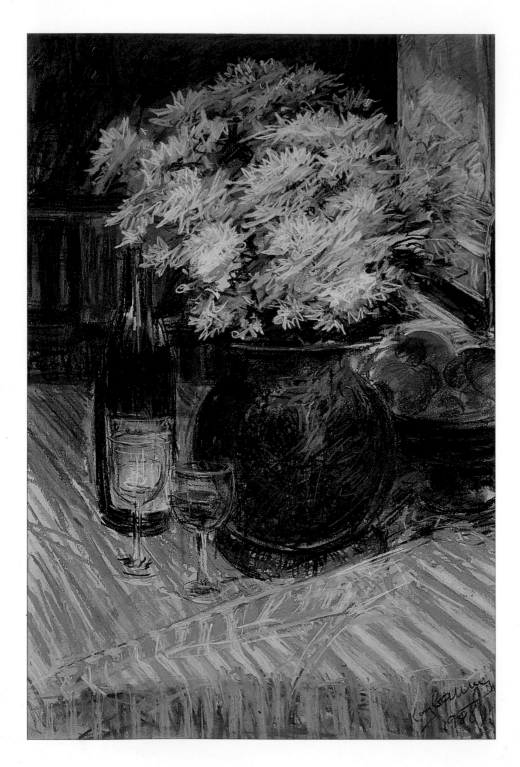

◀ Kay Gallwey
Still Life with White Flowers
As you will see from the pictures on these pages, there are many different ways of using pastels. Gallwey works mainly with the point of the pastel stick, building up forms and colours by means of a network of overlaid lines, with the minimum of blending.

to build up too many layers, but it is easy enough to remove whole areas of a picture simply by applying white spirit and rubbing gently with a rag or cotton wool.

Another advantage of oil pastels is that they don't need fixing, which should make them the ideal medium for outdoor work. In addition, they are quick to use, and since you can mix and blend colours on the paper you need only a small palette. But they do have an unfortunate tendency to melt if the weather is at all hot, so you can find you have more colour on your hands than on the paper. This can be tiresome and messy, so try to work in the shade or at a cool time of day.

MORE ABOUT SOFT PASTELS

Page 69 suggested a basic starter palette for those who have not used pastels before. Anyone who intends to take up the medium seriously is bound to want a larger range of colours in time, but it is not a bad idea to stick to a small palette until you have become familiar with pastel painting. In this way you will quickly learn how to overlay colours so that they mix on the paper, which is a vital skill to acquire. Having said this, however, pastels do not have the versatility of paints and in practice only a limited range of colours can be produced by mixing. Some professional pastellists, like the artist whose work is shown on the previous pages,

186 ▷

► Moira Clinch
Early Morning Train, Greece
In this oil pastel, the artist has emphasized the spiky quality of the trees by using vertical strokes of the pastel throughout the picture, so that the eye is drawn upward, through the trees to the plume of steam from the invisible train.

◄ Nick Swingler
Reflected Lights
The artist has built up rich, luminous colour effects by laying pastel over acrylic paint. Although this is a sympathetic mixture of media, it is not always easy to handle, as the acrylic seals the paper, causing the soft pastel pigment to slide off it. You will need to use fixative.

MEDIA AND METHODS

have hundreds of different colours and tints, but even they find that they cannot always match a particular shade seen in nature without some degree of mixing.

MIXING COLOURS
There are various ways of doing this, and each method creates a different effect. Blending, which involves putting two or more colours on top of each other and

rubbing with a finger, cotton wool ball or rag so that they fuse together, is perhaps the best known. By choosing your colours carefully and blending them thoroughly you can achieve almost any colour or tone, but it is not advisable to rely too much on blending, as it can make your picture look very insipid and lifeless. One of the most exciting things about pastel is its fresh, vigorous, linear quality, and this is quickly sacrificed by

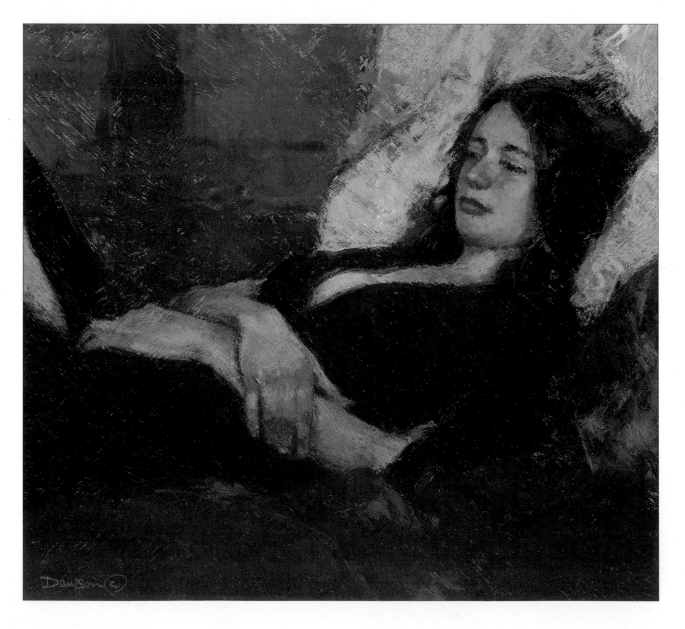

◄ Doug Dawson
In the Gentle Light of the Window
Successive overlays of pastel, built up heavily and blended in places, give a rich, painterly quality to the picture. The lively broken-colour effects, particularly noticeable on the background and the hands and arms, were achieved by working on a textured ground, as demonstrated on page 183.

overblending. A light, unblended application of one colour over another is more vibrant and exciting.

But the great thing about pastel work is that you can rectify mistakes relatively easily, and a bland, oversmooth area of colour can often be given new life and vigour by lightly stroking another colour on top with the tip of a pastel stick. This technique, called feathering, also gives you an opportunity to modify colours and tones or to bring in an element of contrast. An over-dark shadow, for example, could be lightened and revitalized by feathering with a vivid blue or green, while a too-bright colour can be knocked back by an application of its complementary colour.

SURFACES FOR PASTEL WORK

As mentioned on page 66, the colour of the paper used for a pastel painting is very important, because it is seldom covered completely by the pastel strokes. Choosing the colour of the ground (paper) can be quite difficult until you have had some experience, but there are one or two tips to bear in mind. Some artists will choose a paper that harmonizes with the overall colour scheme of the picture, using blue-grey for a wintry landscape or warm yellow for a sunny, summer one. Others take the opposite approach, painting a snow scene on a warm yellow ground so that the contrast enhances the cool colours. You will need to experiment with different papers, since the choice will depend on your way of working, but initially you won't go far wrong with a neutral colour such as beige or light grey.

You will also want to experiment with different textures. The two basic pastel papers shown on page 68 are fine, but there are all sorts of other ones you can use as well. Watercolour paper is a favourite, and you can tint it to any colour you choose, either by laying a watercolour wash or by grinding up pastel and rubbing it on with a cloth (this is called laying a dry wash). Avoid choosing too rough a surface, or you will find that the pastel colour adheres only to the "peaks", giving a speckled effect which makes it difficult to build up solid colour. Two other papers sold specially for pastel work — but usually available from specialist suppliers — are worth trying. One is a fine sandpaper exactly like

the project

PASTEL ON GLASSPAPER
Soft pastels can be used on any surface that is rough enough to provide a "key" that will retain the grains of colour. Most of the abrasive papers which are manufactured primarily for smoothing wood are suitable for use as supports for pastels. These have various names such as glasspaper, garnet paper, sandpaper and flour paper, and depending on the actual abrasive, can be grey, dark red, sand-coloured or almost black. The finer grades are generally best for pastels, partly because they wear away the pastel sticks less quickly. Large size sheets of sandpaper are available from many artists'

materials shops; these are usually a warm yellow-beige.

In this project, choose a subject which will allow you to explore the linear possibilities of the medium as well as its ability to make smooth transitions from one tone or colour to another. This could be a portrait where the head could be translated in smoothly blended colour; while the sitter's clothes could be more freely drawn using line and hatching, with the colour of the support showing through. You will need to choose an abrasive paper which is not only fine enough in grade but is a suitable colour for your subject.

A good way to start is to use charcoal to plan where you intend to position the main objects in your picture. Draw the main shapes of your composition lightly in line on your abrasive paper. If necessary, you will be able to make radical changes in this drawing before embarking on working with pastel. When you have completed your pastels, consider whether you used the blending and linear approaches as you had planned or whether the picture developed in a different way.

that sold in DIY shops but in much larger sheets. The other is velour paper, which has an attractive velvety feel. Both these hold the pigment firmly and allow you to build up colours densely.

The paper you choose for oil pastel work depends to some extent on the way you use the medium. Standard pastel paper is pleasant to work on, but you may find that it deteriorates in time if you have used the colour very wet — the oil can sink into the fibres and cause rot. Watercolour paper is tougher, or you could try working on cardboard, oil painting board or even canvas, which would allow you to combine oil pastel with actual oil paint. Sandpaper and velour paper are suitable for oil pastel used dry, but not for wet applications.

❝ What I find important is that you are drawing and painting at the same time. It speeds up the process, and it also keeps a vitality in the picture. With paints I tended to lose some of the intensity of the drawing…with pastels the whole thing stayed lively and fresh. **❞**

Patrick Cullen

Patrick Cullen trained at St Martin's and Camberwell Schools of Art in London from 1972 to 1976. He now paints full-time and exhibits regularly in both mixed and one-person shows. He has won a number of awards for his pastels and watercolours, and in 1991 was elected a member of the Pastel Society. He is married with one daughter, and lives in North London, when not painting in Tuscany, whose landscape has recently provided the inspiration for much of his work.

Q Do you always work in pastel?

A No, I also use oils and watercolours, but at the moment I'm working with pastels more than anything else. I think I go through phases of different media.

Q What led you to pastels? Did you use them at art school or did you see someone else's work you admired?

A I'm not sure if it was either of those things. I certainly wasn't taught pastel at art school. I worked mainly there on life studies and so on, which each took maybe a couple of weeks, and people tended to work in oils. But I do remember that someone had a box of pastels and I asked to borrow them — I'm not sure why. They were not the kind I use now; they were slightly greasy — somewhere between an oil pastel and a chalk pastel — but they were lovely colours, and I really liked them. I think it was the discovery of these soft and yet strong colours that captivated me originally.

Q But you didn't become a serious pastellist until later.

▲ **Tuscan Landscapes**
These two oil sketches, done on location from two slightly different viewpoints, became the basis for the large pastel, *Vineyards*.

A No, but when I left art school and started working outside much more, I found that pastel was a very good medium for catching fleeting effects and getting things very quickly.

What I find important is that you are drawing and painting at the same time. It speeds up the process since you haven't got two separate stages, and it also keeps a vitality in

▶ **Vineyards**
The composition of the pastel is quite different from either of the sketches, with the perspective of the foreground field dramatically steepened.

the picture which I found hard to achieve with oils. With paints I tended to lose some of the intensity of the drawing, but with pastels the whole thing stayed lively and fresh. I went on using the oil-type pastels for a while and then turned to chalk pastels.

Q Oil pastels have quite a limited colour range, don't they?

A Yes, but it wasn't only that. I think I was also influenced by the fact that Degas used chalk pastels. They were deemed to be the "real thing", while the others were a sort of crayon. In fact

I made quite a lot of pictures using oil and chalk pastels together, but they're not really very compatible — their physical natures are so different.

Q A problem with pastels is that you need so many colours. Did you buy one of the big boxes or start with just a few sticks?

A I don't think I ever bought a whole set. I probably started with about twenty sticks and gradually added more. I now have three or four hundred.

Q You have mentioned Degas, who is the obvious role model for a pastellist, but are there any other artists whose work you have always particularly admired?

A Yes, of all the great masters, Bonnard was the one I was most fascinated by, and continue to be. I think it's because of the particular…how shall I say this …it's the interface between working directly from nature and inventing entirely from one's imagination. I mean, Bonnard always drew his inspiration from things he'd seen and sketched every day of

his life, but his paintings nonetheless are inventions of the imagination. They have a believable light in them and believable space, even though it's not the same light and space that we actually see.

It's this particular kind of in-between area of working which fascinates me. Some would no doubt say that this is the terrain occupied by most figurative painters, but I don't agree. It seems to me that the majority place themselves more or less on one side or other of this interface. Either they are primarily concerned with fidelity to the scene before them and are reluctant to alter, for example, the colour values and shapes of the landscape, or they completely transform the external world.

We could get very bogged down here with the whole question of what fidelity to nature means, but there's a quote of van Gogh's that I've always found illuminating. He said that you start out trying to follow the colours and tones of nature and everything goes wrong. You end up freely creating them from your own palette and nature agrees and follows you. The crucial bit is

in the last five words — the magic which cannot be reduced to rules and theories lies in the question of whether and how nature does follow you.

Q Do you see yourself as occupying this in-between area?

A More and more so. For many years I worked direct from nature, but now I am doing more of my paintings back in the studio. I do still work outside a good deal, but even then I am usually producing a synthesis combining what I'm looking at and what is in my head. It's a sort of continuum, with each picture lying somewhere along it — with some pictures I have a definite agenda of my own, while others are very much direct responses to what I see. When I paint like that I won't fiddle with it afterwards, but sometimes I will start a painting outside and change it a lot when I get home, even transform it into something else altogether.

Q The larger paintings are obviously studio works. What kind of visual reference do you use for them?

▶ **Vines and Olive Groves**
The rich, vibrant colours are achieved by successive layers of pastel, fixed between stages.

A Mainly drawings and colour sketches, but I also use photographs — just standard colour prints. I'm not a very experienced photographer, so I take a lot of shots (photographs) to play safe, but I usually end up using only one or two. I am against making any sort of rules about painting in general, but I do have a strict rule about photographs, which is never to rely on them too much. They have to be just an adjunct, and you must have an idea of what the painting is going to look like. The photos are for information not inspiration.

Some of the large paintings are based on pictures I have previously done on the spot rather than just quick sketches. Sometimes I see something in one of them that suggests a large-scale treatment or an idea I want to develop further. Sometimes I combine two or more sketches of the same place seen from different viewpoints so that the finished painting is a sort of composite; for

instance, in *Vineyards*, the foreground was taken from one sketch and the whole of the background from another. I feel such landscapes are true to a place, in a sense —

I'm concerned about making them believable in terms of light, atmosphere and general structure. But if you were to visit one of the scenes you would never be able to

pin down a particular viewpoint — there isn't one.

Q How long, on average, does one of the large pastels take you?

A It depends. Sometimes I work on a picture over a period of three months, but not every day.

Q When you are working on it, do you turn it round so that you come fresh to it next time or leave it visible so that you can think about it?

A I do both really, but I do try to make myself turn it to the wall. It's very easy to slip into constantly looking at a picture and fiddling with it — you must give yourself enough space to see what's wrong with it.

Q Do you work every day? Or do you do sometimes have "artist's block"?

A Oh certainly I get blocked. Usually I can convince myself at the time that it's because there are other things I have to do, but since it happens rather too often for that to be true I am forced to admit that perhaps I'm deliberately finding other things to do. But I never let more than a few days go by without getting down to something.

Q That sounds as though you have to force yourself to work.

A Yes I do. Sometimes I feel stuck because I really don't know what I want to paint, and then I just have to go out and look for a subject, or perhaps have another go at something I've started. But there are times when I know what I want to paint and I'm quite keen but there's still a resistance to the initial stages — getting the thing mapped out on the paper and getting it blocked in — I can be tremendously listless about it.

Q Is there an element of fear? That you know what you want to do and you are not quite sure that you can do it?

A I think so. The idea that you're going to spoil it. But then I find there's a point about a third of the way through when I'm starting to get more confident. When one or two of the things are beginning to work in the picture and I can see my way through I start getting a head of steam and it

▶ **Ploughed Hills in Tuscany**
The marks of the pastel are most vigorous and expressive in the foreground, giving depth to the composition.

all goes, hopefully, quite well from then.

Q What can you tell me about your working methods? How do you begin a pastel?

A The first thing I do is select a ground — not just the type of paper, but the colour as well. Usually I tone my own papers, though I also keep a selection of precoloured ones, which are useful if you're in a hurry. I like to choose the colour with the subject in front of me, so if I'm working outside and using white watercolour paper I put on a watercolour wash and leave it in the sun for five minutes to dry.

Then, if I'm using a medium tone, I sort out the composition by drawing first with a white pastel pencil, which you can erase fairly easily. After this I tend to block in, not necessarily over the whole surface but certainly to establish some of the key tone and colour values. I don't have any particular rules about where to start, but if some particular aspect of the scene grabs me then I'll deal with that and then move back and forth.

Q I know there's a good deal of controversy about whether to use fixative. Do you?

A I used to fix between stages of a picture, but I do so much less now. I think I've become more experienced in choosing the right paper so that the colour doesn't fall off. With surfaces like sandpaper and velour paper you don't really need to fix, and I don't fix at the end of a picture if I can help it. The best way of preserving pastels is to frame and glaze as soon as possible — if you can afford it!

Painting with mixed media

Although some painters know they can create their best effects with pure oil paints, watercolours or pastels, others find that their expressive range is broadened by breaking away from technical restrictions, and mixed-media works have become increasingly common. In fact, the concept is far from new, but twentieth-century artists are fortunate in having a larger range of materials to experiment with than ever before. Using two or more media in the course of one painting can often offer new directions and different ways of approaching your subject matter.

Mixed-media paintings, in general, fall into two categories — those which exploit the compatibility of two or more media, and those which exploit their differences. An example of the former is pastel and gouache, which go very well together because both have the same kind of dry, matt surface. The classic example of the latter approach is the traditional technique of line and wash — watercolour used with pen and ink or another line medium.

Combining media which have very different qualities can produce an exciting contrast, but it can also destroy the unity of the picture. Only by conducting your own experiments can you discover which combinations work and how you can best exploit the different characters of the media. The great diversity of modern artist's materials makes it impossible to list every potential combination, or to prescribe specific techniques, but the suggestions here will give you a helpful starting point.

WATERCOLOUR WITH OTHER MEDIA

Transparent watercolour is eminently suitable for mixing with other media. Combining it with gouache or acrylic scarcely counts as mixed media, since the paints are similar in nature, but it is worth noting that you can often save an unsuccessful watercolour by working over it in gouache or acrylic. Gouache with pastel is an excellent match of like with like, as is a combination of watercolour and watercolour crayons. The crayons which come in pastel-shaped sticks and pencil form, are almost a mixed media in themselves,

LINE AND WASH

1 ◄ A line medium, such as pen or pencil, is the perfect partner for the delicacy of water-colour. Usually the line drawing is done first, as in this case, but there is no hard-and-fast rule.

2 ◄ The artist has used a water-soluble pen, so that the lines are softened and spread by the washes laid on top. This prevents the line drawing appearing too hard and clear in contrast to the watercolour.

3 ◄ The washes on the shell have been kept to a minimum to preserve the delicate effect for which the technique — which is often used for flower drawings — is so well suited.

PASTEL AND GOUACHE

1 ▲ These two go well together as both are opaque, with similar matt surfaces.

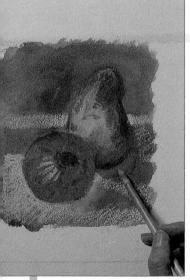

2 ▲ The artist has begun with washes of semi-opaque gouache followed by a light overlay of pastel. She now applies more gouache.

3 ▼ She continues to build up the picture, using the pastel on top of the gouache to provide texture and accents of colour.

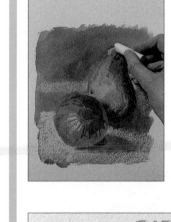

4 ▼ Unless skilfully handled, gouache tends to look rather flat and dull, but the pastel "lifts" it and imparts an attractive sparkle to the colours.

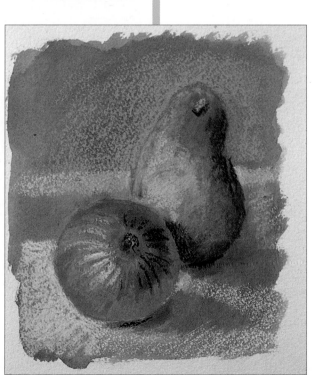

since when dry they can be used like pastels or coloured pencils, but when water is applied to them they become paints. You can combine them with watercolour or gouache at any stage of a painting. It is not unusual to see watercolour and soft pastel in harness also — this mixture is discussed under pastel (below).

Line and wash is the best known of all mixed-media watercolour techniques, and has quite a long history. British watercolourists began to exploit the full possibilities of the medium, in the seventeenth century when watercolour had mainly been used to lay flat washes over pen drawings. The traditional technique is still to make a drawing first and paint over it, but it is difficult to integrate the drawing and the colour so that the result does not look like a "colouring in" exercise. It can be more satisfactory to develop the line and the colour at the same time. Or you can work the other way round, first establishing the main composition with watercolour and then drawing on top.

Line and wash is an exciting technique with a great many possibilities for varied effects. You need not restrict yourself to pen drawing — you can use fibre or felt-tipped pens and hard or soft pencils as well or instead, and you can draw in several colours if you like. Some artists favour water-soluble ink, which runs in places where colour is laid on top, giving a contrast between crisp and soft edges. If you use felt-tipped pens, make sure that the ink colours are light-fast — some fade in quite a short time. You might also try combining line and wash with the masking fluid or wax resist methods described on pages 172 and 173-4.

OIL AND GRAPHITE

1 ◄ Pencil (or a graphite stick, which is darker and denser) can be used successfully with oil paint providing the latter is used thinly. Here the artist has used washes of paint diluted with turpentine.

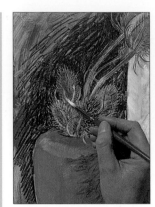

2 ► The thinned paint has dried quickly, and the graphite stick has been used to define the structure of the teasels.

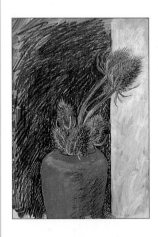

3 ◄ The element of drawing has been taken through the whole picture to avoid the disjointed effect that can occur in mixed media work. More oil paint is now applied to soften the lines on the vase.

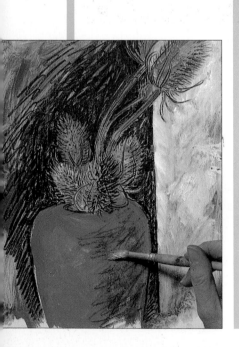

4 ▲ Fine lines of white oil paint complement the linear drawing in black, as well as helping to focus the eye on the painting's centre of interest.

5 ▲ The loosely scribbled drawing in the background, with the curving lines following the direction of the plants' stems, create a lovely feeling of energy and movement.

PASTEL WITH OTHER MEDIA

Pastel can, in theory, be mixed with any of the painting media, but the pastel/watercolour and pastel/gouache combinations are the most successful. Pastel painters sometimes lay initial washes for a picture in watercolour in order to establish swiftly broad areas of colour, but the two media complement each other and can be combined in a more direct way to exploit the contrast between the transparency of watercolour and the matt opacity of pastel. It is simplest to begin with watercolour, leave it to dry and then work pastel on top. You can then lay further washes over the pastel, overlay again with pastel and continue using a kind of layering process. Pastel can also be worked into a damp watercolour wash, which causes the granules to spread out, giving a distinctive texture.

► Philip Wildman
Rooftops
In this lively and inventive painting, pen has been used with gouache, a very different use of the traditional line and wash technique to the one shown on page 192. Instead of drawing first and "filling in" with colour, Wildman has overlaid line with opaque paint in places so that the two separate elements are fully integrated.

◄ Laura May Morrison
Margaret
The sgraffito technique (see page 154) has been used here, with oil pastel laid over oil paint, and scratched through in places to reveal colours beneath.

If you choose to use gouache and pastel, gouache is best used as a base for pastel work. Both are opaque pigments and so the textural contrast is slight, but you can play off areas of flat gouache colour against lively, more linear pastel marks. Acrylic can also be used with pastel, but this is trickier, since acrylic seals the paper and you can't use pastel over it as it tends to slide off the surface.

Pastel and charcoal are often used together, and form a sympathetic alliance because of their similar consistencies. For any subject that is to be relatively dark in overall tone, you can make what is in effect a monochrome underpainting in charcoal, which you then fix and work over in colour. You can also use charcoal at later stages of the work, either to emphasize linear qualities or to build up deep shadows.

Rather surprisingly, pencil can also be an interesting partner for pastel. However skilful you become with pastels, it is difficult to achieve really decisive lines with the soft, crumbly sticks, and some subjects demand touches of crisp definition combined with broader techniques. Even the softest pencil is hard compared to pastel, so don't attempt to use anything harder than 2B, and avoid building up the pencil marks densely or the slightly greasy quality of the graphite will resist the pastel.

OIL PAINTS WITH OTHER MEDIA
Oil paints have greater limitations for mixed-media work than watercolours, as you can't paint over them with water-based media. You can, however, combine oil paint and oil pastel very successfully, as they are

► Ingunn Harkett
Sarah
Charcoal and acrylic, both capable of broad, bold effects, have proved the ideal combination for this strong, expressive portrait. The acrylic has been used thinly; a thicker application would have made it difficult or even impossible to draw over with charcoal.

different versions of the same medium. Marks made with oil pastel on canvas or canvas board have a grainy, linear quality that can contrast well with the marks of a brush, and the texture can be retained if you overlay pastel marks with thin glazes (see page 153). Pencil can also be used over dry paint to add areas of linear definition or provide textural interest — for the best effect the paint needs to be fairly thin.

Another technique worth exploring is oil paint on paper, with pastel worked on top. Degas, who constantly experimented with new methods, and disliked the gloss of oil paint, evolved a technique called *peinture à l'essence*, which involved removing most of the oil from the paint by laying it on absorbent paper and then mixing the paint with turpentine to give it a matt consistency. He frequently painted on unprimed paper or cardboard, which absorbed any remaining oil.

A ground of dry oil paint makes an excellent surface for working on in pastel, and you can allow it to show through the pastel in places to provide textural and colour variations. You can also try scratching away some of the pastel with a razor blade to expose the ground colour. If you work on paper, you do not need to remove the oil from the paint. Oil on paper always has a matt surface because the paper itself absorbs most of the oil. There is, however, a danger that in time the paper will rot. So if you want your experiments to stand the test of time, follow Degas' procedure.

◄ Nick Swingler
Into the Forest
Swingler is intensely interested in colour and light, and uses a variety of media and technique to obtain his effects. Here he has combined oil, pastel and acrylic.

WATERCOLOUR AND PASTEL

There are no specific subjects which are particularly suited to mixed media techniques, so you could choose any subject for this project. You might begin by working in pastel over a discarded watercolour painting (watercolour paper is an excellent surface for pastel work). Alternatively, you might arrange a still life group, choosing some objects which have matt opaque colours and others, like glass and polished metal, which are shiny or transparent.

The usual way to start a watercolour and pastel painting is to lay the watercolour first, but you don't have to work in this way. Try using pastel first and then introducing watercolour later. Unless the watercolour is to be completely overpowered by the pastel use the paint in strong, positive washes. You should also experiment with using a dry brush technique which produces a broken effect that will combine well with the similar effects created by pastel.

When you have completed your painting see whether the two media have, in fact, been used in the way you would have predicted. Has the watercolour, for example, been used to describe the transparent or shiny objects, or in practice have you used pastel for some of these?

◀ David Ferry
Dorset Drawing
A strong linear framework, dramatic contrasts of tone and deep rich colours characterize this powerful work in pastel and ink. Ferry experiments with different combinations of media, and finds that these will often suggest new ways of visualizing an idea.

> **" Mixed-media work is a very open-ended thing. If a painting is going badly and you're having to fight it then its great to know there's another medium you can bring in...At some point something magic happens — through this sort of multiplicity of means there comes a kind of integration of the image. "**

Rosalind Cuthbert

Rosalind Cuthbert began her studies at Somerset College of Art, progressing to the Central School of Art and Design and then the Royal College of Art in London. She now lives in the West of England with her husband, also an artist, and divides her time between teaching and painting. She exhibits widely, with eight solo shows to her credit, and has won several awards. Examples of her work have been bought by various public collections in Britain, including the National Portrait Gallery.

Q I believe you work in almost every medium don't you?

A Well I certainly have worked in several. I love doing portraits, and I usually do them in oils or pastels. I've also done a fair bit of watercolour, including three solid years of what they call purist watercolour. It's an old-fashioned phrase, but it's still used — the idea is that you don't use any opaque paint — no cheating. My first two years after art school were spent painting watercolours on the kitchen table, because I didn't have a studio. Then when I got one I switched to oils, which I'd done a lot of at college.

Q Watercolour isn't usually taught in art schools, is it?

A Perhaps not. On my course most of us worked in either oils or acrylics. But you can do watercolour if you want — you can use any medium as long as you have your reasons for it and it seems to suit your style and subject matter.

Q So you more or less taught yourself watercolour?

A Yes. I learned a great deal in those two years after art school. In those days I was doing very realistic, almost photographic watercolours — not a lot of splashing about and working wet into wet. Then I switched to oils, starting with objects and moving on to portraits — I was obsessed with portraits for quite a long time. Finally I tired of doing nothing else and came back into watercolour. I have always loved drawing with charcoal, and began to involve charcoal with watercolour, working much more freely than before.

Q That seems an unusual mixture.

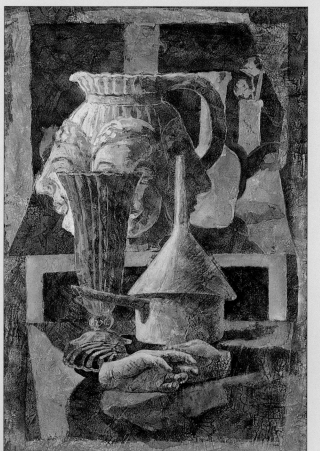

◄ **Still Life with Janus Jug**
A lively picture surface has been created by painting on a textured ground of acrylic medium and pigment with a mixture of watercolour and white ink.

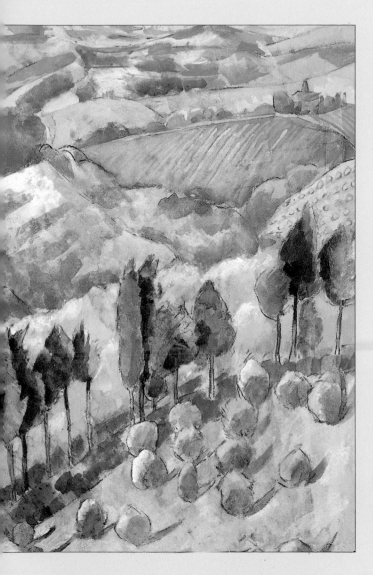

Q **Tell me about the portraiture. You have won prizes, haven't you?**

A I was just fascinated by it, and I got more and more drawn in because of winning prizes and "getting on". I had quite a few commissions, but then I found that I didn't enjoy painting to commission that much. It's a challenge in many ways, but in the end I began to feel that I didn't want this to be my life's work — there were other things I wanted to talk about in paint. I still prefer to do portraits just because I want to do them, without the constraints of a commission.

Q **I suppose there are bound to be constraints of some kind.**

A Yes, though I have done commissions I've enjoyed very much. I think if you find the sitter appealing it doesn't matter — you make a relationship after the first meeting, and there's something going on — invisible — which is interesting, and you become involved in the painting. But if you're less in sympathy with the sitter, it's far more tricky.

Q **Have you ever had to paint someone you felt you really didn't like?**

A No, funnily enough, even when it's someone I feel I shouldn't like, the act of painting them establishes a bond. I've never painted anyone who turned out to be really stroppy, though sometimes people haven't liked the finished picture.

Q **Let's talk about your mixed-media work. What got you started on it?**

A Well…let me think back. I was in quite a strange state of mind when I decided I had come to the end of my tether, at least temporarily, with portraiture. I did a lot

▼ **Still Life in Front of a Landscape**
Transparent and opaque watercolour with charcoal on a ground containing gum arabic.

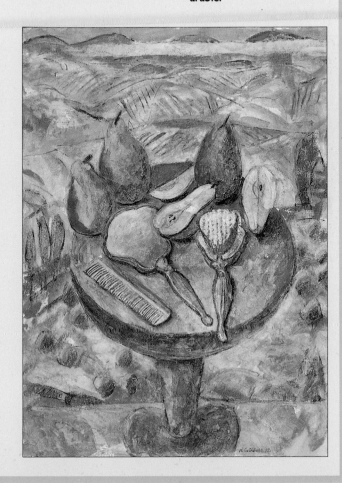

A I think people tend to use pencil or pen more often, but they're usually working on quite a small scale. Most of my watercolours are about A1 size, and I work with biggish brushes — not enormous, but appropriate to that scale, so charcoal seems a fitting

▲ **Tuscan Landscape**
Light touches of charcoal define details, while additions and overlays of white ink give the watercolour a slight opacity without sacrificing its luminous quality.

partner. A very soft pencil would be good too, but I'm drawn by nature to charcoal.

of printmaking and monoprints and also began to experiment again with still lifes. I've always been fond of still lifes, and I wanted to diversify, broaden out, after feeling that I had been going along a certain track for a long time. You come to a gate in the track and you go through and see there's a field there. The track vanishes and you're in a much broader space, facing fresh possibilities. I think this happened to me.

I do still do a straight watercolour, oil painting or pastel from time to time. All these media have intrinsic qualities which are their own, but once you bring them into relationship with another medium a conversation is set up, which can be full of surprises. I like this feeling of casting myself into an unknown situation and then going along with it.

Q So in a way you are having a dialogue with the media, and letting them suggest things to you?

A Often, yes, it does work in that way. I've been doing it for about three years now, and there are certain marriages of media I enjoy more than others and find perhaps more natural to me, but it's still a very open-ended thing. If a painting is going badly and you're having to fight it then it's great to know there's another medium you can bring in. If you're working in gouache, for instance, and it's not talking back to you, you can pick up charcoal, or acrylic or pastel, and bang away with that. At some point something magic happens — through this sort of multiplicity of means there comes a kind of integration of the image. That's what interests me about Cubism, painters like Braque, who were interested in combining all kinds of media. There's diversity of textures and colours, but the image is fully integrated.

Q How much pre-planning do you do before you start a picture?

A It varies — sometimes very little, but one thing I often think about in advance is the ground. I work mostly on paper, usually stretched paper, and I like to put on a ground of some sort, most often a gently textured one, consisting of acrylic matt medium

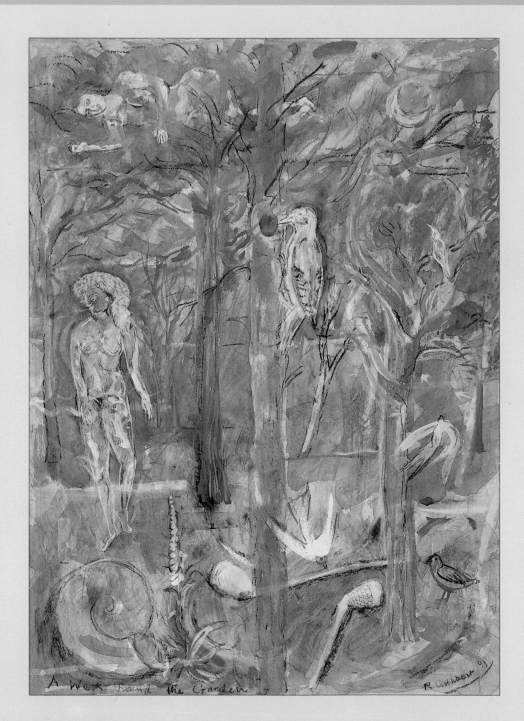

which is binding some sort of light powder — pure pigment or whiting — I use whiting a good deal. But even then I don't always know what I want to paint on it; it may sit around in the studio for some time before I decide. But on other occasions I'll decide on the subject first and then think it might be fun to paint it

◄ A Walk Round the Garden
In this poetic and dreamlike painting in watercolour and charcoal, real objects are combined with those drawn from memory and the imagination.

on such and such a ground.

To me, the ground represents the ground of being — emptiness — into which form, or subject matter, is integrated. I like to experiment with grounds, though there are some I come back to again and again. Acrylic texture paste is interesting — you can put it on with a palette knife, and you can make all kinds of textures in it.

Q **How do you actually go about your paintings? Do you work from drawings, or from an object in front of you?**

A Well, a combination really. For my still lifes obviously I tend to have things in front of me, but I will often introduce a note of fantasy or memory into that, and if I'm in that mood I can actually invent subjects and put them in with real, observed objects. For instance in *Still Life with Janus Jug*, the Janus jug

doesn't actually exist — it was an invention. I am really just extending the logic of a jug by putting faces on it — I'm interested in both faces and hands, and they tend to creep into my still lifes. I love painting *trompe l'oeil* plaster hands — like the clasped hands on Victorian graves — that sort of thing. I suppose I tend to look for a certain atmosphere around objects. But it doesn't have to be anything decorative and nostalgic — it could be something as unremarkable as an old saucepan.

Q **Do you work on one painting at a time, or have several on the go at once?**

A I usually work on one image at a time, which will sometimes take me an afternoon and sometimes a week. But I find it hard to be categorical about how I go about things — because really I work as the spirit moves me. As soon as I say I usually work in such a way I can immediately think of exceptions. I tend to work thematically, though — I'll do a series of still life paintings and then think it might be interesting to try landscape.

Q **I imagine you have to give yourself scope to explore a theme thoroughly.**

A Yes, I think you have to stay with it. It's the same for a medium. When I was working in oils I did so for a long period, and I may go back to it. And now it's mixed-media, and I'm finding that all these different sides of myself are coming together, which is very rewarding. There was a time when I felt I was being too diverse — there were all these things I loved to do, and I felt torn, but now I've brought them all together.

Q **Your subject matter seems to cover a wide area. Is there anything you don't like to paint?**

A For a long time I didn't like landscape painting — I didn't feel there was anything there for me. But last year I went to the Italian lakes and the mountains really woke me up to landscape, so that's something I'm exploring now. It's such a new subject for me that I'm going to have to spend a while working with it before I know what I want to do with it. So that's what I shall spend the next year or so doing.

I've already got two particular loves, one being Tuscany and the other mountains — a complete contrast.

Q **Can you tell me something about your working routine. Do you work every day when you're not teaching?**

A I don't have a routine as such, but I make sure that whenever I can work I do. I don't wait for inspiration to strike.

Q **Most of the artists I've talked to have said the same — you have to regard paintings as work.**

A That's right. Even Matisse said it's ninety per cent perspiration and ten

▲ Still Life with Pinks
Opaque and transparent watercolour on a ground of whiting, raw umber pigment and acrylic matt medium.

per cent inspiration. You can't wake up in the morning and think "Oh I shan't do it today, I don't feel like it". But actually there are very few days when I don't feel like painting. I've always got ideas about what I want to do — life isn't long enough, that's my main problem. But I do think that work generates ideas, and if you are idea-less then you do have to discipline yourself — do something. Just put up a still life and do a drawing — anything to get you going.

Collage

Collage is a term that embraces a wide variety of artistic activities and many different approaches. Dictionaries define it as a method of cutting and pasting paper to form a design, and so it is, but it can also be a truly creative process worthy of the attention of serious artists.

Collage first became a distinct art form in the Cubist period, with the work of Georges Braque (1882-1963) and Picasso, both of whom added pieces of newspaper, stamped envelopes, theatre tickets and so on to their oil paintings. Including "pieces of reality" in this way stressed the existence of the picture as an object in its own right rather than simply an illusion of the three-dimensional world. Because collage is a method that allows unusual juxtapositions, it was also much exploited by the Surrealists, notably Max Ernst and Kurt Schwitters (1887-1948) who was fond of incorporating rubbish like bus tickets and shoe soles in his pictures. A different use of it, a celebration of pure colour and pattern, was made by Matisse; when he became too ill to hold a brush he was still able to cut and paste coloured paper to form some of the most marvellous works of art ever seen, many of them on a grand scale.

COLLAGE ON PAPER

Art teachers will often encourage school children to make collages, as it is great fun and requires no painting and drawing skills, produces quick results, and introduces basic principles of picture-making and design without the inhibitions imposed by overteaching. In this context it is a fairly lighthearted activity, but Matisse's work showed that paper collage can achieve results which compare favourably with any conventional painting method.

Many fine artists now work in this field. Some, like Matisse, paint on or colour their own papers before cutting (he used gouache paints to achieve large areas of vivid, flat colour). Others exploit the contrast between different ready-made materials such as wallpaper, wrapping paper, pieces of fabric and thread and plain, matt cartridge paper, often juxtaposing these with areas of watercolour, inks or pastels. One of

PAPER COLLAGE

1 ▲ The artist has begun by making an outline drawing on the piece of cartridge paper he will use for the base of the collage. This enables him to gauge the sizes and shapes for the first collage pieces. Notice that he tears these rather than cutting them, as this provides a livelier edge.

2 ► With the large pieces in place, he can then consider the smaller details, such as the figure cut from a magazine photograph. This was chosen for its drapery-like effect.

3 ► Only the larger elements have been glued down at this stage. This enables the artist to move the smaller components around until he is happy with their position.

4 ► Sometimes collage material presents itself quite naturally, as in this case, where the close-up of a soluble painkiller provided the perfect sun motif.

5 ▲ As you can see from the finished piece, the contrast between cut and torn edges can be an important element in paper collage work, much like hard and soft edges in painting.

the many delights of this art form is that it allows you to exploit surface textures in a way that is seldom possible with paint alone.

Paper collage can also be used as a stage in painting, to plan a composition and try out various different arrangements of shapes and colours. This was a method taught to Picasso (1881-1973) by his father when he was a young student, and it is very helpful — a great deal quicker and more direct than making a series of sketches. In a portrait, for example, you can cut out some basic shapes for the figure and some for other elements you might include, such as windows, doors, pictures on the wall behind the sitter and the chair he or she is sitting on. These can then be moved around on a sheet of plain paper until a satisfactory arrangement is found.

MATERIALS AND METHODS

The ingredients for collage on paper can be more or less anything you choose, the only technical restriction being that the materials can be glued to the paper which is used as a base. Collage "painters" develop a magpie mentality, collecting and saving any likely-looking fragments until they have assembled an extensive personal "palette". Unfortunately, you won't really know what you might need until you have carried out some experiments of your own, but once you become aware of the potential of this form of picture-making you will begin to see possible materials all around you.

Collage does not, of course, have to be done on or with paper. The first instance of collage used with oil paint was in 1912 when Picasso stuck a piece of oilcloth into a painting to represent a cane chair seat. Wet oil paint is sufficiently adhesive to secure a variety of different collage materials, particularly if it is used thickly, which opens up wider possibilities. You can incorporate substantial materials such as metallic foil as well as a variety of natural objects. Acrylic is also suitable for use with collage, and modelling paste, one of the mediums used for acrylic work (see page 165) allows you to fasten quite heavy objects securely to the picture surface.

▲ June Ferrar Sullivan
Silk City I
Here too, the torn and cut edges of the paper are of great importance, giving a taut linearity to the composition. Instead of using existing coloured paper, as in the demonstration, Sullivan has painted her own collage components with watercolour, laying loose, fluid washes over the glued-down paper.

WORKING METHODS

Although exciting and imaginative collages can be made with no technical expertise or conventional painting skills, the most successful are the result of careful planning. In a sense, collage is a more intellectual exercise than simply painting what is in front of you because with collage you can't depict what you see. You have quite deliberately tried to translate what you see into a variety of pre-selected colours and materials which will evoke the subject.

It is thus a good idea to make some thumbnail sketches before you begin, and, if you are working on paper, to draw out the mainlines of the composition on your working surface before you begin to cut and assemble the pieces. This does not rule out the possibility of changing your mind as you work; collage always has an element of surprise, and you can never be sure of the effect of a certain juxtaposition until you have tried it. The pieces need not be glued down until you have tried out a variety of arrangements, and rejected some of the materials originally chosen in favour of others.

◄ John A McPake
Moscow: Architecture
Fragments of drawings juxtaposed with areas of texture, jewelled colours and lavish use of gold paint express the atmosphere of a city in which golden domes jostle with grim urban blocks.

► David Ferry
Sizewell Series
Ferry frequently makes use of photographic material, or photocopies of photographs, in his collage work. In this powerful and suggestive composition based on a nuclear power station, man-made structures are dwarfed and threatened by the unleashing of powers beyond the control of man, represented by the menacing sweeps of black cloud and fire.

PAPER COLLAGE

If you have not attempted collage before you may find it easiest to begin by basing your first attempt either on a subject you have already painted or on a photograph. Look for a subject with a variety of shapes and colours such as a street scene with buildings and people, or perhaps a still life with a several different objects providing a strong pattern.

Using a sheet of good-quality cartridge paper, white or coloured, make a guide drawing on it to help you place the cut shapes. If you use coloured paper you can leave parts of it incorporated in either the objects or the background.

Shapes can be cut out if you want a neat, precise effect or they can be torn to produce a free shape. The contrast of buildings and trees, for example, could be expressed using torn paper for the tree shapes and cut paper for the buildings. Cut the largest shapes first, and when you are satisfied with these move on to the smaller ones. Don't forget that you can paint or draw over the cut paper shapes, so if the collage seems to need some extra definition or more textural contrast when you have glued down the pieces, experiment with different drawing and painting materials to see how you can improve it.

Most work in collage has a strong pattern element. Don't worry about your collage not being realistic and don't try to make it imitate painting. Allow its potential for making a strong abstract statement to develop and don't use the drawing and painting media merely to superimpose a realistic foreground on an abstract background.

◀ Jack Yates
Three Figures
This lighthearted but elegant collage, for which the artist has combined drawing and painting with pieces of fabric and textured paper, makes an interesting contrast with Ferry's more serious work opposite. Collage is a highly versatile technique, allowing for many different interpretations and treatments.

" I collect papers wherever possible…But I buy a lot of good-quality Japanese paper too; I have to try and forget how much it costs when I'm tearing it up… The floor of my studio is covered with paper, almost like a carpet — a magic carpet "

Barbara Rae

Barbara Rae studied at Edinburgh College of Art in the 1960s, and in 1966 won a travelling scholarship to France and Spain. She has exhibited widely since leaving college, with over twenty solo shows to her credit. In 1975 she was elected to membership of the Royal Scottish Society of Painters in Watercolour (RSW), and in 1992 to the Royal Scottish Academy (RSA). She has won a number of prestigious awards, and has work in commercial institutions and public and private collections in Great Britain, Europe and America. She lives in Edinburgh and teaches at Glasgow School of Art.

Q When did you start working in collage?

A When I was a student, I did a lot of printmaking- silkscreen, lithography and etching- and I was a very bad printer. So I started tearing up the prints and collaging them together, and eventually the collage element became part of the paintings.

Q Do you now work mainly in collage?

A No, I work a good bit in watercolour and mixed media as well. But my large- scale pieces are invariably collage.

Q Your paintings have strong abstract qualities, but they are obviously based in the real world. What do you look for in terms of subject matter?

A Well, I think if I have to condense it into a single idea I'd say that it is the effect of people on the landscape — a garden, for instance, where there's a man-made structure such as a wall or doorway. Or it's the quality of land that's been worked over and over again. I was painting in

Tuscany recently, in autumn when the land was being ploughed, and that's what I was interested in — the way in which the fields had been shaped over centuries. In Scotland what I tend to look for is the feeling you get in several places on the west coast where people have lived but are no longer there. But some of the things I do are concerned with the people who still are there, for instance the fishing industry and peat cutting. I did a lot of sketching at the Leith docks, which is the subject of *The Russian Ship* — these ships used to come in and out quite often.

Q Are there any artists who have influenced your collage work?

A I'd have to say Kurt Schwitters, and when I left college I became aware of Tàpies' work — the various textures that he uses — that's a strong influence too. And John Piper — I think he did collage at one time, but the way he paints suggests it might be collage; he uses a lot of contrasting textures.

In terms of painting in general I have quite a long list of people I admire, with Matisse at the top. It's odd, but

when people ask me about my "favourite painter" he tends to slip out of my mind, but he definitely is my favourite. When I was at college I was looking at English painters a lot — artists like Paul Nash, Graham Sutherland and Ben Nicholson. But I was probably getting more subliminal influence from Scottish artists, because they were always around. William Gillies, for example, was principal at Edinburgh College when I was a student, and I think his way of looking at landscape has had an effect on me.

Q Your collages are obviously not done directly from the subject. Do you make small preliminary sketches on the spot?

A Yes, I have a great many sketchbooks. That's always the first step; I go out and make mixed-media studies from the landscape first. Then I'll come back with a series of drawings and studies from, say, the west coast, where I paint a

▶ **Rooftops, Capileira**
In places, the papers are encouraged to wrinkle, providing additional surface interest.

◄ **The Russian Ship**
The layering of paper, paint and medium creates marvellously rich and complex effects.

— a more sustained piece, looked into more carefully.

Q On the purely practical level, how do you go about a collage piece? How do you begin?

A I normally work on a large piece of heavy board — very large in some cases, for instance *The Russian Ship* is 6 feet (182.9 cm) wide, I start by looking at the image I'm going to translate, but after that I may not refer to it much, because I'm interested in creating something different. I always begin with the paper, so I tear up some, or pick some up from the studio floor, glue it onto the board, and then just go on selecting different kinds of papers and layering them onto the board. I use a lot of mediums too, like acrylic gel medium and PVA, and their different thicknesses also create layering effects. I don't put the paint on until the paper is in place, but I like to start using the paint when the medium is still wet, or semi-dry, so that it all blends together —

lot, and then I may do another series of paintings, simplifying and refining my attitude to the landscape, and trying a subject out in different colours and slightly different compositions, I might not take a subject any further than a mixed-media watercolour piece, but in some cases I'll translate a painting through collage and make something quite different. Once I've had a series of paintings and studies in the studio for a while I'll see that something about one of them — colour, tonal values and so on — suggests that it needs to be on a larger scale

becomes part of one thing. One of the problems with collage is that it just tends to look stuck-on — I prefer it to be really integrated.

▼ The Lily Pond in Winter
Rae now reserves oil paint for small pieces, but for this large collage both acrylics and oils were used.

Q Do you use oil paint or acrylic?

A At one time I used oils, and I still do sometimes for smaller pieces. But I use mainly acrylics now, and there's a good reason for that. When I was in America, working in a big studio and using acrylics, I began to paint with my large canvases or boards on the floor rather than upright. This lets you use really fluid paint with lots of water — the acrylic colours I buy come in bottles and are more liquid than ordinary tube colours. Then I came back to Scotland and began working on big pieces like *The Lily Pond in Winter*, starting with acrylics and then oils on top. But it became impossible — I was throwing buckets of turpentine down to try and make the oil paint move around, and that was really dangerous.

Q I imagine you have a large stock of papers on hand for the collages.

Do you pick up likely pieces whenever you see them?

A Yes, I do collect them whenever possible. Also I've just finished doing two lithographs, and I got a couple of the bad prints — I've already started ripping them up — the colours are marvellous. But, I buy a lot of good-quality Japanese paper too; I have to try and forget how much it costs when I'm tearing it up. Even worse, when I'm working I'll tear off a piece and throw the rest on the floor, and then it gets covered with paint and walked on. The floor of my studio is covered with bits of paper, almost like a carpet — a magic carpet — and I have to crawl around searching for a prime piece — it's really annoying when you finish a favourite paper.

Q How long, on average, does it take you to do a collage painting?

A It depends, but they can take a very short space of time — it's basically a fast process. I like to get the paper and paint put on in one day, and then go away so that I'm not tempted to fiddle about while the paint is drying.

◄ Pink Earth, Orgi
Although most of Rae's work is semi-abstract, the shapes and colours of the Spanish landscape are clearly recognizable here.

▼ Lanjaron Field
Rae's preoccupation with the interaction of man and the landscape is particularly evident in these two Spanish paintings.

Because of the mediums I use, I can't really see what's happening until the whole thing has dried; the PVA is white when wet but then it becomes transparent, and this changes the colours. If it isn't right I may filter in some more colour the next day.

There are some paintings that take longer, though, because they have a more elaborate series of changes in the paint quality — many more layers going to make them up. These can become much darker in tone as I build them up, so I need to put lighter colours on top. Sometimes I use irridescent paint over black, which gives an interesting quality of light. Also I use gold paper, and oil pastel on top of paint — all sorts of different things.

► Dry Dock, Leith
This collage, in which a ship's hull dominates the composition, was based on sketches made at the dockyards.

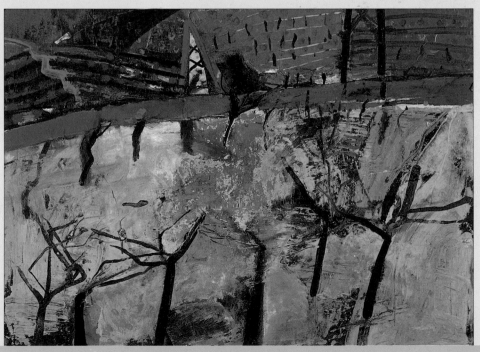

Monoprints

Monoprints, or monotypes as they are sometimes called, are a fascinating cross between painting and printmaking, and they are enjoyable and easy to do. The invention of the monoprint is usually credited to a seventeenth-century painter and draughtsman, GB Castiglione (c. 1610-65), and it came into prominence again in the nineteenth century, when it was marvellously exploited by Degas. The basic idea is simple. A drawing or painting is made on a glass slab or some other non-absorbent surface, using printing inks or oil paints. This is then transferred directly to a sheet of paper by laying the paper over the slab and rubbing with the hand or a roller. There are two types of monotype — the painted monoprint and the rolled slab monoprint — but the many variations within these two kinds of print create an almost unlimited range of effects.

PAINTED MONOPRINT

This was the type of monoprint pioneered by Degas, who was fascinated by all branches of printmaking. He worked mainly on glass in monochrome with printing inks, but you can use oil paints and then there is no restriction on the number of colours you can incorporate into one print. Painting on glass takes a little practice, as it is a much more slippery surface than those normally used for oil painting, and you will also have to experiment to find the right consistency for the paint. It needs to be fairly juicy but not so thick that it will smudge and smear. Avoid allowing the colours to mix too much on the glass, or the print may look confused and muddy. It is easy enough to correct mistakes, however, simply by wiping down the slab.

You may also need to try out different papers — in any printmaking process the texture of the paper is an integral part of the finished print. You could start with smooth cartridge paper, which is easily available, and then try one or two of the more absorbent surfaces sold specially for printing work. Experimenting is part of the excitement of the monoprint process, which is always to some extent unpredictable.

Some exponents of this technique like to build up the colours in separate layers in several stages of

ROLLED-SLAB MONOPRINT

1 ◄ In this version of the method, lino-printing ink or oil paint is rolled evenly over a smooth surface. This can be a piece of formica or metal, or plate glass, as here.

2 ◄ Paper is then placed face down on the ink or paint. Fine Japanese printing paper is used here, but you can experiment with a variety of different surfaces and colours.

3 ◄ A drawing, which can be as simple or elaborate as you like, is then made on the paper. The drawn lines will pick up the ink below and produce a "printed" impression.

4 ◄ The paper can be pulled back as you work so that you can see how the image is forming. If you want to strengthen the drawing or add more detail, simply replace the paper.

PAINTED MONOPRINT

1 ► This is the method used by the artist whose monoprints are shown on pages 214-5. She paints on a sheet of light metal, which she prefers to glass because it is easier to see what she is doing.

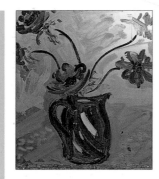

2 ◄ With the painting complete, she first wets the printing paper (ordinary cartridge) all over with turpentine, and then places it over the painting and rubs it with a turps-soaked rag. Usually, hand pressure is enough to produce a print.

3 ► The print is now peeled off. As in the rolled-slab method, it can be replaced if necessary, and further pressure applied to areas that have not picked up the paint.

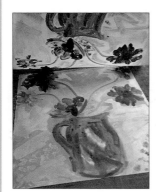

4 ◄ When the print is thoroughly dry, it can be worked into with pastels, oil pastels, or more paint.

▲ David Ferry
Binocular Vision Series
Provided you use a good-quality paper you can work into a monoprint as much as you like. Here a mono-chrome rolled-slab print on cartridge paper has been given additional colour overlays.

printing. In this case you will need to have a system of registration to ensure that the paper goes back in the correct position each time, but this can be simplicity itself. All you need to do is to fix one side of the paper firmly to the slab with two pieces of adhesive tape, you can then simply turn the paper back for the first printing, assess the results and then add more colour to the glass before returning the paper to its original position on the glass for the next "pull". You can achieve interesting effects by this layering method, as the paint builds up on the glass to impart different textures to the print. Further texture, pattern and definition can be added if you like by scraping into the paint with a sharp point, to produce fine white lines.

ROLLED SLAB MONOPRINT

The second basic method involves covering the whole slab with a thin even layer of ink or paint — it is best to apply it with a roller — and then placing the paper on top and making a drawing with a pencil or other

2 ▲ This photograph shows a second printing stage, after the paper has been replaced on the inked slab and further drawing done — this time with a screwdriver.

TWO-COLOUR MONOPRINT

1 ◄ This is the same basic method, but with several stages of printing. The artist begins by cutting a stencil, which he places on the inked slab, with the printing paper on top. A comb is then dragged over the paper to produce a hatching effect.

3 ◄ A second colour is now introduced. The printing paper is held at the top with a strip of masking tape so that it can be replaced in exactly the right position.

4 ▲ The finished result shows the sophis-ticated effects that can be achieved by this simple, "kitchen table" printmaking method.

implement, on the paper. Theoretically, only the drawn lines will print, but some of the ink will come off onto the paper in other places and if you touch the paper with your hand this will also register on the print. This accidental printing can, in a random way, give an attractive textured background and any accidental effects can often be exploited. Accidental marks also add charm and spontaneity — thumbprints are a notable feature of Degas' prints. Again, you may like to try out different kinds of paper; some printmakers use a very thin, Japanese paper, which is particularly suitable for fine, linear effects, and is transparent enough to allow you to see the image developing as you draw.

There are many variations on this method. You don't need to use pencil for the drawing — a wide variety of different marks can be made by implements such as combs, wire brushes, paintbrush handles, and, of course, your fingers. You can also overprint your first print in other colours, using the registration method described above and re-rolling the slab, or selected areas of it, in another tone or colour.

Yet another variation, which is really a cross between both types of monoprint, is to draw the image directly in the rolled-out paint and then lay the paper over it to print it. This will produce a negative print, as the drawn marks will be white. The implement you choose to draw into the paint will depend on the effect you are seeking. For broad, sweeping lines you could use a stiff paintbush or a finger, and for finer ones, a paintbrush handle, the point of a pencil or even a screwdriver. You can also try applying the paint more freely to the glass, using brushes instead of a roller, so that the brushmarks contribute to the finished print.

Whichever method you favour, you need not regard the print you produce as the end product. You can work into monoprints with any other media, such as pastels, oil pastels, oil paint, coloured inks, pastel or crayons. If you intend to do this however, don't use too thin a paper. High-quality cartridge paper will produce a good surface for both the print and the subsequent painting.

One of the beauties of a monoprint is that you can take one subject and treat it in a number of different ways. Look through your sketches and see if you can find one that you think will translate well into a print — perhaps a figure sketch or still life drawing made for one of the projects in Part One of the book. Try the painting on glass method first (you can place your sketch under the glass slab to act as a guide for the painting if it is going to be the same size). When you are satisfied with the painting, place the paper on top, fix one side with two pieces of adhesive tape and rub the paper gently with your hand all over before turning it back on its "hinges". If the print is too faint, replace the paper and apply more pressure with a roller.

Now try the rolled slab method for the same subject. You can't put the sketch under the glass this time, so prop it up in front of you so that you can refer to it as you draw. You can turn the paper back at any stage to see how the work is progressing, but don't let the paint become too dry or it will not print — it should be just tacky. If you are not happy with the drawing, try scraping into the paint in places or darkening some areas by rubbing your finger over the paper. When you have finished the print, pin it up to dry and consider whether you might improve it by painting or drawing on top of the printed image.

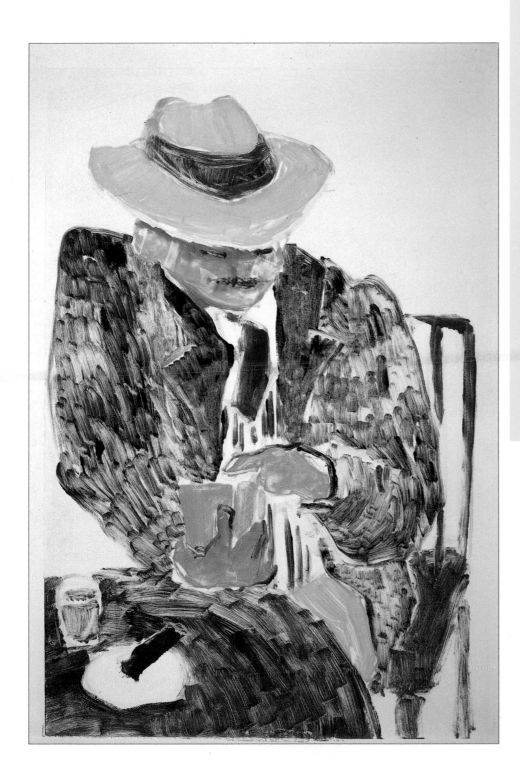

◄ Carole Katchen
The Gambler
In a painted monoprint, the paper picks up the top layer of oil paint, so that the marks of the brush are very obvious, and become an important part of the image. Remember this when you are doing the painting, and take care not to overwork.

MEDIA AND METHODS

> **"** You can work yourself to death on a painting, but monotype has a kind of immediacy that I find very seductive. It forces you to be bold…it's like jumping into a pool when you first begin to swim. **"**

Kay Gallwey

Kay Gallwey entered the City and Guilds School of Art in London at the age of fifteen, and later won a scholarship to the Royal Academy School of Painting. She has worked as an illustrator, costume designer, and portrait painter, and still undertakes portrait commissions, though devoting much of her time to still lifes and flower paintings in oil and pastel. She exhibits regularly at the Pastel Society annual shows, and has held two one-person shows at the Catto Gallery, London.
In addition to a prolific output as a painter, she also writes and illustrates children's books.

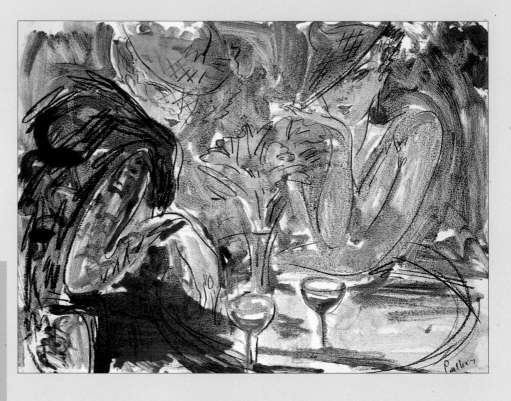

▲ Conversation Piece
The brushmarks and textures form an integral part of the composition, giving a lively sense of movement.

Q **When did you start doing monoprints? What led you to them?**

A *Monotypes* — I always call them monotypes. I don't like the term monoprint, because they aren't really prints; they're something quite on their own, quite different. I think I started about fifteen years ago — before that I hadn't even heard of them.

Q **But you must have seen Degas' monotypes?**

A Yes, but until I bought this marvellous book called *The Painterly Print,* which is all about monotypes, I didn't know that's what Degas was doing. You can't always tell, because he used pastel on top such a lot.
My monotype method is actually not the same as his — he came to it through printmaking, and used printing inks, whereas my method has evolved through oil painting. Do you remember at art

school, when you got stuck with a painting you used to put a sheet of newspaper or sugar paper over it and blot off most of the paint so you could start again?

Q **Yes, tonking — a very useful method.**

A That's right. Well that would create an image on the paper — it often looked much better than the painting itself, which was usually pretty awful by that stage. I didn't realize it at the time, but that was a monotype, and that's more or less how I make mine now, except that I paint on a

sheet of metal or Formica instead of canvas.

Q **What makes you decide to do a monotype one day, rather than an oil or pastel?**

A Often there's a very mundane reason. If I've been doing an oil I usually have a lot of colours left on my palette, and I want to use them up — it's as simple as that.

But also, of course, it's a change from painting. You can work yourself to death on a painting, but monotype has an immediacy that I find very seductive.

Q **Are there some subjects that you think would work better as monotypes?**

A Not really — mostly the subject matter is the same as in my

paintings, but occasionally monotype does seem perfect for something. For instance I was doing some illustrations for a children's book recently — a cat book. Small children need very simple images, but using monoprint I was able to get a variety of different textures and a lot of interest all over the pictures. Although it's such a simple process,

▲ Flowers in a Black Vase
Here the paint has been applied very evenly to produce vivid, flat colours, which provide a background for the lively pastel drawing made on top of the print.

◄ Red Flowers
The attractive textures produced by the monotype method are particularly evident in the lower half of the picture, where the colours have also been encouraged to bleed into one another. When the print was dry, touches of crisp drawing were introduced with the point of a pastel stick.

the results are surprisingly sophisticated to look at.

Q You mentioned texture. Presumably monotypes provide effects you couldn't get in a painting.

A Yes they do, and what's exciting is that you never really know what will happen. Of course you can control things to some extent, and you can change them afterwards. A friend of mine who sometimes works in my studio did a black cat — and then next time I saw her it was a white cat. She'd worked into it and completely altered it.

Q Do you always work into the prints?

A Usually, yes, but to varying degrees. Sometimes I'll put a lot of pastel on, like Degas did, but often I just describe the shapes with a simple line drawing — more like Matisse. It very much depends how the print comes out, because it dictates to you what to do afterwards, but it's important not to kill it — you can very easily.

Q How much control do you have over the print?

► **Flamingoes**
For most of her monotypes Gallwey uses a sheet of metal for the painting, but for this large work she used a glass slab, weighting the printing paper down with books.

A Well, you have a good deal — you soon find out the different effects you can make by using the paint thick or thin, or using a lot of turps on the paper. You can get quite flat effects, like a real print, by using the paint very evenly, leaving a small gap between the colours so that they don't bleed into one another, and then laying down the paper very carefully. Some artists use printing inks, not paints, if they want this kind of result — inks don't hold as much oil. But I usually like a looser, more painterly effect, where the flow of the colours creates its own illusions. In the *Flamingoes*, for instance, I wanted a watery look — the birds are standing in water after all — so I splashed turps all over the place. You dollop some on and then lift up a corner, and this makes the turps run down the paper. You can see what you're doing, but most of the time it's still a surprise — sometimes doing a

monotype will completely change the way I'm looking at something.

Q And of course the image is reversed
too, which makes it look unfamiliar.

A Yes, that can be very confusing if you've been working from a photograph or
something in front of you, like a vase of flowers. When you want to work into the print you can't go back to the original — you have to have the

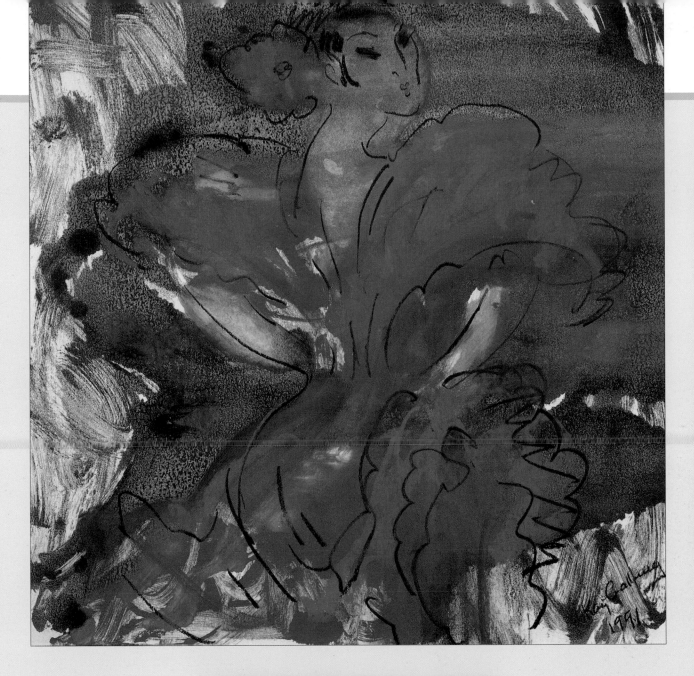

courage of your convictions and just draw — go along with what the print suggests instead of doing something you'd planned in advance. Monotype forces you to be bold — it takes things out of your hands in a way. It's completely different to sitting down with a pencil in your hands and working out a painting — it's like jumping into a pool when you first begin to swim.

Q **It's obviously a great thing to do when you're feeling stuck — and good for amateurs, who often feel nervous about starting a painting.**

A Yes, because it's easy as well as exciting, and you always get an interesting result. But it's perfect for everyone — professionals, amateurs, children. I used to get my daughter and her friends to do poster-paint monotypes when they were about five years old — they loved it, and by the time their mothers came to collect them there were pictures everywhere. It just is fun — no one can possibly not enjoy it.

► Nude Study
The degree to which the print is worked into afterwards is dictated by the print itself; here the pastel drawing is more extensive than in the other examples.

▲ The Spanish Dancer
The soft, fluid merging of colours above the dancer's shoulder and below her right arm is achieved by liberal applications of turpentine. Gallwey's monotype method is demonstrated on page 211.

217

Glossary

ADVANCING COLOURS ~ Colours that appear to come towards the front of the PICTURE PLANE. The colours that have this property are in general the warm, strong ones, such as reds and bright yellows.

AERIAL PERSPECTIVE ~ The effect of colours and tones becoming paler and colder as they recede from the viewer, with diminishing light/dark contrasts.

ALLA PRIMA ~ Literally translated, this Italian term means "at first", and refers to paintings completed during one session, with each colour laid on more or less as it will appear in the final painting. The Impressionists worked in this way, in contrast to the academic painters of the 19th century, who built up their paintings layer by layer over a monochrome UNDERPAINTING.

BACKRUNS ~ in watercolour painting, jagged-edged blotches will sometimes occur when new paint is added into a wash that has not fully dried. Backruns can look unsightly if the colour area is intended to be flat, but they can be an attractive feature of a painting, and are often induced deliberately by watercolourists who paint WET INTO WET.

BINDER ~ The liquid medium that is mixed with PIGMENT to form paint, or pastel sticks. The binder used for watercolour is GUM ARABIC; oil paints are bound with oil, acrylics with a synthetic resin, and pastels with gum tragacanth.

BLOCKING IN ~ The first stage of a painting, in which the main areas of TONE and colour are laid in broadly, to be refined in the later stages.

BODY COLOUR ~ A term exclusive to watercolour painting, meaning opaque water-based paint. It sometimes refers to watercolour mixed with Chinese white, but is also used as an alternative term for gouache paints.

BROKEN COLOUR ~ A slightly imprecise term sometimes used as a synonym for OPTICAL MIXING. In fact, broken colour simply means colour which is not laid as a flat area and does not completely cover another colour below, or the colour of the canvas or paper.

CANVAS ~ A heavy woven fabric, the most commonly used SUPPORT for oil painting, and also frequently used for acrylics.

CHIAROSCURO ~ An Italian word meaning "bright-dark", used in connection with the exploitation of strong light and shade in a painting.

CHROMA ~ The term used to describe and measure the purity of a colour. Pure red or blue, for example, are high on the chromatic scale, while neutral grey contains no chroma.

COLOUR FIELD PAINTING ~ A type of abstract painting making use of large areas of flat, unbroken colour. Colour field painting was developed in the USA in the 1940s and '50s.

COLOURED GROUND ~ Artists working in the opaque paints (which includes pastel) often colour their GROUND before painting. In oil and acrylic, this is usually done by applying a thin layer of paint over a white PRIMER, though some mix pigment into the primer itself. Pastel painters either work on one of the coloured papers specially sold for the purpose or prepare watercolour paper by laying a light wash of colour.

COMPLEMENTARY COLOURS ~ Pairs of colours that appear opposite one another on the colour wheel, such as red and green, and voilet and yellow. When juxtaposed in a painting they create powerful effects.

DEPTH ~ The illusion of space in a painting.

DILUENT ~ Liquids used to thin down paint, such as turpentine or white spirit

for oils and water for the water-based paints.

DRY BRUSH ~ A technique of applying the minimum of paint to the surface, usually with the bristles of the brush slightly splayed out. The method can be used in any of the painting media, but is perhaps best known in the context of watercolour, where it provides a means of describing textures such as hair or grass.

EGG TEMPERA ~ see TEMPERA

ENCAUSTIC ~ Paint made by mixing pigment with hot wax, common in ancient Egypt and the Classical world, and now enjoying a revival of interest.

FAT OVER LEAN ~ The traditional way of building up an oil painting; beginning with thin, non-oily paint (lean) and increasing the thickness and oil content as the painting proceeds. For any painting built up in a series of layers, this is very important. Thick, oily paint takes a long time to dry, and shrinks slightly in the process. If lean paint is used over this, the top layer will dry first, and may crack as the lower layer shrinks.

FIGURATIVE PAINTING ~ A painting of something actual, as opposed to an abstract painting. The word does not imply the presence of human figures.

FIXATIVE ~ Thin varnish sprayed onto a pastel drawing or painting to prevent the pigment smudging and slipping off the surface. Some pastel painters use fixative at regular stages during a painting, while others never use it it all. It has a tendency to darken the colours.

FROTTAGE ~ A technique akin to brass-rubbing, in which a piece of paper is placed over a textured or indented surface and rubbed over with a soft pencil, crayon or pastel stick. Designs or textures created in this way are often used as an ingredient in collage work.

FUGITIVE COLOUR ~ A colour which fades on exposure to light. Nowadays, most paint manufacturers mark their paints with a code denoting the degree of permanence, and very few colours are truly fugitive, though some have a tendency to fade.

GENRE ~ 1 A term used to describe paintings depicting scenes from domestic life, most commonly associated with 17th-century Dutch painters.
2 A category of art, for example, landscape, portraiture and still life are all genres of painting.

GESSO ~ Originally, the brilliant white ground used to prepare a surface for painting and gilding: a chalky pigment mixed with glue and applied to a panel in several successive layers. Gesso grounds are still used by artists who paint in TEMPERA. The preparation known as acrylic gesso, sold for preparing canvases and boards for oil and acrylic painting, is not true gesso, and seldom requires more than one or two coats.

GLAZING ~ A technique of applying oil or acrylic colour in thin, transparent layers so that the colour beneath shows through, modifying the colour of the glaze. Overlaid washes in watercolour are sometimes described as glazes, but this is misleading, since all watercolour is transparent.

GLUE SIZE ~ see SIZE

GOLDEN SECTION ~ A system of organizing the geometrical proportions of a composition to create a harmonious effect, known since ancient times, it is defined as a line which is divided in such a way that the smaller part is to the larger part what the larger part is to the whole.

GROUND ~ A layer of paint or other substance which isolates the SUPPORT from the paint placed on top. A ground is necessary for oil painting because

without it, the oil from the paint sinks into the surface of the canvas or board and eventually causes the fibres to rot. See also COLOURED GROUND.

GUM ARABIC ~ The medium used as a BINDER for watercolour PIGMENT. Mixed with water, the gum can also be used as a painting medium. It enriches the colours and makes the paint less fluid.

HARMONIOUS COLOUR ~ Colours that are close together on the colour wheel (i.e. blues and violets, reds and yellows) and thus do not set up sharp contrasts.

HUE ~ The type of colour, on a scale through red, yellow, green and blue.

IMAGE ~ A term used to describe either the particular subject being painted, the painting itself, or a specific part of the painting.

IMPASTO ~ Paint applied sufficiently thickly to stand proud of the painting surface. Impastos can be put on either with a brush or a knife. Special mediums are sold for bulking out paint for this kind of work.

IMPRIMATURA ~ A layer of colour applied to a GROUND, often used as a middle tone in a painting. See also COLOURED GROUND.

LIFTING OUT ~ A technique used in watercolour and gouache work, involving removing wet or dry paint from the paper with a brush, sponge or tissue to soften edges or make highlights. Wet paint is often lifted out to create cloud effects.

LINEAR PERSPECTIVE ~ Method of representing space by means of the optical illusion which causes distant objects to appear smaller and receding parallel lines to meet at a point on the horizon (the viewer's eye level).

LOCAL COLOUR ~ The actual colour of an object, regardless of the effects created by light or distance.

MAHLSTICK ~ A piece of bamboo or dowel rod with a pad at one end, used for steadying the hand when painting fine details, or in pastel work, to prevent the hand resting on already laid pastel colour and smudging it.

MASKING ~ Masking methods are often used for reserving highlights in watercolour work. The commonest is masking fluid, a rubbery substance painted onto the paper before paint is laid and removed after the paint has dried. For clear, straight edges, masking tape can be used ~ in oils and acrylics as well as watercolour.

MEDIUM 1 The material used for painting (or drawing), i.e. oil, watercolour, acrylic, pastel.
2 Another term for BINDER, a substance used in the manufacture of paint.
3 Substances added to the paint while working to make it thicker, thinner, more glossy and so on. These may be traditional mediums such as poppy oil and linseed oil, or synthetic ones, such as Liquin, Wingel, Oleopasto or acrylic medium.

MODELLING ~ Making an object appear solid and three-dimensional, achieved by gradations of TONE and colour.

OPTICAL MIXING ~ Placing small areas of colour side by side so that when seen from a distance they appear to make a third colour. Colour printing is based on the same system. In painting, the best effects are achieved by keeping the colours close together in tone, for example, a very light yellow and a deep blue will not mix optically to make green.

OX GALL ~ A medium sometimes used in watercolour work to improve the flow of the paint.

PALETTE ~ 1 The object on which paints are mixed. The traditional oil-painting palette is a flat, shaped piece of wood. A wide variety of different palettes are sold for watercolour work, from small, deep dishes to a rimmed plastic version of the oil palette.
2 The kind of colours used in a painting, or those an artist habitually uses i.e. a "limited palette"; a "palette of primaries"; a "cool palette".

PICTURE PLANE ~ The plane occupied by the physical surface of the picture. In most REPRESENTATIONAL PAINTING, all the elements in the picture appear to recede from this plane, while TROMPE L'OEIL effects are achieved by painting objects in such a way that they seem to project in front of the picture plane.

PIGMENT ~ Finely ground particles of colour which form the basis of all paints, including pastels. In the past, pigments came from a wide variety of mineral, plant and animal sources, but most are now synthetically made.

PLEIN AIR ~ A French term describing paintings done in the open air direct from the subject. Plein air painting became fashionable in the 19th century, and was central to the Impressionist movement.

PRIMARY COLOURS ~ Those colours which cannot be made from mixtures of other colours. The primaries are red, yellow and blue.

PRIMER, PRIMING ~ Priming a canvas, board or other SUPPORT simply means laying a GROUND. The paints specifically made for this purpose are sometimes called primers. The most commonly used nowadays is acrylic GESSO, which provides a suitable ground for both oil and acrylic work.

RECEDING COLOURS ~ Cool colours, such as blues, blue-greens and blue-greys, which seem to recede from the viewer,

while the warm, strong colours come forward (see ADVANCING COLOURS).

REPRESENTATIONAL PAINTING ~ Another term for figurative painting.

SATURATED COLOUR ~ Pure, intense colour, unmixed with any black or white.

SCRAPING BACK ~ Small, linear highlights are often made by scratching into dry watercolour or wet oil paint with the point of a knife or similar implement. When used for oils, the technique is usually referred to as SGRAFFITO. Broader effects can also be achieved in oil paintings by scraping off whole areas of wet paint with a palette knife to give a misty, veil-like impression.

SCUMBLING ~ A technique used in all the opaque media including pastels. Scumbling involves dragging a dry, rather thick layer of colour in a deliberately uneven fashion over a dried layer of another colour, thus creating attractive BROKEN COLOUR effects.

SECONDARY COLOURS ~ The colours made by a mixture of two of the PRIMARY COLOURS. Green, orange and purple are all secondary colours.

SGRAFFITO ~ This, an extension of the SCRAPING BACK method, is particularly associated with oil paints and oil pastels. A layer of colour is scratched into with a point to reveal either another layer of colour below or the white of the ground, thus making a linear pattern.

SIZE ~ A form of glue, traditionally made from animal skins, used for sealing canvas or unprimed board before an oil GROUND is put on. Size should not be used with acrylic PRIMER, as this is intended to be applied directly to the surface.

Index
· · · · · ·

SQUARING UP ~ the traditional method of enlarging and transferring a WORKING DRAWING to the painting surface. A grid of squares is ruled over the drawing, and a similar grid, with larger squares, on the painting surface. The information is then transferred from one to the other.

SUPPORT ~ Another word for the painting surface. A support can be anything, from paper to canvas or a wood panel.

TEMPERA ~ Originally, all water-based paint "tempered" with some form of gum was known as tempera, but the term is now used mainly for egg tempera, which was the main painting medium before the development of oil paints. Tempera is a tricky medium to use, but can achieve beautiful effects, and after centuries of neglect it is now enjoying something of a revival.

TERTIARY COLOURS ~ The colours made by mixing the three primary colours or one primary and one secondary, i.e. green (blue + yellow) and red.

TONE ~ The lightness or darkness of a colour, irrespective of its HUE.

TONED GROUND ~ Another name for COLOURED GROUND, particularly where the tone rather than the colour is the important factor.

TONKING ~ Removing surplus oil paint from the canvas by laying a sheet of absorbent paper over it, a correction method used when the surface has become too heavily loaded with paint to allow further work.

TROMPE L'OEIL ~ This French phrase meaning "deceives the eye" is applied to a painting (or object in a painting) which tricks the spectator into believing it is solid rather than a two-dimensional illusion.

UNDERDRAWING ~ A drawing made on the painting surface with a pencil, charcoal or a brush, to act as a guide for the colour.

UNDERPAINTING ~ At one time all oil paintings were begun by making a monochrome underpainting in tone, which was built up to an elaborate stage before the colour was applied on top. The practice went out of favour when the Impressionists' ALLA PRIMA approach became widely accepted, but some artists still work in this way.

VALUE ~ An alternative word for TONE, mainly used in the US.

WET INTO WET ~ Laying a new colour before the previous one has dried. In watercolour, this creates a variety of effects, from softly blended colours to colour "bleeds" and BACKRUNS. In oils the effects are less dramatic, but each new colour is slightly modified by those below and adjacent, so that forms and colours merge into one another without hard boundaries.

WET ON DRY ~ Laying new (wet) colour over a dried layer below.

WORKING DRAWING ~ A drawing made specifically as a basis for a painting, usually from earlier studies and/or photographs. Unlike a sketch, a working drawing establishes the whole composition, and is usually transferred to the painting surface by SQUARING UP or some similar method.

Credits

· · · · · ·

Quarto would like to thank all the artists who kindly submitted work for this book, especially the following, who carried out demonstrations but whose names do not appear in the captions:

Jean Canter 172, 174 ~ David Carr 13-14, 35-36 ~ Rosalind Cuthbert 150, 151, 152, 154, 163 right, 182, 182 left, 192, 193, 194 ~ David Ferry 202, 203, 212 ~ Ellie Gallwey 78-80 ~ Kay Gallwey 20-22, 36-37, 56-57, 70-72, 211 ~ Jeremy Galton 31-32 ~ Hazel Harrison 183 right ~ James Horton 44-46, 74-76 ~ John Lidzey 52-55 ~ Philip Wildman 62-64.

We would also like to thank the following museums and galleries for permission to reproduce works in their collections:

Cleveland Gallery Middlesborough 22 ~ Kirklees Metropolitan Council, Bagshaw Museum, Batley 59 ~ National Gallery of Scotland 94-5 ~ reproduced by courtesy of the Trustees, The National Gallery, London 98-9 ~ Schmidt Bingham Gallery, New York 100 (bottom) ~ Courtauld Institute Galleries, London 102 ~ courtesy National Portrait Gallery 104 ~ Yale University Art Gallery 106-7 ~ The Turner Collection, Tate Gallery, London 114-5 ~ reproduced by courtesy of the Trustees, The National Gallery, London 118-9 ~ courtesy of the owner, David Sprakes 120 ~ Royal Academy, London 122 ~ courtesy England & Co. 124 ~ Courtauld Institute Galleries, London 126-7 ~ Musée d'Orsay (c) PHOTO R.M.N. 130 ~ (c) Detroit Institute of Arts (gift of Mr & Mrs Bert L. Smokler & Mr & Mrs Lawrence A. Fleischman) 134-5 ~ Tate Gallery, London 138-9, 144-5 ~ 146 The Mayor Gallery

Special thanks to F. Hegner & Son, 13 South End Road, London, and Langford & Hill Ltd., 38-40 Warwick Street, London W1, for the loan of artist's materials.